DAVID BUSCH'S CANON® POWERSHOT G12

GUIDE TO DIGITAL PHOTOGRAPHY

David D. Busch | Alexander S. White

Course Technology PTR

A part of Cengage Learning

COURSE TECHNOLOGY
CENGAGE Learning™

Australia, Brazil, Japan, Korea, Mexico, Singapore, Spain, United Kingdom, United States

COURSE TECHNOLOGY
CENGAGE Learning™

David Busch's Canon® PowerShot G12 Guide to Digital Photography
David D. Busch | Alexander S. White

Publisher and General Manager, Course Technology PTR:
Stacy L. Hiquet

Associate Director of Marketing:
Sarah Panella

Manager of Editorial Services:
Heather Talbot

Marketing Manager:
Jordan Castellani

Executive Editor:
Kevin Harreld

Project Editor:
Jenny Davidson

Technical Reviewer:
Michael D. Sullivan

Interior Layout Tech:
Bill Hartman

Cover Designer:
Mike Tanamachi

Indexer:
Katherine Stimson

Proofreader:
Sara Gullion

For product information and technology assistance, contact us at **Cengage Learning Customer & Sales Support, 1-800-354-9706.**

For permission to use material from this text or product, submit all requests online at **cengage.com/permissions**. Further permissions questions can be e-mailed to **permissionrequest@cengage.com**.

Library of Congress Control Number: 2010941293

ISBN-13: 978-1-4354-5950-2

ISBN-10: 1-4354-5950-4

Course Technology, a part of Cengage Learning
20 Channel Center Street
Boston, MA 02210
USA

Cengage Learning is a leading provider of customized learning solutions with office locations around the globe, including Singapore, the United Kingdom, Australia, Mexico, Brazil, and Japan. Locate your local office at: **international.cengage.com/region**.

Cengage Learning products are represented in Canada by Nelson Education, Ltd.

For your lifelong learning solutions, visit **courseptr.com**.

Visit our corporate Web site at **cengage.com**.

Printed in the United States of America
1 2 3 4 5 6 7 13 12 11

For Cathy and Clenise

Acknowledgments

Once again thanks to the folks at Course Technology PTR, who have pioneered publishing digital imaging books in full color at a price anyone can afford. Special thanks to executive editor Kevin Harreld, who always gives me the freedom to let my imagination run free with a topic, as well as my veteran production team, including project editor Jenny Davidson and technical reviewer Mike Sullivan. Also thanks to Bill Hartman, layout; Katherine Stimson, indexing; Sara Gullion, proofreading; Mike Tanamachi, cover design; and my agent, Carole Jelen, who has the amazing ability to keep both publishers and authors happy.

About the Authors

With more than a million books in print, **David D. Busch** is one of the best-selling authors of books on digital photography and imaging technology, and the originator of popular series like *David Busch's Pro Secrets* and *David Busch's Quick Snap Guides*. He has written eight hugely successful guidebooks for Canon digital camera models, including the all-time #1 bestsellers for several Canon EOS models, additional user guides for other camera models, as well as many popular books devoted to digital cameras, including *Mastering Digital SLR Photography, Third Edition* and *Digital SLR Pro Secrets*. As a roving photojournalist for more than 20 years, he illustrated his books, magazine articles, and newspaper reports with award-winning images. He's operated his own commercial studio, suffocated in formal dress while shooting weddings-for-hire, and shot sports for a daily newspaper and upstate New York college. His photos have been published in magazines as diverse as *Scientific American* and *Petersen's PhotoGraphic*, and his articles have appeared in *Popular Photography & Imaging, The Rangefinder, The Professional Photographer*, and hundreds of other publications. He's also reviewed dozens of digital cameras for CNet and *Computer Shopper*.

When About.com named its top five books on Beginning Digital Photography, debuting at the #1 and #2 slots were Busch's *Digital Photography All-In-One Desk Reference for Dummies* and *Mastering Digital SLR Photography*. During the past year, he's had as many as five of his books listed in the Top 20 of Amazon.com's Digital Photography Bestseller list—simultaneously! Busch's 100-plus other books published since 1983 include bestsellers like *David Busch's Quick Snap Guide to Using Digital SLR Lenses*.

Busch is a member of the Cleveland Photographic Society (www.clevelandphoto.org), which has operated continuously since 1887.

Visit his website at http://www.dslrguides.com/blog

Alexander S. White is an attorney, writer, and amateur photographer. He is the author of *Photographer's Guide to the Leica D-Lux 4: Getting the Most from Leica's Compact Digital Camera* and *Dauntless Marine: Joseph Sailer Jr., Dive-Bombing Ace of Guadalcanal*. He began his life-long interest in photography as a teenager, when he was fortunate enough to have his own darkroom in his parents' house in Philadelphia. He also discovered the magic of Super-8 cinematography, and coerced his friends into making numerous amateur productions. He later ventured into the production of sound films and went on to major in Communication at Stanford University, concentrating in Broadcasting and Film, before serving in the U.S. Army and later attending the University of Pennsylvania Law School. His other interests include genealogy; he maintains a family history website and continues to research his family's ancestry. He lives near Richmond, Virginia, with his wife, Clenise.

Contents

**PART I
GETTING STARTED WITH YOUR
CANON POWERSHOT G12**

Chapter 1
Your New Canon PowerShot G12 5

Chapter 2
Taking Your First Canon PowerShot G12
Photos 25

Chapter 3
Canon PowerShot G12 Roadmap　　　　45

Chapter 4
Setting Up Your Canon PowerShot G12　　　69

PART II
GETTING THE MOST FROM
YOUR CANON POWERSHOT G12

Chapter 5
Fine-Tuning Exposure 131

Chapter 6
Advanced Shooting and Movie Making with Your Canon PowerShot G12 169

Chapter 7
Getting the Most from Your Zoom 203

Chapter 8
Making Light Work for You 225

Chapter 9
Downloading and Editing Your Images 255

Glossary 271

Index 281

Preface

You don't want good pictures from your new Canon PowerShot G12—you demand *outstanding photos.* After all, the PowerShot G12 is the most advanced pocket-sized digital camera that Canon has ever introduced. It boasts 10 megapixels of resolution, blazing fast automatic focus, and a dozen and a half special Scene modes that make it easy to take pictures under any type of conditions. But your gateway to pixel proficiency is dragged down by the slim little book included on the CD in the box. You know everything you need to know is in there, somewhere, but you don't know where to start. In addition, the camera manual doesn't offer much information on photography or digital photography. Nor are you interested in spending hours or days studying a comprehensive book on digital camera photography that doesn't necessarily apply directly to your G12.

What you need is a guide that explains the purpose and function of the G12's basic controls, how you should use them, and *why.* Ideally, there should be information about file formats, resolution, aperture/priority exposure, and special autofocus modes, but you'd prefer to read about those topics only after you've had the chance to go out and take a few hundred great pictures with your new camera. Why isn't there a book that summarizes the most important information in its first two or three chapters, with lots of illustrations showing what your results will look like when you use this setting or that?

Now there is such a book. If you want a quick introduction to the G12's focus controls, flash, how to use the focal lengths available with the 5X zoom lens, or which exposure modes are best, this book is for you. If you can't decide on what basic settings to use with your camera because you can't figure out how changing ISO or white balance or focus defaults will affect your pictures, you need this guide.

Introduction

Canon has done it again! It's packaged up many of the most alluring features of its advanced digital SLR cameras and stuffed them into the tiny, pocket-sized confines of the Canon PowerShot G12 camera. Your new camera is loaded with capabilities that few would have expected to find in a "point-and-shoot" digital camera. The G12 gets the most image quality out of its 10-megapixel sensor with astounding high-sensitivity performance that tops out at ISO 12,800!

Yet, the G12 retains the ease of use that smoothes the transition for those new to digital photography. For those just dipping their toes into the digital pond, the experience is warm and inviting. The PowerShot G12 isn't a snapshot camera—it's a point-and-shoot (if you want to use it in that mode) for the thinking photographer.

But once you've confirmed that you made a wise purchase decision, the question comes up, *how do I use this thing?* All those cool features can be mind numbing to learn, if all you have as a guide is the manual furnished with the camera. Help is on the way. I sincerely believe that this book is your best bet for learning how to use your new camera, and for learning how to use it well.

If you're a Canon PowerShot G12 owner who's looking to learn more about how to use this great camera, you've probably already explored your options. There are DVDs and online tutorials—but who can learn how to use a camera by sitting in front of a television or computer screen? Do you want to watch a movie or click on HTML links, or do you want to go out and take photos with your camera? Videos are fun, but not the best answer.

There's always the manuals furnished with the G12. Furnished on the CD, they are compact and filled with information, but inconvenient to carry around, and there's really very little about *why* you should use particular settings or features, and its organization may make it difficult to find what you need. Multiple cross-references may send you flipping back and forth between two or three sections of the book to find what you want to know. The basic manual is also hobbled by black-and-white line drawings and tiny monochrome pictures that aren't very good examples of what you can do.

Also available are third-party guides to the G12, like this one. I haven't been happy with some of these guidebooks, which is why I wrote this one. The existing books range from skimpy and illustrated by black-and-white photos to lushly illustrated in full color but too generic to do much good. Photography instruction is useful, but it needs to be related directly to the Canon PowerShot G12 as much as possible.

I've tried to make *David Busch's Canon PowerShot G12 Guide to Digital Photography* different from your other G12 learn-up options. The roadmap sections use larger, color pictures to show you where all the buttons and dials are, and the explanations of what they do are longer and more comprehensive. I've tried to avoid overly general advice, including the two-page checklists on how to take a "sports picture" or a "portrait picture" or a "travel picture." Instead, you'll find tips and techniques for using all the features of your Canon PowerShot G12 to take *any kind of picture* you want. If you want to know where you should stand to take a picture of a quarterback dropping back to unleash a pass, there are plenty of books that will tell you that. This one concentrates on teaching you how to select the best autofocus mode, shutter speed, f/stop, or flash capability to take, say, a great sports picture under any conditions.

This book is not a lame rewriting of the manual that came with the camera. Some folks spend five minutes with a book like this one, spot some information that also appears in the original manual, and decide "Rehash!" without really understanding the differences. Yes, you'll find information here that is also in the owner's manual, such as the parameters you can enter when changing your G12's operation in the various menus. Basic descriptions—before I dig in and start providing in-depth tips and information—may also be vaguely similar. There are only so many ways you can say, for example, "Hold the shutter release down halfway to lock in exposure." But not *everything* in the manual is included in this book. If you want a large table showing which settings are available in each of the various Image Zone and Creative Zone modes, you'd better have the Functions Available in Each Shooting Mode Table in the original manual. But if you need advice on when and how to use the most important functions, you'll find the information here.

David Busch's Canon PowerShot G12 Guide to Digital Photography is aimed at both Canon and digital camera veterans as well as newcomers to digital photography and digital cameras. Both groups can be overwhelmed by the options the G12 offers, while underwhelmed by the explanations they receive in their user's manual. The manuals are great if you already know what you don't know, and you can find an answer somewhere in a booklet arranged by menu listings and written by a camera vendor employee who last threw together instructions on how to operate a camcorder.

Why the Canon PowerShot G12 Needs Special Coverage

There are many general digital photography books on the market. Why do I concentrate on books about specific digital cameras like the PowerShot G12? One reason is that I feel digital photographers deserve books tailored to their equipment.

When I started writing digital photography books in 1995, digital cameras cost $30,000 and few people other than certain professionals could justify them. Most of my readers a dozen years ago were stuck using the point-and-shoot low-resolution digital cameras of the time—even if they were advanced photographers. I took tons of digital pictures with an Epson digital camera with 1024×768 (less than 1 megapixel!) resolution, and which cost $500.

Today, that same $500 buys you a sophisticated model like the Canon PowerShot G12. The digital camera is no longer the exclusive bailiwick of the professional, the wealthy, or the serious photography addict willing to scrimp and save to acquire a dream camera. Digital cameras have become the favored camera for anyone who wants to go beyond point-and-shoot capabilities. And Canon cameras have enjoyed a dominating position among digital cameras because of Canon's innovation in introducing affordable cameras with interesting features and outstanding performance (particularly in the area of high ISO image quality).

You've selected your camera of choice, and you belong in the Canon camp if you fall into one of the following categories:

- Individuals who want to get better pictures, or perhaps transform their growing interest in photography into a full-fledged hobby or artistic outlet with a PowerShot G12 and advanced techniques.

- Those who want to produce more professional-looking images for their personal or business website, and feel that the PowerShot G12 will give them more control and capabilities than the typical fully automatic point-and-shoot camera.

- Small business owners with more advanced graphics capabilities who want to use the PowerShot G12 to document or promote their business.

- Corporate workers who may or may not have photographic skills in their job descriptions, but who work regularly with graphics and need to learn how to use digital images taken with a Canon PowerShot G12 for reports, presentations, or other applications.

- Professional webmasters with strong skills in programming (including Java, JavaScript, HTML, Perl, etc.) but little background in photography, but who realize that the G12 can be used for sophisticated photography.

- Graphic artists and others who already may be adept in image editing with Photoshop or another program, and who may already be using a film camera (Canon or otherwise), but who need to learn more about digital photography and the special capabilities of the G12 digital camera.

Who Are We?

After spending years as the world's most successful unknown author, I've become slightly less obscure in the past few years, thanks to a horde of camera guidebooks and other photographically oriented tomes. You may have seen my photography articles in *Popular Photography & Imaging* magazine. I've also written about 2,000 articles for magazines like *Petersen's PhotoGraphic* (which is now defunct through no fault of my own), plus *The Rangefinder*, *Professional Photographer*, and dozens of other photographic publications. You might have caught my advice on National Public Radio's *All Tech Considered*. But, first, and foremost, I'm a photojournalist and made my living in the field until I began devoting most of my time to writing books.

Although I love writing, I'm happiest when I'm out taking pictures, which is why I invariably spend several days each week photographing landscapes, people, close-up subjects, and other things. I spend a month or two each year traveling to events, such as Native American "powwows," Civil War re-enactments, county fairs, ballets, and sports (baseball, basketball, football, and soccer are favorites). Recently, I took 14 days for a solo visit to Europe, strictly to shoot photographs of the people, landscapes, and monuments that I've grown to love. And in the months prior to starting on this book, I spent time in Arizona, catching up on baseball Spring Training and natural wonders like the Sedona Red Rocks and the Grand Canyon. I can offer you my personal advice on how to take photos under a variety of conditions because I've had to meet those challenges myself on an ongoing basis.

Like all my digital photography books, this one was written by someone with an incurable photography bug. My first Canon camera was a Pellix back in the 1960s, and I've used a variety of newer models since then. I've worked as a sports photographer for an Ohio newspaper and for an upstate New York college. I've operated my own commercial studio and photo lab, cranking out product shots on demand and then printing a few hundred glossy 8 × 10s on a tight deadline for a press kit. I've served as a photoposing instructor for a modeling agency. People have actually paid me to shoot their weddings and immortalize them with portraits. I even prepared press kits and articles on photography as a PR consultant for a large Rochester, N.Y., company, which shall remain nameless. My trials and travails with imaging and computer technology have made their way into print in book form an alarming number of times, including a few dozen on scanners and photography.

Like you, I love photography for its own merits, and I view technology as just another tool to help me get the images I see in my mind's eye. But, also like you, I had to master this technology before I could apply it to my work. This book is the result of what I've learned, and I hope it will help you master your PowerShot G12 digital camera, too.

As I write this, I'm currently in the throes of upgrading my website and blog, which you can find at www.dslrguides.com/blog, adding tutorials and information about my other books. I'll be adding more tips and recommendations (including a list of equipment and accessories that I can't live without) in the next few months. I hope you'll stop by for a visit.

Meet My Co-Author, Alex

I am very happy and grateful to have, with this book, my latest foray into the "big leagues" of digital photography guidebooks. Like David, I have had a love affair with photography since the 1960s, when, as a teenager, my tolerant parents allowed me to set up a very smelly darkroom in the basement of their Philadelphia home. I was entranced by the process of rolling the exposed film onto a plastic spool, sealing it in a tank, and later placing the developed negatives into an enlarger to produce what to me seemed like great works of photographic art. For those who have long memories or a love of older movies, I must say that one strong influence that sparked my love of the darkroom was the terrific film *Blow-up* by Antonioni, which deepened the mystique of enlarging at leisure an image that was captured by the lens and film in an instant, and that may hold the key to an intriguing and disturbing mystery. I ventured into amateur cinematography and tried my best to emulate the great director, but I'm afraid my Super-8 productions fell a few lightyears short.

Later, after studying broadcasting and film at Stanford, I got sidetracked by military service for a few years, and I guess it was my more practical side that guided me to law school, like several family members before me. But I have kept up with photography and filmmaking through the transitions to digital photography and video. I have used a wide array of equipment, and have been continually amazed at the increasing sophistication of the cameras that have become available in recent years. Finally, when I got a Leica D-Lux 4 in 2009, I was so impressed by the camera that I felt compelled to write a book about its use. No one asked me to write that book; I just wanted to do it. Because of that book, though, I was asked to help David write additional books in his series. I am immensely pleased to have this opportunity to share some of my love of photography and of modern digital cameras with a wider audience.

Part I

Getting Started with Your Canon PowerShot G12

This Part consists of four chapters designed to help you get up and running with the Canon PowerShot G12. Of course, there's a distinct possibility that you've already *done* that prior to opening this book for the first time. You may have taken a few hundred or a few thousand photos with your PowerShot already. Indeed, this camera appeals directly to the sort of avid photographer who is likely to have jumped in and conducted some warmly rewarding experiments with the camera before deciding to buckle down with this book and learn all its features.

Why not? The PowerShot is incredibly easy to use. The initial steps, including charging the battery and inserting a Secure Digital memory card aren't exactly rocket science. Every control you need to begin snapping pictures is nestled on the top surface. There's a power button (cleverly labeled ON/OFF), the shutter release button, a large mode dial that includes an Auto position labeled with green text (plus other settings including one that looks suspiciously like an old-time movie camera), and a zoom lever, located concentrically with the shutter release. The rawest neophyte can turn on the camera, spin the dial to one of those settings, and begin shooting. If you are an old hand with some experience with digital cameras, getting started with the G12 is even more of a no-brainer.

But, even if you didn't march out of a camera store with a G12 box under one arm, and my book in hand, you're probably ready to learn more. It's not a bad idea, once you've taken a few (hundred) orientation pictures with your camera, to go back and review the basic operations of the camera from the beginning, if only to see if you've missed something. This Part is my opportunity to review the Set up procedures for the camera for those among you who are already veteran users, and to help ease the more timid (and those who have never worked with a digital camera before). For the uninitiated, as easy as it is to use initially, the PowerShot *does* have lots of dials and buttons and settings that might not make sense at first, but will surely become second nature after you've had a chance to review the instructions in this chapter and the next one.

Other camera guides I've seen throw you off the dock into deep water and expect you to learn how to swim before you go under for the third time. I've found that a more gentle approach works better. Depending on your experience level, you can either skim through the four chapters in this Part quickly, or pore over them attentively, soaking up the information you need to hit the ground running. (Don't worry: the PowerShot includes a feature called *image stabilization* that will help you avoid blurry images if you try to shoot while hitting the ground and/or running. Your Canon is more than a match for any metaphor!)

Start with any of these four chapters:

- **If you need help in setting up your camera, read:** *Chapter 1: Your New Canon PowerShot G12.* This chapter introduces you to the Canon PowerShot, and will help sort out the array of things found in the compact box your camera came in as you prep the camera for your first shots. I'll explain what each and every item is, how you'll be using it, and provide a list of must-have items you'll want to check out as soon as possible. You'll find a summary of a few nice-to-have accessories to consider, too. By the time you finish this brief chapter, you'll have your camera's battery charged and inserted, your digital "film" ready to capture photos, and a basic understanding of the camera and its key accessories.

- **If you want a quick start to snapping great shots right away, begin with:** *Chapter 2: Taking Your First Canon PowerShot G12 Photos.* Here, I'll guide you through a pre-flight checklist of actually taking your first pictures. Rather than bog you down with excessive detail, I'll leave discussions of the more advanced features for the other Parts of the book. Indeed, I'm going to tell you just what you absolutely *must* understand, accompanied by some interesting tidbits that will help you become acclimated. I'll go into more depth and even repeat some of what I explain here in later chapters, so you don't have to memorize everything you see. Just relax, follow a few easy steps, and then go out and begin taking your best shots—ever.

- **If you know the basics and want a quick introduction to the controls, go to:** *Chapter 3: Canon PowerShot G12 Roadmap.* There are lots of buttons and dials on your PowerShot camera. That may be intimidating but, actually, this is a *good* thing, because your G12 provides direct control over many functions, such as shooting mode, sensor sensitivity, and exposure adjustments. Many lesser cameras (including most point-and-shoot models) send you off to a command buried in a menu each time you want to change some of these functions. This chapter provides a street-level roadmap of all those controls.

- **If you want to jump ahead and begin customizing the camera's settings, start with:** *Chapter 4: Setting Up Your Canon PowerShot G12.* The PowerShot G12 has so many cool features that you will need to access its well-designed menu system to use some of them. This chapter explains all the Shooting menu settings (which you'll adjust from time to time as you take pictures), the Set up menu settings (which you can often set and forget, until you need to change how your camera behaves), and even ways to design your own custom menu with the commands that you use most often.

Your New Canon PowerShot G12

Your PowerShot G12 represents the latest Canon technology in the Canon PowerShot G series, and judging by the reception afforded by serious photographers, the G12 and its predecessors in this series (most recently, the G10 and G11) are easily the most popular cameras in the PowerShot line yet. That's because they combine the small size, portability, and ease of use of point-and-shoot digital cameras with the high image equality and control that avid photographers—both professional and amateur—demand. Indeed, the G12 and its recent precursors are among the first cameras in a long time that are serious contenders as a "second" or "walk-around" camera for those who use a more advanced digital SLR, too.

That's why I purchased my G12. I wanted a smaller camera to carry around all the time, but I wasn't willing to give up image quality or creative control. Many other happy PowerShot G-series owners are photographers who are stepping up from a less-capable point-and-shoot-type camera, because they need the options and extra capabilities, including the 10-megapixel (MP) resolution, low-light performance, and HD video capability, among other features, that this camera offers. No other cameras I've seen have been as popular among serious shooters of all types as the G10, G11, and G12. In fact, I decided to write this book after overhearing a "pro" photographer at a camera club explaining why he loved this camera to several dedicated amateur photographers—who also had selected the PowerShot G12 as their no-compromise "pocket" camera.

TECHIE ALERT

I'll explain about megapixels, LCD displays, telephoto/wide-angle zoom ranges, and movie-making as we continue with this book. I included technical gobbledygook in this introduction as a summary for the photo-techie types the PowerShot G12 seems to attract. If you're not of that ilk, you can learn these terms later, as you don't need to understand them to continue with this chapter.

Of course, the Canon PowerShot G12 does not really fit in a pocket, unless you're sporting a photo vest or are of the marsupial persuasion. This camera, to a certain extent, follows in the tradition of the 35mm *rangefinder* film camera, including the pioneering Leica models, which were solid, well-made compact cameras prized for their image quality, quiet operation, precision construction, and versatility. The G12 departs from that model substantially. For example, it comes equipped with a 28-140mm (full-frame equivalent) non-interchangeable automatic focus zoom lens instead of a complement of Leica-style fixed focal length manual focus non-zoom lenses. Nor is there a rangefinder focus viewfinder, although the G12 does retain a vestigial optical window for framing pictures. Instead, most viewing of images prior to exposure is done using a swiveling 2.8-inch LCD, which does triple duty as the display for pictures *after* they've been taken (something not possible with a film camera at all) and for showing menus used to select camera features.

In truth, the G12 is an evolutionary descendant of a whole line of PowerShot models, especially from the G6 through the G11 (though there was no G8). By the time the PowerShot G series evolved as far as the G9, it had a 12 MP sensor, a 3-inch LCD, and a body very similar to that of the G12, although the 10 MP G12 has double the number of pixels in its backlit display. By the time the species matured into the G10 and G11, you would have an even harder time distinguishing them from the G12 based on their appearance. However, there are powerful distinctions if you take a close look at the newest model. Although the G12 has a 10 MP sensor, its sensitivity in low light has increased dramatically, giving it a range all the way up to a stratospheric 12,800 ISO (though with limitations at that level). The new camera also has a newly enhanced optical image stabilization system that is specifically designed to keep your images free of blur from camera shake, even when shooting extreme close-ups, when any camera movement is magnified because of the proximity to the subject. The camera also now gives you the choice of shooting your images in various different aspect ratios, so you can vary the shape of your pictures while shooting them. Finally, the G12 has had its video-making capabilities enhanced by the inclusion of 720p HD (High Definition) video with stereo sound and special slow frame rates that are used as special effects in order to make your video of a normal-sized scene appear to be footage of a miniaturized model.

Contents of the Table

You probably spread out on a table or desk the contents of the handsome box that transported the Canon PowerShot from its birthplace in Japan. The box is filled with stuff, including connecting cords, booklets, a CD, and lots of paperwork. The first thing you should do (or the *next* thing you should do, if you've already been taking pictures with your camera) is to double-check the contents of the box to make sure nothing was left out, or accidentally removed by the retailer. Someone might have checked out the camera for you as a quality assurance method, or a curious store employee might have rooted through the box to see what this cool new camera actually looks like. In either case, it's entirely possible that something went astray, and it's good to know that *now,* when you can easily bring any missing pieces to the attention of the store that sold you the camera. Otherwise, a month down the road, you're going to decide to see what the output of your PowerShot looks like on your TV screen, and discover that the video cable you *thought* you had has gone AWOL at some unknown time.

So, check the box at your earliest convenience, and make sure you have (at least) the following:

- **Canon PowerShot G12 camera.** This is hard to miss. The camera is the main reason you laid out the big bucks, and it is tucked away inside a soft envelope you should save for protection in case the G12 ever needs to be sent in for repair.

- **Battery pack NB-7L (with terminal cover).** The power source for your PowerShot G12 is packaged separately. You'll need to charge this 7.4V, 1050mAh (milliampere hour) battery before using it. It should be charged as soon as possible (as described next) and inserted in the camera. Save the protective cover. If you transport a battery outside the camera, it's a good idea to re-attach the cover to prevent the electrical contacts from shorting out.

- **Battery charger CB-2LZ or CB-2LZE.** One of these two battery chargers will be included. They are similar, except that the CB-2LZ plugs directly into the wall, while the CB-2LZE uses a cord.

- **Neck strap NS-DC9.** Canon provides you with a suitable neck strap, emblazoned with discreet Canon advertising proclaiming the brand name. Unlike the straps provided with some other cameras, the Canon strap is low-key enough that it doesn't attract unwanted attention from potential thieves. It's entirely acceptable as a "starter" strap. However, if you want a strap that won't easily slip off your shoulder, I recommend the RF-PS, which is made especially for smaller cameras like the Leica M series and Canon PowerShot G-series. It has a patented non-slip pad and 3/8-inch webbed strap, and can be found at www.upstrap.com. (See Figure 1.1.) The strap offers reassuring traction and eliminates the contortions we sometimes go through to keep the camera from slipping off. I know several photographers who refuse to use anything else. If you do purchase an UPstrap, be sure you mention to

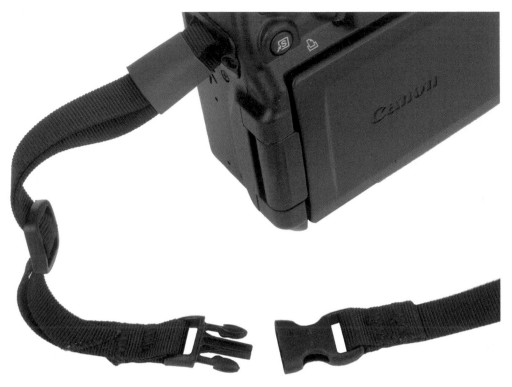

Figure 1.1
You'll probably like a non-slip premium strap like the UPStrap better than the one Canon furnishes with the G12.

photographer-inventor Al Stegmeyer that I sent you hence. You won't get a discount, but Al will get yet another confirmation of how much I like his marvelous neck straps.

- **Interface Cable IFC-400PCU.** You can use this USB cable to transfer photos from the camera to your computer, although I don't recommend using that mode extensively, because direct transfer uses a lot of battery power. It is a standard cable, so you may be able to use it with other cameras you own, or keep it as a spare.

- **AV Cable AVC-DC400ST.** Use this cable to view your camera's LCD output on a larger television screen, monitor, or other device with a yellow RCA composite video input jack. Note that this cable, unlike those for earlier models, has two audio connectors—red and white—because the G12 has been enhanced with stereo sound for its movies.

- **Canon Digital Camera Solution CD.** The disc contains useful software that will be discussed in more detail in Chapter 9.

- **Instruction manuals.** These include the printed Canon PowerShot G12 Getting Started pamphlet, and, on the CD, the Camera User Guide, the Software Guide, and the Personal Printing Guide, in PDF format. Even if you have this book, you'll probably want to check the user's guides that Canon provides, if only to check the

actual nomenclature for some obscure accessory, or to double-check an error code. The CD-based user's guide at page 200 contains a mind-numbing two-page matrix that shows each of the functions available/not available in all 29 of the G12's Shooting/Scene/Movie modes. If you have an old SD card that's too small to be usable on a modern camera (I still have some 128MB and 256MB cards), you can copy the PDF of the user's guide to that. But an even better choice is to put the manual on a low-capacity USB "thumb" drive, which you can buy for less than $10. You'll then be able to access the reference anywhere you are, because you can always find someone with a computer that has a USB port and Adobe Acrobat Reader available. You might not be lucky enough to locate a computer with an SD card reader.

■ **Warranty and Canon Customer Support leaflet.** Don't lose these! You can register your Canon PowerShot G12 by mail or online. You don't really need to register the camera in order to keep your warranty in force, but you may need the information in this paperwork (plus the purchase receipt/invoice from your retailer) should you require Canon service support.

Don't bother rooting around in the box for anything beyond what I've listed previously. There are a few things that are not included with your camera that Canon classifies as optional accessories, even though you (and I) might consider some of them essential. Here's a list of what you *don't* get in the box, but might want to think about as an impending purchase. I'll list them roughly in the order of importance:

■ **Secure Digital (SD) card.** First-time digital camera buyers are sometimes shocked that their new tool doesn't come with a memory card. Why should it? The manufacturer doesn't have the slightest idea of how much storage you require, or whether you want a slow/inexpensive card or one that's faster/more expensive, so why should they pack one in the box and charge you for it? Plan on buying one right away if you don't already own one. For a camera like the PowerShot G12, with a generous-sized 10 MP of resolution and the ability to record RAW files and HD video, both of which eat up storage space voraciously, you shouldn't consider any card smaller than 4GB. This means you need an SDHC card (HC is for high capacity), not a plain SD card, which come in sizes only up to 2GB. A larger 8GB or 16GB card is an even better idea, especially if you travel on vacation or business and won't be able to transfer your photos from the camera to a computer on a daily basis. You can read about some of the latest memory card options in the section that follows this one.

■ **Extra Battery pack NB-7L.** Even though you might get 400 or more shots from a single battery, you very well may need to take more images than that on a single charge, especially given burst shooting, and not to mention recording video scenes, all of which can drain a battery before you know it. Batteries can unexpectedly fail, too, or simply lose their charge from sitting around unused for a week or two. Buy an extra, keep it charged, and free your mind from worry.

■ **Add-on Speedlite.** Your Canon PowerShot's built-in electronic flash is fine for snap-shots or as fill for inky shadows when shooting in daylight. But it can produce the dreaded "red-eye" effect (or yellow/green eyes in some animals) when people are looking directly at the camera lens, especially in a darkened environment. And, the built-in flash only illuminates a scene out to about 23 feet (at best). You may want an add-on electronic flash, such as the small High-Power Flash HF-DC1 that was designed especially for small cameras like the Canon PowerShot G12. This unit, which is furnished with a bracket that allows you to mount it side-by-side with the camera (see Figure 1.2), needs no connecting cord, as its firing is triggered by the main flash. You can also opt for even more powerful flash units, such as the top-of-the-line Canon 580EX II or the less expensive 270EX and 430EX II. I'll explain your options and how they affect your pictures in more detail in Chapter 8.

■ **AC Adapter Kit ACK-DC50.** This set includes the Compact Power Adapter CA-PS700 and DC Coupler DR-50, which are used with a supplied cord to power the G12 independently of the battery. There are several typical situations where this capability can come in handy: when indoors shooting tabletop photos, portraits, class pictures, and so forth for hours on end; when using your G12 for remote shooting as well as time-lapse photography (using external timer/remotes that are readily available from third parties); for extensive review of images on your television; or for file transfer to your computer. These activities all use prodigious amounts of power, which can be provided by this AC adapter.

■ **Remote switch RS60-E3.** This "cable release"-style control (for you old-timers) electronically triggers the camera's shutter when its button is pressed, allowing you to take an exposure without actually touching the camera and thereby creating blur-causing vibrations.

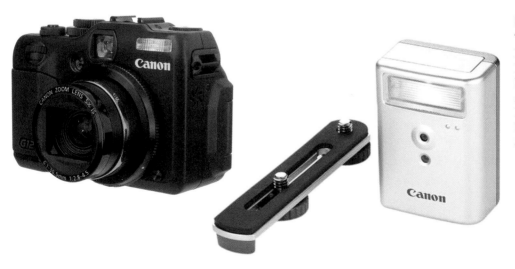

Figure 1.2
The High-Power Flash HF-DC1 boosts the range of the PowerShot's built-in Speedlite.

- **Conversion Lens Adapter LA-DC58K/Teleconverter TC-DC58D.** Although they are sold separately, you need both of these items. The teleconverter lens boosts the PowerShot's focal length to a range of 39mm-196mm, which is roughly the same range offered by the earlier PowerShot G9. You'd use this accessory when you wanted a little extra telephoto reach, and didn't care about narrowing your field-of-view at the wide-angle end. The Conversion Lens Adapter bayonets around the G-series camera's fixed lens, and the teleconverter screws into that. As Canon doesn't offer any other accessories for the lens adapter, they really should have been bundled together. While the adapter has a 58mm thread, it can produce darkened corners (*vignetting*) at many zoom settings. In Chapter 7, I'll describe alternative adapters from LensMate (www.lensmateonline.com) that are more versatile.

- **Other stuff.** There are other accessories you might find useful, including brackets, off-camera shoe cords for flash units, printers, and waterproof cases for underwater shooting, but I'll describe these as appropriate in other chapters as we go along.

Memory Card Variations

Nowadays, all new computers should be compatible with SDHC cards, which come in sizes from 4GB to 32GB. You might need to get a new card reader if you are using a reader more than a year or two old, because the older SD card readers cannot read SDHC cards. If you really want to flex your storage muscles, you can spring for one of the newest types of SD card, called the SDXC, for extended capacity. One of the enhanced capabilities of the PowerShot G12 is its ability to use these new super-storage cards. SDXC cards are currently available in capacities of 48GB or 64GB, which is more than enough for any application, except maybe doing photo IDs for the entire population of a small city. Theoretically, these cards can be made in capacities up to 2TB (terabytes), the equivalent of about 2,000GB. If you feel like splurging (which you'll have to do at current prices of at least $200) for an SDXC card, you need to be careful about compatibility, not just with the card reader (you'll likely need a new one), but with your computer.

At this writing, SDXC cards can be read by most computers using Windows 7, but most Macintosh computers cannot read these cards without a software patch. (An exception is the newest Mac Mini.) My MacBook Pro was unable to read an SDXC card at all (even through a USB connection to the camera) until I purchased a 21-in-1 Multimedia Memory Card Reader & Writer for ExpressCard/34 by a company called Sonnet (www.sonnettech.com). Luckily, my computer has an ExpressCard/34 slot to accommodate the reader; many computers don't have that type of slot. Also, I had to download a special driver from Sonnet's website to enable the computer to read the SDXC card, even with that new reader. Once I downloaded the driver, though, the MacBook Pro could read the card even when the images were transferred to the computer through

a USB connection to the camera. The message here is to be very careful about computer compatibility before investing in an SDXC card.

Your Canon PowerShot also accepts MultiMediaCard (MMC) memory cards, which look very similar to SD cards (but are slightly less thick), and which have been used in cell phones, digital audio players, and other devices. They have largely been supplanted by other media, which may be smaller and/or faster, but if you own some older MMC cards, you can use them with your G12. If your new cell phone requires a microSD card, you now have a use for the MMC card your old phone included.

Finally, there's one other option you may want to consider for your storage card. The PowerShot G12 provides compatibility with the Eye-Fi card, a special type of SDHC card that includes a tiny transmitter for transferring images directly to your computer over a wireless (Wi-Fi) network. The card works just like any other SDHC card, but, once the camera records an image (or video), the card immediately connects to your network and starts sending the image to your computer; you will see a little window open up on your computer's screen, and the file will be available for editing or viewing within a number of seconds or minutes, depending on its size. This is a terrific technology that can provide a real boost to your productivity if you shoot a lot of images, such as in a studio or laboratory environment.

Initial Setup

The initial setup of your Canon PowerShot G12 is fast and easy. Basically, you just need to charge the battery, attach the strap, and insert a memory card. I'll address each of these steps separately, but if you already feel you can manage these setup tasks without further instructions, feel free to skip this section entirely. You should at least skim its contents, however, because I'm going to list a few options that you might not be aware of.

Battery Included

Your Canon PowerShot is a sophisticated hunk of machinery and electronics, but it needs a charged battery to function, so rejuvenating the NB-7L lithium-ion battery pack furnished with the camera should be your first step. A fully charged power source should be good for approximately 370 shots under normal temperature conditions, or up to 1,000 shots if the LCD is switched off. (In that case, you'd be using the optical viewfinder to frame your images, and not reviewing them after they are taken.) If you use the built-in flash, expect to achieve fewer shots per battery charge. Remember that things like picture review, playing with menus, and using the image stabilization features of your camera can use up more power than you might expect. If your pictures are important to you, always take along one spare, fully charged battery.

And remember that all rechargeable batteries undergo some degree of self-discharge just sitting idle in the camera or in the original packaging. Lithium-ion power packs of this type typically lose a few percent of their charge every few days, even when the camera isn't turned on. So, it's very likely that the battery purchased with your camera, even if charged at the factory, has begun to poop out after the long sea voyage on a banana boat (or, more likely, a trip by jet plane followed by a sojourn in a warehouse), so you'll want to revive it before going out for some serious shooting.

There are many situations in which you'll be glad you have that spare battery:

- **Remote locales.** If you like to backpack and will often be far from a source of electricity, rechargeable cells won't be convenient. They tend to lose some charge over time, even if not used, and will quickly become depleted as you use them. You'll have no way to recharge the cells, lacking a solar-powered charger that might not be a top priority for your backpacking kit.

- **Unexpected needs.** Perhaps you planned to shoot landscapes one weekend, and then are given free front-row tickets to a Major League Soccer game. Instead of a few dozen pictures of trees and lakes, you find yourself shooting hundreds of images of David Beckham and company, which may be beyond the capacity of the single battery you own. If you have a spare battery, you're in good shape.

- **Unexpected failures.** I've charged up batteries and then discovered that they didn't work when called upon, usually because the rechargeable cells had gone past their useful life, the charger didn't work, or because of human error. (I *thought* I'd charged them!) That's one reason why I always carry two (or three) times as many batteries as I think I will need.

- **Long shooting session.** Perhaps your niece is getting married, and you want to photograph the ceremony, receiving line, and reception. Several extra batteries will see you through the longest shooting session.

Power Options

Several battery chargers and power sources are available for the Canon PowerShot G12. The compact CB-2LZ, shown in Figure 1.3, plugs directly into a wall socket and is commonly furnished with the camera. Canon also provides the CB-2LZE, which is similar, but has a cord. Purchasing one of the optional charging devices offers more than some additional features: You gain a spare that can keep your camera running until you can replace your primary power rejuvenator. Here's a list of your power options:

- **CB-2LZ.** The standard charger for the G12, this one is the most convenient, because of its compact size and because, with its built-in wall plug prongs that connect directly into your power strip or wall socket, it requires no cord. This charger, as well as the CB-2LZE, has a switching power module that is fully compatible with

100V to 240V 50/60 Hz AC power, so you can use it outside the US with no problems. When I travel to Europe, for example, I take my charger and an adapter to convert the plug shape for the European sockets. No voltage converter is needed.

- **CB-2LZE.** This unit is similar to the CB-2LZ, and also charges a single battery, but requires a cord. That can be advantageous in certain situations. For example, if your power outlet is behind a desk or in some other semi-inaccessible location, the cord can be plugged in and routed so the charger itself sits on your desk or another more convenient spot. The cord itself is a standard one that works with many different chargers and devices (including the power supply for my laptop), so I purchased several of them and leave them plugged into the wall in various locations. I can connect my charger, my laptop computer's charger, or any one of several other electronic components to one of these cords without needing to crawl around behind the furniture. The cord itself draws no power when it's not plugged into a charger.

- **AC Adapter Kit ACK-DC50.** This kit, which consists of Compact Power Adapter CA-PS700 and DC Coupler DR-50, allows you to operate your PowerShot directly from AC power, with no battery required. Studio photographers need this capability because they often snap off hundreds of pictures for hours on end and want constant, reliable power. The camera is probably plugged into a flash sync cord (or radio device), and the studio flash units are plugged into power packs or AC power, so the extra tether to this adapter is no big deal in that environment. You also might want to use the AC adapter when viewing images or videos on a TV connected to your camera, or when shooting remote or time-lapse photos.

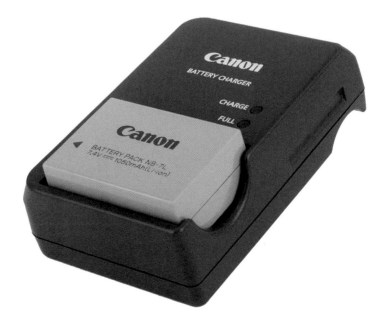

Figure 1.3
The NB-7L battery fits only one way into the charger.

Charging the Battery

To charge your battery, just follow these steps:

1. **Remove battery.** If the battery is already in the camera, remove it by sliding open the battery cover door (move it towards the nearest outer edge of the camera) and pressing the red/brown lever inside towards that same edge of the camera. The battery will pop out. (See Figure 1.4.)

Figure 1.4
Press the red-brown lever towards the outside edge of the camera to remove the battery.

2. **Insert in charger.** Tilt the battery downward so that the gray triangle on the battery is aligned with the matching white triangle on the socket in the battery charger. (You can't insert the battery if you try to stuff the aft end in first.) The battery will click when in place.

3. **Connect to power.** Flip out the plug on the back of the CB-2LZ charger or, if you're using the CB-2LZE, attach the supplied cord. Plug the charger into a power outlet.

4. **Charge battery.** The upper LED, labeled CHARGE, will begin to glow red/orange, and will continue to illuminate while the charging process continues. When charging is complete, the CHARGE LED will turn off, and the lower, FULL LED will glow green. The process will take about 2 hours and 20 minutes.

5. **Remove battery.** Extract the battery from the charger by lifting up on the back end, using the semi-circle cutout area for access.

6. **Insert in camera.** Unfortunately, Canon neglected to "key" the NB-7L battery, so there are four different ways you can insert it into the bottom of the PowerShot. Three of them are wrong, and won't let you seat the battery fully. The end with the gold contacts goes into the battery cavity first, and the side with the large Canon logo faces the back of the camera; the "fine print" information faces the front. (See Figure 1.5.)

7. **Close door.** When the battery is seated fully, flip the door shut, and slide it towards the center of the camera to lock it.

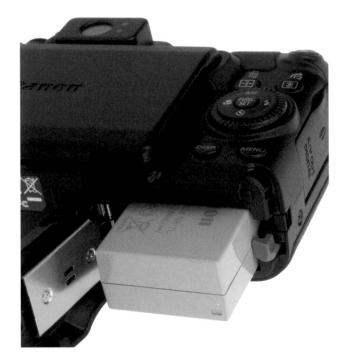

Figure 1.5
Insert the battery into the camera with the Canon logo facing the back.

Final Steps

Your Canon PowerShot G12 is almost ready to fire up and shoot. You'll need to adjust the viewfinder for your vision, and insert a memory card. Each of these steps is easy, and if you've used any Canon camera (or most other brands) in the past, you already know exactly what to do. I'm going to provide a little extra detail for those of you who are new to the Canon or digital camera worlds.

Adjusting Diopter Correction

Those of us with less than perfect eyesight can often benefit from a little correction in the optical viewfinder (which is rather tiny and difficult to view through in any case). Your contact lenses or glasses may provide all the correction you need, but if you are a

glasses wearer and want to use the optical viewfinder of the PowerShot without your glasses, or use your glasses with your camera's optical window and can benefit from some additional correction, you can take advantage of the camera's built-in diopter adjustment. It can be varied from –3 to +1 correction. Look through the viewfinder and aim at something that lets you focus sharply and definitely, such as text on a computer screen or in a book, then rotate the adjacent diopter adjustment wheel (see Figure 1.6) while looking through the window until the image appears sharp and is comfortable to view without squinting. If more than one person uses your camera, and each requires a different diopter setting, you can save a little time by noting the number of clicks and direction (clockwise to increase the diopter power; counterclockwise to decrease the diopter value) required to change from one user to the other. There are 10 detents in all.

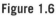

Figure 1.6
Viewfinder diopter correction from –3 to +1 can be specified with this dial.

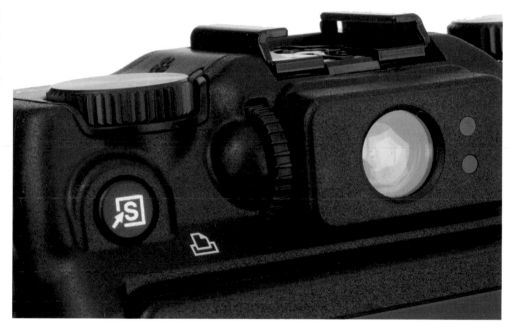

Inserting a Memory Card

You can't take photos without a memory card inserted in your PowerShot. The LCD will scold you with a **No Memory Card** warning at its upper edge if you try. So, your final step will be to insert a memory card, which fits in the same compartment as the battery. Slide the door on the underside of the body toward the near outer edge of the camera to release the cover, and then open it. You should only remove the memory card when the camera is switched off. If you open the compartment door when not actively shooting, the camera switches off automatically; if you try that while actually taking pictures, the G12 will beep a warning before turning off. (The beep is your cue to expect

that you might have just lost the most recent shot you took.) In practice, we rarely try to replace a battery or memory card while in the midst of shooting, so in most cases your images will be safe.

To remove a memory card that's already in the camera, press down on the edge of the card. It will pop right out. Insert a memory card with the label facing the front of the camera (towards the battery), as shown in Figure 1.7, oriented so the edge with the gold contacts goes into the slot first.

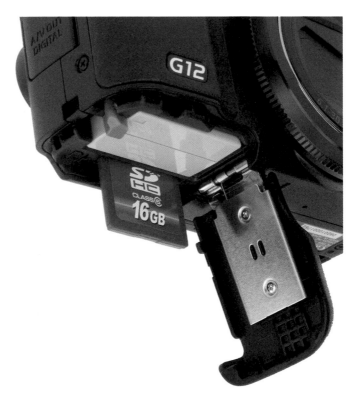

Figure 1.7
The memory card is inserted with the label facing the front of the camera.

WRITE PROTECT?

Some (but by no means all) SD, SDHC, and SDXC cards have a notch on the long side opposite the one with the diagonal cutout. If the notch is exposed (that is, the write-protect slide is in the lower position, or not present), the card cannot be used by the camera to store photographs. A **Memory Card Locked** message appears on the upper edge of the LCD screen. Not all devices recognize the write-protect notch (which is an optional feature for SD/SDHC/SDXC cards), but the PowerShot G12 does.

Formatting a Memory Card

There are four ways to create a blank SD card for your G12, and three of them are at least partially wrong. Here are your options, both correct and incorrect:

- **Erase images in the camera.** The Playback menu (discussed in Chapter 4 of this book) allows you to select individual images to delete, or to choose them by range, date, or folder. You can create a blank memory card by selecting **All images** for deletion using this menu option. This method won't give you a truly blank card, however, as it doesn't affect files you've labeled as Protected (using the **Protect images** function in the Playback menu). Nor does it identify and lock out parts of your memory card that have become corrupted or unusable since the last time you formatted the card.

- **Transfer (move) files to your computer.** When you transfer (rather than copy) all the image files to your computer from the SD card (either using a direct cable transfer or with a card reader, as described later in this chapter), the old image files are erased from the card, leaving the card blank. Theoretically. As with the **Erase images** function, this method does *not* remove files that you've labeled as Protected, nor does it "freshen" your card as the **Format** command (found in the Set up menu) does. The main reason for erasing or transferring images is when you *want* to leave the protected/unerased images on the card for awhile longer, say, to share with friends, family, and colleagues.

- **(Don't) Format in your computer.** With the SD card inserted in a card reader or card slot in your computer, you can use Windows or Mac OS to reformat the memory card. Don't! The operating system won't necessarily arrange the structure of the card the way the camera likes to see it (in computer terms, an incorrect *file system* may be installed). The only way to ensure that the card has been properly formatted for your camera is to perform the format in the camera itself. The only exception to this rule is when you have a seriously corrupted memory card that your camera refuses to format. Sometimes it is possible to revive such a corrupted card by allowing the computer's operating system to reformat it first, then trying again in the camera.

- **Set up menu format.** The best way to create a blank card is to use the recommended method to format a memory card, using the Set up menu.

To format a memory card, just follow these steps:

1. **Turn on the camera.** Since you won't necessarily be taking a photo at the moment, the fastest way to switch the camera on is to press the Playback button on the back of the camera (with the blue right-pointing triangle), next to the optical viewfinder. You can also turn on the camera by pressing the ON/OFF button, because the Set up menu you'll be using is available in either playback or shooting mode.

MODES FOR MENUS

When you turn the camera on using the Playback button, the lens remains retracted behind its protective cover, and the Playback, Print, and Set up menus become available when you press the MENU button. If you turn on the camera using the ON/OFF button on the top panel, the lens pops out so you can take a picture, and the available menus that pop up when you press the MENU button are the Shooting, Set up, and My Menu options. In that mode, you can also press the Playback button followed by the MENU button to switch to the second complement of menus. Just remember that to access the Shooting and My Menu options, the camera must be in *shooting* mode; to access the Playback and Print menus, the camera must be in *playback* mode. The Set up menu is always available in either mode.

2. **Press the MENU button.** The button is located in the lower-right corner of the back of the camera. The main menu appears. Locate the right cursor button (which has a lightning bolt on it, because it is also used for other things, including Flash functions). Press this cursor button once or twice until the Set up menu (with wrench and mallet icons) is highlighted. Figure 1.8 shows the Set up menu as it appears when accessed from playback mode; the menu is located one tab to the left when you access it from shooting mode.

3. **Rotate the control dial.** It's the ridged wheel located concentric with the cursor pad on the back of the camera. This dial has several uses; one of them is to scroll up and down through the menu screens. Continue scrolling down with the control dial until the **Format** command is highlighted. (If you prefer, you can press the down cursor button to scroll down.) Then press the FUNC./SET button, in the center of the cursor pad. You'll see a screen like the one in Figure 1.9.

4. **Choose OK. Cancel** will be highlighted, so you'll need to press the right cursor button to highlight **OK**. Then press the FUNC./SET button one more time. You will now see a final confirmation screen warning you that all data on the card will be erased. Use the up cursor button or the control dial to highlight **OK**, and press FUNC./SET to start the formatting process.

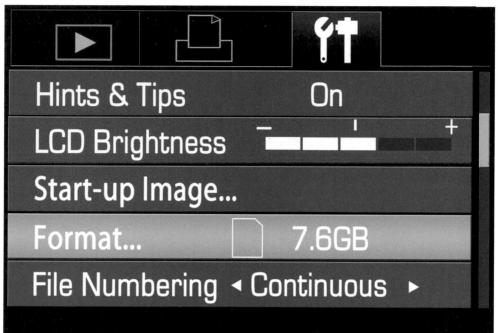

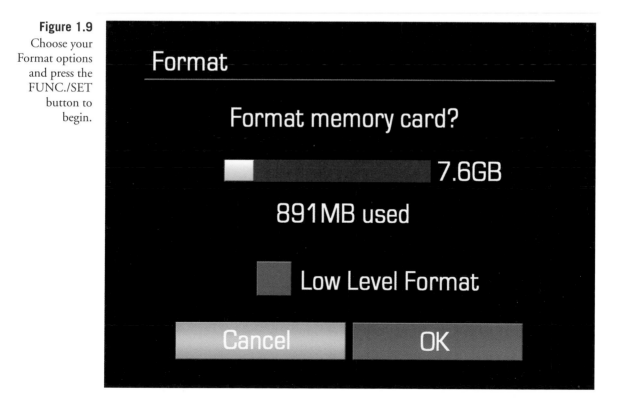

LOW-LEVEL FORMAT

When the Format screen appears, you can also use the up or down cursor button (or the control dial) to navigate to the **Low Level Format** box. Press the left or right cursor button to mark or unmark this box. Activating this option tells the G12 to perform an additional, more thorough, formatting of the card after the initial format is finished. The low-level format serves to remove data from all writable portions of your memory card while locking out "bad" sectors, and can be used to restore a memory card that is slowing down as it "trips" over those bad sectors. This extra step takes a bit longer than a standard reformat, and need not be used every time you format your card.

Powering Up/Setting Date and Time

Tap the On/Off switch on top of the camera to switch the camera on, if you intend to take a picture. Or, if you just want to review shots already on your memory card, or need to access a menu, press the blue right-pointing triangle that marks the Playback button on the back of the camera to the right of the optical viewfinder. As I mentioned, this action powers up the camera, but doesn't cause the lens to pop out.

The first time you use the PowerShot, it may ask you to enter the time and date. (If it doesn't, this information may have been set by someone checking out the camera on your behalf prior to sale.) Just follow these steps:

1. **Press the MENU button.** The button is located in the lower-right corner of the back of the camera. The main menu appears. Press the right cursor button until the yellow Set up menu icon (with the wrench and mallet) is highlighted.

2. **Rotate the control dial.** Scroll down through the Set up menu screens with the control dial (or with the down cursor button) until the **Date/Time** command is highlighted. Then press the FUNC./SET button. The screen shown in Figure 1.10 appears. The time zone you've currently selected will be indicated by an icon next to the **Set Date/Time** entry. Either the House icon (**Home**) or Airplane icon (**World Time**) will appear. The sidebar that follows explains a little more about this option.

3. **Select the values for your currently selected time zone.** There are seven values you can change: **Month, Day, Year, Hour, Minutes, Date format**, and **Daylight Savings Time** (**On** or **Off**). Use the left/right cursor buttons to move the gold selection box until it highlights the value you want to change. A pair of up/down pointing triangles appears above and below the value.

4. **Modify the values.** Press the up/down keys (or turn the control dial) to adjust the value up or down.

Figure 1.10
Choose the
Date/Time
options from
the Set up
menu.

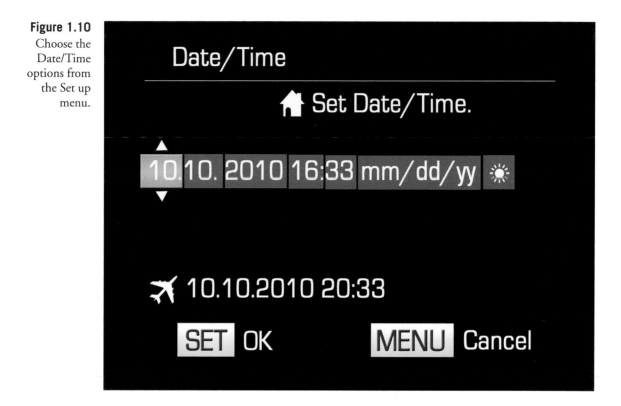

5. **Change other values.** Repeat steps 3 and 4 for each of the other values you want to change. The date format can be switched from the default mm/dd/yy to yy/mm/dd or dd/mm/yy.

6. **Confirm your settings.** When finished, press the FUNC./SET button to confirm, or the MENU button to cancel your changes and return to the Set up menu.

HOME AND WORLD TIME ZONES

You can set the correct Time Zone for your Canon PowerShot G12 using the **Time zone** entry in the Set up menu. Two settings appear: **Home** and **World** zones. Use the cursor buttons or the control dial to choose either the **Home** (House icon) or **World** (Airplane icon) option, and select the city from a scrolling map. Then, you can switch back and forth between them at any time. Perhaps you spend most of your time on the East Coast of the United States, but frequently visit another exotic location, like Cairo or Los Angeles, on business. Specify one location for your **Home** zone, and the second for your **World** (travel) zone, and switch between them easily. If you hop around a lot, you can change your **World** setting as many times as you want.

2

Taking Your First Canon PowerShot G12 Photos

If you've read Chapter 1, or have decided to begin with this chapter because your camera is all set up and ready to go, you'll find all the basic information you need to take your first photos with your PowerShot G12. In the first part of this chapter, I'm going to give you the 52-Second No-Option Quick Tour that will have you taking great pictures in less than a minute. Then, in the second part of this chapter, you'll find the 10-Minute Introduction, which allows you to make a few choices that will have you taking even better photos with only a few minutes' prep.

This chapter is strictly an introduction to some basic features. You'll learn how to make simple settings, and, later in the chapter, select the easiest exposure, metering, and autofocus modes. After you've finished either of this chapter's crash courses and taken a few pictures, you can return to this book with Chapters 3 and 4 to learn more about how your Canon PowerShot G12 operates, as you work your way towards Part II, which *really* looks at the camera's great features in depth.

But first, let's get snapping.

52-Second No-Option Quick Tour for Still Photos

To begin taking still photos immediately (once you have charged the battery and inserted a formatted memory card), just follow these easy steps:

1. **Press the ON/OFF switch on top of the camera.** The lens pops out of the camera body, a green LED illuminates in the center of the power button, the start-up sound plays through the speaker on the left side of the camera body, and the

start-up image displays briefly on the LCD monitor on the back of the camera before the scene in front of the camera shows up on the screen. I'll show you how to change the start-up sound and image (or to disable them) in Chapter 4.

2. **Set the fully automatic shooting mode.** Rotate the mode dial (the tallest dial on the right top of the camera) to the green Auto setting. (See Figure 2.1.) The PowerShot makes all the exposure settings for you at this setting.

3. **Frame your image.** First, make sure you've rotated the LCD on its hinges into viewing position. Once you have the viewing surface facing out from the camera's back, view the image on the LCD. It will look something like Figure 2.2 (some of the information overlaid on the image may differ, depending on how your camera is set up). Reframe, as desired, by rotating the zoom lever located concentric with the shutter release button: a clockwise push zooms in; counterclockwise zooms out.

4. **Focus.** When the image is composed the way you want, press the shutter release button halfway to set the focus. The upper LED to the immediate right of the optical viewfinder window will flash green, and you'll hear a beep (unless the camera has been set to **Mute**) when focus is achieved. If the lighting is so dim that the camera's built-in electronic flash will fire, the LED will flash orange instead.

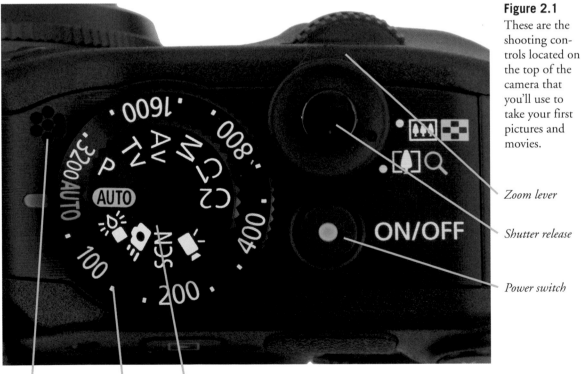

Figure 2.1
These are the shooting controls located on the top of the camera that you'll use to take your first pictures and movies.

Zoom lever

Shutter release

Power switch

Microphone *ISO dial* *Mode dial*

Figure 2.2
Frame your
photo using the
color LCD.

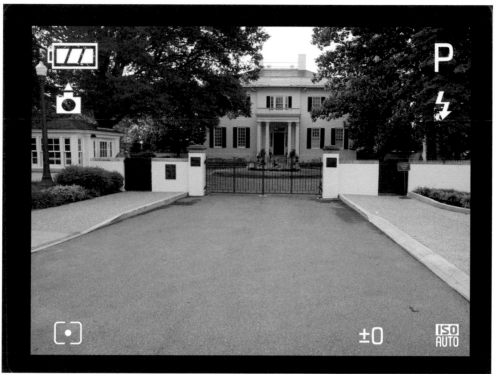

5. **Take your best shot.** Press the shutter release down the rest of the way to take the picture. The same green LED that indicated focus will flash as the picture is being stored on your memory card. The admonition **Busy** will appear on the bottom edge of the LCD at the same time.

6. **Review your result.** Continue to hold down the shutter release button after you've taken a picture and your shot will display on the LCD until you release the button. If you release the button immediately, the picture will be displayed for review for about 2 seconds. (I'll show you how to increase this display time in Chapter 4.)

52-Second No-Option Quick Tour for Movies

To begin taking movies immediately, just follow these easy steps:

1. **Press the ON/OFF switch on top of the camera.** The lens pops out of the camera body, a green LED illuminates in the center of the power button, the start-up sound plays through the speaker on the left side of the camera body, and the start-up image displays briefly on the LCD monitor on the back of the camera before the scene in front of the camera shows up on the screen. I'll show you how to change the start-up sound and image (or to disable them) in Chapter 4.

2. **Set the Movie shooting mode.** Rotate the mode dial (the tallest dial on the right top of the camera) to the Movie setting, with the movie camera icon. (It's four clicks clockwise past the green Auto setting.)

3. **Choose Standard movies.** Press the FUNC./SET button on the back of the camera, which will bring up a menu screen with several options. Using the cursor buttons, highlight the top option on the left, which is a movie camera icon, then highlight the left-most option on the bottom of the screen, as shown in Figure 2.3, and press the FUNC.SET button again to confirm your selection. This choice sets the movie mode to Standard. (Chances are, this choice will already be highlighted when you first press the FUNC./SET button; if it isn't, you need to follow the above steps to make this setting.)

4. **Frame your image.** View the image on the LCD on the back of the camera. Reframe, as desired, by rotating the zoom lever located concentric with the shutter release button: a clockwise push zooms in; counterclockwise zooms out.

5. **Focus.** When the image is composed the way you want, press the shutter release button halfway to set the focus. The upper LED to the immediate right of the optical viewfinder window will flash green, and you'll hear a beep (unless the camera has been set to Mute) when focus is achieved.

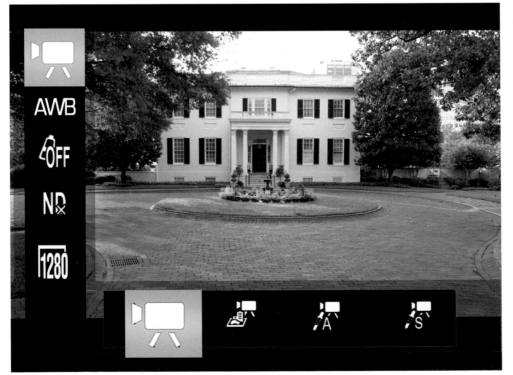

Figure 2.3
To select Standard shooting mode for movies, use the FUNC./SET button to bring up the menu of shooting options, then highlight the Standard movie mode icon at the left of the row of icons on the bottom of the screen.

6. **Begin shooting a movie clip.** Press the shutter release down the rest of the way to begin shooting video. An orange ● Rec indicator displays in the upper-right corner of the LCD monitor while recording is underway, and an elapsed time indicator counts off the recording time in the upper-left corner. (See Figure 2.4.)

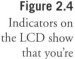

Figure 2.4
Indicators on the LCD show that you're shooting a video clip, and display the elapsed time.

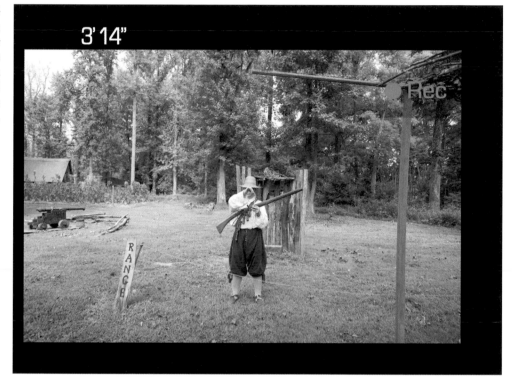

7. **Finish shooting.** When finished recording, press the shutter release a second time. The green LED at the optical window will blink green while the remaining portion of your clip is stored on the memory card. If your card fills, or you reach the maximum clip size of one hour duration or 4GB in size, recording will stop automatically.

8. **Review your result.** If you want to take a quick look at your footage, press the Playback button (marked with a blue triangle), then press the FUNC./SET button twice—once to bring up the movie playback screen, and once to activate the Play control to start the movie playing. Press the FUNC./SET button again to pause.

Your 10-Minute Introduction

If you have more than 52 seconds to spare, read or skim through this section to begin shooting, and apply a few options that will make your images even better. You'll learn how to choose a shooting mode, metering mode, focusing mode, and make other simple settings.

That's a lot of modes! Here's what each of the main types of settings does for you:

- **Shooting modes.** These are set using the large raised dial on the top-right side of the G12. They include automatic exposure modes like the special Scene (SCN) and Auto settings; the semi-automatic Av (Aperture priority/value), Tv (Time/Shutter priority), P (Program auto exposure/AE), and M (Manual) modes. Also on this dial are the Movie setting, Low Light mode (which allows you to shoot under dim illumination), and Quick Shot mode (which continuously adjusts settings automatically to help you capture impromptu grab shots). The G12 also has two Custom Setting modes that store and retrieve your own personalized shooting options in slot positions labeled C1 and C2.

- **Metering modes.** Three metering modes are available that allow you to choose what areas of the image the PowerShot G12 uses to calculate correct exposure. They include Evaluative (which combines information from several different zones within the image); Center weighted averaging (which meters the entire image but places the emphasis on the subject matter in the center); and Spot AE (which calculates exposure based on a small area, either the center of the frame or the current point being used to calculate autofocus). You make this selection by pressing the metering mode button, located to the upper right of the control dial.

- **Focusing modes.** The PowerShot G12 has two different types of AF (autofocus) options. The first option, **AF mode**, determines *when* the camera locks in focus. You can choose **Continuous AF**, which adjusts focus for whatever subject is in the frame at all times, or **Single AF**, which focuses only when the shutter release is pressed (which saves battery power). The second option, **AF Frame** mode, determines *where* in the scene the camera focuses—that is, what areas of the image are used to calculate focus. You make your selections of **AF mode** and **AF Frame** mode using the Recording menu, as described in Chapter 4.

I'll introduce each of the shooting, metering, and focus modes separately in the sections that follow.

Selecting a Shooting Mode

You choose your shooting method from the mode dial located on the top right of the Canon PowerShot G12. (See Figure 2.5.) This dial has 11 different settings, which let you select the various shooting modes. These modes have various levels of automation and a variety of features. The P, Tv, Av, and M settings (for Program, Time/Shutter speed value, Aperture value, and Manual) are often referred to as the Creative Zone settings, because they are the ones to use when you want to exercise creative control over how the camera operates. I'll be discussing those shooting modes and the settings to make when using them in considerable detail in later chapters.

Figure 2.5

The mode dial includes settings for the special-purpose and automatic modes (Auto, SCN, Movie, Low Light, and Quick Shot), as well as the less-automatic modes that give you more creative control (Program AE, Aperture priority, Shutter priority, and Manual).

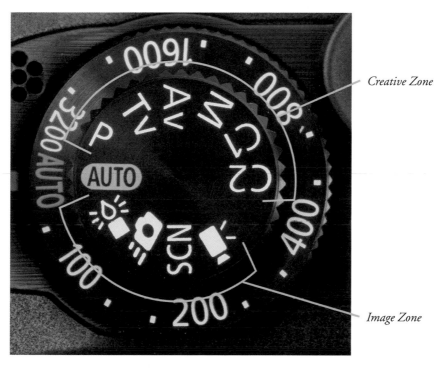

Creative Zone

Image Zone

The G12 also offers a collection of other shooting modes that are sometimes classified by Canon as Basic Zone modes or Image Zone modes, including the SCN (for Scene) and Auto modes. Finally, there are more specialized modes that are designed for particular purposes, including Movie mode, Quick Shot mode, and Low Light mode. I'll explain each of these modes also, though I'll be concentrating most heavily on the P, Tv, Av, and M settings, because it's with those settings that you'll have the opportunity to use your knowledge of photographic principles to the greatest extent.

If you're very new to digital photography, you might want to set the camera to Auto (highlighted in green on the mode dial) or P (Program AE mode) and start snapping away. Either mode will make all the appropriate settings for you for many shooting situations. If you have a specific type of picture you want to shoot, you can try out one of the Scene types by turning the mode dial to the SCN setting, then pressing the FUNC./SET button and choosing from the menu that appears at the bottom of the screen (see Figure 2.6). In this chapter, I'll provide a quick introduction to each shooting mode. I'll follow up with more details in later chapters.

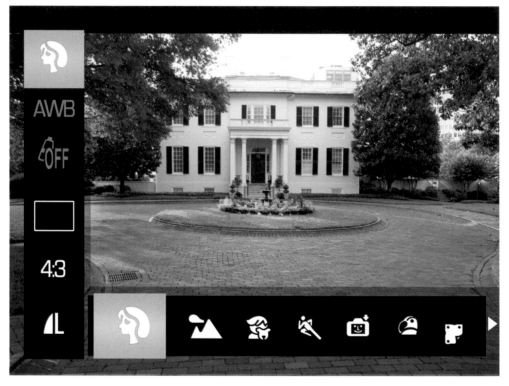

Figure 2.6
The icons for the Scene modes indicate what type of picture each is suited for.

Tip

If you want a more complete discussion of the various shooting modes, and the differences between them, jump to Chapter 5.

First, the special-purpose and automatic modes. Select the Auto, Movie, Low Light, and Quick Shot modes by turning the mode dial to their respective icons. For the Scene modes, there's one further step. Once the mode dial is set to the SCN position, press the FUNC./SET button, then, with the Portrait icon highlighted at the top of the menu on the left of the LCD, use the right cursor button or rotate the control dial (the knurled ring to the right of the LCD) to navigate through the menu of Scene types on the bottom of the screen until the one you want is highlighted. Once it is, press FUNC./SET, and the icon for that Scene type will be shown in the upper-right corner of the LCD. The special-purpose and automatic modes are as follows.

- **Auto.** With the mode dial set to this position, the G12 makes all the exposure decisions for you, and will pop up the flash if necessary under low light conditions.

- **Portrait.** This Scene mode, and the 18 that follow, are set by rotating the mode dial to the SCN position, then pressing the FUNC./SET button and turning the control dial or using the left/right cursor buttons to choose a specific mode. Use the Portrait option when you're taking a picture of a subject standing relatively close to the camera and want to de-emphasize the background, maximize sharpness, and produce flattering skin tones.

- **Landscape.** Select this mode when you want extra sharpness and rich colors of scenes.

- **Kids & Pets.** An "action" scene mode for capturing fast-moving pets and children without subject blur. The camera may boost the ISO to a higher level than normal to allow a fast shutter speed.

- **Sports.** Use this mode to freeze fast-moving subjects. Again, a high ISO setting may be used.

- **Smart Shutter.** This setting is not so much of a Scene type as a way to set the camera's automatic face detection features. I'll provide details about its operation in Chapter 5.

- **Super Vivid.** This setting increases the saturation of the colors in a scene, making them appear much richer and more intense than normal. Use it for dramatic effect, but you'll probably want to use this one sparingly, because it could wear out its welcome rapidly.

- **Poster Effect.** This setting, like the previous one, is not intended for a specific type of scene; rather, it imposes a particular type of processing on the image. In this case, it provides a degree of "posterization," increasing contrast with bright color effects.

- **Color Accent.** Creates a special effect: Choose one color on the LCD, and all the other colors in an image are converted to black-and-white. I'll explain how it works in Chapter 5.

- **Color Swap.** Changes one color to another. If you want to see Kentucky bluegrass that's *really* blue, this is the mode for you.

- **HDR.** This is Canon's setting for producing in-camera processing of a High Dynamic Range image, by taking three pictures in one sequence at different exposures, and then combining them into a final product that uses the most clearly exposed portions of the different shots. I'll discuss this mode, and provide further information about HDR in general, in Chapter 5.

- **Nostalgic.** This setting lets you ramp down the saturation of the colors in your images, giving the appearance of a faded, antique photograph.

- **Fish-eye Effect.** This setting simulates the bulging, distorted view produced by an extreme wide-angle "fish-eye" lens.

- **Miniature Effect.** This setting lets you select a portion of the image to be shown clearly, while blurring the top and bottom, resulting in an effect like viewing a miniaturized model.

- **Beach.** This setting provides properly exposed human subjects against a bright background of water, sand, and reflected sunlight.

- **Underwater.** This setting is intended specifically for use under the surface with the optional Canon Waterproof Case WP-DC34. It removes bluish color casts and reduces the intensity of the flash. The camera may use a high ISO setting to compensate for the reduced amount of light underwater.

- **Foliage.** Another saturation-rich setting for shooting trees and leaves, with emphasis on bright and vivid greens.

- **Snow.** Like Beach, this setting properly exposes people and other subjects, despite glaring ice and snow, while removing the blue tinge often caused by snow backgrounds.

- **Fireworks.** Offers vivid photos of fireworks with a longer exposure to capture an entire burst.

- **Stitch Assist 1 and 2.** These last two settings in SCN mode (one for left-to-right shots and the other for right-to-left) help you expose two or more overlapping images (up to 26 in total) that are merged to create a panorama on your computer with the supplied PhotoStitch program.

- **Low Light mode.** This mode and Movie mode occupy their own slots on the mode dial. Low Light mode is geared for shooting in dark conditions using a high ISO setting. The G12 has a native ISO 3200 setting for full-resolution images. However, the Low Light mode has a "boosting" function for shooting under very poor lighting conditions. When you choose the Low Light mode on the mode dial, the G12 (or you, if you want, using the FUNC./SET menu) can select an ISO setting from ISO 4000 to ISO 12,800 if necessary to make the exposure. As a trade-off for this extra sensitivity, though, the camera will automatically reduce the resolution of the images to 2.5 megapixels (1824 × 1368 pixels).

- **Movie mode.** Rotate the mode dial to this position when you want to shoot videos, as described earlier in this chapter, and in more detail in Chapter 6.

- **Quick Shot mode.** This mode provides you with the ability to take properly exposed and focused shots when you need to trigger the shutter as rapidly as possible without pausing to frame shots with the LCD, but still need the ability to make adjustments to settings such as image size and quality, white balance, ISO, and others.

If you have more photographic experience, you might want to opt for one of the less specialized, less automatic settings. These, too, are described in more detail in Chapter 5. These modes, which let you apply a little more creativity to your camera's settings, are indicated on the mode dial by letters M, Av, Tv, and P. There are also two Custom Setting positions on the dial, labeled C1 and C2, which can be used to store a group of settings, including any of the less automatic modes along with current menu settings, plus additional parameters, like the zoom and manual focus settings at the time you load the settings into C1 or C2, and your customized My Menu settings. I'll explain how to use the C1 and C2 modes in Chapter 4. Here is a brief introduction to the "creative" shooting modes:

- **M (Manual).** Select when you want full control over the shutter speed and lens opening, either for creative effects or because you are using a studio flash or other flash unit not compatible with the PowerShot's automatic flash metering.

- **Av (Aperture priority).** Choose when you want to use a particular lens opening, especially to control sharpness or how much of your image is in focus. The G12 will select the appropriate shutter speed for you. Av stands for *aperture value*.

- **Tv (Shutter priority).** This mode (Tv stands for *time value*) is useful when you want to use a particular shutter speed to stop action or produce creative blur effects. The camera will select the appropriate f/stop for you.

- **P (Program).** This mode allows the G12 to select the basic exposure settings, but you can still override the camera's choices to fine-tune your image.

Choosing a Metering Mode

Metering mode determines what areas of the frame are used when calculating exposure. You might want to select a particular metering mode for your first shots, although the default Evaluative metering (which is set automatically when you choose one of the more automatic shooting modes, such as Auto or SCN) is probably the best choice as you get to know your camera. I recommend staying with Evaluative metering as you begin shooting with your PowerShot.

Tip

If you want to learn more about how to select and use the Evaluative, Center weighted averaging, and Spot AE Point metering modes, jump to Chapter 5.

To change metering modes, switch to the P, Av, Tv, or M shooting mode and press the metering mode button, located on the back of the camera just northeast of the control dial. A screen pops up on the LCD offering three choices. Rotate the control dial until the choice you want is highlighted. Then press the metering mode button again to confirm your choice. The options are shown in Figure 2.7:

- **Evaluative metering.** The standard metering mode; the G12 attempts to intelligently classify your image and choose the best exposure based on readings from several different zones in the frame. (Canon doesn't specify how many zones there are, or where they are located.) Use this mode for most scenes, especially when the most important areas are located outside the center of the frame.

- **Center weighted averaging metering.** The G12 meters the entire scene, but gives the most emphasis to the central area of the frame. This mode is useful when the most important subject matter is in the middle of the frame.

- **Spot AE point metering.** Exposure is calculated from a smaller spot. The metering frame is either the center of the LCD monitor or, when you're using the FlexiZone autofocus mode, the same position as the AF frame you've chosen. I'll show you how to set the autofocus mode and zone in Chapter 6. This metering mode is useful when there is a large difference between the brightness of your main subject and other areas of the photo, and you want to be able to zero in on a specific area.

Figure 2.7
Metering modes
(left to right)
Evaluative,
Center weighted
averaging, Spot
AE Point.

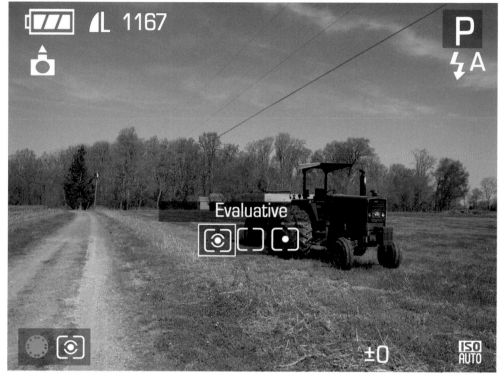

Figure 2.7 Metering modes (left to right) Evaluative, Center weighted averaging, Spot AE Point.

Choosing a Focus Mode

The Canon PowerShot G12 offers both manual focus and automatic focus, and, when using autofocus (AF), you can choose *when* and *where* focus is calculated. *When*, in this case, means whether the camera continuously refocuses when your subject moves within the frame, or whether focus is locked down when you press the shutter release halfway. *Where*, on the other hand, determines what part of the frame is considered your main subject when the camera decides to lock in focus. You can select from three different types of "focus frames," including automatic detection of human faces using nine possible areas within the frame; automatic tracking of a moving subject that you choose; and FlexiZone, which allows you to choose what part of the image to focus on. Also, in some cases, the camera will set the focus in the center of the frame: when FlexiZone is selected but it's not possible or desirable to move the focus frame around the screen.

Tip

For more detail on selecting each of these focusing modes, and their advantages, jump to Chapter 6.

Manual Focus

You can manually focus the G12, either entirely by yourself if you want to set the focus point precisely or by using the Safety MF feature, which allows you to set the focus point manually, at which point the camera uses its autofocus features to fine-tune the focus for you. I'll explain all the manual focus options in Chapter 6. In this quick start, all you need to know is to initiate manual focus, press the up cursor button, then rotate the control dial to adjust the focus point. A scale at the right side of the LCD shows you the approximate distance to the focus point as a guideline, and a magnified area in the center (it can be turned off as described later) shows an enlarged view of the center of the frame as you focus. To turn off manual focus, press the MF (up cursor) button a second time. Figure 2.8 shows the LCD with manual focus activated.

> **Tip**
>
> To use Safety MF, press the AF Frame Selector/Single Frame Erase (Trash) button. The G12 will fine-tune your focus and beep. The Safety MF feature must be turned on through the Shooting menu. If it is not turned on, pressing the button will still result in a beep, but the focus will not be fine-tuned. Also, note that pressing this button will not focus the image if it is badly out of focus; it will only fine-tune your manual focusing.

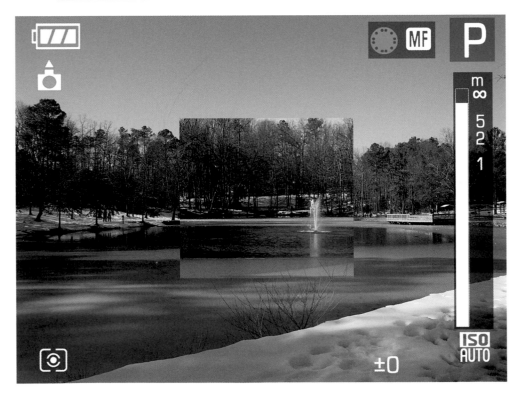

Figure 2.8
Press the MF button to initiate manual focus.

Other Settings

There are a few other settings you can make if you're feeling ambitious, but don't feel ashamed if you postpone using these features until you've racked up a little more experience with your PowerShot G12.

Adjusting White Balance and ISO

If you like, you can custom-tailor your white balance (color balance) and ISO sensitivity settings when you're using the non-automatic modes. To start out, it's best to set white balance (WB) to Auto, and ISO to ISO 100 or ISO 200 for daylight photos, and to ISO 400 for pictures in dimmer light.

To set the white balance quickly, press the FUNC./SET button in the center of the control dial (the directional pad) and use the up/down buttons to navigate to the **White Balance** entry near the top of the left-side menu. Then use the left/right buttons or rotate the control dial to select from among Auto, Daylight, Cloudy, Tungsten, Fluorescent, Fluorescent H, Flash, Underwater, or Custom white balance. (See Figure 2.9.) I'll show you how to use each of these in Chapter 4, where you'll also learn how to tweak settings slightly by pressing the DISP. button to produce an adjustments screen.

Figure 2.9
Choose the white balance setting you want.

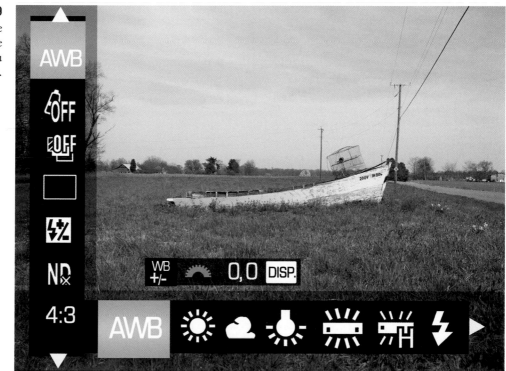

ISO sensitivity is even easier to adjust. Just rotate the ISO dial (which is concentric to the mode dial) to the setting you want to use, from ISO 80 to 3200, or to the Auto position to allow the camera to choose an appropriate ISO setting for you. (As I discussed earlier, if you want to use ISO settings above 3200, up to 12,800, you have to use the Low Light shooting mode and set the ISO using the FUNC./SET menu.)

Using the Self-Timer

If you want a short delay before taking a picture—say, to allow the camera to steady itself, or to allow you to get in the shot, the built-in self-timer is at your beck and call. The self-timer is accessed by pressing the down cursor button. I'll explain its various options in more detail in Chapter 3. But here's a quick introduction.

You activate the self-timer by pressing the down button once to bring up the self-timer screen; then press the down button again to move down to the self-timer **On** selection on the two-item menu. If you want to change the time delay, turn the front dial (the wheel that falls under your right index finger on the front of the camera) to select from 0 to 30 seconds for the delay. (Don't ask me why a 0-second delay is available.) Use the left and right buttons to select the number of shots to be taken, from 1 to 10.

After you have made your selections, press the FUNC./SET button to exit the self-timer screen. A self-timer icon will remain on the screen. When the camera is set up (presumably on a tripod), press the shutter button to start the countdown. Once the countdown is started, it can be cancelled by pressing the down button again. Remember, there are other options similar to the self-timer, including the Smile, Wink, and Face detection triggers, which are discussed in Chapter 5 in connection with the Scene modes.

Using the Built-in Flash

Working with the G12's built-in flash (as well as external flash units like the Canon 580EX II) deserves a chapter of its own, and I'm providing one. (See Chapter 8.) But the built-in flash is easy enough to work with that you can begin using it right away, either to provide the main lighting of a scene or as supplementary illumination to fill in the shadows. The G12 will automatically balance the amount of light emitted from the flash so that it illuminates the shadows nicely, without overwhelming the highlights and producing a glaring "flash" look. (Think *Baywatch* when they're using too many reflectors on the lifeguards!)

For now, all you need to do is learn how to turn the flash on and off. Just press the right cursor button, and choose either **Flash Off** (to disable the flash), **On** (to enable it), or **Auto** (to let the camera decide whether to fire it). The third choice, **Slow Synchro**, can be used to provide a balance between the ambient light and the flash, avoiding dark backgrounds. I'll explain the use of that mode, as well as the other flash options that appear when you press the MENU button while using this Flash menu, in Chapter 8.

Reviewing the Images You've Taken

The Canon PowerShot G12 has a broad range of playback and image review options, including the ability to jump ahead by 10 or 100 images at a time, or to jump using other parameters, such as the dates pictures were taken. I'll cover the other options, including filtering and viewing images in the form of slide shows, in Chapter 3. For now, you'll want to learn just the basics.

- **View an image.** Press the Playback button (marked with a blue right-pointing triangle) to the right of the optical viewfinder to display the most recent image on the LCD.

- **Scroll among images.** Press the left cursor button to view a previous image. Press the right button to view the next image. You can also use the control dial to scroll through the images. If you turn the dial rapidly, you will see an iPod-like stream of smaller images. I'll discuss this feature further in Chapter 3.

- **Zoom in and out.** Press the zoom lever towards the right to zoom in on an image. Press towards the left to zoom out. While zoomed in, you can use the cursor buttons to move the zoomed area around within the frame. You can also use the control dial to move to other images at the same enlargement factor.

- **View index thumbnails.** From full-frame view, keep pressing the zoom lever towards the left to view four or nine thumbnails, and continue with presses of the lever to view 36 and 100 increasingly smaller thumbnail images. Use the cursor buttons to maneuver around the index images, and press the FUNC./SET button to view a highlighted thumbnail as a full-frame image.

Transferring Photos to Your Computer

The final step in your picture-taking session will be to transfer the photos you've taken to your computer for printing, further review, or image editing. Your G12 allows you to print directly to PictBridge-compatible printers and to create print orders right in the camera, plus you can select which images to transfer to your computer. I'll outline those options in Chapter 4.

For now, you'll probably want to transfer your images either by using a cable transfer from the camera to the computer or by removing the memory card from the G12 and transferring the images with a card reader. The latter option is the best, because it's usually much faster and doesn't deplete the battery of your camera. However, you can use a cable transfer when you have the cable and a computer, but no card reader (perhaps you're using the computer of a friend or colleague, or at an Internet café). Finally, if you like to use the latest cool technology, consider using an Eye-Fi card, which lets you transfer images to your computer over a Wi-Fi network.

To transfer images from the camera to a Mac or PC computer using the USB cable:

1. Turn off the camera.

2. Pull up the cover that protects the PowerShot's USB port on the right side of the camera (as you hold it in the shooting position), and plug the USB cable furnished with the camera into the USB port, the bottom of the two openings. (See Figure 2.10.)

Figure 2.10
Images can be transferred to your computer using a USB cable.

3. Connect the other end of the USB cable to a USB port on your computer.

4. Turn on the camera. Your installed software usually detects the camera and offers to transfer the pictures, or the camera appears on your desktop as a mass storage device, enabling you to drag and drop the files to your computer.

To transfer images from a memory card to the computer using a card reader, as shown in Figure 2.11:

1. Turn off the camera.

2. Slide open the memory card/battery door on the bottom of the camera, and press on the card, which causes it to pop up so it can be removed from the slot.

3. Insert the memory card into your memory card reader. Your installed software detects the files on the card and offers to transfer them. The card can also appear as a mass storage device on your desktop, which you can open, and then drag and drop the files to your computer.

Figure 2.11
A card reader is the fastest way to transfer photos.

If you want to transfer your images using an Eye-Fi card, you will need to have a PC running Windows XP, Vista, or Windows 7, or a Macintosh running Mac OS X version 10.4 or later. You will also need access to a broadband internet connection and a wireless (Wi-Fi) router. As for the Eye-Fi card itself, I recommend that you get a Pro X2 version or better with at least 8GB of capacity. (See Figure 2.12.) This variety of Eye-Fi

Figure 2.12
An Eye-Fi card is the coolest way to transfer photos.

card is capable of handling RAW files and video; lesser models can't deal with such large files. Once you have the card and the needed network connection, here are the basic steps to take:

1. With the Eye-Fi card inserted into the card reader that comes with it, connect the card reader to a USB port on your computer and allow the computer to recognize the card and reader.

2. Install the software that came with the card on your computer and follow the on-screen instructions.

3. When the software and network settings are properly configured, remove the card from the reader, leaving the reader plugged into the USB port. Insert the card into your PowerShot G12.

4. On the PowerShot G12, go into the Set up menu and select **Eye-Fi settings**. (Note: That option will not show up on the menu until an Eye-Fi card is inserted into the camera.) Make sure the **Enable** option is selected. If you have problems, select the **Connection Info** option from the Eye-Fi Settings menu to see the status of the connection of the card to the network.

5. Take a picture. If the software has been set up properly, a window should appear on your computer's screen showing a thumbnail of the image as it uploads to your computer. In a short while, the image will be available for viewing or editing in the folder that was designated during the set up process.

3

Canon PowerShot G12 Roadmap

One of the reasons that the Canon PowerShot lineup of cameras has been popular with beginning snapshooters, avid photo hobbyists, and advanced photographers—including both amateurs and pros—is their easy access to features. The G12 continues this combination of a rich set of functions that are quickly available with a well-designed array of controls and menus. Whether you're just learning to work with your PowerShot G12 as your first advanced digital camera or you're a seasoned photographer looking for the kind of tools you expect from a sophisticated compact camera, you'll easily find what you need.

Whenever a camera manufacturer develops a new camera, there have to be tradeoffs among several design goals: easy access to controls, clarity of control functions, and simplicity. There's no perfect approach to the physical layout of the camera. If it bristles with dozens of buttons and wheels, the photographer can immediately get access to many functions, but may not intuitively understand which one to use for a particular purpose. On the other hand, a camera may be sleek and streamlined with few physical controls, but that design may require the user to master an obscure and deeply buried array of menu commands to carry out even the simplest of functions.

With the PowerShot G12, Canon has done a good job of providing ready access to the tools you need. Easily accessible dials and buttons simplify tasks like setting the ISO sensitivity of the sensor, modifying the brightness/lightness of the image through exposure compensation, and switching among available shooting modes. However, as is the case with any camera as capable and sophisticated as this, the average user needs a clear

guide to explain what each control does, and how to achieve the desired results using the various switches and dials.

Traditionally, there have been two ways of providing a roadmap to guide you through this maze of features. The most common approach, taken by Canon in the user's guide that ships with the PowerShot G12 on CD, uses a few small black-and-white line drawings or photos that are peppered with dozens of labels or callouts keyed to the numbers of the pages in the book that tell you what these components do. (See, for example, pages 42-43 of the G12 Camera User Guide.) Even if you can decipher these illustrations without a magnifying glass, getting the information you need from a miniature camera diagram is a lot like being presented with a world globe when what you really want to know is how to find the capital of Belgium.

I originated a more useful approach in my field guides, providing you with, instead of a long-range satellite view, a street-level map that includes close-up full-color photos of the camera from several angles (see Figure 3.1, for example), with a smaller number of labels clearly pointing to each individual feature. And, I don't force you to flip back and forth among dozens of pages to find out what a particular component does. Each photo is accompanied by a brief description that summarizes the controls available in that view, so you can begin using the features right away. Only when a particular function deserves a lengthy explanation do I direct you to a more detailed write-up later in the book.

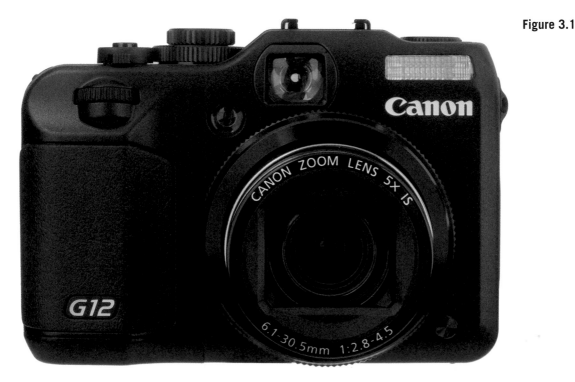

Figure 3.1

So, if you're wondering what the DISP. button does, I'll tell you up front, rather than have you flip to Page 44 of the camera's user guide, where there isn't much information anyway. This book is not a scavenger hunt. But after I explain how to use the ISO dial to change the sensitivity of the G12, I *will* provide a cross-reference to a longer explanation later in the book that clarifies noise reduction, ISO, and the effects of ISO on exposure.

It's really not possible to explain *everything* about *every* feature the first time that capability is mentioned. Many features of this PowerShot camera are interdependent. To really understand ISO sensitivity, you also need to understand how exposure works. So, to avoid having humongous 150-page chapters, I'll provide the key information you can use immediately up front, and use limited cross-references to direct you to the in-depth discussions you need to really understand a feature and all its options. I think this kind of organization works best for cameras as sophisticated as the PowerShot G12.

By the time you finish this chapter, you'll have a basic understanding of every control and what it does. I'm not going to delve into menu functions here—you'll find a discussion of your Set up, Shooting, and Playback menu options in Chapter 4. Everything here is devoted to the button pusher and dial twirler in you.

Front View

When we picture a given camera, we usually imagine the front view. That's the view that your subjects see as you snap away, and the aspect that's shown in product publicity and on the box. The frontal angle is, for all intents and purposes, the "face" of a camera like the PowerShot G12. But, not surprisingly, most of the "business" of operating the camera happens *behind* it, where the photographer resides. The front of the G12 actually has very few controls and features to worry about. Nine front-located features are readily visible in Figures 3.2 and 3.3:

- **Hand grip.** This gently raised area has a lightly textured leather-like coating that provides a comfortable hand-hold, so the camera does not slip readily out of your grip.

- **Front dial.** This feature, newly added to the PowerShot line on the G12, is a welcome enhancement, which gives you ready access to various options within quick reach of your right index finger, and lets you use one dial to control shutter speed, with another to control aperture while in Manual exposure mode. Among the various tasks it carries out, this dial sets shutter speed when the camera is in Manual or Shutter priority mode, and it sets aperture when the camera is in Aperture priority mode. It also is used for some less critical roles, such as jumping to categories of images in Playback mode, making fine adjustments to white balance, and changing the time delay of the self-timer. In addition, as I'll discuss in Chapter 4, you can assign certain other functions to this dial using the **Set dial functions** option on the Shooting menu.

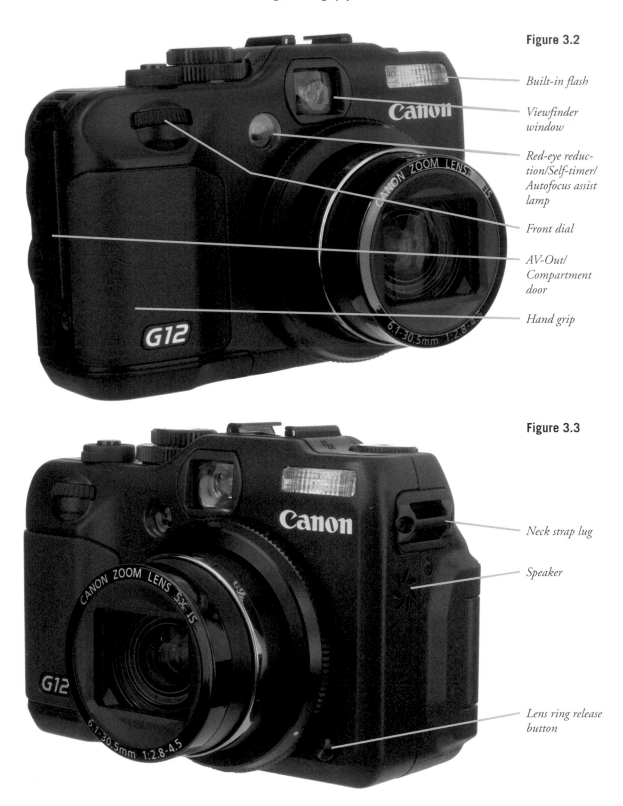

Figure 3.2

Built-in flash

Viewfinder window

Red-eye reduction/Self-timer/Autofocus assist lamp

Front dial

AV-Out/Compartment door

Hand grip

Figure 3.3

Neck strap lug

Speaker

Lens ring release button

- **Red-eye reduction/Self-timer/Autofocus assist lamp.** This LED provides a blip of light shortly before a flash exposure to cause the subjects' pupils to close down, reducing the effect of red-eye reflections off their retinas. When you're using the self-timer, this lamp also flashes to mark the countdown until the photo is taken. For its third trick, this versatile light beams into poorly illuminated areas in front of the camera to help the PowerShot's autofocus apparatus see what it's doing.

- **Viewfinder window.** This is the "eye" of the photographer when he or she is looking through the viewfinder, as opposed to using the LCD screen to compose a shot.

- **Built-in flash.** The PowerShot G12 sports this very handy little built-in flash tube that is always ready to fire at your command, unlike the units on some cameras that need to be manually popped up in order to be ready. Of course, this flash is not nearly as powerful as the external units that can be connected to the camera's accessory shoe, but it serves a very useful purpose for general snapshooting and as a fill-in flash for some outdoor shots.

- **AV-Out/compartment door.** This little door on the right side of the camera (as you hold it to shoot) conceals the location of the ports or jacks that are used to connect your camera to a computer, TV set, or remote switch. The top port is for an optional HTC-100 mini-HDMI cable to connect the camera's video output to a high-definition TV set; the middle jack is for the optional remote switch; and the bottom one is a mini-USB port that accepts two cables that come with the camera: one for normal audio-video output to a standard TV set, and the other for connecting to a computer.

- **Speaker.** When you're playing back movies, the sound will emanate from the tiny speaker built into the side of the camera. It the sound is muted, move your hand!

- **Ring release button.** This inconspicuous little button is reminiscent of the lens release buttons found on dSLRs and other cameras that take interchangeable lenses. The difference is that this button does not release the lens; it just releases the ring around the lens, so you can install an adapter that is required when you are attaching certain accessories, such as a tele-converter lens or macro ring flash. And, if you're a somewhat wild and sporty type, there's good news—you have the option of changing the ring color by purchasing a set of three different colored lens rings from Canon!

- **Neck strap mounts.** On both sides of the camera there are mounting brackets for the neck strap that's included with the camera. It's a good idea to install that strap (or an optional one of your own choosing, as discussed in Chapter 1) as one of your first steps after taking the camera out of the box, to give you some protection against dropping your new acquisition while getting acquainted with its features.

The LCD Screen: To Swivel or Not to Swivel

At this point in our tour of the PowerShot G12's real estate, before we embark on our perusal of the back yard, we need to pause for a close examination of one of the main features of the camera. I'm talking about the LCD screen—that marvelously informative rectangular expanse on the back of the camera that, depending on the context, shows you the shot you're composing, displays the scenes you've already captured, or provides you with detailed information about those images, as well as the camera's menus and settings. As you can see in Figure 3.4, the PowerShot G12 has a swiveling display, consisting of a 2.8-inch LCD with a 461,000 pixel resolution and with the ability to rotate on both vertical and horizontal axes.

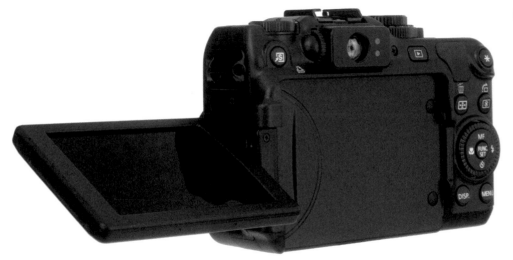

Figure 3.4

The swiveling capability of the PowerShot G12's LCD screen is no small matter, and it is worth taking a few moments to discuss the benefits (and tradeoffs) that this enhancement brings to the camera.

Let's start with the tradeoffs, or disadvantages, which are not major. First, the G12's swiveling mechanism adds some weight and complexity to the camera and introduces the possibility of failure or breakage of that mechanism. However, the Canon design is rugged, and your swivel screen pivot is likely to last as long as the rest of the camera. Second, the addition of that mechanism necessarily reduces the diagonal size of the actual display area, but only slightly, from the 3 inches found on many cameras with fixed screens (such as the PowerShot G10) to 2.8 inches. The G12's swiveling screen has 87 percent of the area of the G10's fixed LCD, but exactly the same resolution and sharpness.

Now let's discuss how the swiveling screen works, and what advantages that capability provides. When you first take the camera out of its box, you will find that the LCD screen is in its "closed" position (see Figure 3.5). In this position, the screen is folded in against the back of the camera, with its display surface hidden from view.

Figure 3.5

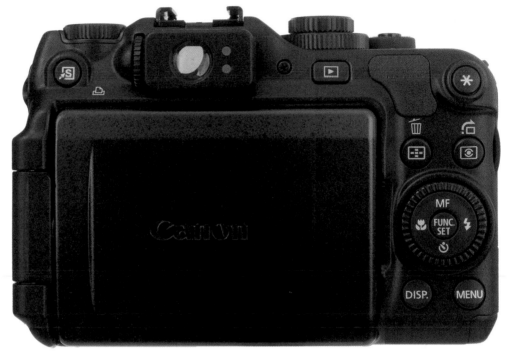

Why is this a useful configuration? For several reasons. First, it's a great way to protect the screen from damage, dirt, or the elements. Other cameras, including the PowerShot G10, have their screens exposed to possible harm whenever they're out of their cases. The ability to fold the screen in provides a built-in screen protection system. In addition, in some situations you may want to take your pictures in as discreet a way as possible, such as at concerts or religious ceremonies, and you may not want to distract persons near you by having the LCD display showing. Of course, you can turn off the display of other digital cameras—at least those that have optical viewfinders like the G10, so you won't be shooting blind. But it may be easier and more effective to just fold it in against the camera.

Flip open the LCD on the PowerShot G12 and take a look at what it has to offer in the way of photographic versatility. First, check out Figure 3.6. In this position, the screen is swiveled out to the left at various angles, allowing you to view your subject from one side, or even turn the display so you're looking around a corner. From here, you can swivel the screen vertically so it is aiming up at the sky, down towards the ground, or

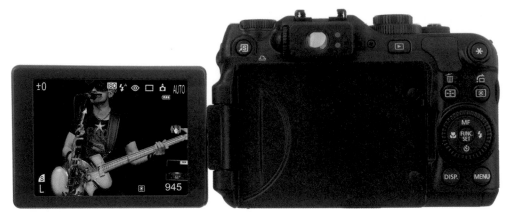

Figure 3.6

even turned all the way around to face in the same direction as the lens. These positions give you several options. With the screen swiveled out to the left and then flipped upwards, you can easily hold the camera down at waist level and compose your image without bending over. In this way, you can compose a photograph that looks better when taken from a low angle, and you don't have to get down on your belly or crouch in a squat. On the other hand, if you flip the screen downwards, you can hold the camera above your head to peer over the tops of crowds or physical obstructions, and compose the image in the LCD, sort of like submarine commanders with their raised periscopes. I appreciate this mode at concerts, because I can raise the camera up over the heads of the multitude milling around in front of me. Finally, swivel the screen around to face the front, and you can indulge your narcissistic side by pointing the camera at yourself and taking a self-portrait that is nicely framed in the versatile LCD. (See Figure 3.7.)

Figure 3.7

The Canon PowerShot G12's Business End

The back panel of the PowerShot G12 is dominated by the swiveling LCD screen, but the camera's designers also managed to find room for about a dozen different controls in the form of buttons and dials. That might seem like a lot of controls to learn, but I think you'll find, as I noted earlier, that it's usually a good deal easier to press a dedicated button or spin a dial than to navigate through a menu system every time you want to change a setting.

You can see the controls that populate the back of the G12 in Figure 3.8. Because there are so many different controls, I've divided them into two illustrations. First, the controls on the upper half of the camera, as shown in Figure 3.9. The key controls and components and their functions are as follows:

■ **Viewfinder eyepiece.** You can frame your composition by peering into the viewfinder. The PowerShot G12 has no luxurious rubber eyecup or other frills; all you get is a small window to peer into and a view of the scene being viewed by your lens, at the current zoom factor. Unlike the situation with the typical dSLR camera, you get absolutely no information in the viewfinder other than an image.

But you should be fairly happy with that view; there are quite a few cameras in this class that have no optical viewfinder at all, leaving you holding the unsteady camera out at arm's length, even in low-light situations where steadying the camera

Figure 3.8

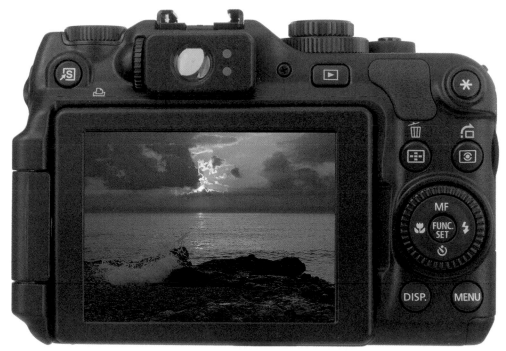

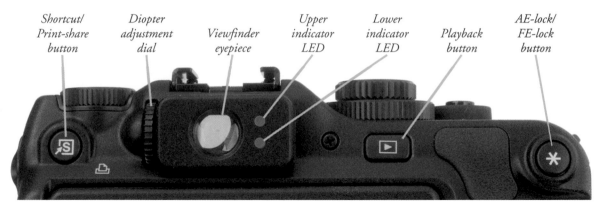

Figure 3.9

against your forehead might provide a more stable view. Or, without recourse to an optical viewfinder, you might be forced to squint at an LCD screen that can be washed out in bright sunlight. The viewfinder on the G12 is not fancy, but it provides a very useful capability.

- **Diopter adjustment dial.** The little wheel just to the left of the viewfinder lets you adjust the viewfinder to correct for your eyesight, as described in Chapter 1.

- **AE/FE (Auto exposure/Flash exposure) lock.** This button at the upper right of the camera's back, which is labeled with a star (*), has several functions, which differ depending on the AF point and metering mode. You can find more about these variations in Chapter 5.

 In shooting mode, pressing this button locks the exposure or flash exposure that the camera sets when you partially depress the shutter button. The exposure lock will be released if you press another button after releasing the AE/FE lock button.

 When using flash, pressing the * button fires an extra preflash that allows the unit to calculate and lock exposure prior to taking the picture with the flash.

- **Upper indicator light.** The G12 is equipped with a set of two indicator lights just to the right of the viewfinder window. Because you can see them out of the corner of your eye, the information is available to you even when you're using the optical viewfinder. The upper indicator light provides these signals:

 - **Green.** Ready to shoot.

 - **Blinking green.** Image recording/reading/erasing/transfer underway. While that is happening, be careful not to turn off the camera, open the memory card door, or otherwise disturb the process. If you do, data could be lost or corrupted.

 - **Orange.** Ready to shoot (flash on).

 - **Blinking orange.** Ready to shoot (camera shake warning).

- **Lower indicator light.** This is a yellow LED signal for focus conditions.

 - **Yellow.** Indicates you're using macro or manual focus modes, or AF lock mode.

 - **Blinking yellow.** Accompanied by a single beep, indicates that the camera is having trouble focusing.

- **Set shortcut/Direct print button.** This button, sitting away from its peers way up on the left side of the camera, is like a wildcard or programmable function button, giving you the chance to take one favorite action and assign it to this button for one-press access. To take advantage of this capability, go to the Shooting menu and select the **Set shortcut button** option, scroll to the function you want to assign to the button, and press FUNC./SET to confirm your selection. I'll explain the Shooting menu in more detail in Chapter 4.

 On the G12 your choices are: **Not Assigned**, **i-Contrast**, **White Balance**, **Custom White Balance 1**, **Custom White Balance 2**, **My Colors**, **Bracketing**, **Drive Mode**, **Flash Exposure Compensation/Flash Output**, **ND filter**, **Aspect Ratio**, **Select RAW or JPEG**, **Recording Pixels/Compression**, **Movie Quality**, **Servo AF**, **Red-Eye Correction**, **AF Lock**, **Digital Tele-Converter**, and **Display Off**.

 What you do with this button depends on your own working habits. If you often attach and detach the tele-converter lens, having the setting for that function at your fingertips could be a bonus, or, if you want to save battery power by turning the display off when you don't need it, you might assign that function to the shortcut button. With the G12, Canon has added many more options to the list that this button can accommodate, so it's pretty likely you'll find one you like. Personally, I'm glad to see the addition of an option to select RAW or JPEG images.

 Finally, this button, like many of the others, has a second, completely unrelated function as the Direct Print button. If you connect the G12 to a PictBridge-compatible printer, you can use this button to send images directly to the printer. I'll also describe this function in Chapter 4.

- **Playback button.** Pressing this button with the blue triangle displays the last picture taken (unless you use the menu system to change to showing the last picture viewed). Thereafter, you can move back and forth among the available images by pressing the left/right cursor buttons to advance or reverse one image at a time, using the control dial to move forward or back either image by image or using the front dial to move using a jump method you've selected. (See the section below for more on jumping.) To quit playback, press this button again. The G12 also exits Playback mode automatically when you press the shutter button (so you'll never be prevented from taking a picture on the spur of the moment because you happened to be viewing an image).

PLAYBACK PAYBACK

There's one other convenient feature of the G12: when the camera is turned off, you can turn it back on with the Playback button, so you are immediately in playback mode. Press the Playback button again to turn it off. However, once you're in recording mode, pressing the Playback button toggles back and forth between recording and playback. You'll need to use the Power button to turn the camera off. The Playback on/Playback off trick works only if you remain in playback mode the whole time the camera is on, for example, simply to review images.

The right half of the PowerShot G12 is dominated by a set of buttons that includes the cursor buttons, which serve as your directional controls for navigating around the screen and menus, and which do double duty with other direct-access functions. The key controls shown in Figure 3.10 are as follows:

■ **MENU button.** Summons/exits the menu displayed on the LCD of the G12. When you're working with submenus, this button also serves to exit a submenu and return to the main menu.

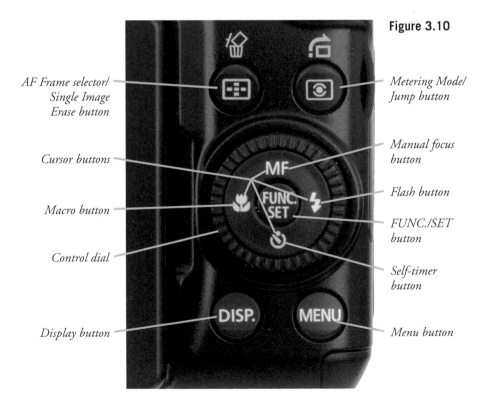

Figure 3.10

AF Frame selector/ Single Image Erase button

Metering Mode/ Jump button

Cursor buttons

Manual focus button

Macro button

Flash button

Control dial

FUNC./SET button

Self-timer button

Display button

Menu button

■ **DISP. button.** When pressed repeatedly in shooting mode, changes the amount of picture information displayed. In playback mode, pressing the DISP. button cycles among basic display of the image; a display with limited information, including battery life, image number, date, and time; a detailed display with a thumbnail of the image, shooting parameters, and a brightness histogram; and a display with two views of the image for checking focus. (I'll discuss that function later in this chapter.) The DISP. button also serves a variety of other purposes, such as selecting various options in connection with particular camera functions. These uses will be discussed in their respective sections.

■ **LCD.** This is the 2.8-inch swiveling display that shows the image that is being composed; image review after the picture is taken; information display before the photo is snapped; and all of the menus used by the PowerShot G12.

■ **Control dial.** This ridged dial that surrounds the array of cursor buttons and the FUNC./SET button is a workhorse that performs several functions. In many cases, such as scrolling through the menu screens, you can use either the control dial or the cursor buttons to carry out the same operation. This dial also is used to move through your images in playback mode and to make settings for various functions, such as choosing among the options for metering mode and setting fine adjustments to white balance. In manual focus mode, you use the control dial to adjust the focus. In addition, this dial is used to set the aperture value in Manual exposure mode, while the front dial sets shutter speed. However, you can reverse these roles of the two dials using the **Set dial functions** item on the Shooting menu, and you can also set any one of several other functions to be performed by the control dial, including setting aspect ratio, white balance adjustments, and i-Contrast. I discuss these options in Chapter 4. In some cases, in Manual exposure mode, the control dial can have two different functions assigned to it at the same time. In that event, you can switch between the two settings by pressing the metering mode button, just above and to the right of the control dial.

■ **Cursor buttons.** This array of four directional buttons provides left/right/up/down movement to navigate menus, and is used to cycle among various options (usually with the left/right buttons) and to choose amounts (with the up/down buttons). The four cursor buttons also have secondary functions to select macro shooting, manual focus, flash options, and self-timer settings. (I'll describe these separately next.)

■ **Left cursor/Macro button.** Press this button to engage Macro mode. In Macro mode, the camera's focusing system is limited to close-up focusing. The distance range in Macro mode is about 0.4 in (1 cm) to 1.6 ft (50 cm) from the subject to the end of the lens, when the camera is zoomed out to the wide-angle setting. At the telephoto end of the zoom range, the distance range for macro shooting is about 1 ft (30 cm) to 1.6 ft (50 cm).

■ **Top cursor/MF button.** One push of this button and the camera enters manual focus mode, in which you adjust the focus using the control dial on the back of the camera. I'll supply more information about this procedure in Chapter 6.

■ **Right cursor/Flash button.** This button gives you access to various functions associated with the built-in flash unit. If you press it lightly, each press moves to one of several options (depending on the shooting mode) for the flash setting: **Automatic**; **Always on, slow synchro**; and **Always off**. If you hold down the button firmly, the camera displays the Flash Control menu, giving you access to additional flash settings. All of this is discussed more fully in Chapter 8.

■ **Bottom cursor/Self-timer button.** This button gives you instant access to the camera's versatile self-timer capability. Press the button to activate the self-timer screen, then use the cursor buttons and the front dial to make your desired settings for timer delay and number of shots.

■ **FUNC./SET button.** Push this button in to confirm a selection or activate a feature. It also provides direct access to the FUNC. menu, described in detail in Chapter 4. The FUNC. menu allows you to quickly access frequently changed settings, such as white balance and image size. As you'll see in Chapter 4, making those settings can be accomplished much faster in this way than by using the regular menu system, and you'll also find that less-used parameters are tucked away in the main menus.

■ **AF frame selector/Single image erase button.** This button's primary function is to let you perform certain functions in connection with the autofocus system, as described in the discussion of menu options in Chapter 4 and in the autofocus section in Chapter 6. This button's secondary function is to erase individual images. Press the button once when an image is displayed in playback mode, and the image will be erased if you confirm the operation with the navigation buttons and the FUNC./SET button.

■ **Metering mode/Jump target button.** The primary job of this button is to let you select the exposure metering mode to be used by the camera, as described in Chapter 5.

 ■ In shooting mode, press the button, then turn the control dial directly below the button to choose Evaluative (to base exposure on several different areas within the frame); Center weighted averaging (to emphasize the center area when calculating exposure); or Spot (to meter from a small area in the frame).

 ■ In Manual mode, if you have set the control dial to have two different functions at the same time, such as setting aperture and aspect ratio, using the **Set dial functions** option on the Shooting menu, you switch between the two functions using

this button. Note, though, that pressing this button also activates the Metering Mode selection screen, so you will likely have to press this button a few times before it will switch the control dial's function to the one you are looking for. You will see a green circle representing the control dial next to the aperture or metering mode when it is controlling those functions; when it is controlling the third function, the green circle disappears from the screen.

■ When reviewing images, the button's third function is to let you specify the way the camera "jumps" between images when rotating the control dial. I'll talk more about this capability a little later in this chapter.

Self-Timer

The PowerShot G12, like virtually all modern digital cameras, has a self-timer mechanism that adds considerably to the camera's usefulness in more than one situation. The obvious application of the self-timer is when you are taking a group photograph, of a family or school group, say, and you, the photographer, need to be in the picture as part of the group. Following the standard drill, you set the camera firmly on a tripod, and compose the group photo nicely using the viewfinder or LCD screen, leaving a gap in the assembled group that you can slip into quickly. Then you activate the self-timer, setting it for ten seconds; the self-timer starts to beep or flash, and you race around the tripod to insert yourself into the group. You manage to plant your feet firmly in place and smile just before the beeping and flashing speed up before the final shutter sound and flash.

The PowerShot G12 is quite capable of handling this scenario, with a bit of extra sophistication thrown in. Here is the basic method for taking a picture using the self-timer:

■ **Select a shooting mode.** Turn the camera on, and set it to an appropriate shooting mode. For a group photo using the self-timer, I suggest using the Auto mode, since you won't be behind the camera to tweak any settings; you may as well let the camera's automation earn its keep. But choose another mode if it's called for, such as Aperture-priority if the group is several rows deep and you need a small aperture to achieve a large depth-of-field.

■ **Press the self-timer button.** Press the button once to summon up a submenu on the right side of the screen, as shown in Figure 3.11. Press the self-timer button again (in its role as the down button) to move down to the lower option, which turns the self-timer on.

■ **Set the time delay and number of shots.** Turn the front dial to select the number of seconds of delay, from 0 to 30, and use the right/left cursor buttons to select the number of shots to be taken when the shutter fires after the time delay, from 1 to 10.

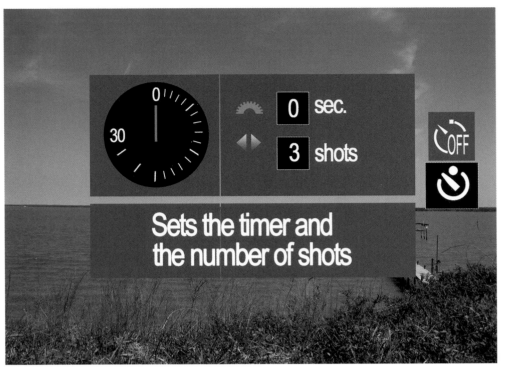

Figure 3.11

■ **Press the shutter button.** Take one last look at the LCD screen or through the viewfinder, then get a bead on the space you're going to occupy in the group photo, press the shutter button, and run like the dickens to get into place! Just as you get settled, the flashing and beeping on the camera will speed up, then the shutter will fire, the flash will go off (if needed), and the historical record of your membership in that group will be a bit more complete.

■ **Turn off the self-timer when you're done with it.** If you don't, it will remain on until you power the camera off, and all your shots will have to wait for the self-timer to count down.

Tip

On the G12 there are several variations to the self-timer settings that you can explore as needed. As noted, you can set a custom delay between 0 and 30 seconds, and you can set the camera to take from 1 to 10 shots when the self-timer triggers the shutter. Those are the only options available using the self-timer button and its little menu. However, if you set the mode dial to the SCN setting, and then scroll to the **Smart Shutter** setting, you will find several other options that function like self-timers. These are the **Smile Detection**, **Wink Self-timer**, and **Face Self-timer** options. I explain these in the discussion of Scene mode in Chapter 4.

Other Uses for the Self-Timer

Although the group photo described above is probably the most common scenario for using the self-timer, there are a couple of other situations when you might want to consider it. One is candid photography. There may be occasions when you want to catch your subject(s) off-guard, and you might be able to accomplish that in some cases by leaving the camera sitting off to the side of an elementary school classroom, say, or hold it casually down beside your hip and leave it set to take 10 shots when the self-timer triggers it. You might snag some good shots of kids who were not aware they were going to be photographed.

Another possible use for the self-timer is when you need to make sure the camera is not moved or jiggled, as it can be when you press the shutter, even if it's on a tripod. This can be important when you're taking long exposures of the night sky, for example, or for macro photography, when any camera movement is magnified. If you don't have a remote release switch available, the self-timer can be a workable substitute, because you won't be touching the camera when the shutter is pressed, so the risk of camera shake is greatly reduced.

Going Topside

The top surface of the Canon PowerShot G12 has a few frequently accessed controls of its own. The key controls, shown in Figure 3.12, are as follows:

■ **Exposure compensation dial.** One of the very attractive features of the G12 is the existence of this dial, which gives you instant access to adjust the exposure compensation, without having to immerse yourself in the menu system or embark on a series of button pushes. One quick twist of this knob, and you can dial in the amount of compensation you need, to account for backlighting or other challenging exposure conditions. I discuss exposure in more depth in Chapter 5.

■ **Flash hot shoe.** Slide an electronic flash into this mount when you need a more powerful Speedlite. A dedicated flash unit, like those from Canon, can use the multiple contact points shown to communicate exposure, zoom setting, white balance information, and other data between the flash and the camera. There's more on using electronic flash in Chapter 8.

■ **ISO dial.** As with the exposure compensation dial, this dial is a very welcome feature of the G12. ISO (sensitivity to light) is a very important concept for getting exposure right, and we will delve into it in some detail in Chapter 5. It's great to be able to dial in your desired ISO setting without the fanfare or fuss required on cameras that bury this function in menus or behind obscure buttons.

■ **Mode dial.** This dial is used to select among the various shooting modes offered by the G12. I discuss the shooting modes in Chapter 5.

Figure 3.12

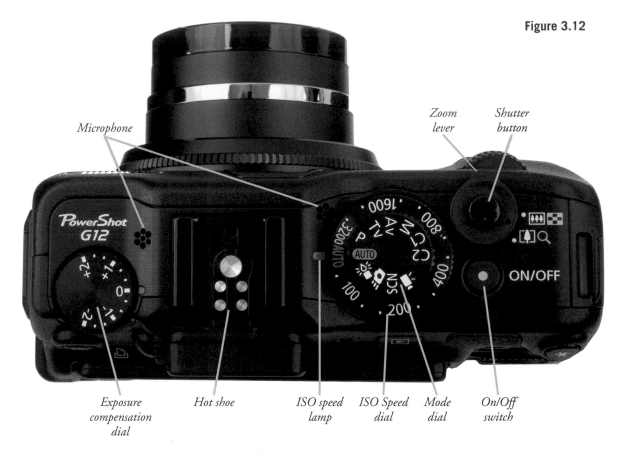

Microphone

Zoom lever

Shutter button

Exposure compensation dial

Hot shoe

ISO speed lamp

ISO Speed dial

Mode dial

On/Off switch

- **Shutter release button.** Partially depress this button to lock in exposure and focus. Press all the way to take the picture. You can partially depress the shutter button to switch from playback mode to recording mode, also. When making movies, you press this button once to start the recording, and then press it once more to stop. You can also press this button halfway to wake the camera up from its sleep mode.

- **Zoom lever.** This control has quite a few functions. Its primary purpose is to change the focal length of the PowerShot G12's lens between its 28mm wide-angle setting and its full optical zoom length of 140mm. You can also use this lever to magnify the image beyond the optical zoom length, using the digital zoom feature, discussed in Chapter 4. In playback mode, discussed later, it changes views of your images, and when viewing menus, you can use this lever to switch from one menu system (Shooting, Playback, Set up) to another.

- **On/Off switch.** Press down to turn the PowerShot G12 on, and press it again to turn the camera off. The green power light in the center of the button will illuminate while the power is on.

Port-Side Terminals

When you're holding the PowerShot G12 in your hands, the starboard (right) side of the camera is, oddly enough, the "port" side, where, underneath the terminal cover, you'll find three ports that let you connect the G12 to the outside world. These connectors, shown in Figure 3.13, are as follows:

- **HDMI terminal.** This upper terminal accepts the optional Canon HDMI cable, model number HTC-100. You also can use any standard HDMI cable with a mini-HDMI connector at the camera end and a standard HDMI connector at the TV end. With the cable, you can connect the camera to a high-definition (HD) television set or monitor.

- **Remote terminal.** This small round jack accepts a wired remote switch, the Canon RS60-E3, which you can use to control the camera from a distance in the same way as the cable releases used on film cameras. There also are wireless remote switches available that are compatible with this connection.

- **USB/Digital terminal.** This single connector has two purposes—to connect the camera to a computer or printer using the USB cable that is provided with the camera (or a generic equivalent), and also to connect the camera to a standard TV set, using the supplied AV cable.

Figure 3.13

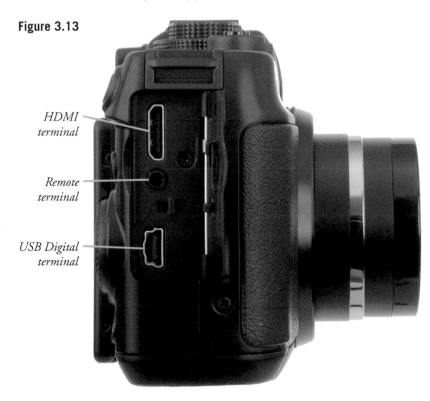

HDMI terminal

Remote terminal

USB Digital terminal

LCD Panel Readouts

The PowerShot G12 does not have a monochrome status LCD, like the one found on the top panel of many digital SLR cameras, and does not provide any display inside its viewfinder, as most dSLRs do. Lacking these auxiliary information displays, the G12 uses the color LCD to show you everything you need to see, from images to a collection of informational data displays. When the camera is in shooting mode, the screen displays only basic information, including battery status, exposure mode, and a few values, including shutter speed and f/stop. Using the Custom Display option on the Recording menu, you can also set the camera to display grid lines, a histogram, and an electronic level, as I'll explain in Chapter 4.

When the camera is in playback mode, it can display your images accompanied by several different screens of information. Here's an overview of these displays, and how to access them.

Image Playback Displays

When the G12 shows you a picture for review, you can select from among four different information overlays (three for movies). To switch among them, press the DISP. button while the image is on the screen. The LCD will cycle among:

- **Single image display,** which shows just the image that is on the memory card (or the initial frame of a movie); no other information is displayed (Figure 3.14).

- **Single image display with recording quality**, which also shows the image number, date, and time the image was taken. (Figure 3.15.) For movies, the information shown is slightly different.

- **Histogram display**, which shows basic shooting information such as shutter speed and aperture as well as a brightness histogram at bottom left (Figure 3.16). (I'll explain how to work with histograms in Chapter 5.)

- **Focus checking display.** A special screen designed to let you make a detailed assessment of the image's focus. This screen (shown in Figure 3.17) shows one view, on the left, of about normal size, with an orange frame showing where the camera's focus was set when the picture was taken. On the right is a smaller frame, enlarged. Move the zoom lever to the right to switch to the enlarged view, which then becomes highlighted. You can then change the magnification of this view with the zoom lever and scroll around it with the cross keys, to check the focus. This screen does not appear for movies.

Figure 3.14 Single image display.

Figure 3.15 Single image display with basic information.

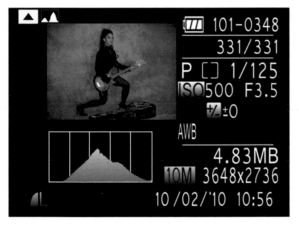

Figure 3.16 Histogram display.

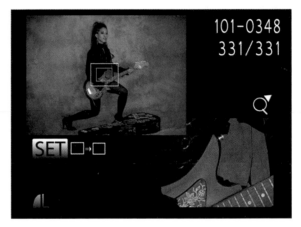

Figure 3.17 Focus checking display.

Jumping/Zooming Around

When you're ready to view the pictures you've taken, either on the camera's own LCD display or on a connected TV set, the PowerShot G12 offers plenty of options for viewing them. You'll find more details about some of these functions later in this chapter or in other chapters that I point you to. Here is the must-know information.

■ **Start review.** To begin reviewing your pictures, press the Playback button located above the LCD screen to the right of the viewfinder window. The image that shows up on the screen will be either the most recently viewed image or the most recently taken image, depending on your settings in the Playback menu. If the next item is a movie, press the FUNC./SET key to call up a VCR-like set of controls on the screen. Use the FUNC./SET key to operate those controls.

- **Cycle through information displays.** To view more or less information on the screen, press the DISP. button to move through the three (for movies) or four (for still images) different levels of items that show up on the screen. These displays can be invaluable in helping you to check composition, exposure, and focus, using tools such as the histogram and the focus check display.

- **View thumbnail images.** To change the view from a single image to 4, 9, 36, or 100 thumbnails, or to use the jump button to move among shots by categories, dates, and other criteria, see the "Viewing Thumbnails" and "Jumping Around" sections that follow.

- **Zoom in and out.** To zoom in or out, press the zoom lever, following the instructions on "Zooming Around" in the next section.

- **Move back and forth.** To advance to the next image, press the right cursor button; to go back to a previous shot, press the left button. You can also use either the front dial or the control dial to move through your images. When you reach the first or last photo in your memory card's folder, the display "wraps around" to the next shot in the sequence.

- **Move back and forth rapidly using Scroll Display.** To advance through the images rapidly using the single image display, turn the control dial on the back of the camera quickly, and the images will scroll in a way similar to the "cover flow" scrolling on an iPod. When this **Scroll Display** feature is active, a pair of up and down arrows will appear on the screen, inviting you to select images by date; choose a date with the up/down cursor buttons. Go back to normal Playback display by pressing the DISP. button or the FUNC./SET button. You can disable this feature altogether using the **Scroll Display** option on the Playback menu; in that case, the control dial merely moves through your images normally.

- **Erase images.** To delete an image that's currently on the screen, press the Trash button, then move the highlight from **Cancel** to **Erase** on the screen, and press the FUNC./SET key to confirm the operation.

- **Cancel playback.** To cancel image review, press the Playback button again, or simply tap the shutter release button. (If you turned the camera on using the Playback button, pressing the button again will turn off the camera.)

Zooming Around

When an image is displayed in playback mode, press the zoom lever to the right (in the direction for zooming the lens) to fill the screen with a slightly magnified version of the image. You can keep pressing the zoom lever to magnify images up to about 10 times the normal size. Press the lever in the other direction as many times as needed to reduce

the size to normal, or press the MENU button to reduce it to normal immediately. While the image is zoomed, you can scroll around in the zoomed image with the four cursor buttons. You can move to other images with the control dial while the images are zoomed.

Viewing Thumbnails

The PowerShot G12 provides other options for reviewing images in addition to zooming in and out. You can switch between single image view and an index screen with 4 thumbnail images by moving the zoom lever to the left, toward the wide-angle view. Further pushes of the zoom lever take you to successive **index** screens with 9, 36, and 100 thumbnail images, assuming you have that many images stored on your memory card. One of the thumbnail images will be highlighted by a frame, and you can move to the other images on the screen one at a time with the cursor buttons or one row at a time with the control dial. Move the zoom lever back to the right to move back to screens with fewer thumbnails. When an individual image is highlighted on an index screen, you can erase it by pressing the Trash button and then confirming the action when prompted by the camera.

Jumping Around with Filtered Playback

The PowerShot G12 has one more image-viewing trick up its sleeve, and a pretty powerful one at that. Some previous Canon models (not to mention models from other brands) have a Calendar function that lets you view images taken on a particular date. The G12 can perform a similar feat, but with added punch—it will let you "jump" to other images not just by date, but also by category, first image in the folder, movies versus stills, 10-image jumps, and 100-image jumps. So, for example, if, like me, you use 16GB SDHC cards (which can hold thousands of images each) this is a welcome way to narrow down your search for images on a given card. Here's how to perform this sort of jump-search, which Canon calls Filtered Playback:

1. **Press the Playback button.** The camera enters playback mode.

2. **Press the jump button.** That's the button above the right side of the control dial, directly below the * button. This action brings up a submenu on the left of the screen showing a line of icons. From top to bottom, these icons represent Favorites; date; category; still/movie; jump 10 images; and jump 100 images.

3. **Scroll to the search type you choose.** Scroll down to highlight one of the above criteria you want to use to base your search on. If you're basing your search on the categories of images or on Favorites, see the discussions of those topics in Chapter 4.

4. **Select the filter data.** If there is more than one possibility for the search, such as with dates or categories, use the left/right cursor buttons to select the details of the search you want. For example, select the particular date you're searching for, or choose between stills and movies. If there's only one possibility for the search, such as jumping to Favorites, go directly to the next step below.

5. **Turn the control dial.** This is the step that actually takes you to the first image that meets the search factors you have chosen. Turn the dial to the right to select that first image of the search set, then keep turning it to continue displaying those images.

6. **Press the jump button again.** Pressing the jump button again will exit from this search mode.

Underneath Your PowerShot G12

There's not a lot going on with the bottom panel of your PowerShot G12. Besides the door to the battery and memory card compartment, you'll find a tripod socket, which secures the camera to a tripod, or to certain optional accessories, such as the BKT-DC1 bracket, which is used to mount a macro ring flash unit and other external flash units. Figure 3.18 shows the underside view of the camera.

Figure 3.18

4

Setting Up Your Canon PowerShot G12

For a highly portable "point-and-shoot" camera, the PowerShot G12 provides you with an impressive collection of options and settings that let you customize the way your camera operates. Not only can you change shooting settings used at the time the picture is taken, but you can adjust the way your camera behaves. Indeed, if your G12 doesn't operate in exactly the way you'd like, chances are you can make an adjustment in the Shooting menu, the Playback menu, or the Set up menu to tweak the camera's behavior to your liking. If you don't like the organization of the menus themselves, you can create a customized mini-menu system of your own by gathering your favorite functions using the My Menu feature. In addition, you can get virtually instant access to several of the most important choices for setting up your shots through the FUNC. menu, which is summoned with one press of your finger.

This chapter will help you sort out the settings for all the G12's menus. These include the aforementioned Shooting, FUNC., and Playback menus, which determine how the G12 uses many of its shooting features to take a photo and how it displays images on review. In addition, I'll show you how to use the Set up menu to adjust items such as power-saving timers, screen brightness, and others.

As I've mentioned before, this book isn't intended to replace the manual you received with your G12, nor have I any interest in rehashing the contents of the Canon user's guide. The owner's manual is useful as a standby reference that lists every possible option in exhaustive (if excruciating) detail—without really telling you how to use those options to take better pictures. There is, however, some unavoidable duplication between the Canon manual and this chapter, because I'm going to explain all the key menu choices

and the options you may have in using them. You should find, though, that I will give you the information you need in a much more helpful format, with plenty of detail on why you should make some settings that are particularly difficult to understand.

I'm not going to waste a lot of space on some of the more obvious menu choices in these chapters. For example, you can probably figure out, even without my help, that the **Sound options** item on the PowerShot G12's Set up menu deals with the solid-state sound chip in your camera that produces electronic chirps and beeps during various activities (such as the self-timer countdown). In this chapter, I'll devote no more than a sentence or two to the blatantly obvious settings and concentrate on the more confusing aspects of G12 Set up, such as autofocus. I'll start with an overview of using the G12's menus themselves.

Anatomy of the PowerShot G12's Menus

The main menu system of the PowerShot G12 should seem quite familiar to anyone who has used a similar-sized digital camera, especially another PowerShot, within the past few years. After all, given the profusion of features found on modern cameras, there are only so many ways that engineers can organize menu items for all of those features in a logical and user-friendly manner.

The designers of the PowerShot G12 menu system have succeeded quite well in the user-friendliness arena. To make use of the system, just press the MENU button, located in the lower-right corner of the back of the camera, and use either the left/right cursor buttons or the zoom lever (surrounding the shutter button) to highlight the menu tab you want to access—Shooting or Playback, depending on the mode the camera is in, or Set up, which is accessible from either shooting or playback mode. (There's also a printing menu, for functions relating to printing images directly from the camera, and the My Menu tab, which lets you set up a customized menu.) Then, scroll up and down within a menu with the up/down cursor buttons or by spinning the control dial.

Here's a shortcut: If you happen to be stuck one or more screens down in the options of one of the menus, you can quickly switch back to either of the other menus by moving the zoom lever to the right or left. That way, you don't have to scroll all the way back up to the top of one menu system before switching to another one, as you otherwise would. One more tip: when you get to the bottom (or top) of a menu, you can wrap around by continuing in that direction. For example, if you're on the top item of a long menu and want to get to the bottom item, or to an item that's closer to the bottom than to the top, your quickest route will be to scroll up beyond the top item, which will take you straight to the last item, from which you can then scroll up to the neighboring items. This technique can save lots of time when you need to navigate the menus in a hurry.

On the PowerShot G12, pressing the MENU button brings up a typical menu screen like the one shown in Figure 4.1. (If the camera goes to "sleep" while you're reviewing

Figure 4.1
The PowerShot
G12's menus
are arranged in
a series of tabs.

a menu, you may need to wake it up again by tapping the shutter release button or the MENU button.) There are three menu tabs visible while the camera is set to shooting mode: Shooting, Set up, and My Menu. (When the camera is in playback mode, the three menu choices are Playback, Printing, and Set up. We'll discuss those later.)

The tabs are labeled with icons: a camera for the Shooting menu, a wrench and hammer for the Set up menu, and a star for the My Menu tab. (The Playback menu is represented by a right-pointing triangle, and the Printing menu by a printer icon. Neither is shown in the view presented in Figure 4.1; you'll work with them later in this chapter.) The currently selected menu's icon is highlighted in orange. Here are the things to watch for as you navigate the menus:

- **Menu tabs.** In the top row of the menu screen, the menu that is currently active will be highlighted as described earlier. Just remember that the camera icon stands for shooting options; the right-pointing triangle represents playback options; the wrench/hammer icon stands for Set up options; and the star stands for personalized menus.

- **Selected menu item.** The currently selected menu item will be highlighted by an orange-colored bar.

- **Other menu choices.** The other menu items visible on the screen will have a dark gray background. With the PowerShot G12, you won't always see "grayed out" menu lines for items that are not available in a particular mode. Instead, in some

Figure 4.2 When the PowerShot G12 is set to Auto shooting mode, some menu options simply don't appear, such as AF Frame (left). When the camera is set to Program shooting mode, that option reappears (right).

cases, those items just will not appear on the menu if they are not available. For example, when the camera's shooting mode is set to Auto, several Shooting menu options, such as **AF Frame**, **Servo AF**, and certain **Flash Control** options are not available, and simply do not show up—they are left out of the menu list. (See Figure 4.2.) However, there are other situations in which the camera *does* use the "grayed out" approach. If you remain in a particular shooting mode but select an option that renders some menu selections unusable, those selections will be "grayed out." For example, if you are in Program mode, most of the menu options are available. But if you then select manual focus by pressing the MF button on the back of the camera, Presto! No more AF options are available on the menu; they are "grayed out."

- **Current setting.** The current settings for visible menu items are shown in the right-hand column. Unlike some other cameras' menu systems, in most cases, the full screen of the G12 menu stays visible on the camera's display while you select the value for a particular menu item. (With some other cameras, when you select a menu item, it takes up the whole screen, and all other menu items disappear until that item's value has been selected.)

When you've used the up/down cursor buttons (or the control dial) to move the menu highlight bar to the menu item you want to work with, press the left/right cursor button to select the desired value for the item. Many of the items can be set only to On or Off, but others can have one of several values. For example, the **Review** function, which determines how long a new image stays on the screen for review, can be set to a time from 2 to 10 seconds, to hold indefinitely, or to be off altogether—a total of 11 separate choices, any of which can be selected by moving the left and right cursor buttons.

In a few cases, such as **Flash Control**, once you've highlighted the menu item, you need to press the FUNC./SET key to get access to a submenu with further options (see Figure 4.3). Such menu items have three dots after their names, to indicate that more details

Figure 4.3
The Flash Control item on the Shooting menu leads to this submenu with numerous options, in some shooting modes. In the more automatic modes, fewer options appear on this list.

are available by pressing FUNC./SET. In most cases, though, you can make all your selections for the various menu items without leaving the main menu screen. This system makes it clean and easy to make your settings without having to go through a lot of extra button pushes or to go into and out of a series of submenus.

In order to select your desired menu option, you ordinarily only have to highlight it; you don't have to press the FUNC./SET key to select it. Once your selection is highlighted, just press the MENU key or press halfway down on the shutter button to exit the menu system, and you're ready to shoot with the newly selected option activated.

Shooting Menu Options

The various settings that are controlled directly by buttons and dials on the top and back panels of the camera, including ISO sensitivity, metering mode, exposure compensation (EV), self-timer, and flash, are likely to be the most common settings you make, with changes during a particular session fairly common. You'll probably find that the Shooting menu options, along with the FUNC. menu options, which I'll discuss later, are those that you access second-most frequently. You might make such adjustments as you begin a shooting session, or when you move from photographing one type of subject to another. Canon makes accessing these changes very easy.

This section explains the options of the Shooting menu and how to use them. As noted earlier, the G12 sometimes changes its list of visible menu options according to the current context, such as whether the camera is set to Auto shooting mode. This system is good in that it eliminates the need to scroll through a series of options that you can't select, but it has the negative aspect of making it somewhat confusing to discuss the options that are available, because some of them will be invisible to you if the camera is set to a mode in which you can't make certain selections. (If you would like to go through the Shooting menu and see almost all of the available options, set the camera to Aperture priority mode by turning the mode dial to the A setting; that mode has more Shooting menu options available than any other mode, as you can see from the chart at pages 202-203 of the camera's User Guide.)

With that caveat, then, the options you'll find in the Shooting menu, at least in some shooting modes, are the following:

- AF Frame
- Digital Zoom
- AF-Point Zoom
- Servo AF
- Continuous AF
- AF-assist Beam
- MF-point Zoom
- Safety MF
- Flash Control
- ISO Auto Settings
- Spot AE Point
- Safety Shift
- Wind Filter
- Review
- Review Info
- Blink Detection
- Custom Display
- Reverse Display
- IS Mode
- Converter
- Date Stamp
- Set Dial Functions
- Set Shortcut button
- Save Settings

AF Frame

The first choice presented to you in the Shooting menu is **AF Frame**, which gives you three options for the behavior of the autofocus frame. The first choice is **Face AiAF**, which I am going to venture to translate as "artificial intelligence autofocus." With this option, the camera attempts to find a human face in the scene before the camera. When it has found one or more likely candidates, it puts a white frame on what seems to be the main subject, as shown in Figure 4.4, and places gray frames on up to two other

Figure 4.4
Face AiAF can
locate faces in a
frame, and lock
in focus.

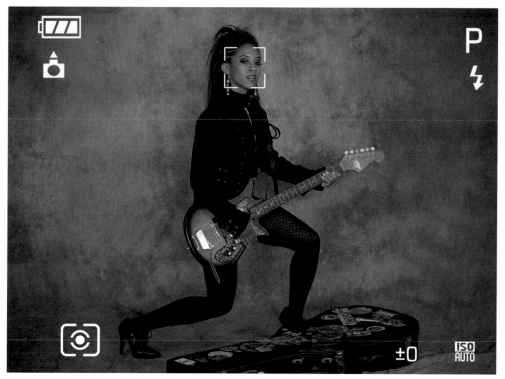

faces. If it finds no apparent faces, or no apparent main face, once you press the shutter button halfway, the camera will set up to nine green frames to show the points it will use for autofocus.

The second option on this menu is **Tracking AF**. When you choose this option, the focus area on the screen becomes a small white box with four little lines sticking out in each direction. Place this box over your subject (such as a fidgety child or pet), and press the AF Frame/Trash button, to the upper left above the control dial. The camera will then attempt to keep your chosen subject in its cross-hairs, even as it (or the camera) moves. When you're ready to take the picture, press the shutter button halfway to calculate focus and exposure; the camera will continue to adjust focus and exposure on your subject until you press the shutter button all the way to take the picture.

Your third option here is **FlexiZone**, which I personally find preferable to the others for most ordinary shooting, when I don't need to track a moving subject. With **FlexiZone**, you work with a single AF frame, whose size and position you can change, so you can focus on a particular area of the scene in question to achieve a fairly precise level of control over your composition. Once you have selected this AF method, press the AF Frame/Trash button, and the AF frame will turn orange. The frame then becomes movable. Move it around the screen quickly with the control dial or the front dial, or in

smaller steps with the cursor buttons. If you press the DISP. button, you can then change the size of the frame between normal and small. Fix the frame's location and size by pressing the FUNC./SET button or by pressing the shutter button halfway to focus.

If you do a lot of photography involving groups of people and the face-detection works for you, that's great. For me, though, the FlexiZone system offers an excellent approach to achieving sharp focus. Of course, with a camera like the PowerShot G12, with its small sensor and large depth-of-field, focus often will not be a major issue, particularly when the lens is zoomed back to its wide-angle position. For those shots when focus is more of a concern, though, FlexiZone can help. Decide what part of the image you want to be in the sharpest focus, select **FlexiZone**, and place a small-sized AF frame over that area while the lens is zoomed in. (If focus is sharp when the lens is zoomed in, it's sure to be sharp when zoomed back also.) Then zoom the lens back out if that's the view you want, and take the picture. Your focus should be right on the mark.

I'll discuss your focus options in more detail in Chapter 6.

Digital Zoom

Digital zoom, quite frankly, is not a feature to get particularly excited about. The PowerShot G12, like most compact digital cameras, has a nice "optical zoom" capability, going from 28mm (wide angle) to 140mm (telephoto), using the standard 35mm-equivalent ratings of focal length. That means that the camera's lens zooms in to a focal length that makes objects look five times larger than at the shortest focal length. That capability can be called a "real" zoom capability, because the image is magnified as with binoculars or a telescope; in other words, you actually get more information through the viewfinder and in your final image than without the zoom.

With the "digital zoom," on the other hand, you really don't get any more picture information for your final image. What happens is that the camera electronically magnifies a portion of the image that the lens sees, in the same way that you can blow up the image on your computer to enlarge a small part of it. Just as on a computer, the enlarged part becomes blocky, or pixellated, and you don't really see any more information than without the enlargement. That's not to say that digital zoom has no useful purpose at all. When the camera magnifies your view like this, then the exposure metering can be limited to a small part of the image, and you may be able to compose your shot better by zooming in digitally. But don't expect to get the benefit of a real enlargement of the image, as with optical zoom.

If you want to turn **Digital Zoom** on, the aspect ratio (see later discussion in this chapter) has to be set to 4:3. In any other aspect ratio, the **Digital Zoom** option will be dimmed on the menu and cannot be selected. Your choices in the menu system are to leave it off, or turn it on at a zoom factor of 1.4 or 2.3, or at a setting of **Standard**, which

gives you the whole zoom range, up to 20 times the normal view, with a highly pixel-lated image at the 20X range. I recommend leaving **Digital Zoom** turned off, unless you're faced with a situation in which it may be of some advantage to have your image electronically enlarged for purposes of exposure or composition.

If you do choose to use **Digital Zoom**, you can tell when it's active by looking at the numbers that show up near the top of the LCD to report the magnification level of your zoom, such as 5.0X, or 18X. If those numbers are blue rather than white, that means that **Digital Zoom** is being used to achieve that magnification level. Also note that **Digital Zoom** is not available, and will be grayed out on the menu, when you are using RAW quality (or RAW+JPEG).

AF-Point Zoom

This is a handy little feature that gives you the option of having a magnified autofocus frame. The only option is to turn it on or off. When it's on, if the **AF Frame** is set to **FlexiZone** or a face is detected in **Face AiAF** mode, the AF frame will be magnified when you press the shutter button down halfway to check the focus. This system lets you check to make sure the autofocus has locked on and focused properly. If you find the magnified frame distracting, turn it off, but I find it quite useful and reassuring to be able to see the focus point more clearly. Note that the feature does not function in all situations, such as when the **AF Frame** is set to **Tracking AF** or to **Face AiAF** and no faces are detected. It also cannot function if **Servo AF** is activated or **Digital Zoom** is set to 1.4X or 2.3X (a **Standard** setting is fine). (If you find that **AF-Point Zoom** is grayed out on the menu, check to see if **Digital Zoom** or **Servo AF** is interfering; if so, deactivate the offending setting and **AF-Point Zoom** will become available again.)

Servo AF

Ordinarily, when you press the shutter button down halfway, the focus and exposure are locked in. If you keep the shutter button halfway down and move the camera, you will keep the same settings until you press the shutter all the way in. If you have a digital SLR, that function is often called *Single Servo AF,* or AF-S. With the G12, the **Servo AF** setting on the Shooting menu is the equivalent of *Continuous Servo AF* (AF-C) on a digital SLR. In **Servo AF** mode, the G12 readjusts focus as required. So, when you press the shutter halfway, the focus and exposure will continuously adjust as the subject or camera moves, or as lighting conditions change. You will hear the camera make a continuous whirring or clicking sound as the focus mechanism keeps adjusting. This feature is great if you are tracking a moving subject and want to have the focus and exposure ready for the instant when you finally snap the picture. As you might guess, the downside is that you may run through batteries faster than you would like. I'll discuss the uses of this feature in more detail in Chapter 6.

Continuous AF

This feature, which has a name that's similar to that of the continuous servo feature found in digital SLRs, is similar to **Servo AF**, but in a different context. Normally, when this feature is off, the camera autofocuses on your subject only when you press the shutter button halfway. If you turn this feature on, then the camera constantly alters its focus as you move the focus frame over different subjects, *without the need to partially depress the shutter release*. In other words, this feature controls whether the camera constantly focuses *before* you press the shutter halfway, and the **Servo AF** feature controls whether the camera constantly focuses *after* you have pressed the shutter halfway. Of course, this feature, like the previous one, has a good side and a bad side: it can help you achieve sharp focus quickly, but it also can drain your battery quite rapidly. More about this feature in Chapter 6.

AF-Assist Beam

The autofocus mechanism sometimes needs some extra light in order to figure out whether the scene before the camera is in sharp focus. Without that light, the shape in question might be too indistinct for the camera to find the straight lines that can help it determine focus. If you're shooting at a religious ceremony or in another environment in which you don't want to send out beams of light, or you believe your focus will be adequate without that help, go ahead and set this feature to **Off** in the menu system. Be warned, though, that you may still see the same beam of light, because the camera also sends out a similar beam to reduce the red-eye effect. So, unless you have **Red-eye reduction** *and* **AF-assist Beam** turned off, beware the Light Beams!

MF-Point Zoom

When you set the camera to manual focus using the MF button, ordinarily the focus area in the center of the LCD screen is magnified so you can fine-tune the focusing by turning the control dial. If for some reason you prefer not to have that enlarged area appear (maybe you find it distracting from the composition), you can turn off the enlarging effect with this menu option.

Safety MF

This is another feature that works in conjunction with manual focus. Ordinarily, even when you are using manual focus, you have the option of fine-tuning the focus to full sharpness, after first focusing roughly with the control dial, by pressing the shutter button halfway, or pressing the AF Frame/Trash button. This feature is called **Safety MF**. If you want to disable this feature, you can do so with this menu option. You might want to disable it if you have a tricky manual focusing situation, and you don't want the camera to change your manual focus when you press the shutter button down to take the picture.

Flash Control

This menu item is one of those that lead to several other options; it's not just an **On** or **Off** feature. I'll be talking about the use of flash in more detail in Chapter 8, but I'll discuss the main options of the Flash Control menu here for reference. After highlighting the **Flash Control** line on the Shooting menu, press the FUNC./SET button to bring up the submenu with the options discussed below.

Flash Exposure Compensation

This entry is a way to set flash exposure compensation (that is, raising or lowering the normal flash output) as an alternative to doing so through the FUNC. menu. To set this value using the Shooting menu, highlight this option, then dial in the amount of flash EV compensation you want using the left/right cursor buttons. Press the MENU button to exit. This setting works for both the built-in flash and for a compatible external flash that's inserted in the camera's hot shot, such as the Canon Speedlite 430EX II or 580EX II. However, there are differences in the operation of this feature, depending on what flash is being used. You can adjust the flash output up to plus or minus 2 EV with the built-in flash; with some external units, you can adjust it up to 3 EV in either direction. In addition, with the built-in flash, you can make the adjustment by pressing the Flash key (right cursor button) and then immediately turning the front dial; that method is not available with an external flash unit. If the camera is set to Manual exposure mode, the same adjustment can be made, but it is then considered **Flash Output** rather than **Flash Exposure Compensation**, and the adjustment units are shown differently, but the effect is the same.

Flash Mode

This option, available only in the Shutter priority and Aperture priority shooting modes, can be set to either **Auto** or **Manual**. It lets you control the flash output in those modes. When this option is set to **Manual**, the **Flash Output** option becomes available so you can control the intensity of the flash. When it is set to **Auto**, the **Flash Exposure Compensation** option is available instead of **Flash Output**.

Flash Output

As discussed in connection with **Flash Mode**, above, this option becomes available when the camera is set to Shutter priority or Aperture priority shooting mode and the **Flash Mode** is set to **Manual**. In those circumstances, you can set the intensity of the flash manually using this feature. You can also use this feature when the shooting mode is set to **Manual**.

Shutter Sync

You can choose **1st Curtain sync**, which fires the flash as soon as the shutter is completely open (this is the default mode). Alternatively, you can select **2nd Curtain sync**, which fires a pre-flash used to measure exposure as soon as the shutter release is pressed down all the way, but before the shutter opens, and then triggers a second flash at the end of the exposure, just before the shutter starts to close. This action allows photographing a blurred trail of light from moving objects with sharp flash exposures at the beginning and the end of the exposure. I'll explain how it works in Chapter 8.

Red-Eye Correction

You're probably familiar with the red-eye effect that populates snapshots at parties with people looking as if they wandered off the set of a *Twilight* movie. The problem is that electronic flash (or, rarely, illumination from other sources) bounces off the retinas of the subjects, with the red from retinal blood vessels adding the unwanted coloration to the eyes. The PowerShot G12 attacks this problem with two distinct approaches, which are very different even though they both are housed on the Flash Control menu. The camera uses both *correction* and *reduction*. Reduction involves shining a light at the subject's eyes to narrow the pupils, thereby reducing the chance of reflections from the retinas. We'll return to that approach in a moment; it's the next menu choice. For now, the topic is red-eye correction.

The first arrow in the G12's quiver of anti-red-eye measures is digital correction. Put simply, this means that the camera's circuitry looks for unnaturally red areas in or near people's eyes, and attempts to de-redden them digitally. This system is not perfect; this correction technique may take effect when someone has red makeup applied near the eyes, so don't rely on it too heavily to fix red-eye. This feature can be turned either **On** or **Off**.

Red-Eye Lamp

This is the second way the G12 combats the scourge of red-eyed photos. If this feature is turned on, the camera lets loose a beam of light toward the subject before the flash fires for taking the picture, in order to narrow his or her pupils, as discussed above. (You may have to ask the subject to look straight at the camera to gain maximum effect.) Actually, the best way to truly eliminate red-eye is to raise the flash up off the camera so its illumination approaches the eye from an angle that won't reflect directly back to the retina and into the lens. That alone is a good reason for using an external flash. If you're working with your G12s's built-in flash, your only recourse may be to use the two red-eye-reduction strategies discussed here. Figure 4.5 shows the effects of wider pupils (left) and those that have been contracted using the G12's **Red-Eye Lamp** feature.

Figure 4.5
Red-eye is bla-
tant (left), but
tamed (right)
thanks to the
PowerShot
G12's Red-eye
reduction
lamp.

Figure 4.5
Red-eye is bla-
tant (left), but
tamed (right)
thanks to the
PowerShot
G12's Red-eye
reduction
lamp.

Safety FE

This final option on the Flash Control menu is a safety mechanism programmed into the camera. When this feature is activated (as it is by default), the camera automatically adjusts the aperture and shutter speed when the flash fires, to prevent a situation in which the shot is overexposed by an overly powerful flash discharge. If you turn this feature off, the camera will let the chips fall where they may, and your highlights may be blown if the flash turns out to be too bright for the conditions. This setting is not available in Manual exposure mode or in other modes when **Flash Mode** is set to **Manual**. You can turn this option off if you have a particular need to let the flash overexpose the image, but it's generally a useful feature to leave in place, to minimize the chance of pictures that are completely washed out by excessive brightness from the flash.

ISO Auto Settings

This menu option gives you the ability to change the way the **ISO Auto** setting works. There are two settings available: **Maximum ISO Speed** and **Rate of Change**. The Maximum ISO can be set to **400**, **500**, **640**, **800**, **1000**, **1250**, or **1600**. You might want to set a number lower than 1600 if you're using the **Auto ISO** setting and you want to make sure that the camera does not set ISO high enough to introduce noticeable noise into your images. The **Rate of Change** option can be set to **Standard**, **Fast**, or **Slow**. This setting regulates how quickly the camera will change its ISO setting when **ISO Auto** is active. You might want to set it to one of the slower speeds to avoid having unwanted shifts in ISO during a shooting session. However, if you are shooting in

a rapidly changing environment (such as an area where clouds are periodically blocking the sunlight), you might want to set the **Rate of Change** to **High** so the camera can keep up with the changing lighting conditions.

Spot AE Point

This feature has one very specific purpose—to link the exposure frame to the focus frame when you have the camera set for both **FlexiZone** autofocus and **Spot** metering, so you can choose a particular spot for the camera to set both focus and exposure. Here are the steps to follow:

1. Using the metering mode button and the control dial, select **Spot** as the metering method.

2. Set the **AF Frame** option on the Shooting menu to **FlexiZone**.

3. Select **Spot AE Point** on the Shooting menu, and set the option to **AF Point** (as opposed to **Center**).

4. In the center of the LCD screen, you will see a double set of brackets enclosed within a rectangle, indicating that both the focus and the exposure are being determined by this small area in the middle of the screen (see Figure 4.6). (The brackets look slightly different if you set the **AF Frame** to its smaller size.)

Figure 4.6
The FlexiZone focus frame is linked to the Spot metering frame using the Spot AE Point feature.

Now, since the camera is set to the **FlexiZone** focusing mode, you can press the AF Frame button and then move or resize the focus frame as you wish. You may notice dramatic changes in exposure of the scene as you move the small exposure and focus area to different parts of the scene before you, because of the effect of the Spot metering. You won't want to use this technique without a good reason, but if you know your exposure and focus should both be determined by the same small area of the scene, it's a good item for your photographic toolkit.

Safety Shift

This feature is another one with a very limited purpose. This menu option appears only when the shooting mode is set to Aperture priority or Shutter priority. When you activate **Safety Shift** in one of those shooting modes with the flash turned off, the camera will automatically shift the setting you made (for aperture or shutter speed) if proper exposure cannot be obtained using that setting. For example, let's say you're using Shutter priority mode and have set the aperture at 1/2,000th of a second in a dimly lit room with the flash turned off. With **Safety Shift** off, if you take the picture at these settings, you can enter the result into a contest for photos of coal-bin interiors with a good chance of victory. With **Safety Shift** turned on, the camera is quite likely to switch your shutter speed to something like 1/6th of a second, and you will now have a reasonably visible representation of your dimly lit room. With this option, the camera will raise the ISO setting to a certain extent to achieve a correct exposure, but it will likely still shift your setting in order to avoid raising the ISO too high. Of course, if the shutter speed is shifted to a slow value, such as 1/6th of a second, you will have to hold the camera very steady or use a tripod.

Wind Filter

I'm discussing this feature here in the interest of covering all items on the Shooting menu, even though this one applies only to movies, and not to stills, and doesn't appear on the menu unless the PowerShot G12 is set to Movie mode. With this feature activated, the camera will attempt to suppress wind noise coming into its tiny microphone. It may or may not help, and it may result in unnatural-sounding audio if there is no wind, so experiment and see if it's useful before you activate this feature for important footage in any particular environment.

Review

This menu option controls how long an image displays on the LCD screen after it has just been recorded. You can set the review time to any value from 2 to 10 seconds; to hold on the screen until the shutter button is pressed halfway; or not to display at all (see Figure 4.7). Keeping the review time short is one good way to preserve your battery's charge.

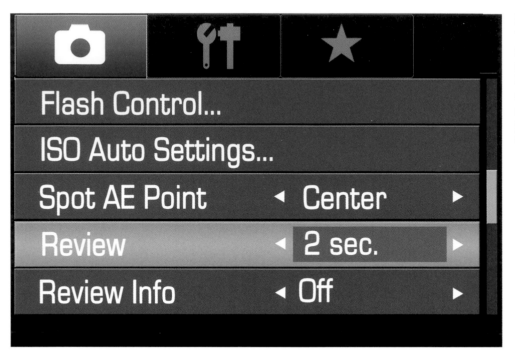

Figure 4.7
The Review function determines how long an image displays on the screen after the picture is taken.

Review Info

This menu option works in conjunction with the **Review** function, discussed above, to set how images display on the screen right after they've been shot. Therefore, this option is available only if the **Review** function is turned on with the previous menu option. The choices for **Review Info** are **Off**, **Detailed**, and **Focus Check**. With **Off**, there's no information displayed, just the image. With **Detailed**, the screen provides details about the exposure as well as a histogram showing the brightness values graphically. With **Focus Check**, the camera displays a special screen that lets you enlarge various portions of the image for closer inspection of the image's focus. I discuss histograms in Chapter 5, and **Focus Check** in Chapter 3.

Blink Detection

With this setting turned on, the camera will display a frame with a little blinky-eyed face if it detects that an image you have taken has a person with his or her eyes shut. This option may seem at first blush to be a bit Big Brotherish, but it actually could be useful, because it can be pretty hard for you as the photographer to check your subject's eyes during a shooting session.

Custom Display

This menu option lets you customize the information that is shown on the LCD screen when you are in Shooting mode. Once you have selected this option, you are presented with a matrix containing the three screens that can be shown with successive presses of the DISP. button (see Figure 4.8). In the first two columns of this matrix, you can choose among four items to be displayed on the two screens summoned by the DISP. button: (1) shooting info, which includes things such as battery life, quality and image size settings, and general settings such as **i-Contrast** and the like; (2) grid lines, a set of intersecting lines that can help with composition; (3) electronic level, a bar with a pointer that centers and turns green when the camera is being held level; and (4) histogram. The third column lets you choose whether to have a blank screen display in the cycle of screens summoned by the DISP. button. If you want to have a blank (dark) screen available, navigate to the top of the second column, then move right to the third column, and press the FUNC./SET button to put a check mark in that column. In daily use, you may want to have your first screen uncluttered with much of this information, and your next screen (summoned by the DISP. button) to show just grid lines. It's all a matter of how you use the information on the screen. The electronic level is a nice feature, and I like to include it on both information screens.

Figure 4.8
The Custom Display menu option lets you specify what information appears on the detailed shooting information display and lets you decide whether to have a blank screen appear as one option when the DISP. button is pressed.

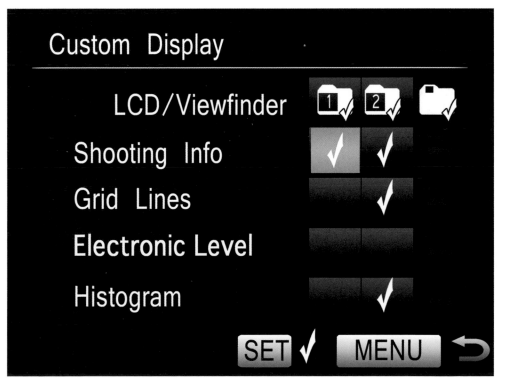

Reverse Display

Here's another menu item that was created to address a very specific issue, which arises because of the PowerShot G12's swiveling screen. If you fold the LCD screen out to the side and then flip it vertically (on its horizontal axis), the screen will be facing you if you are staring at the lens. With the **Reverse Display** setting turned on, you will see a mirror image in the screen, rather than the normal image that the camera's lens sees. This is done largely so you can take a self-portrait; in other words, the LCD shows you a mirror image of what it's aimed at, though, if you then take the picture, when you view it later it will be oriented correctly, not a mirror image. If you don't want the image in the LCD screen reversed when the screen is flipped around to the front, you can turn this setting off.

IS Mode

The PowerShot G12 is equipped with a very capable image stabilization system, which detects camera motion and uses electronic circuitry to counteract it, thus reducing the chances your shots will be marred by blurring if the camera shakes while you're taking pictures. With image stabilization engaged (set to Continuous on this menu), you can hand-hold the camera at slower shutter speeds without ending up with ruined images, so it's a very useful feature. The problem is that it eats up battery life, so if you're out in the field without access to batteries or chargers, you may want to minimize the use of this feature. One way to do so is by the use of a tripod, which is a good idea for any situation in which you can use one. There is nothing like a good, solid tripod for contributing to strong, clear photographs. If you do use a tripod, you should set this option to **Off**, even if battery life is not an issue, because the feature is not needed in that situation, and possibly could degrade the image slightly in some way. If turning stabilization completely off is not a viable option, you can use this menu item to switch it to **Shoot Only**, which means stabilization will be applied only when the shutter is pressed. **Panning** is intended for use when you are using a hand-held camera to track objects moving horizontally, such as horses or runners, and you want to counteract vertical motion but not the horizontal motion.

Converter

This menu option is for use when you have attached the Canon TC-DC58D Tele-converter add-on lens to the camera. It tells the optical image stabilization system to adjust its correction for the teleconverter's magnification. When that 1.4X telephoto accessory lens is attached, you should set this menu option to indicate that fact. Otherwise, leave it set to its default setting of **None**. If you have set the **Image Stabilization** setting to **None**, you do not need to change the Converter menu setting, even if the converter is attached, as there is no IS to adjust.

Date Stamp

When you turn this menu option on (by setting it to **Date** or **Date and Time**, as opposed to **Off**), the PowerShot G12 will display the date (or date and time) in the lower-right corner of each image taken while the option is activated. The word **Date** will be shown in the lower-right corner as you are shooting to remind you that this function is set. You need to be sure you want to do this before you set the function, because the information is permanently embedded in the image, and cannot be removed unless you crop it out of the picture or otherwise alter the image. Your images will always have the date information recorded in the file anyway, so you can tell when the image was taken (assuming the date and time were set correctly). The Date Stamp function does not work with RAW images.

Set Dial Functions

One of the very welcome new features of the PowerShot G12 is the addition of the front dial, which gives you one dial to adjust aperture and one to adjust shutter speed when in Manual exposure mode. Of course, as I have already discussed throughout this book, both the front dial and the rear-located control dial have numerous other functions as well. The Set Dial Functions menu option gives you the ability to make certain choices about what duties these two dials carry out.

There are two main things you can accomplish with this menu option. First, you can change the roles of the two dials for controlling shutter speed and aperture. By default, the front dial adjusts shutter speed in Tv and M modes, it adjusts aperture in Av mode, and the control dial adjusts aperture in M mode. If you select this menu option and press the FUNC./SET button, you will see an orange block that says either **Front Dial 1**, **Front Dial 2**, or **Control Dial**. Scroll through those three choices using the left/right cursor buttons. If you leave this option set at its default setting of **Front Dial 1**, shutter speed and aperture are handled as noted above. If you set this block to **Front Dial 2**, the roles of the two dials are reversed: the front dial controls aperture, and the control dial controls shutter speed. If you set the orange block to **Control Dial**, then the control dial controls both shutter speed and aperture; in Manual mode, you need to alternate between the two settings by pressing the metering mode button. (I presume the control dial setting is for people who got used to this system on previous PowerShot G models, which had only the single dial.)

In addition, no matter which of the three main settings you select (**Front Dial 1**, **Front Dial 2**, or **Control Dial**), you have the option of making some other assignments of functions to either or both dials. For example, if you have chosen **Control Dial** as the main setting, then you can assign a function to the front dial for each of the relevant

shooting modes: M, Av, Tv, and P. There are only three settings you can assign: **Aspect Ratio**, **White Balance fine adjustments**, and **i-Contrast**. In some cases, you can assign one of these three settings to a dial that already is handling either aperture or shutter speed. In that case, you alternate between those functions for the dial by pressing the metering mode button.

Set Shortcut Button

This menu option lets you set the Shortcut button, at the upper left of the camera's back, to carry out one function that you want to be able to activate quickly, without going through menu options. When you choose this item on the Shooting menu, you are presented with a screen showing the possible selections: **Not Assigned**, **i-Contrast**, **White Balance**, **Custom White Balance 1**, **Custom White Balance 2**, **My Colors**, **Bracketing**, **Drive Mode**, **Flash Exposure Compensation/Flash Output**, **ND filter**, **Aspect Ratio**, **Select RAW or JPEG**, **Recording Pixels/Compression**, **Movie Quality**, **Servo AF**, **Red-Eye Correction**, **AF Lock**, **Digital Tele-Converter**, and **Display Off**. Just choose the one option you're most likely to want at your fingertips, and select it with this menu option. Of course, you can easily change to a different option whenever you want to.

Save Settings

This is a very useful, well designed function. When you choose **Save Settings** from the Shooting menu, you are presented with a very simple, but powerful pair of options—you can save your current settings to one of two locations in the camera, either C1 or C2 (see Figure 4.9). If you look at the mode dial on top of the camera, you will see those two settings, right along with Program, Shutter priority, Aperture priority, and the rest. So, in effect, you can design your own two custom Shooting modes through this very simple option. When you choose to save your current settings to either of these slots, here is what is saved: your Shooting mode (P, Tv, Av, or M); all of the items that you have set for that mode, such as shutter speed, aperture, exposure compensation, and the like; all of the items you have set through the Shooting menu; the zoom position of the lens; the manual focus position; and the inclusion of any items in the My Menu settings. You can reset either the C1 or the C2 slot to the default settings by choosing **Reset All** from the Set up menu. Once you are comfortable with the camera's settings, you may well find some good uses for this capability. Many cameras will let you save some settings in this way, but the G12 is unusually flexible in this area, and you may find it very helpful to be able to twirl the mode dial slightly and instantly have the camera set up with your favorite settings, including the amount of zoom.

Figure 4.9
Use the Save Settings option on the Shooting menu to save a set of your favorite shooting settings to the C1 or C2 location on the mode dial.

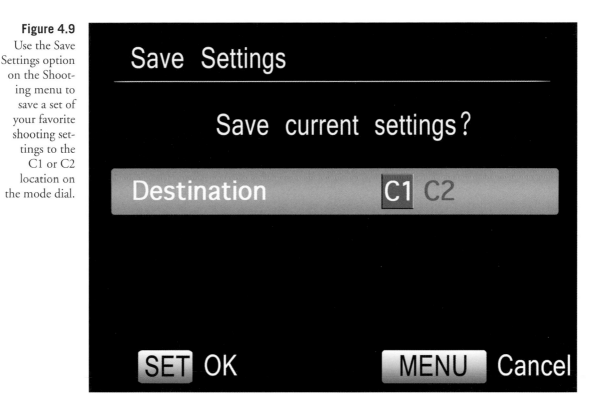

Playback Menu Options

The Playback menu is where you select options related to the display, review, transfer, and printing of the photos you've taken (see Figure 4.10). The choices you'll find are as follows:

- Smart Shuffle
- Slideshow
- Erase
- Protect
- Rotate
- Favorites
- My Category
- i-Contrast
- Red-Eye Correction
- Trimming
- Resize
- My Colors
- Scroll Display
- Resume
- Transition

Figure 4.10
The Playback menu includes options for viewing, printing, and transferring images.

Smart Shuffle

This option is basically a way to entertain yourself (or your friends) with a random sampling of your images. If you have at least 50 images shot with this camera on your memory card, select this option and the camera will display one image at random, with thumbnails of four others arranged in each direction. Use the cursor buttons to choose one direction, and the next image will be selected from that side of the first image. The process can continue as long as you want it to. To exit from **Smart Shuffle**, press the MENU button.

Slideshow

The **Slideshow** option is a convenient way to review images one after another, without the need to manually switch between them. To activate this feature, just choose **Slideshow** from the Playback menu. During playback, you can press the FUNC./SET button to pause and then restart the "slideshow" (in case you want to examine an image more closely). You also can use the left and right cursor buttons or the control dial during playback to move the show along. You can hold down the left/right cursor button to fast forward or fast reverse through the images. For example, you might want to

review a set of images to judge the exposure of the group of pictures. It's important to note that the **Slideshow** option does not include any mechanism for selecting what images to include in the show. To make that selection, you need to use the **My Category** option, discussed later in this section. To set up your slideshow, follow these steps:

1. **Begin set up.** Choose **Slideshow** from the Playback menu, pressing FUNC./SET to display the screen shown in Figure 4.11.

Figure 4.11
Set up your slideshow using this screen.

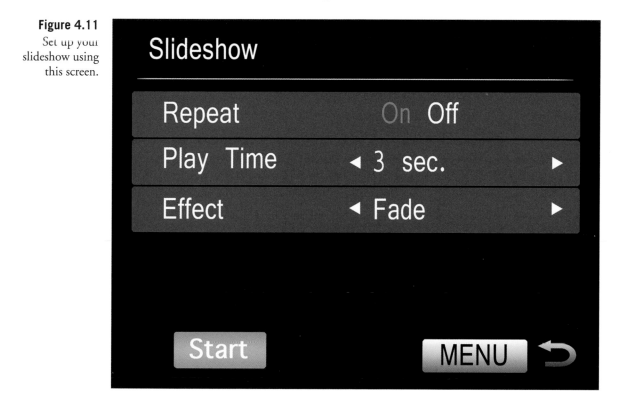

2. **Choose Repeat options, Play time, and Effect.** Navigate to highlight **Repeat** and select **On** or **Off**, to determine whether the show will repeat after it ends. Move down to **Play Time** and select a time for each image to display, from 3 to 10, or 15 or 30 seconds. Then move to **Effect**, and select one of the transition effects listed.

3. **Start the show.** Highlight **Start** and press FUNC./SET to begin your show. (If you'd rather cancel the show you've just set up, press MENU instead.)

4. **Use show options during display.** Press FUNC./SET to pause/restart; left and right cursor buttons or the control dial to speed through the images; and MENU to stop the show.

Erase

As I discussed earlier, one way to delete images from the memory card in the camera is to press the AF Frame/Trash button while a single image is displayed, and then confirm the operation using the navigation keys and the FUNC./SET key. If you need to erase more than just one or two images at a time, though, you're probably better off using the **Erase** option on the Playback menu. Choose this menu entry and you'll be given three choices: **Select**, **Select Range**, and **All Images** (see Figure 4.12).

■ **Select.** The first option displays the most recent image. Press the left/right cursor buttons or use the control dial to navigate through the images, and mark or unmark various images for deletion using the FUNC./SET key (a check mark will appear in a box in the upper-left corner when an image is marked for deletion). If you try to mark a protected image for deletion, the warning **Protected** appears on the screen. When finished marking pictures, press the MENU button, and you'll see a screen that says **Erase?** with two options, **Stop** and **OK**. Highlight **OK**, then press the SET button to erase the images, or select **Cancel** and press the SET button to return to the selection screen. Press the MENU button to leave your selections marked and return to the display of marked images.

■ **Range.** To speed things up, you can select a range of images rather than marking them individually. After choosing the **Select Range** option, navigate to the first

Figure 4.12
The Playback menu's Erase menu item on the PowerShot G12 gives you options for what images to erase.

image in the range to be deleted, and select it with the FUNC./SET key. Then navigate to the last picture in the range (which must be higher numbered than the first one), and press FUNC./SET again. Confirm your selections as with the first option.

■ **All Images.** If you're ready to part with all images on your memory card, choose the **All Images** option and confirm with the FUNC./SET key when prompted by the menu system. This choice removes all the pictures on the card, except for those you've marked with the **Protect** command, and does not reformat the memory card. If you have categorized your images using the **My Category** option (described later), you can display images in a particular category, and use the **All Images** option to erase just the images from that category. If you want to erase all images on the card and don't need to preserve any protected ones, your best bet is to use the Format command, which not only removes the images but also prepares the card for reuse with a new file system.

Protect

If you want to keep an image from being accidentally erased (either with the Erase button or by using the **Erase** menu option that we just discussed), you can mark that image for protection. To protect one or more images, enter Playback mode, press the MENU button, and choose **Protect**. Then either select individual images or a range of images, in the same way as with the Erase procedure described above. A key icon will appear on each image when it is marked as protected, and when that image is reviewed later. To remove protection, repeat the process and use the FUNC./SET key to remove the protection from individual images or a range of images. You can also protect all images on the card, using the **All Images** selection. In addition, if you have used the **My Category** function to place images in categories, you can display images from a given category, and then use the **All Images** selection to protect all images in that category. Image protection will not save your images from removal when the card is reformatted.

Rotate

The PowerShot G12 will automatically rotate images that you take while holding the camera in the vertical position, so they will display vertically on the horizontal screen during playback. You can rotate the camera to the vertical position, and the camera will rotate the image to suit, so it's always shown in its correct orientation. You can't turn this automatic rotation function off, but you can manually rotate an image during playback using this menu selection, so it will display as originally oriented. Select **Rotate** from the Playback menu, use the left/right cursor buttons to page through the available images on your memory card until the one you want to rotate appears, then press FUNC./SET. The image will appear on the screen rotated 90 degrees, as shown in Figure 4.13. Press FUNC./SET again, and the image will be rotated another 90 degrees. You

Figure 4.13
An image can be manually rotated in 90-degree increments using the Rotate function on the Playback menu.

can keep rotating it until you achieve the desired orientation, including returning it to its original position.

When rotating an image, viewing a vertical image in correct orientation when holding the camera horizontally means that the longest dimension of the image is shown using the shortest dimension of the LCD, so the picture is reduced in size.

Favorites

This menu option is similar in its functioning to the **Erase** and **Protect** functions discussed above. After selecting this menu option, navigate through your images and mark/unmark them as Favorites using the FUNC./SET button. A star will appear in the lower-left corner of each image marked as a favorite. You can then use the **Jump** function, discussed in Chapter 3, to filter your images by the Favorites classification, and delete or protect all images in that classification, for example.

My Category

This menu option is quite powerful and useful. It permits you to organize your images in the camera into several categories that are predefined for you. Choose **My Category** from the Playback menu and press the FUNC./SET button. Press the up/down cursor

buttons or turn the control dial to choose either **Select** or **Select Range** and press the FUNC./SET button again to make your choice. If you choose **Select**, you are presented with a screen displaying your first image, with a list of categories on the left, each one having a selection box beside it. The categories are: **People**, **Scenery**, **Events**, **Category 1**, **Category 2**, **Category 3**, and **To Do**. For each image, you can scroll down through this list of categories and use the FUNC./SET button to check the box for one or more categories. Then move to the next image and continue the process, until you have placed any or all of your images into as many categories as you want. If you prefer, you can use the **Select Range** option, which lets you assign a range of images to a category (or to multiple categories).

Once you are done assigning your images to categories, you can then perform any of the following operations on all the images in a given category at once: viewing slideshows; protecting images; erasing images; and choosing images for printing directly to a printer. You can also view your images by category, using the filtered playback procedure with the metering mode/jump button. The PowerShot G12 also automatically places some images into one of three categories (**People**, **Scenery**, or **Events**) when they are shot, basing its decisions on various factors, such as whether a face was detected, whether a scenic setting such as **Beach** or **Fireworks** was used, and the like. However, you can manually unassign images from any of those categories.

i-Contrast

This option gives you an opportunity to let the camera bring out additional detail in an image by tweaking the contrast or brightness in particular areas, such as faces. Select this option from the Playback menu, then scroll through your images to choose an image to be adjusted. Once your chosen image is displayed, use the left/right cursor buttons or the control dial to select **Auto** and let the camera make the adjustment, or choose a **Low**, **Medium**, or **High** amount of adjustment, and then press FUNC./SET to apply the desired correction. The changed image will be saved as a new file, and the original image will still be present on the memory card. Note that you cannot make this adjustment to a RAW image. (You shouldn't need to, because RAW images are intended to be subjected to considerable post-processing through software in any event.) The **i-Contrast** settings are also available while shooting pictures, as discussed later in this chapter in the section on the FUNC. menu.

Red-Eye Correction

This menu item is an old friend that we saw earlier on the Shooting menu. This option lets you apply digital correction to an image of a person with the red-eyed vampire stare. Just as with its counterpart on the other menu system, this procedure does not come with a guarantee of success, or even of improvement of the image, but it is worth a try.

Scroll through your images until you find one that appears to need correction, then press FUNC./SET to apply it. If the camera detects red-eye it will attempt to correct it. When the correction has been applied, you have the choice of saving the new version to a new file, or overwriting the original image with the altered one. As with **i-Contrast**, this procedure cannot be performed on a RAW image.

Trimming

This is another one of the procedures available through the G12's menu system that gives you the ability to alter the images you have already taken. In this case, you can crop an image to remove unwanted parts or to emphasize certain subjects by altering the composition. Since I use software such as Adobe Photoshop, Photoshop Elements, or similar programs to perform post-processing actions like cropping, I tend to view features of this sort as not having that much value. However, there could be situations in which a photographer out in the field needs to create a slideshow quickly, without access to a computer. In such a case, this **Trimming** function could be a lifesaver. To use it, highlight this option on the Playback menu, then use the left/right cursor buttons or the control dial to display the image to be trimmed and select it by pressing the FUNC./SET button. Then, follow the prompts given by the camera to change the size and location of the trimming frame. Use the zoom lever to change the size of the frame, the four cursor buttons to move it, and the DISP. button to change it between vertical and horizontal. Use the control dial to switch between gray frames, which the camera will display to indicate faces in the image. (Those frames can be used for trimming.) Once you have the trimming frame set the way you want it, press FUNC./SET to make the crop. The trimmed image will be saved as a new image file. This function cannot be performed on RAW images or on Small images.

Resize

This procedure lets you change the image size of a picture that is already saved on the camera's memory card. Note that "resize" is used here in a very specific sense; you can't really change the apparent size of the image; all you can do is cause the camera to save a new copy of the original image with a smaller file size. Here again, this is something I ordinarily would do using a computer, but there probably are situations in which it could be useful to do this in-camera. After you've selected this option from the Playback menu, navigate to the image in question, then follow the camera's prompts to select the new size, and press FUNC./SET to save the new, smaller file. As with the **Trimming** function, this procedure cannot be used with RAW images or those that are already of the smallest possible size.

My Colors

This option allows you to perform another sort of post-processing in the camera on your saved images by applying one of the camera's several built-in color settings to alter the general appearance of the picture. These are the same color settings you can apply when taking pictures using the FUNC. menu, as discussed later in this chapter. In this case, you select My Colors from the Playback menu, and then use the left/right cursor buttons or the control dial to highlight the image to be changed, then press the FUNC./SET button to select it. You can then use the left/right cursor buttons or the control dial to select whichever of the available color settings you want to apply: **Vivid**; **Neutral**; **Sepia**; **Black and White**; **Positive Film**; **Lighter Skin Tone**; **Darker Skin Tone**; **Vivid Blue**; **Vivid Green**; **and Vivid Red**. This transformation cannot be done with RAW images. The **My Colors** settings are discussed in more detail in the section later in this chapter describing the features of the FUNC. menu.

Scroll Display

This menu option lets you turn on and off the **Scroll Display** feature. If this feature is enabled (as it is by default), then, when the camera is in Playback mode, if you spin the control dial on the back of the camera rapidly enough, the images will display in a horizontal stream, in which you can see the images before and after the current one as they scroll by (see Figure 4.14). In addition, the camera displays the date of the image, with

Figure 4.14
When the Scroll Display feature is enabled, turning the control dial causes the images to display in a continuous stream.

arrows beside the date to let you quickly change it using the up and down cursor buttons, thereby switching the display to select images from that date. A gray "thermometer" scroll bar appears below the images to know where you are in the stack. You might want to disable this feature if you would find it distracting to have the display suddenly switch from a conventional progression through your images to a more rapid scrolling with date selection that you don't need. In addition, the scrolling display shows the images at a slightly reduced size in order to accommodate the multiple pictures and the date selection area, so you might want to disable the feature in order to keep the images displayed at their normal sizes.

Resume

This menu option is quite simple and straightforward. Its only purpose is to give you the option of which image will be displayed on the camera's screen when you go into playback mode—either the last image you had viewed previously or the last image that was shot. Select **Last seen** or **Last shot**, and you're done with this option.

Transition

Use this selection on the Playback menu to choose from the three possible effects that are available to mark the transition from one image to the next when you are viewing single images on the camera's display. The three choices are **Fade**, **Scroll**, and **Slide**. Or, you can choose **Off**, and the images will appear with simple "cuts" from one to the next, with no transitions between them.

Print Menu Options

When the PowerShot G12 is set to playback mode, there are three menus displayed at the top of the menu screen. We've already talked about one of them—Playback—and will move quickly on to the Set up menu next. The third menu, likely to be the least used of the three, is the Print menu, tucked between the Playback and Set up menus in playback mode (and not visible at all when you're using shooting mode).

The options in this menu are of use only when you have connected the camera directly to a PictBridge-compatible printer and are preparing to send images straight from the camera to the printer. I'm not going to spend a lot of time discussing these menu options, because they're essentially self-explanatory. Your choices are as follows:

- **Print.** Use this choice to begin printing once you have selected the images using the other entries in the Print menu.

- **Select Images & Qty.** This entry allows you to scroll through the images on your memory card using the left/right cursor buttons. Press the FUNC./SET button to activate the up/down cursor buttons and specify the number of prints for each image. (Leave the quantity at zero if you don't want to make any prints of a given photo.) Press the MENU button when you've finished to return to the Print menu.

- **Select Range.** As with the **Erase** command, to speed things up, you can select a range of images rather than marking them individually. After choosing the **Select Range** option, navigate to the first image in the range to be printed, and select it with the FUNC./SET key. Then navigate to the last picture in the range (which must be higher-numbered than the first one), and press FUNC./SET again.

- **Select All Images.** Use this to mark all the images on your card.

- **Clear All Selections.** This entry allows you to unmark all images and start your selection process over again.

- **Print Settings.** Choose whether to print thumbnail images (using the Index option), full-size images (using the Standard option), or both, and decide whether to include the dates and file numbers with the images.

To print in PictBridge mode:

1. **Connect camera.** First link the camera to the printer, using the mini-USB cable that comes with the camera. Plug it into the bottom connector inside the door on the right side of the camera, then connect it to the printer.

2. **Choose images to print.** Go into the Print menu, and you will find options for selecting the images to print, either by marking them individually using the FUNC./SET button or by selecting a range, in the same way as with the **Erase** and **Protect** functions discussed earlier.

3. **Specify print format.** When you have the images selected, choose **Print Settings** and specify how you want the images printed.

4. **Print selected images.** When all your choices are made, select **Print**, and sit back while the printer does its work.

Set Up Menu Options

The Set up menu (shown in Figure 4.15 as it's accessed while in shooting mode, where its tab is located in the middle) provides the opportunity to make adjustments on how your camera *behaves* during your shooting session, as differentiated from the Shooting menu (discussed later in this chapter), which adjusts how the pictures are actually taken, and the Playback menu, which adjusts how images are viewed.

Figure 4.15
The Set up menu gives you access to many options for controlling the camera's operations.

Your choices on the Set up menu include:

- Mute
- Volume
- Sound Options
- Hints & Tips
- LCD Brightness
- Start-up Image
- Format
- File Numbering
- Create Folder
- Lens Retract

- Power Saving
- Time Zone
- Date/Time
- Distance Units
- Electronic Level
- Video System
- Ctrl via HDMI
- Eye-Fi Settings
- Language
- Reset All

Mute

This first option on the Set up menu is a simple on-off selection—you can set the camera either to mute all electronic sounds, or set them to be heard. Obviously, this option can be of use if you're at a school play or other event where it's best to keep your

auditory footprint to a minimum. If you set **Mute** to **On**, then the camera will not emit an electronic sound when the shutter is released, and there won't be any beeps when you move from one image to another on the screen or press a navigation key. This is not to say the camera will be so silent that you could sneak through a secret laboratory and photograph the plans of the next doomsday device without being detected; the camera still will emit some clicks and other sounds from its purely mechanical operations. But you will cut down on the general cacophony of electronic chatter.

Volume

This option allows you to control individually the volume of four operational sounds the camera makes. This menu item will be grayed out and unavailable if you have turned the **Mute** feature **On**. If **Mute** is **Off**, then you can choose to set the volume from level 1 to 5 in each of four categories: the camera's **Start-up Volume**; its **Operation Volume** (essentially, beeps as you press buttons); **Self-timer Volume**; and **Shutter Volume**.

Sound Options

Now that we have covered how to mute the camera's operational sounds and how to adjust their volume, here is the menu option on the PowerShot G12 that lets you select what sounds are assigned to each of the four categories we discussed in connection with the **Volume** setting. I don't know that there's a very good way to describe these sounds in words; you just have to sample each one and decide which type of high-tech beepy or chirpy noise you like the best for each category.

Hints & Tips

With this setting, which is turned on by default, as you scroll through the lines of a menu, including the FUNC. menu, a line or two of explanation shows up at the bottom of the LCD screen to give a little extra information about the item that is highlighted (see Figure 4.16 for an example). I personally find this feature quite useful. One nice point is that this feature is somewhat context sensitive. So, for example, if you have **Mute** set to **On**, and highlight the **Mute** line, the hint at the bottom of the screen will say: **Turns on camera sounds.** If you have **Mute** set to **Off**, the hint line will say: **Turns off camera sounds.** The reason to turn this feature **Off** would be to regain one line of screen real estate; in other words, if **Hints & Tips** is turned **Off**, one more line of the menu has room to display, so you don't have to scroll quite as much to get through the menus.

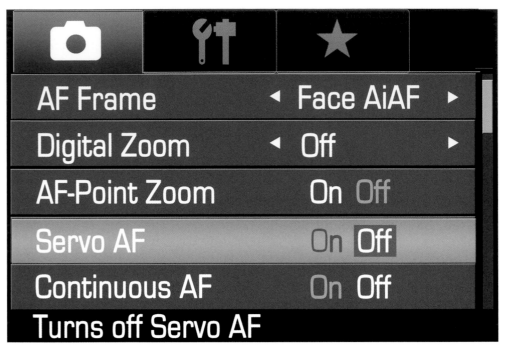

Figure 4.16
The Hints &
Tips feature on
the PowerShot
G12 provides
information
about each
menu item.

LCD Brightness

This menu option lets you adjust the brightness of the LCD display screen within a five-point range. This setting will remain in effect even after the camera is turned off and then on again. An alternative way to adjust the brightness is to hold down the DISP. button for one second or more. That procedure will increase the screen's brightness to its maximum, unless it has already been set that high. Pressing and holding the DISP. button one more time will return the brightness to what it was before.

Start-up Image

With this setting, you can select from three preset start-up screen images supplied by Canon, or you can choose to have no start-up image. The preset screens show the Canon logo or the PowerShot G12 logo. If you want, you also have the option of choosing one of the images on your memory card in the camera as the start-up image. In order to do this, you have to have the camera in playback mode, and access the Set up menu while in that mode. Then, select option number 3 on the **Start-up Image** menu item, and press FUNC./SET. Scroll through your images until you find the one you want to use as the start-up image, and press FUNC./SET again. The camera will ask if you want to "register" that image; choose **OK** if you do, and that image will now appear briefly whenever you power up the camera.

Format

Use this menu option to erase everything on your memory card and set up a fresh file system ready for use. When you select **Format**, you'll see a display like Figure 4.17, showing the capacity of the card, how much of that space is currently in use, and two choices at the bottom of the screen to **Cancel** or **OK** (proceed with the format). A bar appears on the screen to show the progress of the formatting step. You also are presented with the option to perform a **Low Level Format**, which is a slower, but more thorough reformatting that can help restore a memory card that has picked up some bad sectors that aren't locked out by the normal **Format** step.

Figure 4.17
You must confirm the format step before the camera will erase a memory card.

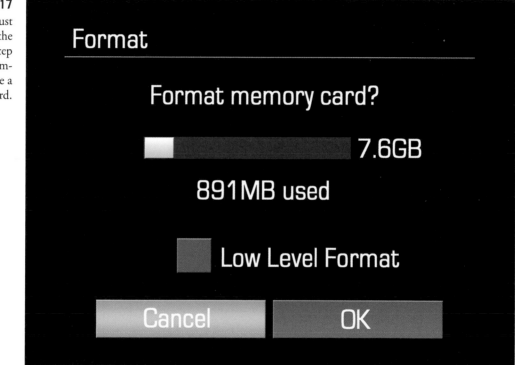

File Numbering

The PowerShot G12 will automatically apply a file number to each picture you take, using consecutive numbering for all your photos over a long period of time, spanning many different memory cards, starting over from scratch when you insert a new card, or when you manually reset the numbers. Numbers are applied from 0001 to 9999, at which time the camera creates a new folder on the card (100, 101, 102, and so forth),

so you can have 0001 to 9999 in folder 100, then numbering will start over in folder 101. A given folder can hold only 2000 images, but, as discussed below, the numbering of images in a folder can still go as high as 9999.

The camera keeps track of the last number used in its internal memory. That can lead to a few quirks you should be aware of. For example, if you insert a memory card that had been used with a different camera, the G12 may start numbering with the next number after the highest number used by the previous camera. (I once had a brand new camera start numbering files in the 8000 range.) I'll explain how this can happen next.

On the surface, the numbering system seems simple enough: In the menu, you can choose **Continuous** or **Automatic Reset**. Here is how each works:

- **Continuous.** If you're using a blank/reformatted memory card, the G12 will apply a number that is one greater than the number stored in the camera's internal memory. If the card is not blank and contains images, then the next number will be one greater than the highest number on the card *or* in internal memory. (In other words, if you want to use continuous file numbering consistently, you must always use a card that is blank or freshly formatted.) Here are some examples.

 - You've taken 4,235 shots with the camera, and you insert a blank/reformatted memory card. The next number assigned will be 4236, based on the value stored in internal memory.

 - You've taken 4,235 shots with the camera, and you insert a memory card with a picture numbered 2728. The next picture will be numbered 4236.

 - You've taken 4,235 shots with the camera, and you insert a memory card with a picture numbered 8281. The next picture will be numbered 8282, and that value will be stored in the camera's menu as the "high" shot number (and will be applied when you next insert a blank card).

- **Automatic Reset.** If you're using a blank/reformatted memory card, the next photo taken will be numbered 0001. If you use a card that is not blank, the next number will be one greater than the highest number found on the memory card. Each time you insert a memory card, the next number will either be 0001, or one higher than the highest already on the card.

Create Folder

By default, the PowerShot G12 creates new folders each month. With this option in the Set up menu, you can change this so the camera creates a new folder for each new shooting date. Just change the setting for this menu item from **Monthly** to **Daily** to accomplish this result.

Lens Retract

By default, when you're in shooting mode and you then switch to playback mode, the camera's lens retracts back into its housing about one minute after you press the Playback button, because it appears that you won't be needing the lens for a while, and it's a good idea for it to be pulled back away from sources of possible scratches or damage. You can change this setting to zero seconds, in which case the lens will retract almost immediately after you push the Playback button while the lens is out. If you're likely to go back and forth between shooting and playback modes, I suggest sticking with the normal one-minute wait time, to avoid overstraining the motor with the motions of a frantic turtle. This setting does not affect lens retraction when the camera is turned off while in shooting mode.

Power Saving

This entry in the Set up menu allows you to determine whether the PowerShot G12 powers itself off after not being used for about three minutes in shooting mode, and after about five minutes in playback mode. Your only options here are to turn the feature on or off; you don't get to select how long the camera waits before powering down (see Figure 4.18). If you leave this feature turned on, the camera will turn itself completely off after the three minutes, and you then will have to press the power button to

Figure 4.18
The Power Saving menu option controls whether the camera powers off after a few minutes and how soon the display goes dark when not in use.

turn it back on. If you leave this feature off, you have to be careful to turn the camera off when you're done with it, or you'll drain the battery before you know it.

This menu item also has a second option that involves turning off just the display screen after a certain amount of time. In this case, you do get to select the timing—you can choose to have the screen turn off automatically after 10, 20, or 30 seconds, or 1, 2, or 3 minutes. The screen power-off feature is available even if the general power-saving feature is turned off.

SAVING POWER WITH THE POWERSHOT G12

There are three settings and several techniques you can use to help you stretch the longevity of your G12's battery. The first setting is the **Review** option described earlier in this chapter under the Shooting menu. The big 2.8-inch LCD uses a lot of juice, so reducing the amount of time it is used (either for automatic review or for manually playing back your images) can boost the effectiveness of your battery. Second, **Power Saving** turns off the camera and/or the LCD screen after defined intervals, depending on your settings. The third setting is the **LCD Brightness** adjustment on the Set up menu, described above. If you're willing to shade the LCD with your hand, you can often get away with lower brightness settings outdoors, which will further increase the useful life of your battery. The techniques? Use the internal flash as little as possible; no flash at all or fill flash use less power than a full blast. Turn off image stabilization if you're using a tripod or if you just feel you don't need it. When transferring pictures from your G12 to your computer, use a card reader instead of the USB cable. Linking your camera to your computer and transferring images using the cable takes longer and uses a lot more power.

Time Zone

Using this entry in the Set up menu, you can set your home time zone. Then, when you travel to another time zone, you can set the camera to a travel time zone, so the images will be recorded with the correct local time. To set your **Home Time Zone**, follow the camera's prompts, and, using the FUNC./SET button and the left/right cursor buttons, move the yellow highlight over the world map to select your home base. To set the destination time zone for a trip, follow a similar procedure, highlighting the airplane symbol instead of the home symbol. Then, when you are leaving on your trip, go into this menu option and highlight the airplane symbol, and it will then appear on the Set up menu's **Time Zone** line, indicating that the camera will be using the destination time zone until you reset it back to **Home**.

Date/Time

Use this option to set the date and time, which will be embedded in the image file along with exposure information and other data. Having this information recorded accurately will also let you select your images for viewing by date. I showed you how to set the date and time in Chapter 1. See Figure 1.10 if you need a refresher. Note that setting the date and time does not embed them visibly in your images; if for some reason you need to do that, you have to use the Date Stamp function on the Recording menu, discussed above.

Distance Units

Use this option to select feet and inches or meters and centimeters, according to your preference. The camera will then display distances in your preferred system of notation.

Electronic Level

As I noted earlier, one of the nice new features provided with the PowerShot G12 is the option to display an electronic level on the LCD screen while you're shooting images. When you turn this option on using the **Custom Display** item on the Shooting menu, the camera shows a small black bar with a pointer that moves left and right of center to indicate whether the camera is level, when you are shooting still images (not movies). The **Electronic Level** item on the Set up menu lets you calibrate the level. Make sure the camera is solidly positioned and completely level, and select **Calibrate** from the submenu; when the operation is done, the level will be calibrated to provide an accurate leveling readout. If for some reason you have second thoughts about your current calibration, you can select **Reset** and set the level back to its previous calibration.

Video System

This setting controls the output of the G12 through the supplied AV cable when you're displaying images on an external monitor. You can select either **NTSC**, used in the United States, Canada, Mexico, many Central, South American, and Caribbean countries, much of Asia, and other countries; or **PAL**, which is used in the UK, much of Europe, Africa, India, China, and parts of the Middle East.

Ctrl via HDMI

This option has just two settings—**Enable** or **Disable**. Choose **Enable** if you are connecting the G12 to an HDTV and you want to control the camera using the TV's remote control. This setup may not work with all types of HDTVs, but this setting may help the two devices speak the same electronic language.

VIEWING ON A TELEVISION

Canon makes it quite easy to view your images on a standard television screen with the PowerShot G12, and not much more difficult on a high-definition television (HDTV). (You have to buy a separate cable for HDTV.) For regular TV, just open the port cover on the right side of the camera, plug the small connector on the cable supplied with the camera into the socket labeled AV Out, and connect the other ends to the yellow VIDEO RCA composite jack and the red and white audio jacks (for movies) on your television or monitor.

For HDTV display on the G12, purchase the optional HDMI Cable HTC-100 (or a generic equivalent) and connect it to the mini-HDMI terminal above the standard video terminal on the right side of the camera. Connect the other end to an HDMI input port on your television or monitor (my 42-inch HDTV has three of them; my 26-inch monitor has just two). Then turn on the camera and press the Playback button. The image will appear on the external TV/HDTV/monitor and will not be displayed on the camera's LCD. HDTV systems automatically show your images at the appropriate resolution for that set.

If you plug in the HD cable, be aware that you cannot also plug in the Remote cable, which goes into an adjacent port; trying to plug them both in at the same time could result in damage to the camera or the cables.

Eye-Fi Settings

This menu option does not appear at all unless you have installed an Eye-Fi card into the camera. This type of card, as described in Chapter 1, has a tiny transmitter that sends your images wirelessly to your computer over a Wi-Fi network. This menu option has two subitems that may help this process work properly. The first item lets you choose **Enable** to help ensure that the Eye-Fi card's transmitter is functioning. The other item, **Connection Info**, provides information about what Wi-Fi access point, if any, the card is connected to. If you are having trouble getting your Eye-Fi card to transmit images, use these menu settings to help correct the problem. Also, if you are using an Eye-Fi card for image storage but have no network available at a given time, you can choose **Disable** on this menu so the camera does not waste its power in trying to help the Eye-Fi card connection when no connection is available.

Language

Choose from 26 languages for menu display, rotating the control dial or using the cursor buttons until the language you want to select is highlighted. Press the SET button to activate. Your choices include **English**, **German**, **French**, **Dutch**, **Danish**, **Portuguese**, **Finnish**, **Italian**, **Ukrainian**, **Norwegian**, **Swedish**, **Spanish**, **Greek**,

Russian, **Polish**, **Czech**, **Magyar**, **Romanian**, **Turkish**, **Arabic**, **Thai**, **Simplified Chinese**, **Traditional Chinese**, **Korean**, and **Japanese**.

If you accidentally set a language you don't read and find yourself with incomprehensible menus, don't panic. Just choose the second option from the bottom of the Set up menu, and select the idioma, sprache, langue, or kieli of your choice. Also, if you want to bypass the Set up menu, just push the Play button to enter playback mode, then, while pressing and holding the FUNC./SET button, press the MENU button; this action will bring up the language-selection screen.

Reset All

This is a very handy function to have available if you've been fooling around with the camera's settings for hours and don't want to have to retrace all your steps to get things back to normal. Just go into the Set up menu and select this option; your only choices are to confirm the reset or cancel. This action will put most settings back to their defaults, but note that there are certain settings that will not be reset. These include **Date/Time**; **Language**; **Video System**; and a few others.

My Menu

The Canon PowerShot G12 has a great feature that allows you to define your own menu, with just the items listed that you want. You can set up My Menu to include only the items you use most often, and jump to those items quickly by pressing the MENU button. To create your own My Menu set of options, you just have to select the menu items you want to include. To do so, follow these steps:

1. Press the MENU button and use the left/right cursor buttons or the zoom lever to highlight the My Menu tab, marked by a star. When you first begin, the personalized menu will be empty except for the My Menu Settings entry. Highlight this line and press the FUNC./SET button to select it. You'll then see a screen like the one shown in Figure 4.19.

2. Use the up/down cursor buttons to highlight **Select Items**, then press the FUNC./SET button.

3. Use the up/down cursor buttons or the control dial to scroll down through the continuous list of all menu entries that can be selected to find one you would like to add. Press FUNC./SET to set a check mark beside that item.

4. Continue to select up to five of the listed menu entries for your My Menu set; press FUNC./SET for each one.

5. When you're finished, press the MENU button twice to return to the My Menu screen to see your customized menu, which might look like Figure 4.20.

Figure 4.19
The My Menu settings screen gives you access to the ability to select various menu items to include on your personalized My Menu list.

Figure 4.20
A typical set of options added to the My Menu list might include items such as those shown here.

In addition to selecting menu items, you can perform other functions at the My Menu Settings screen:

- **Changing the order.** Choose **Sort** to reorder the items in My Menu. Select the menu item to be moved and press the SET button. Press the up/down cursor buttons to move the item up and down within the menu list. When you've placed it where you'd like it, press the MENU button to lock in your selection and return to the previous screen.

- **Set Default View.** Ordinarily, when you press the MENU button, the G12 displays the menu system with the Shooting menu highlighted. However, if you enable the **Set Default View** option, pressing the MENU button will *always* display My Menu first. You are free to switch to another menu tab if you like, but the next time you press the MENU button, My Menu will come up again. Use this option if you work with My Menu a great deal and make settings with other menu items less frequently.

FUNC. Menu

We have now discussed all of the "official" menus that are present in the PowerShot G12: Shooting, Playback, Set up, Printing, and My Menu. Those are the only menus in the camera that look and act like traditional menus—that is, menus that take up the whole screen and present you with lines of items that you scroll through to choose various options. But we're not done yet with the menu system of this camera. The G12 comes equipped with another, different sort of menu system, used only to select shooting options, which Canon calls the FUNC. menu, because it is invoked with a press of the FUNC./SET key.

The FUNC. menu is very convenient to use once you get the hang of it, but it may take a little practice to get a feel for it. Here is how it works. When you're in shooting mode, just press the FUNC./SET key in firmly, and at the left and bottom of the LCD screen you will see two lines of symbols. The vertical list on the left, reading from top to bottom, represents the categories of settings that you can change with this system: **i-Contrast**; **White Balance**; **My Colors**; **Bracketing**; **Drive Mode**; **Flash Control**; **Neutral Density Filter**; **Aspect Ratio**; **Image Quality**; and **Image Size**. These categories include some of the most important settings you can make. Let's go through them all in order.

i-Contrast

When you first press the FUNC./SET button to get access to the FUNC. menu, the i-Contrast symbol will be highlighted at the top of the vertical list and its four possible settings will be arrayed at the bottom of the screen in a horizontal list. This setting,

which we encountered earlier on the Playback menu, is also available when shooting your images. This setting essentially is used to increase the dynamic range of your images. That is, the camera's digital sensor does not have the wide range of adaptability to varying intensities of light that the human eye does. As a result, a given image may be properly exposed for items that are in sunlight, but badly underexposed and muddy in the areas that are in the shade. With the varying levels of the **i-Contrast** settings, the G12 will attempt to pull some details out of the overly dark areas of an image and vary the contrast to reduce blown highlights. There are two components to be adjusted: Dynamic Range Correction, or **DR Correction**, which reduces blown highlights, and **Shadow Correct**, which pulls detail out of dark areas of the image.

With the **i-Contrast** option selected at the top of the left-side vertical menu, scroll across the bottom menu to highlight the degree of correction you want for **DR Correction**: **Off**, **Auto**, **200%**, or **400%**. Then press the DISP. button to bring up the options for **Shadow Correct**, which has only two settings: **Off** or **Auto**. Experiment with these settings to see how they help when you are taking photographs in challenging environments with bright and shadowy areas. These settings are not available when image quality is set to RAW or RAW + JPEG, and the i-Contrast icon will be grayed out in those cases.

White Balance

When you press the FUNC./SET button to get access to the FUNC. menu, the AWB symbol will be at the next-to-top place on the vertical list and at the left of the horizontal list, assuming you have not previously changed the white balance setting (and assuming you're not in **Auto** shooting mode, in which case you won't be able to change the white balance setting) (see Figure 4.21). AWB stands for Automatic White Balance. In many cases, you can leave this setting alone and let the G12 assess the lighting situation and set the white balance for you. If you would prefer to set the white balance to one of the predefined settings, use the right cursor button or the control dial to scroll through the list at the bottom of the screen until you find the one you want, then press FUNC./SET to select it, and the lists will disappear, leaving your setting in place. The choices are: **Automatic White Balance**; **Daylight**; **Cloudy**; **Tungsten**; **Fluorescent**; **Fluorescent H**; **Flash**; **Underwater**; and **Custom 1** and **Custom 2**. If you select **Custom 1** or **Custom 2**, you need to follow the instructions below to establish a value for that setting. That value will be retained permanently for that Custom slot until you go back and reset the value to something else.

Figure 4.21
The FUNC. menu is called up by a press of the FUNC./SET key. Here, the white balance item is set to AWB, for Automatic White Balance.

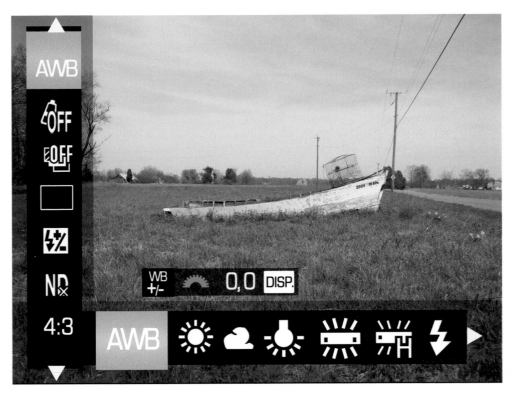

To use the Custom settings to set the white balance to an appropriate color temperature under the current ambient lighting conditions:

1. Press the FUNC./SET key.

2. Use the up/down cursor buttons to highlight the top icon on the list at the left of the screen, for white balance.

3. Use the right cursor button or the control dial to scroll over to **Custom 1** or **Custom 2** on the list at the bottom of the screen. (Or use the left cursor button and wrap around to the left to reach the Custom settings a bit quicker.)

4. Aim the camera so the screen (or viewfinder) is filled with the white (or gray) color you are using as a standard.

5. Press the MENU key. The camera will evaluate the correct white balance for the current lighting conditions and store that value under the **Custom 1** or **Custom 2** setting.

6. Press the FUNC./SET button to exit back to shooting mode.

7. Set the white balance to that saved setting again whenever you need to shoot under those same lighting conditions.

You can adjust the white balance setting even further, if you want. Regardless of which setting you have used for white balance, that is, **Daylight**, **Cloudy**, **Tungsten**, or a **Custom** one, you can go on to make manual adjustments. To do so, with the current white balance setting on the screen, press the DISP. key, and you will be presented with a screen that contains a square surrounded by the letters B, G, A, and M, for Blue, Green, Amber, and Magenta (see Figure 4.22). Use the four cursor buttons or the control dial and the front dial to move the axes for these color settings higher or lower, to fine-tune your white balance setting.

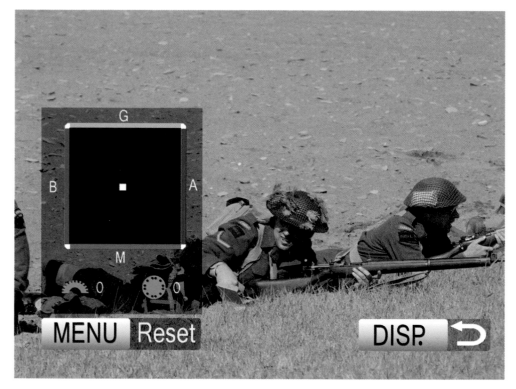

Figure 4.22
On the PowerShot G12, it is possible to fine-tune any white balance setting by using the four cursor buttons and the camera's two dials to adjust the levels of blue, green, amber, and magenta.

My Colors

This option gives you the opportunity to exercise a bit of color-oriented creativity when you're shooting your images. Select this third option down from the top of the FUNC. menu's vertical list, and the horizontal list at the bottom of the screen will give you 11 settings for altering the color cast of your images: **Vivid**, **Neutral**, **Sepia**, **B/W (Black & White)**, **Positive Film**, **Lighter Skin Tone**, **Darker Skin Tone**, **Vivid Blue**, **Vivid Green**, **Vivid Red**, and **Custom Color** (see Figure 4.23). Or, of course, you can also set this feature to **Off**. Most of these choices are self-explanatory; the **Vivid** choices emphasize the given color; **Positive Film** combines the effects of having all three **Vivid**

Figure 4.23
The My Colors option on the FUNC. menu lets you choose from an array of adjustments to color intensity and shades. Here, the Sepia option is highlighted.

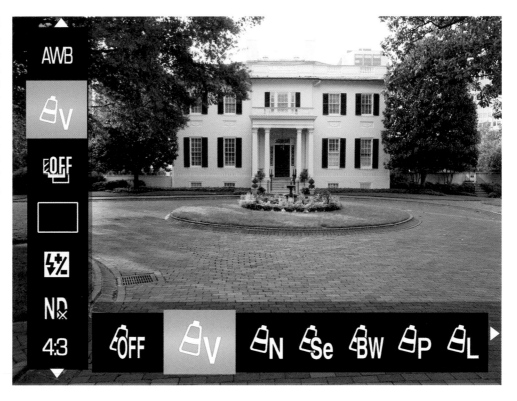

colors together. **Neutral** tones down all colors. You may want to play around with these and see which ones yield results that meet your needs. Note that this feature is not available and can't be selected when shooting RAW images, because you can tweak your RAW images to produce the same effects when importing your photos into your image editor.

Although the **My Colors** feature is not as powerful or flexible as the **Picture Styles** feature introduced to the Canon EOS camera line with the Canon EOS 30D back in February 2006, it does offer considerable benefits. Canon has set the parameters for the ten predefined selections to suit the needs of most photographers. Unlike the situation with **Picture Styles**, you cannot adjust the settings for those predefined selections. However, you can use the **Custom Color** option to create one brand-new selection that is all your own. If you want rich, bright colors to emulate Velvia film or the work of legendary photographer Pete Turner, you can build your own color-soaked style. If you want soft, muted colors and less sharpness to create a romantic look, you can do that, too. Perhaps you'd like a setting with extra contrast for shooting outdoors on hazy or cloudy days.

To make use of **Custom Color**, highlight that final option in the list of **My Colors** choices. (This is a good opportunity to wrap around by using the *left* cursor button.)

Then press the DISP. button. You will then see the word **Contrast** on the screen (see Figure 4.24). Use the left/right cursor buttons or the control dial to adjust the amount of contrast up or down, then use the up/down cursor buttons to highlight the other parameters (**Sharpness**, **Saturation**, **Red**, **Green**, **Blue**, and **Skin Tone**, discussed next). Make your desired adjustments to each of them. When you are finished adjusting all of the parameters to your liking, press the DISP. key again and then the FUNC./SET key to exit the My Colors screen.

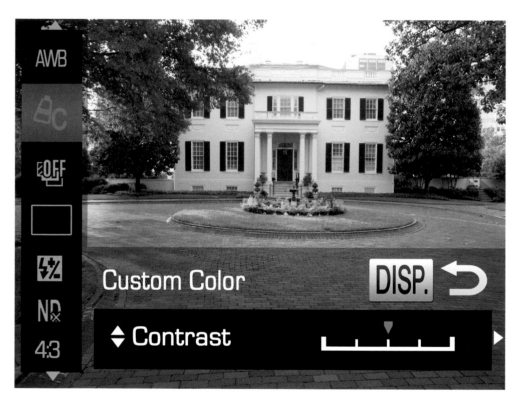

Figure 4.24
The My Colors option lets you adjust several parameters for each setting: contrast, sharpness, saturation, red, green, blue, and skin tone. On the screen shown here, contrast can be adjusted with the left/right cursor buttons or the control dial.

The parameters that you can adjust with the **My Colors** option are as follows:

- **Contrast.** Adjust this slider to change the number of middle tones between the deepest blacks and brightest whites. Low contrast settings produce a flatter-looking photo, whereas high contrast adjustments may improve the tonal rendition while possibly losing detail in the shadows or highlights.

- **Sharpness.** This parameter determines the apparent contrast between the outlines or edges in an image, which we perceive as image sharpness. When adjusting sharpness, remember that more is not always a good thing. A little softness is necessary to reduce or eliminate the moiré effects that can result when details in your image form a pattern that is too close to the pattern, or frequency, of the sensor itself. The default (0) level sharpening was chosen by Canon to allow most moiré interference

to be safely blurred to invisibility, at the cost of a little sharpness. As you boost sharpness, moiré can become a problem, plus, you may end up with those noxious "halos" that appear around the edges of images that have been oversharpened. Use this adjustment with care.

■ **Saturation.** This parameter controls the richness of the color, making, say, a red tone appear to be deeper and fuller when you increase saturation, and tend more towards lighter, pinkish hues when you decrease saturation of the reds. Boosting the saturation too much can mean that detail may be lost in one or more of the color channels, producing what is called "clipping."

■ **Red.** Adjusts amount of red.

■ **Green.** Adjusts amount of green.

■ **Blue.** Adjusts amount of blue.

■ **Skin Tone.** This adjustment has the most effect on skin tones, making them either redder or yellower.

Bracketing

Bracketing is a method for shooting several consecutive exposures using different settings, as a way of improving the odds that one of them will be exactly right, or for use in Photoshop or another application to merge images with a larger range of dark-to-bright tones. Many cameras have the ability to bracket exposures at different settings, and some cameras also can bracket other settings, such as white balance. The PowerShot G12 provides bracketing for two settings: exposure and focus, through the FUNC. menu.

Navigate one icon below **My Colors** on the FUNC. menu and you arrive at the **Bracketing** option. Highlight that icon, and the list at the bottom of the screen shows three choices: **Off**, **AEB**, and **Focus-BKT** (see Figure 4.25). The default selection is **Off**. Following are descriptions of the other two choices, each of which sets the camera up to automatically shoot a sequence of three images, one at the chosen setting, and one each at settings greater and lesser than that setting, with the goal of having one of those three images be right on the mark with its results.

Auto Exposure Bracketing

The **AEB** setting produces a series of shots as follows: standard exposure, underexposure, and overexposure. To use this option, follow these steps:

■ **Turn off the flash.** Exposure bracketing won't work if the flash fires. To turn it off, press the Flash key (right cursor button) repeatedly until you see the Flash Off icon.

■ **Select Bracketing from the FUNC. menu.** Press the FUNC./SET key and navigate down to the **Bracketing** option.

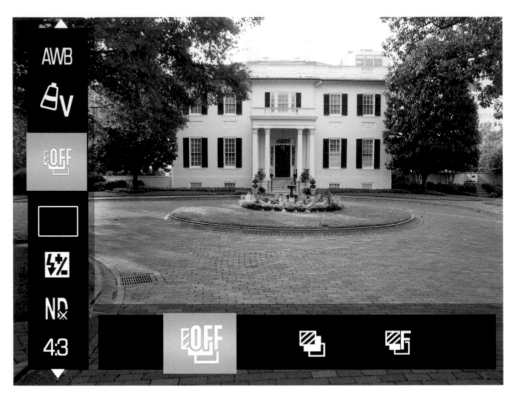

Figure 4.25
The Bracketing option on the FUNC. menu gives you access to Auto Exposure Bracketing and Focus Bracketing.

- **Select AEB.** Move the highlight to the AEB icon at the bottom of the screen to select Auto Exposure Bracketing.

- **Press the DISP. button.** This gives you access to the bracketing scale (see Figure 4.26).

- **Set the interval for the three exposures.** Use the left/right cursor buttons or the control dial to move the little orange markers to the desired intervals on the scale for exposure bracketing. You can select an interval of up to 2 Exposure Value (EV) units, in increments of 1/3 EV. If you have dialed in any exposure compensation, that will be reflected in these settings, so be sure to check the exposure compensation dial before setting the exposure bracketing interval. When you've made your choice of interval, press FUNC./SET to lock in the choice.

- **Take the pictures.** Aim at your subject and hold the camera steady while it makes its three successive exposures. If you've made good choices, one of those exposures should be right on the money.

Figure 4.26
The Auto
Exposure
Bracketing
option can be
set to take
exposures at
intervals from
1/3 EV to
2 EV.

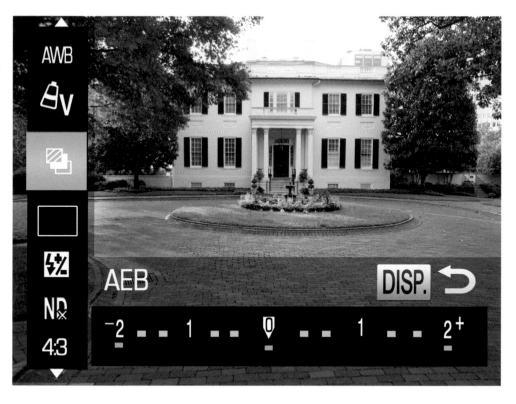

Focus Bracketing

Focus Bracketing sets up the camera to take three images: one at the manual focus position, one nearer, and one farther. The steps to take are just like those for **Auto Exposure Bracketing**. Again, the flash must be forced to **Off**. Also, of course, the camera must be set to Manual focus. Select **Bracketing** from the FUNC. menu and scroll over to the third icon at the bottom of the screen to select **Focus Bracketing**. As with **Auto Exposure Bracketing**, use the DISP. button to get access to the bracketing scale, then move the orange markers to indicate how far apart the three focus settings should be. Press FUNC./SET to lock in those settings, and press the shutter button to take the three bracketed images.

Drive Mode

This next option on the FUNC. menu gives you access to the continuous shooting capabilities of the PowerShot G12. When you turn on one of the options for multiple shots, the G12 will fire off a stream of shots as long as you hold your finger on the shutter button, but with some limitations. For one thing, there is no continuous shooting available in Auto mode or in several of the Scene modes. Also, depending on the camera's

settings, such as whether a slow shutter speed is set or flash is being used, the shooting may slow down or come to a stop. Despite its limitations, this is a very useful feature to have available, especially now in the digital age, when you don't have to run through 100 feet of expensive film (plus processing) to capture the fleeting expressions of portrait subjects or the fast-breaking events of a sporting contest.

To turn continuous shooting on, select the fifth icon down on the FUNC. menu's list at the left of the screen—the icon that looks like a rectangle or stack of rectangles, depending on what mode is currently in effect. Then move the highlight to the icon you want at the bottom of the screen. The three choices are the default, **Single Shot**; **Continuous**; and **Continuous AF**. With Continuous shooting, you can take about two images per second. The focus and exposure are locked as soon as the first image is taken, and they won't change after that, even if conditions change. If you choose **Continuous AF**, the camera autofocuses for every shot, and the speed is reduced to about 0.7 images per second. In certain modes, though, such as when the camera is set to Manual focus, **Continuous AF** will be changed to **Continuous LV**, and the camera will not autofocus. If you want to speed things up, you can set the mode dial to the **Low Light** shooting mode, in which case the continuous shooting speeds up considerably, to about four images per second, though the quality of your images is reduced, as is always the case with that shooting mode.

Flash Exposure Compensation

In this case, unlike the other options on the FUNC. menu discussed above, the FUNC. menu provides an alternate way to accomplish something that is available from the "regular" menu system. In certain shooting modes, **Flash Exposure Compensation** can be selected from the Shooting menu, under the **Flash Control** setting. But, if you want to get quicker access to that setting, the FUNC. menu is a good way to do so. Press FUNC./SET to bring up the lists of options, then select the sixth icon down on the left side—the lightning bolt with a plus and minus sign. With this setting, the scale you need is displayed immediately; all you have to do next is to use the left/right cursor buttons or the control dial to select as much positive or negative flash exposure compensation as you want, in 1/3-stop increments (see Figure 4.27). (Depending on the Shooting mode, the available option may be **Flash Output** instead of **Flash Exposure Compensation**.) Oh, and in case you thought that having two distinct ways to choose this option were not enough, here are two more: press the Flash key, then the MENU button, or just hold down the Flash button, until the Flash Exposure Compensation scale appears. These work with both internal and external flash. Somebody at Canon *really* likes this feature.

Figure 4.27
Flash Exposure
Compensation
can easily be
adjusted from
the FUNC.
menu.

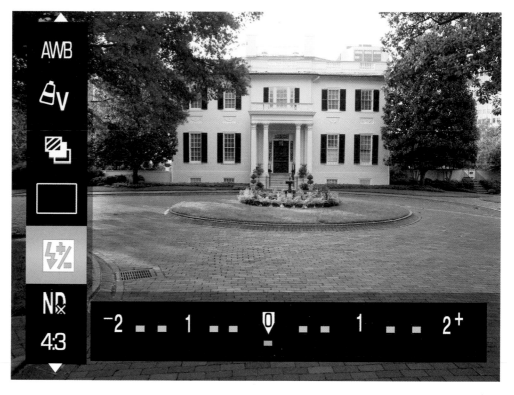

Neutral-Density Filter

This next option down the list on the FUNC. menu gives you the choice of using a virtual Neutral-Density (ND) filter. With film cameras, and with digital cameras for that matter, you can use a physical ND filter, which is essentially a dark piece of glass that cuts down the light reaching the film, for use when light conditions are too bright, or for when you need to use a slow shutter speed or large aperture for some reason. With the PowerShot G12, the filtering is applied electronically, with the effect of reducing the light reaching the sensor to one-eighth of its actual value, resulting in an exposure setting that needs to be three f/stops greater. (For example, if you were shooting with your aperture at f/8.0, you could change it to f/2.8 to reduce depth-of-field for selective focus with the ND turned on.) This option is easy to set. Select the ND icon on the list at the left, then move the highlight on the bottom list to **ND**, and you're done. See Figure 4.28, which illustrates how a neutral-density filter allows using a 1/2 second exposure that normally wouldn't be available even under overcast conditions, with an ISO setting of 80 and a minimum aperture of f/8.

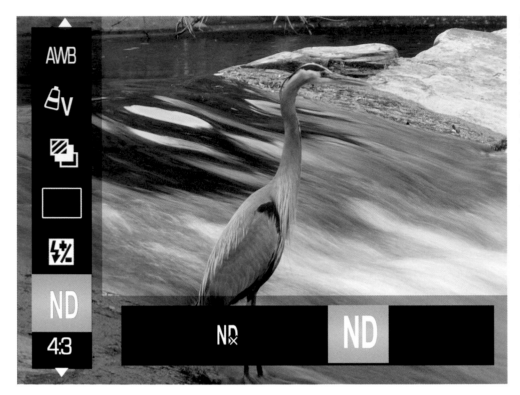

Figure 4.28
Dial in the neutral-density filter if you want to use longer exposures than normally available with a minimum ISO setting of ISO 80 and an f/8 minimum aperture.

Aspect Ratio

The next option down the list on the FUNC. menu, **Aspect Ratio**, lets you choose the shape of the image recorded by the G12. There are five available options, each one expressed as a ratio of the width of the image to its height: **16:9**, **3:2**, **4:3**, **1:1**, and **4:5**. Each of these has its merits and uses. The **16:9** ratio is often called "widescreen"; it is the ratio used by most widescreen TV sets. The **3:2** ratio is a very common one; it is the same ratio as that for 35mm film and for the 6-inch by 4-inch prints that are the most widely used size for photographic prints in the United States. The **4:3** ratio also is a very familiar one, being the same shape as the camera's LCD screen. The **1:1** ratio, of course, represents a square. It has the advantage of being perfectly symmetrical, not favoring one dimension over the other. Finally, the **4:5** ratio is the only one in which the image is taller than it is wide. It can be useful for taking portraits or images of thin or vertically oriented subjects. For RAW images, the aspect ratio is fixed at **4:3**. Of course, though, with any image, you can alter the aspect ratio through cropping in your photo-editing software, so, if you plan to process your photos on your computer, you don't need to be too concerned about shooting in a particular aspect ratio. If you want to use the digital zoom feature, you have to set the aspect ratio to **4:3**; otherwise, digital zoom is not available.

Image Quality and Size

The final two options on the FUNC. menu, and two of the most important, are the ones at the bottom of the menu's list, which give you choices for three significant attributes of your shots: **Image Type**, **Image Quality**, and **Image Size**. Although these are three separate selections on the menu, they are so closely related (two of them—image size and quality—are even on the same selection screen) that it makes sense to discuss them together. After pressing the FUNC./SET key to call up the menu, move the highlight all the way down the list on the left, just below the **Aspect Ratio** item. This action takes you to the selection area for these choices. Before I describe the details of making your selections, this topic needs some background.

There are three separate choices you need to make when selecting your image size and quality. Your first decision is whether to shoot everything in RAW files, which provide the best possible quality and most post-processing options, but which take up considerably more space on your memory card than JPEG files. You'll sometimes be told that RAW files are the "unprocessed" image information your camera produces, before it's been modified. That's nonsense. RAW files are no more unprocessed than your camera film is after it's been through the chemicals to produce a negative or transparency. A lot can happen in the developer that can affect the quality of a film image—positively and negatively—and, similarly, your digital image undergoes a significant amount of processing before it is saved as a RAW file. Canon even applies a name (DIGIC 4) to the digital image processing (DIP) chip used to perform this magic in the PowerShot G12.

A RAW file is more similar to a film camera's processed negative. It contains all the information, captured in 14-bit channels per color (and stored in a 16-bit space), with no compression, no sharpening, no application of any special filters or other settings you might have specified when you took the picture. Those settings are *stored* with the RAW file so they can be applied when the image is converted to a form compatible with your favorite image editor. However, using RAW conversion software such as Adobe Camera Raw or Canon's Digital Photo Professional, you can override those settings and apply settings of your own. You can select essentially the same changes there that you might have specified in your camera's picture-taking options.

RAW exists because sometimes we want to have access to all the information captured by the camera, before the camera's internal logic has processed it and converted the image to a standard file format. RAW doesn't save as much space as JPEG. What it does do is preserve all the information captured by your camera after it's been converted from analog to digital form.

So, why don't we always use RAW? Although some photographers do save only in RAW format, it's more common to use either RAW plus the JPEG option or just shoot JPEG and eschew RAW altogether. While RAW is overwhelmingly helpful when an image needs to be fine-tuned, in other situations working with a RAW file can slow you down significantly. RAW images take longer to store on the memory card, and require more

post-processing effort, whether you elect to go with the default settings in force when the picture was taken, or make minor adjustments.

As a result, those who depend on speedy access to images or who shoot large numbers of photos at once may prefer JPEG over RAW. Wedding photographers, for example, might expose several thousand photos during a bridal affair and offer hundreds to clients as electronic proofs for inclusion in an album. Wedding shooters take the time to make sure that their in-camera settings are correct, minimizing the need to post-process photos after the event. Given that their JPEGs are so good, there is little need to get bogged down shooting RAW. Sports photographers also eschew RAW files for similar reasons.

JPEG was invented as a more compact file format that can store most of the information in a digital image, but in a much smaller size. JPEG predates most digital cameras and was initially used to squeeze down files for transmission over slow dialup connections. Even if you were using an early digital camera with 1.3 megapixel files for news photography, you didn't want to send them back to the office over a modem at 1,200 bps.

But, as I noted, JPEG provides smaller files by compressing the information in a way that loses some image data. JPEG remains a viable alternative because it offers several different quality levels. At the highest quality Fine level, you might not be able to tell the difference between the original RAW file and the JPEG version, even though the RAW file occupies, by Canon's estimate, about 15MB on your memory card, while the Large, Fine JPEG takes up about 2.5MB of space. You've squeezed the image by five-sixths without losing much visual information at all. If you don't mind losing some quality, you can use more aggressive Normal compression with Large JPEG to cut the size in half again, to about 1.2MB.

So, using the above considerations, first decide whether to use RAW (or RAW plus JPEG) for all your shooting. If you go that route, you don't need to spend too much time thinking about other decisions regarding image quality and size, because all RAW files on this camera are of the same size and quality.

If you decide to shoot in one of the JPEG formats, though, you have some more decisions to make: First, what image size to select, and, second, what amount of JPEG compression to choose. Here are your choices of image size, showing the figures for an aspect ratio of 4:3; other aspect ratios have smaller numbers of pixels, except the 16:9 ratio, which has more:

- L (10 megapixels or 3,648 × 2,736 pixels)
- M1 (6 megapixels or 2,816 × 2,112 pixels)
- M2 (2 megapixels or 1,600 × 1,200 pixels)
- S (0.3 megapixels or 640 × 480 pixels)
- RAW (10 megapixels or 3,648 × 2,736 pixels)

Now let's look at the second choice you need to make from the FUNC. menu—the amount of compression to be used for your JPEG images, which directly affects their quality. To reduce the size of your image files and allow more photos to be stored on a given memory card, the G12 uses JPEG compression to squeeze these images down to a smaller size. This compacting reduces the image quality a little, so you're offered your choice of various levels of compression. Here again, the two models take different approaches.

The G12 provides just two levels of compression: **Fine** and **Normal**. The choice of **Fine** compression is represented on the camera's screen by a smooth quarter-circle (see Figure 4.29). That level of compression provides the smoothest results, while **Normal** compression, signified on the screen by a stair-step icon, provides lower-quality, "jaggier" images.

Image size, quality, and compression go hand-in-hand to determine the overall quality of your images, so the PowerShot G12 provides you with the ability to make these three choices together in the same menu system. On the G12, the quality choice (**JPEG**, **RAW**, or **RAW+JPEG**) is made on the next-to-bottom level of the FUNC. menu's list of icons; the image size choice (**L**, **M1**, **M2**, **S**) and the compression choice are both made on the bottom level.

Figure 4.29
The FUNC. menu's first choices for the images you shoot with the PowerShot G12 involve selecting an image type (RAW, JPEG, or RAW+ JPEG) and a quality (Fine or Normal).

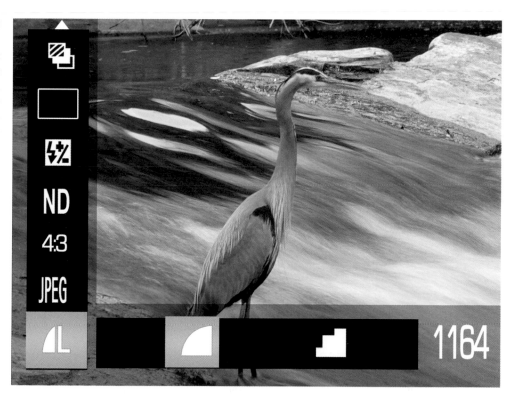

After pressing the FUNC./SET button, navigate with the up/down cursor buttons to the next-to-bottom icon on the left side of the screen, then use the control dial or the cursor buttons to select **JPEG**, **RAW**, or **RAW+JPEG**. If you select **RAW**, you're done; no other choices need to be (or can be) made, and you can exit the menu by pressing the FUNC./SET button again.

If you selected **JPEG** or **RAW+JPEG**, you still need to select the size and compression level for the JPEG images. Navigate down to the bottom item on the FUNC. menu, then move the highlight across the menu on the bottom of the screen to select **L**, **M1**, **M2**, or **S** for the image size. As you are making this choice, you will see the DISP. icon on the screen. Without exiting from the image size screen, press the DISP. button and you'll be shown a pair of icons representing the two choices of image compression: the smooth quarter-circle and the jagged stair-step shape. At this point, move the highlight to select either the quarter-circle (**Fine**) or the stair-step shape (**Normal**), then press the FUNC./SET key to confirm the selection (see Figure 4.30).

In practice, you'll probably want to use only the **Fine** compression and the **L** (Large) or **RAW** selections for your serious photography. There are some limited advantages to using the **M** (Medium) and **S** (Small) resolution settings, and **Normal** JPEG

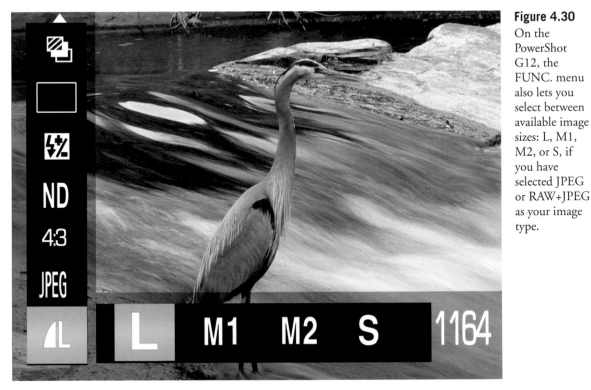

Figure 4.30
On the PowerShot G12, the FUNC. menu also lets you select between available image sizes: L, M1, M2, or S, if you have selected JPEG or RAW+JPEG as your image type.

compression setting. They all allow stretching the capacity of your memory card so you can shoehorn quite a few more pictures onto a single memory card. That can be useful when you're on vacation and running out of storage, or when you're shooting non-critical work that doesn't require full resolution (such as photos taken for real estate listings, web page display, photo ID cards, or similar applications). Some photographers like to record **RAW+JPEG Fine** so they'll have a JPEG file for review, while retaining access to the original RAW file for serious editing.

For most work, using lower resolution and extra compression is false economy. You never know when you might actually need that extra bit of picture detail. Your best bet is to have enough memory cards to handle all the shooting you want to do until you have the chance to transfer your photos to your computer or a personal storage device.

MANAGING LOTS OF FILES

The only long-term drawback to shooting everything in RAW+JPEG is that it's easy to fill up your computer's hard drive if you are a prolific photographer. Here's what I do. My most recent photos are stored on my working hard drive in a numbered folder, say G12 - 01, with subfolders named after the shooting session, such as 100901Trees, for pictures of trees taken on September 1, 2010. An automatic utility (TrueImage Home) copies new and modified photos to a different hard drive for temporary backup four times daily.

When the top-level folder accumulates about 30GB of images, I back it up to DVDs and then move the folder to a 1.5TB (1500GB) drive dedicated solely for storage of folders that have already been backed up onto DVD. Then I start a new folder, such as G12 -02, on the working hard drive and repeat the process. I always have at least one backup of every image taken, either on another hard drive or on a DVD.

Part II

Getting the Most from Your Canon PowerShot G12

This Part consists of five chapters designed to help get the most out of your Canon PowerShot G12, now that you've mastered the basic controls and features of the camera. After all, if all you wanted to do was point-and-shoot, you would have purchased a less versatile camera. If you, like the majority of G12 owners, belong to the point-*think*-shoot crowd, you'll want to read each of the following chapters so you can get the most from the capabilities at your fingertips.

At the beginning of this book, I promised not to throw you off the dock into deep water and expect you to learn how to swim before you went under for the third time. Instead, I've helped you learn all the basic strokes, in preparation for Part II, in which, I trust, you'll master the techniques that will transform you from a dog paddler to a championship swimmer.

As with Part I, you can start with any of the five chapters that follow, depending on your interests and skill level:

- **If you want to learn how to capture a full range of tonal values, every time, read:** *Chapter 5: Fine-Tuning Exposure.* This chapter will show you how to handle tricky situations, such as backlighting, how to create silhouette images, how to choose from among the G12's exposure and metering modes, and techniques for optimizing exposure using tools like histograms.

- **If you want to explore some cool techniques like super-long or ultra-short exposures and get up to speed on shooting movies, jump to:** *Chapter 6: Advanced Shooting and Movie Making with Your Canon PowerShot G12.* Here, I'll guide you through some specialized techniques, help you understand how focus works, and show you how to shoot movie clips and do simple editing right in the camera.

- **If you know that using your G12's lens effectively involves more than just pressing the zoom lever, you'll want to go to:** *Chapter 7: Getting the Most from your Zoom.* Discover what telephoto and wide-angle perspectives can do for your photos, and how to avoid the most common pitfalls of each end of the zoom scale. Learn about macro shooting, and discover some interesting add-ons that make your zoom even more versatile.

- **If you'd like to use light more effectively to create a mood or effect, read:** *Chapter 8: Working with Light.* Available light and electronic flash are powerful tools, but you need to understand how they work to harness their capabilities. This chapter shows you how to choose between continuous illumination and flash, and the best way to progress beyond the limitations of your PowerShot G12's built-in flash.

- **If you want to jump ahead and begin working with your images on your computer, you'll want to look at:** *Chapter 9: Downloading and Editing Your Images.* It's not a how-to chapter for image editing. Instead, it explains your options for transferring images and then processing them with easy-to-use, but powerful, software options, from Canon's Digital Photo Pro to Photoshop.

Fine-Tuning Exposure

The Canon PowerShot G12 offers the best of two worlds when it comes to capturing exactly the right exposure—a picture with the optimum balance of tones and colors that are neither too light nor too dark to reveal all the detail in the original subject. You can select one of the numerous predefined shooting modes suitable for your subject matter—such as portrait, landscape, underwater, sports, or beach—and the camera will do an excellent job of calculating the right settings to give you an outstanding picture with little input on your part beyond the initial mode dial selection. If you can't decide for yourself which of those specific shooting modes is best, you can select the green Auto icon instead, and the PowerShot G12 will still do a fine job.

So, why do I include an entire chapter titled "Fine-Tuning Exposure" in all my Canon books? As you learn to use your PowerShot G12 creatively, you're going to find that the right settings—as determined by the camera's exposure meter and intelligence—need to be *adjusted* to account for your creative decisions or special situations.

For example, when you shoot with the main light source behind the subject, you end up with *backlighting*, which results in an overexposed background and/or an underexposed subject. The PowerShot G12 recognizes backlit situations nicely, and can properly base exposure on the main subject, producing a decent photo. A feature like i-Contrast (introduced in Chapter 4) can fine-tune exposure to preserve detail in the highlights and shadows.

But what if you *want* to underexpose the subject, to produce a silhouette effect? Or, perhaps, you might want to make use of the camera's built-in flash unit to fill in the shadows on your subject. The more you know about how to use your PowerShot G12, the more you'll run into situations where you want to creatively tweak the exposure to provide a different look than you'd get with a straight shot.

This chapter shows you the fundamentals of exposure, so you'll be better equipped to override the PowerShot G12's default settings when you want to, or need to. After all, correct exposure is one of the foundations of good photography, along with accurate focus and sharpness, appropriate color balance, freedom from unwanted noise and excessive contrast, as well as pleasing composition.

Understanding Exposure

Exposure determines the look, feel, and tone of an image, in more ways than one. Incorrect exposure can impair even the best-composed image by cloaking important tones in darkness, or by washing them out so they become featureless to the eye. On the other hand, correct exposure brings out the detail in the areas you want to picture, and provides the range of tones and colors you need to create the desired image. However, getting the perfect exposure can be tricky, because digital sensors can't capture all the tones we are able to see. If the range of tones in an image is extensive, embracing both inky black shadows and bright highlights, the sensor may not be able to capture them all. Sometimes, we must settle for an exposure that renders most of those tones—but not all—in a way that best suits the photo we want to produce. You'll often need to make choices about which details are important, and which are not, so that you can grab the tones that truly matter in your image. That's part of the creativity you bring to bear in realizing your photographic vision.

For example, look at the two typical tourist snapshots presented side by side in Figure 5.1. The camera was mounted on a tripod for both, so the only way you can really see that they are two different images is by examining the differences in the way the water flows over the rocks. However, the pair of pictures does vary in exposure. The version on the left was underexposed, which helps bring out detail in the ridges and sky in the background, but makes the water and foreground look murky and dark. The overexposed version on the right offers better exposure for the foreground area, but now the ridges and sky are too light.

With digital camera sensors, it's tricky to capture detail in both highlights and shadows in a single image, because the number of tones, the *dynamic range,* of the sensor is limited. The solution, in this particular case, was to resort to a technique called High Dynamic Range (HDR) photography, in which the two exposures from Figure 5.1 were combined in an image editor such as Photoshop, or a specialized HDR software program. The resulting shot is shown in Figure 5.2. I'll explain more about HDR photography later in this chapter. For now, though, I'm going to concentrate on showing you how to get the best exposures possible without resorting to such tools, using only the features of your Canon PowerShot G12.

Figure 5.1
At left, the image is exposed for the background highlights, losing shadow detail. At right, the exposure captures detail in the shadows, but the background highlights are washed out.

Figure 5.2
Combining the two exposures produces the best compromise image.

To understand exposure, you need to understand the six aspects of light that combine to produce an image. Start with a light source—the sun, an interior lamp, or the glow from a campfire—and trace its path to your camera, through the lens, and finally to the sensor that captures the illumination. Here's a brief review of the things within our control that affect exposure.

- **Light at its source.** Our eyes and our cameras—film or digital—are most sensitive to that portion of the electromagnetic spectrum we call *visible light.* That light has several important aspects that are relevant to photography, such as color, and harshness (which is determined primarily by the apparent size of the light source as it illuminates a subject). But, in terms of exposure, the important attribute of a light source is its *intensity.* We may have direct control over intensity, which might be the case with an interior light that can be brightened or dimmed. Or, we might have only indirect control over intensity, as with sunlight, which can be made to appear dimmer by introducing translucent light-absorbing or reflective materials in its path.

- **Light's duration.** We tend to think of most light sources as continuous. But, as you'll learn in Chapter 8, the duration of light can change quickly enough to modify the exposure, as when the main illumination in a photograph comes from an intermittent source, such as an electronic flash.

- **Light reflected, transmitted, or emitted.** Once light is produced by its source, either continuously or in a brief burst, we are able to see and photograph objects by the light that is reflected from our subjects towards the camera lens; transmitted (say, from translucent objects that are lit from behind); or emitted (by a candle or television screen). When more or less light reaches the lens from the subject, we need to adjust the exposure. This part of the equation is under our control to the extent we can increase the amount of light falling on or passing through the subject (by adding extra light sources or using reflectors), or by pumping up the light that's emitted (by increasing the brightness of the glowing object).

- **Light passed by the lens.** Not all the illumination that reaches the front of the lens makes it all the way through. Filters can remove some of the light before it enters the lens. Inside the lens barrel is a variable-sized diaphragm called an *aperture* that dilates and contracts to control the amount of light that enters the lens. You, or the PowerShot G12's autoexposure system, can control exposure by varying the size of the aperture. The relative size of the aperture is called the *f/stop.*

- **Light passing through the shutter.** Once light passes through the lens, the amount of time the sensor receives it is determined by the PowerShot G12's shutter, which can remain open for as long as 15 seconds or as briefly as 1/4,000th second.

■ **Light captured by the sensor.** Not all the light falling onto the sensor is captured. If the number of photons reaching a particular photosite doesn't pass a set threshold, no information is recorded. Similarly, if too much light illuminates a pixel in the sensor, then the excess isn't recorded or, worse, spills over to contaminate adjacent pixels. We can modify the minimum and maximum number of pixels that contribute to image detail by adjusting the ISO setting. At higher ISOs, the incoming light is amplified to boost the effective sensitivity of the sensor.

These factors—the quantity of light produced by the light source; the amount reflected or transmitted towards the camera; the light passed by the lens; the amount of time the shutter is open; and the sensitivity of the sensor—all work proportionately and reciprocally to produce an exposure. That is, if you double the amount of light that's available, increase the aperture by one stop, make the shutter speed twice as long, or boost the ISO setting 2X, you'll get twice as much exposure. Similarly, you can increase any of these factors while decreasing one of the others by a similar amount to keep the same exposure.

Most commonly, exposure settings are made using the aperture and shutter speed, followed by adjusting the ISO sensitivity if it's not possible to get the preferred exposure (that is, the one that uses the "best" f/stop or shutter speed for the depth-of-field or action-stopping we want). Table 5.1 shows equivalent exposure settings using various shutter speeds and f/stops.

When the PowerShot G12 is set for P mode, the metering system selects the correct exposure for you automatically. However, you can change quickly to an equivalent exposure by holding down the shutter release button halfway and pressing the * button ("locking" the current exposure), and then spinning the control dial (on the back of the camera) until the desired equivalent exposure combination is displayed. The equivalent exposures appear as a pairing of shutter speeds and f/stops on the LCD, which you can change using the control dial. This Program Shift feature does not work when you're using flash.

In Aperture priority (Av) and Shutter priority (Tv) modes, you can change to an equivalent exposure, but only by adjusting either the aperture (the camera chooses the shutter speed) or shutter speed (the camera selects the aperture). I'll cover all these exposure modes later in the chapter.

Table 5.1 Equivalent Exposures

Shutter speed	f/stop	Shutter speed	f/stop
1/250th second	f/8	1/1,000th second	f/4
1/500th second	f/5.6	1/2,000th second	f/2.8

F/STOPS AND SHUTTER SPEEDS

If you're *really* new to more advanced cameras, you might need to know that the lens aperture, or f/stop, is a ratio, much like a fraction, which is why f/2.8 is larger than f/5.6, just as 1/2 is larger than 1/4. However, f/2.8 is actually *four times* as large as f/5.6. (If you remember your high school geometry, you'll know that to double the area of a circle, you multiply its diameter by the square root of two: 1.4.)

Apertures in digital cameras are usually marked with intermediate f/stops that represent a size that's twice as much/half as much as the previous aperture. So, a lens might be marked:

f/2.8, f/4, f/5.6, f/8, with each larger number representing an aperture that admits half as much light as the one before, as shown in Figure 5.3, which illustrates a generic lens, not the one in the PowerShot G12.

Shutter speeds are actual fractions (of a second), but in some cameras' displays the numerator is omitted, so that 60, 125, 250, 500, 1000, and so forth represent 1/60th, 1/125th, 1/250th, 1/500th, and 1/1,000th second. In the PowerShot G12, Canon actually found room to include the numerators. However, to avoid all chance of confusion, Canon uses quotation marks to signify longer exposures: For example, 0"5, 2", and 4" represent 0.5, 2.0, and 4.0 second exposures, respectively.

Figure 5.3
Top row (left to right): f/2.8, f/4; bottom row, f/5.6, f/8.

How the PowerShot G12 Calculates Exposure

Your Canon PowerShot G12 calculates exposure by measuring the light that passes through the lens to sensors located near the focusing surface, using a pattern you can select (more on that later) and based on the assumption that each area being measured reflects about the same amount of light as a neutral gray card with 18-percent reflectance. That assumption is necessary, because different subjects reflect different amounts of light. In a photo containing a white cat and a dark gray cat, the white cat might reflect five times as much light as the gray cat. An exposure based on the white cat will cause the gray cat to appear to be black, while an exposure based only on the gray cat will make the white cat washed out. Light-measuring devices handle this by assuming that the areas measured average a standard value of 18-percent gray—a figure that's been used as a rough standard for many years (most vendors don't calibrate their metering for exactly 18-percent gray; the actual figure may be closer to 13 or 14 percent).

In most cases, your camera's light meter will do a good job of calculating the right exposure, especially if you use the exposure tips in the next section. But if you want to double-check, or feel that exposure is especially critical, take the light reading off an object of known reflectance. Photographers sometimes carry around an 18-percent gray card (available from any camera store) and, for critical exposures, actually use that card, placed in the subject area, to measure exposure (or to set a custom white balance if needed).

You could, in many cases, arrive at a reasonable exposure by pointing your PowerShot G12 at an evenly lit object, such as an actual gray card or the palm of your hand (the backside of the hand is too variable). It's more practical, though, to use your camera's system to meter the actual scene, using the options available to you when using one of the more advanced shooting modes (P, Tv, Av, and M). (In the Auto and SCN modes, the metering decisions are handled by the camera's programming.)

> **Tip**
>
> Of course, if you use such a gray card, strictly speaking, you need to use about one-half stop *more* exposure than metered, because the PowerShot G12 is calibrated for a lighter tone, rather than the 18-percent gray you just measured. If you're using a human palm instead, add one full stop more exposure.

To meter properly using the more advanced shooting modes, you'll want to choose both the *metering method* (how light is evaluated) and *exposure method* (how the appropriate shutter speeds and apertures are chosen). I'll describe both in the following sections. But first, let's clear up that black cat/gray cat/white cat conundrum, without using any

actual cats. Black, white, and gray cats have been a standard metaphor for many years, so I'm going to explain this concept using a different, and more cooperative, life form: fruit.

Figure 5.4 shows three ordinary pieces of fruit. The yellow banana at left represents a white cat, or any object that is very light but which contains detail that we want to see in the light areas. The orange in the middle is a stand-in for a gray cat, because it has most of its details in the middle tones. The deep purple plum serves as our black cat, because it is a dark object with detail in its shadows.

Figure 5.4
The yellow banana, orange, and deep purple plum represent light, middle, and dark tones.

Figure 5.5 Exposing for the light-colored banana at left renders the other two fruit excessively dark.

Figure 5.6 Exposing for the dark plum (right) causes the two fruit at left to become too light.

Figure 5.7 Exposing for the middle-toned orange produces an image in which the tones of all three subjects appear accurately.

The colors confuse the issue, so I'm going to convert our color fruit to black-and-white. For the version shown in Figure 5.5, the exposure (measured by Spot metering) was optimized for the white (yellow) banana, changing its tonal value to a medium, 18-percent gray. The dark (purple) and medium-toned (orange) fruit are now *too* dark. For Figure 5.6, the exposure was optimized for the dark (purple) plum, making most of its surface, now, fall into the middle-tone, 18-percent gray range. The light yellow banana and midtone orange are now too light.

The solution, of course, is to measure exposure from the object with the middle tones that most closely correspond to the 18-percent gray "standard." Do that, and you wind up with a picture that more closely resembles the original tonality of the yellow, orange, and purple fruit, which looks, in black-and-white, like Figure 5.7.

Choosing a Metering Method

The PowerShot G12 has three different schemes for evaluating the light received by its exposure sensors—Evaluative, Center weighted, and Spot. You can choose among them by pressing the metering mode button (directly under the * key) and rotating the control dial until the mode you want is selected. (In this case, you can't use the left/right cursor buttons to make the selection, because pressing those keys in this context will activate their other functions—selecting Macro shooting or Flash.)

- **Evaluative.** The PowerShot G12 slices up the frame into various different zones. (As is typical with its non-dSLR cameras, Canon doesn't reveal how many zones there are, or exactly where they are located.) The camera evaluates the measurements, paying special attention to the metering zones that appear to include certain levels of brightness or features such as human faces, to make an educated guess about what kind of picture you're taking, based on examination of thousands of different real-world photos. For example, if the top sections of a picture are much lighter than the bottom portions, the algorithm can assume that the scene is a landscape photo with lots of sky. This mode is the best all-purpose metering method for most pictures. It's the mode used when the camera is set to Auto shooting.

- **Spot AE Point.** This mode confines the reading to a limited (and non-specified) area in the center of the viewfinder, making up only a small percent of the image. This mode is useful when you want to base exposure on a single, limited area in the frame. If that area is in the center of the frame, so much the better. If not, you'll have to take steps to make sure the reading is accurate. One way is to make your meter reading by placing the center spot over the main part of the subject and then locking exposure by pressing the shutter release halfway, or by pressing the AE lock button, before moving the camera back into position for taking the picture. Another way is to use the FlexiZone focusing capability, discussed in Chapter 6, which lets you move the autofocus bracket around the screen. Using the Spot AE Point option

on the Shooting menu, as discussed in Chapter 4, you can link the Spot AE Point to the AF Point. Then, when you move the FlexiZone AF Frame around the screen, you will be moving the Spot AE Point at the same time, so you can choose precisely what area of the scene is measured for your exposure. The Spot AE Point Frame and AF Frame are moved around using the cursor buttons or the dials after you press the frame selector button (just east of the LCD). The frame turns orange and can be changed in size using the DISP. button. I'll explain this technique in more detail in Chapter 6.

- **Center weighted averaging.** In this mode, the exposure meter emphasizes a zone located roughly in the center of the frame to calculate exposure, on the theory that, for most pictures, the main subject will be located in the center. Center weighting works best for portraits, architectural photos, and other pictures in which the most important subject is located in the middle of the frame. As the name suggests, the light reading is *weighted* towards the central portion, but information is also used from the rest of the frame. If your main subject is surrounded by very bright or very dark areas, the exposure might not be exactly right. However, this scheme works well in many situations if you don't want to use one of the other modes.

Choosing an Exposure Method

If you set the PowerShot G12's shooting mode dial to Auto, SCN, Low Light, or Quick Shot, the camera will take care of choosing an exposure method (Evaluative) and calculating the exposure for you. But if you're inclined to exercise more control over the exposure decision, you'll find three semi-automated methods—Program, Aperture priority, and Shutter priority—plus the Manual mode for choosing the appropriate shutter speed and aperture. Just spin the mode dial to choose the method you want to use. Your choice of which is best for a given shooting situation will depend on things like your need for lots of (or less) depth-of-field, a desire to freeze action or allow motion blur, or how much noise you find acceptable in an image. Each of the PowerShot G12's non-automatic exposure methods emphasizes one aspect of image capture or another. This section introduces you to all four.

Aperture Priority

In Av (the letters stand for Aperture value) mode, you specify the lens opening used, and the PowerShot G12 selects the shutter speed. Aperture priority is especially good when you want to use a particular lens opening to achieve a desired effect. Perhaps you'd like to use the smallest f/stop possible to maximize depth-of-field in a close-up picture. Or, you might want to use a large f/stop to throw everything except your main subject out of focus, as in Figure 5.8, a chilling portrait of a menacing lizard, taken by talented Cleveland photographer Kris Bosworth. Maybe you'd just like to "lock in" a particular

Figure 5.8
Use Aperture priority mode to "lock in" a large f/stop when you want to blur the background.

f/stop because it's the sharpest available aperture. Or, you might prefer to use, say, f/4, even though the camera's lens has a maximum aperture of f/2.8, because you want the best compromise between speed and sharpness.

Aperture priority can even be used to specify a *range* of shutter speeds you want to use under varying lighting conditions, which seems almost contradictory. But think about it. You're shooting a soccer game outdoors with a telephoto zoom setting and want a relatively high shutter speed, but you don't care if the speed changes a little should the sun duck behind a cloud. Set your PowerShot G12 to Av, and adjust the aperture until a shutter speed of, say, 1/1000th second is selected at your current ISO setting. (In bright sunlight at ISO 200, that aperture is likely to be around f/8.) Then, go ahead and shoot, knowing that your camera will maintain that f/8 aperture (for sufficient depth-of-field as the soccer players move about the field), but will drop down to 1/800th or 1/500th second if necessary should the lighting change a little.

A shutter speed of **1/4000** or **1"** displaying in orange (rather than white) on the LCD indicates that the PowerShot G12 is unable to select an appropriate shutter speed at the selected aperture, and that over- or underexposure will occur at the current ISO setting (see Figure 5.9). That's the major pitfall of using Av: you might select an f/stop that is too small or too large to allow an optimal exposure with the available shutter speeds. For example, if you choose f/2.8 as your aperture and the illumination is quite bright (say, at the beach or in snow), even your camera's fastest shutter speed might not be able to cut down the amount of light reaching the sensor to provide the right exposure. Or,

Figure 5.9
When the PowerShot G12 cannot achieve proper exposure in Av mode, the shutter speed will turn orange.

if you select f/8 in a dimly lit room, you might find yourself shooting with a very slow shutter speed that can cause blurring from subject movement or camera shake. (However, you can minimize this risk by turning on the Safety Shift feature through the Shooting menu, as described in Chapter 4.) In general, Aperture priority is best used by those with a bit of experience in choosing settings. Many seasoned photographers leave their cameras set on Av all the time.

Note that there may be situations in which the expected aperture cannot be set. This can happen when the built-in flash is turned on, because, on the PowerShot G12, the fastest shutter speed available when using the built-in flash is 1/2000. So, for example, if you are photographing in bright conditions and set a wide aperture such as f/2.8, and the appropriate shutter speed would be 1/4000, the G12 will reset the aperture to a value such as f/5.6, so the shutter speed can be reset to no faster than 1/2000.

Finally, note that, with the G12, as you zoom the lens in beyond its wide-angle setting of 28mm, some apertures become unavailable. For example, when the lens is zoomed all the way in to its 120mm telephoto value, the widest aperture available is f/4.5. That's because the *effective* aperture of the f/2.8 lens becomes f/4.5 at the maximum zoom position.

Chapter 5 ■ Fine-Tuning Exposure 143

Shutter Priority

Shutter priority (Tv, for Time value) is the inverse of Aperture priority: you choose the shutter speed you'd like to use, and the camera's metering system selects the appropriate f/stop. Perhaps you're shooting action photos and you want to use the absolute fastest shutter speed available with your camera; in other cases, you might want to use a slow shutter speed to add some blur to a sports photo that would be mundane if the action were completely frozen. Or, you might want to give a feeling of motion, as with another Kris Bosworth image of an antique auto cruising down the parkway at dozens of miles per hour. (See Figure 5.10.) Shutter priority mode gives you some control over how much action-freezing capability your digital camera brings to bear in a particular situation.

You'll also encounter the same problem as with Aperture priority when you select a shutter speed that's too long or too short for correct exposure under some conditions. I've shot outdoor soccer games on sunny Fall evenings and used Shutter priority mode to lock in a 1/1000th second shutter speed, only to find my camera refused to shoot when the sun dipped behind some trees and there was no longer enough light to shoot at that speed, even with the lens wide open.

As with Av mode, it's possible to choose an inappropriate shutter speed using Tv mode. If that's the case, **2.8**, the maximum aperture of your lens (to indicate underexposure) or **8.0**, the minimum aperture (to indicate overexposure) will show up as orange on the LCD display (see Figure 5.11). Again, as with Av mode, you can avoid this problem by turning on Safety Shift through the Shooting menu.

Figure 5.10
Lock the shutter at a slow speed to introduce blur, as with this panned image of an antique automobile.

Figure 5.11
A minimum or maximum aperture displayed in orange means the camera cannot achieve a correct exposure in Shutter priority mode.

Note that, just as with aperture settings, there may be times when you think you've set a particular shutter speed—say, 1/4000, but the camera seems to ignore your setting and changes it to 1/2000 or 1/250. Here's why this happens. As noted above, the fastest shutter speed the G12 can use with the built-in flash in Tv mode is 1/2000, and it will reset itself to that shutter speed when the flash is activated, even though it will let you set a faster speed of 1/2500, 1/3200, or 1/4000 initially. However, if you have a compatible external flash attached, then the fastest shutter speed the camera will let you set is 1/250th second. In that situation, if you set a faster shutter speed, the camera will reset it to no faster than 1/250th second.

Program Mode

Program mode (P) uses the PowerShot G12's built-in smarts to select the correct f/stop and shutter speed using a database of picture information that tells it which combination of shutter speed and aperture will work best for a particular photo. If the correct exposure cannot be achieved at the current ISO setting, the shutter speed and aperture indicators in the viewfinder will *both* display in orange at their extreme settings, showing **1"** and **2.8** to indicate underexposure or **1/4000** and **8.0** to indicate overexposure. You can then boost or reduce the ISO to increase or decrease sensitivity.

The PowerShot G12's recommended exposure can be overridden if you want. Use the exposure compensation feature (described later, because it also applies to Tv and Av modes) to add or subtract exposure from the metered value. And, as I mentioned earlier in this chapter, you can change from the recommended setting to an equivalent setting (as shown earlier in Table 5.1) that produces the same exposure, but with a different combination of f/stop and shutter speed. To accomplish this, use the Program Shift feature as follows:

1. **Disable flash.** Make sure the flash is forced off by pressing the Flash button and highlighting the icon showing the lightning bolt with a line through it.

2. **Lock exposure.** Press the shutter release halfway to lock in the current base exposure, and press the AE lock button (*) on the back of the camera (in which case the * indicator will be displayed on the screen to show that the exposure has been locked).

3. **Choose exposure combination.** A pair of slide-rule-like dials will immediately appear on the screen, with the apertures on top, and the corresponding shutter speeds below them. Spin the control dial to move the pairings of shutter speed and aperture in tandem until you find the combination you want.

4. **Take photo.** Press the shutter button to grab your shot.

Your adjustment remains in force for a single exposure; if you want to change from the recommended settings for the next exposure, you'll need to repeat those steps.

Making EV Changes

Sometimes you'll want more or less exposure than indicated by the PowerShot G12's metering system. Perhaps you want to underexpose to create a silhouette effect, or overexpose to produce a high key look. It's easy to use the camera's exposure compensation system to override the exposure recommendations, as long as you're using the Program, Aperture priority, or Shutter priority shooting mode.

Exposure Compensation with the PowerShot G12

One of the great features of the PowerShot G12 is the presence of a dial dedicated to exposure compensation. This is one of the functions that serious photographers really appreciate—the ability to tweak the camera's automatic exposure setting according to conditions, and, more importantly, according to the photographer's vision of how the image should look. With the addition of this dedicated dial, you have immediate access to this adjustment. So, the instructions for using this feature on the G12 are quite brief—turn the exposure compensation dial to the desired value: into the + area to lighten the image, and into the − area to darken it. (See Figure 5.12.)

Figure 5.12
If your image is too bright (top), rotate the exposure compensation dial to –1 to produce a version that's better exposed (middle). Don't go too far: –2 exposure compensation (bottom) creates an image that's too dark.

When using exposure compensation, it's important to remember that any adjustment you make to that value will remain in place even after the camera has been turned off and back on again; you have to be sure to move the exposure compensation dial back to zero when you no longer need the adjustment. The adjustment is not available in Manual or Auto shooting mode. However, if you turn the dial while in one of those modes, the adjustment will take effect if you later switch to a shooting mode that does permit exposure compensation.

Manual Exposure

Part of being an experienced photographer comes from knowing when to rely on your PowerShot G12's automation (including Auto mode, P mode, and other automated settings), when to go semi-automatic (with Tv or Av), and when to set exposure manually (using M). Some photographers actually prefer to set their exposure manually, but that doesn't leave you completely on your own; the PowerShot G12 provides an analog exposure scale on the LCD to indicate when its metering system judges your manual settings provide the proper exposure.

Manual exposure can come in handy in some situations. You might be taking a silhouette photo and find that none of the exposure modes or EV correction features give you exactly the effect you want. For example, when I shot the dancer in Figure 5.13 in front

Figure 5.13
The only way to expose this shot of a dancer correctly was to use Manual exposure.

of a mostly dark background highlighted by an illuminated curtain off to the right, there was no way any of my camera's exposure modes would be able to interpret the scene the way I wanted to shoot it. So, I took a couple test exposures, and set the exposure manually, using the exact shutter speed and f/stop I needed. Or, you might need to set the aperture manually when working with non-dedicated flash units, and your camera's exposure meter can't interpret the flash exposure at all.

Although, depending on your proclivities, you might not need to set exposure manually very often, you should still make sure you understand how it works. Fortunately, the PowerShot G12 makes setting exposure manually quite easy. Here are the steps to take:

1. **Choose Manual exposure.** Set the mode dial to M.

2. **Set shutter speed and aperture.** Rotate the front dial to set your desired shutter speed, and rotate the control dial to select the f/stop you want. (Those are the standard functions of those dials by default. As discussed in Chapter 4, you can use the **Set Dial Functions** menu item to change the roles of the dials, if you want.)

3. **Check metered exposure.** Press the shutter release halfway and the camera will determine what the metered exposure should be. Look at the vertical scale with tick marks at the right of the screen; it will have a white marker on the right side of the scale that moves up and down as the manual exposure setting changes. (See Figure 5.14.)

Figure 5.14
When setting exposure manually, an exposure scale shows the difference between your settings and the metered exposure.

4. **Make corrections, if desired.** If that marker goes above the mid-point on the scale, that means the camera considers the manual exposure setting to be too bright; if the marker goes below the mid-point, the camera believes the exposure setting is too dark. If the difference becomes greater than 2 EV in either direction, the white marker on the right turns orange. Change shutter speed and/or aperture, as described in Steps 2 and 3, until the exposure you want is set.

5. **Or, let the camera correct your manual exposure settings.** If you prefer to let the camera set the exposure, you can press the AE lock (*) and the camera will attempt to change your manual exposure setting to its own metered setting by adjusting either the aperture or the shutter speed. (If the manual settings are both too far away from the metered settings, the camera will not be able to achieve a proper exposure setting by adjusting shutter speed or aperture. You'll have to do it manually.)

6. **Take your photo.** Once you have adjusted the shutter speed and aperture to your liking, and checked them against the vertical scale on the right of the screen, press the shutter button to take the picture.

Automatic and Scene Modes

Other important tools in your exposure repertoire are the numerous automatic and scene-oriented shooting modes, which can automatically make all the basic settings needed for certain types of shooting situations, such as portraits, landscapes, sports, fireworks, underwater pictures, and others. These "autopilot" modes are especially useful when you suddenly encounter a picture-taking opportunity and don't have time to decide exactly which of the more advanced shooting modes you want to use. Instead, you can spin the mode dial to select the appropriate automatic mode and fire away, knowing that at least you have a fighting chance of getting a good or usable photo.

These modes are also helpful when you're just learning to use your PowerShot G12. Once you've learned how to operate your camera, you'll probably prefer one of the advanced modes that provide more control over shooting options. The automatic or Scene modes may give you few options or none at all. In some cases, the AF mode, drive mode, or metering mode will be set for you, or your options for selecting those items may be sharply limited.

Auto Mode

First, we need to mention Auto mode, because it occupies its own separate place on the mode dial. Turn the dial to that setting, and most of the time you are likely to be pleased with the results of your shots, because the camera will use its electronic intelligence to make reasonably good judgments about shutter speed, aperture, backlighting, and other factors. This is the mode to use when you hand your camera to a total stranger and ask

him or her to take your picture posing in front of the Eiffel Tower. All the photographer has to do is look through the viewfinder and press the shutter release button. Just about every other decision is made by the camera's electronics. You can still set image size and quality (but you can't shoot in RAW quality), and you can control exposure compensation, aspect ratio, and a few other items, but enough basic decisions are made by the camera to result in a usable image virtually every time. However, you should be aware that, perhaps because the PowerShot G12 is intended for use by more experienced photographers, the camera does not (always) treat you like a dummy—it will let you change settings that you might not expect. For example, in Landscape mode, although the flash is set to Off initially, you still have the option of turning it back on if you want to for some reason. In Fireworks mode, though, the camera *does* treat you like a dummy, and won't let you turn the flash on. However, in most SCN modes, you can choose to have the flash on, off, or automatically selected when needed. In Auto mode, you can choose to turn the flash on or off. You also have the option to turn on Tracking AF by pressing the metering mode button (which is available for this unusual purpose because it can't be used to select the metering mode in the Auto shooting mode).

Scene Modes

Next, we come to the impressive array of specific shooting modes that Canon's engineers have devised to help you cope with the ever-changing environment that you're confronted with in the varied activities of your life. To get access to these modes, set the mode dial to the SCN setting, then turn the control dial to move to the specific scene type you want to select. As you rotate the control dial, the camera displays the name of each scene type on the screen (for example, "Foliage") so you're not left guessing what the sometimes-cryptic icons represent. And, the camera goes so far as to display a short phrase on the screen explaining what the selected mode is designed for (for example, "shoot foliage in vivid colors"). One important note: None of these settings is available if you're shooting with RAW quality. I'll provide some brief points about each of these scene modes in the list below.

- **Portrait.** This mode tends to use wider f/stops and faster shutter speeds, providing blurred backgrounds and images with no camera shake. If you want, you can turn on continuous shooting using the FUNC. menu, as discussed in Chapter 4. Then, if you hold down the shutter release, the PowerShot G12 will take a continuous sequence of photos, which can be useful in capturing fleeting expressions in portrait situations.

- **Landscape.** The camera tries to use smaller f/stops for more depth-of-field, and boosts saturation slightly for richer colors.

- **Kids & Pets.** An "action" scene mode for capturing fast-moving pets and children without subject blur and with continuous focusing.

■ **Sports.** In this mode, the camera tries to use high shutter speeds to freeze action, switches to continuous drive to allow taking a quick sequence of pictures with one press of the shutter release, and uses Continuous AF to continually refocus as your subjects move around in the frame. You can find more information on autofocus options in Chapters 4 and 6.

■ **Smart Shutter.** Although this setting is bunched in with Portrait, Landscape, and other subject-specific Scene types, it is really designed to set the camera's automatic face-detection features for any type of scene involving people—whether at a party, on the beach, or in a business or school environment. After you select this setting, press the DISP button. This action pops up a small menu at the bottom of the screen, letting you choose from Smile Detection, Wink self-timer, and Face self-timer. Use the cursor buttons or control dial to highlight one of these options, then press FUNC./SET to select it. With Smile Detection, the camera will take a picture whenever a person smiles; with the Wink self-timer, you need to press the shutter button halfway to be sure that a person's face is framed in a green rectangle on the LCD. Then, press the shutter button fully, and the LCD will say, Wink to take picture. Once the person whose face is in the green frame winks, the camera should take the picture within two seconds. Finally, with the Face self-timer, you focus on a group of people and press the shutter button. Then you run over and join the group; the camera will take the picture once it detects a new face (yours). If it doesn't detect a new face, it will take the picture anyway, after 15 seconds. If you find this feature of use, that's great; personally, I will stick to the regular old self-timer. When one of these settings is highlighted, you can press the up/down cursor buttons to select the number of shots to be taken when the shutter fires, up to 10.

■ **Super Vivid.** This setting increases the saturation of the colors in a scene, making them appear much richer and more intense than normal. Use it for dramatic effect, when appropriate.

■ **Poster Effect.** This setting, like the previous one, is not intended for a specific type of scene; rather, it imposes a particular type of processing on the image. In this case, it provides a degree of "posterization," increasing contrast with bright color effects, to achieve a highly stylized effect reminiscent of pop-art on an entertainment poster.

■ **Color Accent.** This is the first of three SCN mode settings that are not designed for specific scene types, but, rather, are ways to manipulate your images. They are accessed by turning the control dial in the same way as for the SCN varieties mentioned previously. The first is Color Accent, which lets you retain just one color in an image, converting the rest of the image to black-and-white. Once you have selected Color Accent, press the DISP. button, which will bring up a box at the bottom of the screen filled with a color. Then move the camera so the center frame is aimed at the one color you want to retain. Press the left cursor button, and the box

at the bottom of the screen will fill with that color. Then press the shutter button, and only objects of that color will retain any color in the final image (see Figure 5.15). This option is available when shooting movies, also.

- **Color Swap.** This operation is similar to Color Accent, except that, rather than retain the color you first select, you change objects of that color to the second color that you select. After pressing the DISP. key, position the center frame over the object whose color you want to change, and press the left cursor button. The left box at the bottom of the screen will fill with that color. Then position the center frame over the color you want to change the first object to, and press the right cursor button. The right box at the bottom of the screen will fill with that color. Then take the picture, and any object of the first color will have been changed to the second color. This option is also available for movie shooting.

- **HDR.** With this setting, the camera uses its internal processing to take three pictures in rapid sequence in order to create a High Dynamic Range image. This processing results in a final image that includes a wider range of bright, well-exposed areas than could be recorded in a single shot. This feature can be especially useful if you are faced with a situation in which part of your subject is in bright sunlight and part in shadow. Using the different exposure levels from the three separate

Figure 5.15
With the Color Accent SCN mode option, you can tell the camera which single color to retain—in this case red; the rest of the image is transformed to black-and-white.

images, the camera essentially discards the excessively bright and excessively dark portions, and attempts to put together a pleasing final product. Because the camera needs to process the three images into one, it's best to use a tripod, though you may have reasonable success if you hold the camera very steady and the lighting is bright enough that a fast shutter speed will be used, to avoid blur from camera movement. It's also recommended that you disable image stabilization, which could interfere with the camera's ability to process the three images properly.

■ **Nostalgic.** This setting lets you ramp down the saturation of the colors in your images, giving the appearance of a faded, antique photograph. When you select this option, the camera puts a message on the LCD advising you to turn the front dial to "age your pictures." If you then turn that dial to the right, the saturation of the colors will decrease. If you dial in all five of the available increments, the image will be black-and-white, and four increments will be almost completely drained of color. I find that three levels on the dial yields a noticeable, but not overwhelming, fading effect.

■ **Fish-eye Effect.** This setting simulates the bulging, distorted view produced by an extreme wide-angle "fish-eye" lens. This is an interesting effect, and is worth playing around with to see if you find it can be of use, or of entertainment value in some situations. Here again, as with the Nostalgic effect, you can select the intensity of the alteration of the image. If you press the DISP. button, you can then use the left/right cursor buttons or the control dial to set the level of the fish-eye effect to Off, Low, Medium, or High. You can see the effect of the setting on the LCD before you snap the shutter, to evaluate how high you want to set it. Note that, if you want to achieve a fish-eye effect without using a fish-eye lens, another way to do so is in post-processing software. For example, in Photoshop you can simulate a fish-eye effect for any image using the command Filter-Distort-Spherize.

■ **Miniature Effect.** This option produces another interesting effect, along the lines of an optical illusion. The idea here is that you take a photo of a "real" subject, such as a full-sized house, but the camera blurs the image at the top and bottom, so that the final image looks like a photo of a miniaturized model of a house. When you're aiming at the subject, press the Display button to activate the white frame on the screen, then use the zoom lever and the cursor buttons to enlarge or contract the frame and move it around, so you can choose how much of the middle of the image is kept sharp and un-blurred. This illusion works because photos of models are taken with the camera close to the subject, which makes the depth-of-field quite narrow, so it is difficult to have the entire model in focus. The blurring at the top and bottom of the image simulate this effect, so the eye is tricked into thinking it's actually looking at a model. Now, when and why would you want to use this effect? I haven't yet figured that out, unless it's just included as a neat effect to impress your friends.

- **Beach.** This setting provides properly exposed human subjects against a bright background of water, sand, and reflected sunlight. The metering mode is set to Evaluative.

- **Underwater.** This setting is intended specifically for use under the surface with the optional Canon Waterproof Case WP-DC-34. It sets the white balance to the **Underwater** setting to remove bluish color casts, and reduces the intensity of the flash.

- **Foliage.** Another saturation-rich setting for shooting trees and leaves, with emphasis on bright and vivid greens.

- **Snow.** Like **Beach**, this setting properly exposes people and other subjects, despite glaring ice and snow, while removing the blue tinge often caused by snow backgrounds.

- **Fireworks.** Offers vivid photos of fireworks with a multi-second exposure to capture an entire burst. You should set the camera firmly on a tripod and turn image stabilization off. The flash is forced off and cannot be turned on.

- **Stitch Assist 1 and 2.** These two settings (one for left-to-right shots and the other for right-to-left) are set up to help you take two or more overlapping images, as many as 26 in all, that are later merged to create a seamless panorama on your computer with the supplied PhotoStitch program.

Low Light Mode

This mode is considered significant enough to be given its very own spot on the mode dial. This option gives you a tool for shooting in some seriously dark locations, such as candle-lit settings and other places with very little ambient light (see Figure 5.16), without using flash. The camera sets itself to a relatively slow shutter speed and to an impressively high ISO setting as necessary to achieve a proper exposure. The ISO setting is the distinguishing factor with this mode, because that setting can go higher in Low Light mode than you can set it from the ISO dial. If you use the physical ISO dial, the highest ISO setting available is 3200, whereas, with this special mode, the camera can set the ISO as high as 12,800. You can set the ISO to Auto in this mode, or you can set it yourself to any numerical value up to 12,800. To do this, press the FUNC./SET button, which brings up a special ISO menu. Use the control dial or the left/right cursor buttons to move the pointer along the ISO scale to your desired value. The camera will still allow you to set the flash on automatic when you're shooting in Low Light mode, but you may want to turn the flash completely off if you're really trying to take an available-light shot in very low light. You also should note that the camera automatically sets the image size to M (1,824 × 1,368 pixels, or 2.5 megapixels) in this mode.

Figure 5.16
The image shown here was taken outdoors in a dimly lit plaza in Low Light mode with the PowerShot G12 handheld; the camera set itself to ISO 3200.

Quick Shot Mode

This mode, another special setting with its own place on the shooting mode dial, offers a dramatically different shooting experience from the other shooting modes on this camera. Its icon on the dial is an image of a camera with speed lines trailing it. This mode is designed for use by the photographer who needs to snap photos very quickly, with no time to stop for elaborate compositions, or even to check the scene in the LCD display before snapping the shutter. The camera sets itself to use Evaluative metering and Continuous AF with AF Frame set to Face AiAF; you can't change these settings, though you can adjust exposure compensation and ISO. You can shoot in RAW quality if you want, and you can turn on continuous shooting.

When you turn the dial to Quick Shot mode, the LCD display stops displaying the image seen by the lens, and switches to an information-only screen that shows several of the camera's settings. Before you press the shutter button halfway to check exposure, the screen shows settings including exposure compensation, ISO value, flash exposure compensation, flash status (auto, on, slow synchro, off), i-Contrast, white balance, My Colors, image size and quality, drive mode, self-timer, aspect ratio, and a brightness histogram. Once you press the shutter button halfway to check the exposure, the display shows the selected shutter speed, aperture, and ISO (which may have been set to Auto, so no numerical value was displayed earlier) (see Figure 5.17). You will hear the

Figure 5.17
In Quick Shot mode, the PowerShot G12's screen shows only the camera's settings, not the scene itself. The shutter speed and aperture values appear when the shutter button is pressed halfway to evaluate the exposure.

constant sound of the Continuous AF system adjusting the focus. You can change any of the settings shown quickly; just press the FUNC./SET button and scroll through the settings with the control dial or the cursor buttons; when you reach one you want to adjust, use the front dial to make the adjustment. (For exposure compensation and ISO, though, you need to use the dedicated dials on top of the camera to make adjustments.) Using Quick Shot mode depletes the battery much more rapidly than normal because the camera constantly adjusts focus and exposure. You can save some power by turning off the screen display when not shooting; to blank the display, press the DISP. button when no adjustments are being made.

The overall idea for this mode is that you will quickly check and adjust your settings on the highly readable information screen, and hold the camera's optical viewfinder up to your eye to quickly compose and snap each shot. The camera is set up for quick action in a setting such as that of a fast breaking news event, or perhaps for tracking small children and pets at play. It may take some time with this mode to get used to having no image shown on the LCD screen before shooting, but if the mode's attributes work for you, it can't hurt to have this setup available.

Adjusting Exposure with ISO Settings

Another important tool for achieving good exposure is the camera's capability for changing the ISO sensitivity setting. Sometimes photographers forget about this option, because the common practice is to set the ISO once for a particular shooting session (say, at ISO 100 or 200 for bright sunlight outdoors, or ISO 800 when shooting indoors) and then forget about ISO. ISOs higher than ISO 100 or 200 are seen as "bad" or "necessary evils." However, changing the ISO is a valid way of adjusting exposure settings, particularly with the Canon PowerShot G12, which produces good results at ISO settings that create grainy, unusable pictures with some other camera models.

Indeed, I find myself using ISO adjustment as a convenient alternate way of adding or subtracting EV when shooting in Manual mode, and as a quick way of choosing equivalent exposures when in automatic or semiautomatic modes. For example, suppose I've selected a manual exposure with both f/stop and shutter speed suitable for my image using, say, ISO 200. I can change the exposure in full-stop increments by turning the ISO dial one click at a time. The difference in image quality/noise at the base setting of ISO 200 is negligible if I dial in ISO 100 to reduce exposure a little, or change to ISO 400 to increase exposure. I keep my preferred f/stop and shutter speed, but still adjust the exposure.

Or, perhaps, I am using Tv mode and the metered exposure at ISO 200 is 1/500th second at f/8. If I decide on the spur of the moment I'd rather use 1/500th second at f/5.6, I can rotate the ISO dial to switch to ISO 100. Of course, it's a good idea to monitor

your ISO changes, so you don't end up at ISO 3200 accidentally. ISO settings can, of course, also be used to boost or reduce sensitivity in particular shooting situations. The PowerShot G12 has direct ISO settings from 80 to 3200. It can go as high as ISO 12,800 with the Low Light mode (at reduced resolution), discussed earlier, although you can't make that setting with the ISO dial.

The G12 can also adjust the ISO automatically as appropriate for various lighting conditions. When you choose the Auto ISO setting, the camera adjusts the sensitivity dynamically to suit the subject matter. Remember that if the Auto ISO ranges aren't suitable for you, individual ISO values can also be selected in any of the more advanced shooting modes (Av, Tv, P, and Manual, as well as Quick Shot). However, there is one somewhat confusing aspect of the ISO settings on the PowerShot G12 that you should be aware of. Even though the camera is equipped with an ISO dial, which you can turn to any setting you want at any time, in some cases what looks like a legitimate setting will have no effect. In other words, the camera can't stop you from turning the dial so it looks as if the ISO is set to, say, 100, but it *can* keep that setting from taking effect. For example, in Manual exposure mode, you cannot set the ISO to Auto. Go ahead and try this if you want—set the camera to Manual exposure, then turn the ISO dial to Auto. You will see the word Auto, slightly grayed out, outlined briefly on the LCD screen by the ISO selector. But, you will then see that the camera has set the ISO to 80. There will not be any warning message, and, in fact, at first I thought that the Auto ISO system had chosen 80 as the correct value. I soon realized, though, that the camera is just refusing to accept Auto as the ISO setting. You can set the ISO to any numerical value you want in Manual mode, just not to Auto ISO.

Similarly, with any of the SCN mode varieties (Portrait, Sports, Beach, Posterization, HDR, Fireworks, etc.), the only ISO setting the camera will accept is Auto, no matter where you set the ISO dial. Here, again, you can turn the ISO dial all you want, and you will see the numbers change, but when the dust settles, the camera will rather stubbornly leave the ISO setting at Auto, with no warning or explanation.

Bracketing

Bracketing is a method for shooting several consecutive exposures using different settings, as a way of improving the odds that one will be exactly right. Before digital cameras took over the universe, it was common to bracket exposures, shooting, say, a series of three photos at 1/125th second, but varying the f/stop from f/8 to f/11 to f/16. In practice, smaller than whole-stop increments were used for greater precision. Plus, it was just as common to keep the same aperture and vary the shutter speed, although in the days before electronic shutters, film cameras often had only whole increment shutter speeds available.

Today, cameras like the PowerShot G12 can bracket exposures much more precisely, taking three shots immediately at the press of the shutter release, and bracket focusing as well. While focus bracketing is sometimes used when there is a tricky situation involving manual focus, auto exposure bracketing (AEB) is used much more often. When this feature is activated, the camera takes three consecutive photos: one at the metered "correct" exposure, one with less exposure, and one with more exposure, using an increment of your choice up to plus 2/minus 2 stops. The procedure for setting up exposure bracketing is discussed in Chapter 4, in connection with the FUNC. menu.

Basically, you press the FUNC./SET key, scroll down to the fourth option, which is bracketing, scroll over to the right to select exposure bracketing, and press the DISP. key to get to the screen where you set the exposure interval. One key point you need to bear in mind, which the camera does not warn you about: you need to have the flash turned off for bracketing to work. So, if you have carefully set up exposure (or focus) bracketing to take three exposures at a set interval, and then press the shutter button, but hear and see only one picture taken, you may have the flash set to Auto or On. You need to force the flash off for bracketing to work.

Be sure to turn bracketing off when you're done with that feature. Bracketing is available only in P, Av, Tv, and M modes, though exposure bracketing is not available in M mode. Once bracketing is turned on, it remains in effect after the first set of three images is taken, and the setting will continue to be in effect even after the camera has been turned off and then back on, until you turn the electronic flash back on, or return to the FUNC. menu to cancel bracketing. (If you turn the flash back on, you can't use bracketing while the flash is on, but bracketing will still be in effect if you then turn the flash back off. You have to use the FUNC. menu to fully cancel the bracketing setting.)

Bracketing and Merge to HDR

HDR (High Dynamic Range) photography is, at the moment, an incredibly popular fad. There are entire books that do nothing but tell you how to shoot and process HDR images. If you aren't familiar with the technique, HDR involves shooting two or three or more images at different bracketed exposures, giving you an "underexposed" version with lots of detail in highlights that would otherwise be washed out; an "overexposed" rendition that preserves detail in the shadows; and several intermediate shots. These are combined to produce a single image that has an amazing amount of detail throughout the scene's entire tonal range.

I call this technique a fad because the reason it exists in the first place is due to a (temporary, I hope) defect in current digital camera sensors. It's presently impossible to capture the full range of brightness that we perceive; digital cameras, including the PowerShot G12, can't even grab the full range of brightness that *film* can see, as I showed you in Figures 5.1 and 5.2 at the beginning of this chapter.

But as the megapixel race slows down, sensor designers have already begun designing capture electronics that have larger density (dynamic) ranges, and I fully expect to see cameras within a few years that can produce images similar to what we're getting now with HDR manipulation in image editors.

HDR works like this: Suppose you wanted to photograph a dimly lit room that had a bright window showing an outdoors scene. Proper exposure for the room might be on the order of 1/60th second at f/2.8 at ISO 200, while the outdoors scene probably would require f/11 at 1/400th second. That's almost a 7 EV step difference (approximately 7 f/stops) and well beyond the dynamic range of any digital camera, including the PowerShot G12.

When you're using Merge to HDR, a feature found in Adobe Photoshop (similar functions are available in other programs, including Photomatix [www.hdrsoft.com; free to try, $99 to buy]), you'd take several pictures. As I mentioned earlier, one would be exposed for the shadows, one for the highlights, and perhaps one for the midtones. Then, you'd use the Merge to HDR command (or the equivalent in other software) to combine all of the images into one HDR image that integrates the well-exposed sections of each version. You can use the PowerShot G12's exposure bracketing feature to produce those images.

The images should be as identical as possible, except for exposure. So, it's a good idea to mount the camera on a tripod, use a remote release (or the self-timer), and take all the exposures in one burst. Just follow these steps:

1. **Set up your camera on a sturdy support.** Mount the PowerShot G12 on a tripod and connect a remote release switch (such as the optional Canon RS60-E3), if available. If a remote is not available, set the self-timer to a delay of several seconds.

2. **Specify RAW.** Set the camera to shoot RAW images, as described in Chapter 4.

3. **Choose bracketing.** Set exposure bracketing to a two-stop increment, as described earlier in this chapter and in Chapter 4.

4. **Focus.** Manually focus or autofocus the camera.

5. **Take your shots.** Trigger the camera to expose your set of three images.

6. **Process the photos.** Copy your images to your computer and continue in Photoshop with the Merge to HDR steps listed next.

The next steps show you how to combine the separate exposures into one merged High Dynamic Range image. The sample images shown in Figures 5.18, 5.19, and 5.21 show the results you can get from a two-shot bracketed sequence. I merged only two pictures for simplicity, because the differences between three or more bracketed exposures, even when taken at exposures that are two stops apart, may not show up well on the printed page.

1. If you use an application to transfer the files to your computer, make sure it does not make any adjustments to brightness, contrast, or exposure. You want the real RAW information for Merge to HDR to work with. If you do everything correctly, you'll end up with at least two photos like the ones shown in Figures 5.18 and 5.19.

2. Load the images into Photoshop using your preferred RAW converter.

3. Save as .PSD files.

4. Activate Merge to HDR by choosing File > Automate > Merge to HDR.

5. Select the photos to be merged, as shown in Figure 5.20, where I have specified the two PSD files. You'll note a checkbox that can be used to automatically align the images if they were not taken with the camera mounted on a rock-steady support.

6. Once HDR merge has done its thing, you must save in the .PSD (Photoshop) file format, to retain the file's full color information, in case you want to work with the HDR image later. Otherwise, you can convert to a normal 24-bit file and save in any compatible format.

Figure 5.18 Make one exposure for the shadow areas.

Figure 5.19 Make a second exposure for the highlights, such as the sky.

Figure 5.20 Use the Merge to HDR command to combine the two images.

If you do everything correctly, you'll end up with a photo like the one shown in Figure 5.21, which has the properly exposed foreground of the first shot, and the well-exposed sky of the second image. Note that, ideally, nothing should move between shots. In the example pictures, the river is moving, but the exposures were made so close together that, after the merger, you can't really tell.

Figure 5.21
You'll end up with an extended dynamic range photo like this one.

What if you don't have the opportunity, inclination, or skills to create several images at different exposures, as described? If you shoot in RAW format, you can still use Merge to HDR, working with a *single* original image file. What you do is import the image into Photoshop several times, using Adobe Camera Raw to create multiple copies of the file at different exposure levels.

For example, you'd create one copy that's too dark, so the shadows lose detail, but the highlights are preserved. Create another copy with the shadows intact and allow the highlights to wash out. Then, you can use Merge to HDR to combine the two and end up with a finished image that has the extended dynamic range you're looking for.

Dealing with Noise

Image noise is that random grainy effect that some like to use as a visual effect, but which, most of the time, is objectionable because it robs your image of detail even as it adds that "interesting" texture. Noise is caused by two different conditions: high ISO settings and long exposures.

High ISO noise commonly appears when you raise your camera's sensitivity setting above ISO 400. With the Canon G12 camera, noise may become visible at ISO 800, and is usually fairly noticeable at ISO 1600. This kind of noise appears as a result of the amplification needed to increase the sensitivity of the sensor. While higher ISOs do pull details out of dark areas, they also amplify non-signal information randomly, creating noise.

A similar noisy phenomenon occurs during long time exposures, which allow more photons to reach the sensor, increasing your ability to capture a picture under low light conditions. However, the longer exposures also increase the likelihood that some pixels will register random phantom photons, often because the longer an imager is "hot" the warmer it gets, and that heat can be mistaken for photons.

Fortunately, Canon's electronics geniuses have done a good job minimizing noise from all causes in the PowerShot G12. When the camera takes an exposure of longer than one second, you will notice a delay after the image is taken, while the camera uses its noise-reduction circuitry to minimize the visual noise in the image. It also processes high-ISO shots to reduce noise. However, there are no noise-related settings you can adjust yourself on the G12. You can apply noise reduction to some extent using Photoshop or similar software, and when converting RAW files to some other format, using your favorite RAW converter, or an industrial-strength product like Noise Ninja (www.picturecode.com) to wipe out noise after you've already taken the picture.

Fixing Exposures with Histograms

While you can often recover poorly exposed photos in your image editor, your best bet is to arrive at the correct exposure in the camera, minimizing the tweaks that you have to make in post-processing. However, you can't always judge exposure just by viewing the image on your PowerShot G12's LCD before or after the shot is made. Ambient light may make the LCD difficult to see, and the brightness level you've set can affect the appearance of the playback image.

Instead, you can use a histogram, which is a chart displayed on the PowerShot G12's LCD that shows the number of tones being captured at each brightness level. You can use the information to provide correction for the shot you are about to take, or for the next shot you take. The G12 offers a histogram that shows overall brightness levels for an image, which can be displayed during shooting mode or playback mode.

A brightness histogram like that used in the PowerShot G12 is a chart that includes a representation of up to 256 vertical lines on a horizontal axis that show the number of pixels in the image at each brightness level, from 0 (black) on the left side to 255 (white) on the right. (The 2.8-inch LCD of this PowerShot model doesn't have enough pixels to show each and every one of the 256 lines, but, instead, provides a representation of the shape of the curve formed.) The more pixels at a given level, the taller the bar at that position. If no bar appears at a particular position on the scale from left to right, there are no pixels at that particular brightness level.

DISPLAYING HISTOGRAMS

To view histograms on your screen, press the DISP. button while an image is shown on the LCD, either before shooting or during playback. Keep pressing the button until the histogram is shown. The display will cycle between several levels of information, one of which will include the histogram. If you don't see the histogram while in shooting mode, go to **Custom Display** on the Shooting menu and change that setting so that histograms will be displayed. The histogram will display only in Program, Shutter priority, Aperture priority, Manual, and Quick Shot shooting modes. (It will display in Quick Shot mode even if you have turned it off on the Custom Display menu.) You also can display the histogram on the review image that displays right after you have taken a picture. Set that option by choosing **Review Info** from the Shooting menu, and then selecting **Detailed**. The histogram always displays on the detailed screen in playback mode. If you press the top cursor button while the histogram is displayed in playback mode, an RGB histogram appears, presenting the brightness graphs for the three component colors of the image. Press that button again to go back to the normal screen. In addition, on the detailed playback screen, any overexposed areas of the thumbnail image will blink to warn you that the highlights may be blown out.

A typical histogram produces a mountain-like shape, with most of the pixels bunched in the middle tones, with fewer pixels at the dark and light ends of the scale. Ideally, though, there will be at least some pixels at either extreme, so that your image has both a true black and a true white representing some details. Learn to spot histograms that represent over- and underexposure, and add or subtract exposure using an EV modification to compensate.

For example, Figure 5.22 shows the histogram for an image that is badly underexposed. You can guess from the shape of the histogram that many of the dark tones to the left of the graph have been clipped off. There's plenty of room on the right side for additional pixels to reside without having them become overexposed. Or, a histogram might look like Figure 5.23, which is overexposed. In either case, you can increase or decrease the exposure (either by changing the f/stop or shutter speed in Manual mode or by adding or subtracting an EV value in Program mode) to produce the corrected histogram shown in Figure 5.24, in which the tones "hug" the right side of the histogram to produce as many highlight details as possible. See "Making EV Changes," earlier in this chapter for information on dialing in exposure compensation.

Figure 5.22
This histogram shows an underexposed image.

Figure 5.23
This histogram reveals that the image is over-exposed.

Figure 5.24
A histogram for a properly exposed image should look like this.

The histogram can also be used to aid in fixing the contrast of an image, although gauging incorrect contrast is more difficult. For example, if the histogram shows all the tones bunched up in one place in the image, the photo will be low in contrast. If the tones are spread out more or less evenly, the image is probably high in contrast. In either case, your best bet may be to switch to RAW (if you're not already using that format) so you can adjust contrast in post processing. However, you can also change to a user-defined setting using the **My Colors** feature (not available when shooting RAW), with contrast set lower or higher as required.

Advanced Shooting and Movie Making with Your Canon PowerShot G12

Getting the right exposure is one of the foundations of a great photograph, but a lot more goes into a compelling shot than good tonal values. A sharp image, proper white balance, good color, and other factors all can help elevate your image from good to exceptional. So, now that you've got a good understanding of exposure tucked away, you'll want to learn how to use the automatic and manual focusing controls available with the Canon PowerShot G12, and master some of the many ways you can fine-tune your images. We'll also discuss some creative ways to use exposure, including using very short or long exposures, and we'll look at techniques to improve your movie-making with this camera.

Getting into Focus

Learning to use the Canon PowerShot G12's autofocus system is easy, but you do need to fully understand how the system works to get the most benefit from it. Once you're comfortable with autofocus, you'll know when it's appropriate to use the Manual focus option, too. The important thing to remember is that focus isn't absolute. For example, some things that appear to be in sharp focus at a given viewing size and distance might not be in focus at a larger size and/or closer distance. In addition, the goal of optimum focus isn't always to make things look sharp. Not all of an image will be or should be

sharp. Controlling exactly what is sharp and what is not is part of your creative palette. Use of depth-of-field characteristics to throw part of an image out of focus while other parts are sharply focused, particularly when shooting close-up photos, is one of the most valuable tools available to a photographer. But selective focus works only when the desired areas of an image are in focus properly. For the digital camera photographer, correct focus can be one of the trickiest parts of the technical and creative process.

Your camera's autofocus sensors require a certain minimum amount of light to operate. If necessary, the AF assist beam built into the PowerShot G12 and Canon's dedicated flash units provide additional light that helps assure enough illumination for autofocus.

Focus Modes and Options

As you've come to appreciate by now, the PowerShot G12 offers many options for how it approaches photography. Focus is no exception. Of course, as with other aspects of this camera, you can set the shooting mode to Auto, and the camera will do just fine in its focusing in most situations. (Actually, the G12 will still let you choose some auto-focus options, such as Face Detect, even if the shooting mode is Auto.) But, if you want more creative control, the choices are there for you to make. The PowerShot's focus options actually provide you with more choices than any other aspect of the camera's operation.

Assuming you're not going to set the shooting mode to Auto, your first choice is whether to use autofocus or manual focus. (Manual focus is not available in Quick Shot, and some Scene modes, such as Fireworks.) Manual focus, of course, was the only choice available to photographers from the nineteenth century days of Daguerreotypes until about the 1980s, when autofocus started becoming available. Manual focus presents you with great flexibility along with the challenge of keeping the image in focus under what may be challenging conditions, such as rapid motion of the subject, darkness of the scene, and the like. We'll talk more about manual focus later in this chapter. For now, we'll assume you're going to rely on the camera's AF capabilities.

The PowerShot G12 has two basic AF modes: One Shot AF (also known as Single Autofocus) and Continuous AF. Oddly enough, what Canon calls One Shot AF with its digital SLR cameras is actually just Continuous AF (Off) with the G12; when you turn off Continuous AF, the camera switches to One Shot mode. Beyond those two basic modes, there is a more specialized mode called Servo AF that is designed for one particular type of situation. Once you have decided on which AF mode to use, you also need to tell the camera how to set the AF Frame. In other words, after you tell the camera how to autofocus, you also have to tell it where to direct its focusing attention. I'll explain each of the three focus modes, and other aspects of focus in more detail later in this section.

MANUAL FOCUS

With manual focus activated by pressing the up cross key, your PowerShot G12 lets you set the focus yourself by turning the control dial. There are some advantages and disadvantages to this approach. While your batteries will last slightly longer in manual focus mode, it will take you longer to focus the camera for each photo, a process that can be tricky. Modern digital cameras depend so much on autofocus that the viewfinders are no longer designed for optimum manual focus. The optical viewfinder on your PowerShot, for example, can't be used for manual focusing at all—you must rely on the view (magnified or otherwise) on the LCD. So, although manual focus is still an option for you to consider in certain circumstances, it's not as easy to use as it once was. I recommend that you try to use the camera's various AF options first, and switch to manual focus only if AF is not working for you.

Focus Pocus

Although Canon began adding autofocus capabilities to its film cameras in the 1980s, prior to that focusing was always done manually. Honest. Imagine what it must have been like to focus manually under demanding, fast-moving conditions such as sports photography.

Focusing was problematic because our eyes and brains have poor memory for correct focus, which is why your eye doctor must shift back and forth between sets of lenses and ask "Does that look sharper—or was it sharper before?" in determining your correct prescription. Similarly, manual focusing involves jogging the focus ring back and forth as you go from almost in focus, to sharp focus, to almost focused again. The little clockwise and counterclockwise arcs decrease in size until you've zeroed in on the point of correct focus. What you're looking for is the image with the most contrast between the edges of elements in the image.

The PowerShot G12's autofocus mechanism, like all such systems found in modern digital cameras, also evaluates these increases and decreases in sharpness, but it is able to remember the progression perfectly, so that autofocus can lock in much more quickly and, with an image that has sufficient contrast, more precisely. Unfortunately, while the PowerShot's focus system finds it easy to measure degrees of apparent focus at each of the focus points in the viewfinder, it doesn't really know with any certainty *which* object should be in sharpest focus. Is it the closest object? The subject in the center? Something lurking *behind* the closest subject? A person standing over at the side of the picture? Many of the techniques for using autofocus effectively involve telling the PowerShot G12 exactly what it should be focusing on.

Adding Circles of Confusion

But there are other factors in play, as well. You know that increased depth-of-field brings more of your subject into focus. But more depth-of-field also makes autofocusing (or manual focusing) more difficult because the contrast is lower between objects at different distances. So, autofocus with the camera's lens set to its maximum 140mm focal length may be easier than at the minimum 28mm focal length (or zoom setting), because at the longer focal length the lens has less apparent depth-of-field.

To make things even more complicated, many subjects aren't polite enough to remain still. They move around in the frame, so that even if the PowerShot is sharply focused on your main subject, the subject may change position and require refocusing. An intervening subject may pop into the frame and pass between you and the subject you meant to photograph. You (or the PowerShot) have to decide whether to lock focus on this new subject, or remain focused on the original subject. Finally, there are some kinds of subjects that are difficult to bring into sharp focus because they lack enough contrast to allow the PowerShot's AF system (or our eyes) to lock in. Blank walls, a clear blue sky, or other subject matter may make focusing difficult.

If you find all these focus factors confusing, you're on the right track. Focus is, in fact, measured using something called a *circle of confusion*. An ideal image consists of zillions of tiny little points, which, like all points, theoretically have no height or width. There is perfect contrast between the point and its surroundings. You can think of each point as a pinpoint of light in a darkened room. When a given point is out of focus, its edges decrease in contrast and it changes from a perfect point to a tiny disc with blurry edges (remember, blur is the lack of contrast between boundaries in an image). (See Figure 6.1.)

If this blurry disc—the circle of confusion—is small enough, our eye still perceives it as a point. It's only when the disc grows large enough that we can see it as a blur rather than a sharp point that a given point is viewed as out of focus. You can see, then, that enlarging an image, either by displaying it larger on your computer monitor or by

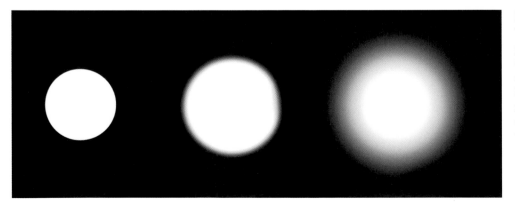

Figure 6.1
When a pinpoint of light (left) goes out of focus, its blurry edges form a circle of confusion (center and right).

making a large print, also enlarges the size of each circle of confusion. Moving closer to the image does the same thing. So, parts of an image that may look perfectly sharp in a 5 × 7-inch print viewed at arm's length, might appear blurry when blown up to 11 × 14 and examined at the same distance. Take a few steps back, however, and the image may look sharp again.

To a lesser extent, the viewer also affects the apparent size of these circles of confusion. Some people see details better at a given distance and may perceive smaller circles of confusion than someone standing next to them. For the most part, however, such differences are small. Truly blurry images will look blurry to just about everyone under the same conditions.

Technically, there is just one plane within your picture area, parallel to the back of the camera (or sensor, in the case of a digital camera), that is in sharp focus. That's the plane in which the points of the image are rendered as precise points. At every other plane in front of or behind the focus plane, the points show up as discs that range from slightly blurry to extremely blurry. (See Figure 6.2.) In practice, the discs in many of these planes

Figure 6.2
The model is in focus, but the area behind her appears blurry because the depth-of-field is limited.

will still be so small that we see them as points, and that's where we get depth-of-field. Depth-of-field is just the range of planes that includes discs that we perceive as points rather than blurred splotches. The size of this range increases as the aperture is reduced in size and is allocated roughly one-third in front of the plane of sharpest focus, and two-thirds behind it. The range of sharp focus is always greater behind your subject than in front of it.

Using Manual Focus

As I noted earlier, manual focus is not as attractive an option nowadays as it used to be when cameras were designed for that method of focusing and were equipped with readily visible focusing aids. But Canon's designers have done a good job of letting you exercise your initiative in the focusing realm, so you certainly should become familiar with the technique for those occasions when it makes sense to take control in this area. Here are the basic steps:

- **Select a shooting mode other than Auto, Quick Shot, or Fireworks/Sports Scene modes.** If you set the mode to Auto, you'll be pressing the MF button in vain; it just won't respond, because manual focus is not available in that mode.

- **Press the MF button (top cross key).** The large letters MF will appear on the screen, then fade to a small icon at the top right of the screen. An abbreviated focus scale appears on the right side of the LCD with 2 feet, 5 feet, 10 feet, and infinity marked.

- **Aim at your subject and turn the control dial to focus.** The focusing block in the center of the screen will enlarge to help you assess whether the image is in focus. (That is, unless you turned off this feature, called **MF-point Zoom**, through the Shooting menu.) Turn the dial until the subject appears to be in the sharpest possible focus. Be careful when turning the control dial. It's all too easy to hit a cross key by mistake when rotating.

- **Use the Safety MF feature to fine-tune the focus.** After you have made your focus adjustments with the control dial, you can press either the shutter button or the AF Frame/Trash button to "fine-tune" the focus. Actually, this just means that after going through all the trouble of using manual focus, you're going to punt and use autofocus after all, which may seem a bit strange. But, in some circumstances this could be a useful procedure, because you are getting the focus system started by showing it exactly where to focus, then letting it finish up the process. It also may help you get used to the manual focus procedure by practicing and comparing your results to those of the autofocus mechanism. This **Safety MF** feature is not available if you turn it off through the Shooting menu.

- **If your subject is a particular, small area of the overall scene, set the camera to single-shot AF** (which, on the G12, is **Continuous AF off**), and set the AF Frame to FlexiZone. Use the AF Frame entry in the Shooting menu to switch to Flexizone, and then set the focus frame to its smallest size and move it over the area of the scene that needs to be in sharpest focus.

Hyperfocal Distance—A Tool for Quick Candid Shots

There is one somewhat specialized area in which you might want to consider a particular advantage of using manual focus—to grab quick shots without using any of the autofocus options at all, and without having to manually focus the camera. In effect, this technique lets you convert your sophisticated autofocusing camera into something like a Kodak Brownie from days of old—a box camera that shoots with a fixed focus, but still manages to take quite presentable pictures.

The key here is to use manual focus, and preset it to what is called the camera's *hyperfocal distance*, which is defined as the focusing distance at which everything from half that distance to infinity will appear to be in sharp focus. Note that I say things will "appear" to be in sharp focus. As I discussed earlier in this chapter, there is only one mathematical plane in which images will actually be in perfectly sharp focus for a given lens, taking into account factors such as focal length and aperture. However, because of our old friends the circles of confusion, even though images may not be in perfect focus, if those circles are small enough, they will still appear to be in sharp enough focus to pass our visual inspection.

If you aspire to what some call "street photography"—snapping candid shots of people and other subjects on city streets (or in other public locations) when you see something that catches your eye, you may want to try this technique. With the camera's focus preset, you don't have to fiddle with any controls or settings; you can just fire away at anything that catches your interest within the zone of sharp focus. There are many varied approaches taken by different photographers in this area, and you will need to experiment to find a system that works for you. Following is one possible way to set up the PowerShot G12 for quick, candid shots using the hyperfocal distance:

- **Set up the camera's other shooting options.** I suggest setting the shooting mode to Aperture priority (Av) and using as small an aperture as you can manage, given the prevailing lighting conditions. Try to use at least f/4.5 to widen the depth-of-field. I suggest using Evaluative exposure metering, auto white balance, and RAW + L image size and quality to leave your options open for post-processing. Set the flash to forced off. Set continuous shooting on, so you can snap lots of shots when the right moment comes. You may want to turn off the camera's operational sounds to avoid attracting attention. With the PowerShot G12, consider using the swivel screen at an angle so you don't have to face in the direction you're shooting.

- **Set the camera to manual focus at the hyperfocal distance.** This step requires that you do some homework before you go out on your candid shooting expedition. You can go to www.dofmaster.com to find tools to calculate the camera's hyperfocal distance. You have to base the calculation on the actual focal length of the camera's lens. In our case, although the 35mm equivalent focal length of the PowerShot G12's lens at its wide-angle setting is 28mm, its actual focal length (marked on the lens) is 6.1mm. Using that value, and f/4.5 as our aperture, the answer is that the hyperfocal distance for the PowerShot's lens is 3.9 feet. This means that, if you set the camera's manual focus to 3.9 feet and leave it there, everything you shoot, from a distance of about 2 feet (half of 3.9 feet) to infinity will appear sharp, as long as you're using the full wide-angle setting for your lens. Of course, the PowerShot camera does not have a focusing scale that shows exactly where 3.9 feet is. If you want to be as exact as possible, get a measuring tape and set the camera up exactly 3.9 feet from a subject, then adjust the Manual focus control until focus is sharp, and note exactly where the focusing bar reaches on the camera's scale.

- **Save all of these settings to C2.** Once all of the above settings are just the way you want them, choose Save Settings from the Shooting menu and save all of them to C2 on the mode dial. (I suggest C2 just because it's the last setting on the dial, and might be easier to turn to in a hurry than C1.)

- **When you see a likely subject, turn to C2 and fire away.** Try these settings for a while and check out the results. If they don't measure up, change various settings until you have created the perfect instrument for super street photography.

Your Autofocus Mode Options

Choosing the right autofocus mode and the way in which focus points are selected is your key to success. Using the wrong mode for a particular type of photography can lead to a series of pictures that are all sharply focused—on the wrong subject. When I first started shooting sports with an autofocus camera (back in the film camera days), I covered one baseball game alternating between shots of base runners and outfielders with pictures of a promising young pitcher, all from a position next to the third base dugout. The base runner and outfielder photos were great, because their backgrounds didn't distract the autofocus mechanism. But all my photos of the pitcher had the focus tightly zeroed in on the fans in the stands behind him. Because I was shooting with film instead of a digital camera, I didn't know about my gaffe until the film was developed. A simple change, such as locking in focus or focus zone manually, or even manually focusing, would have done the trick.

To save battery power, your PowerShot ordinarily doesn't start to focus the lens until you partially depress the shutter release. But, autofocus isn't some mindless beast out there snapping your pictures in and out of focus with no feedback from you after you press that button. There are several settings you can modify that return a fair amount

of control to you. Your first decision should be whether you set the PowerShot G12 to Continuous or Continuous Off (what the rest of the world calls One-Shot AF).

1. Press the MENU button and navigate to the Shooting menu.

2. Scroll to the entry called Continuous AF (shown in Figure 6.3).

3. Set AF Continuous AF to On or Off.

4. Press the MENU button again to exit.

Figure 6.3
Press the left/right cross keys until the AF choice you want is selected.

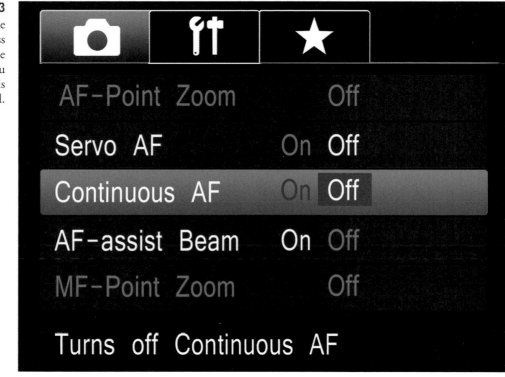

Here is what each of the available autofocus modes do:

Single Autofocus/Continuous AF Off

If you've elected to leave Continuous AF turned off, you'll be using the mode also called *Single Autofocus* by most of the universe. In this mode, focus is set when you press the shutter button halfway and remains locked at that focus setting until the button is fully depressed, taking the picture, or until you release the shutter button without taking a shot. For non-action photography, this option is usually your best choice, as it minimizes out-of-focus pictures, at the expense of spontaneity, because the camera will not take a picture at all while it is seeking focus. You're locked out of shooting until the autofocus mechanism is happy with the current focus setting. Continuous AF Off/One Shot

AF/Single Autofocus is sometimes referred to as *focus priority* for that reason. Because of the small delay while the camera zeroes in on correct focus, you might experience slightly more shutter lag. This mode uses less battery power than Continuous AF.

When sharp focus is achieved, the focus frame will turn green and you'll hear a little beep (assuming you have normal shooting and setup options enabled). By keeping the shutter button depressed halfway, you'll find you can reframe the image by moving the camera to aim at another angle while retaining the focus (and exposure) that's been set.

Continuous AF

Continuous AF is a mode you might want to use when photographing sports, young kids at play, and other fast-moving subjects. In this mode, the autofocus system continues to operate all the time, even when the shutter button is not depressed halfway. In other words, the camera always attempts to focus the image. When you use this mode, the camera will be ready to fine-tune its focus quickly once you decide on a final subject at which to aim the camera, because the focusing apparatus is doing its best to be ready for the current focusing conditions. Of course, this option drains battery power quite quickly, so turn it off unless you have a definite need for it (or have an endless supply of batteries). In addition, this option can have the drawback of the camera's switching its focus to any subject that enters the focus frame, thereby drawing the focus away from a subject you were interested in. That's where the next AF mode comes into play.

Servo AF

Servo AF is another option that can be turned on from the Shooting menu (see Figure 6.4) and can be used alone, or with Continuous AF activated. This option tells the camera to lock autofocus on the subject in the focus frame when you press the shutter release halfway, and then continue to keep that subject in focus, as long as it remains within the focus frame.

The focus frame in the center turns blue when you lock on to a subject in this way, and the camera will continue to lock its focus on the subject within that blue frame, as long as you are able to keep the subject in the focus frame. This option is designed for situations such as tracking a particular athlete at a sporting event, a particular performer at a concert, or a particular child racing around on a playground. This focus mode addresses the situation we just discussed in connection with Continuous AF mode, in which a new subject moves into the frame and steals the focus away from the subject you are most interested in, by ensuring that the subject you want to focus on stays in focus (as long as you keep it within the blue frame). Again, as with Continuous AF (which can be used at the same time as Servo AF), this option puts a strain on your battery supply, so preserve it for occasions when it is of definite use.

I know these three focus options can be confusing, so Table 6.1 is a summary of when to use each of them:

Figure 6.4
Select Servo AF from the Shooting menu when you want to keep the focus on a particular moving subject.

Table 6.1 Autofocus Modes		
Mode	**What It Does**	**When to Use**
Continuous AF Off (Single autofocus)	Locks focus only when shutter release is pressed halfway, and does not refocus if subject moves. Camera will shoot picture only when focus is achieved.	When shooting subjects that are not in motion, when you want to minimize number of out-of-focus shots.
Continuous AF	Tries to focus at all times, even before shutter release is pressed halfway. Camera will shoot picture even if focus is not achieved.	Moving subjects, when you want the camera to focus and refocus for a possible shot.

Table 6.1 Autofocus Modes (continued)

Mode	What It Does	When to Use
Servo AF	Locks focus on subject within focus frame when shutter release is pressed halfway, and refocuses if the subject moves but remains within the focus frame. Camera will shoot picture even if focus is not achieved.	Use when you want to lock focus on a particular subject that may be moving, and want the camera to ignore other moving objects that come into the frame *after* you've pressed the shutter release button halfway. Use with or without Continuous AF, so the camera will/will not also focus *before* pressing the shutter halfway.

Setting the AF Frame

You're not done yet with choosing the settings for autofocus on these PowerShot models. The settings already discussed—Continuous AF Off/Single-Shot AF, Continuous AF, Servo AF, and Manual focus, all tell the camera *how* to focus. But, with the AF modes, the camera needs to be told not only how to focus, but *where* to focus. That is the subject of our next discussion—telling the camera where to focus, by setting the options for the AF Frame. (This function is not available in Movie or Auto modes.)

The PowerShot G12 offers a fairly impressive array of autofocus frame options, which help you dictate exactly where in the scene the sharpest focus should be. To select the AF Frame mode, follow these steps:

1. Press the MENU button, navigate to the Shooting menu, select the top entry (**AF Frame**), and press the left/right cross keys to select from among the choices available with your current shooting mode. (With some modes, the choice will be either **On** or **Off**.) Press MENU again to exit.

 Or:

2. Press the AF Frame/Trash button on the back right of the camera, followed by the * button located to the right of the AF Frame button.

3. As you press the * button, the AF Frame mode cycles among the modes available using your current shooting mode setting. When you've selected the mode you want to use, press the AF Frame button again to confirm it. You can move the frame with the cross keys or the control dial.

With the G12, Canon has streamlined and consolidated the AF Frame choices somewhat. With this PowerShot model, the only two choices on the Shooting menu in most shooting modes are Face AiAF and FlexiZone.

■ **Face AiAF.** Face AiAF combines the functions of Face Detect and AiAF from earlier PowerShot cameras. The camera will display frames for up to nine detected faces. You can press the AF frame button to enter Face Select mode, in which the camera places a frame over what it believes to be the main subject, and up to two additional faces. (Similar to Figure 6.5.) You can move this frame to another face by pressing the AF frame button, and then pressing the left/right cross keys. Or, hold down the AF frame button again to deselect the face. Then take the picture.

In Auto shooting mode, only Face AiAF is available. In other shooting modes, if FlexiZone is selected, it is changed to Center if the LCD display is turned off. (That makes sense, because you would have a hard time moving the focus frame around the screen if you couldn't see the screen!)

■ **FlexiZone.** The AF Frame starts out as a rectangle in the center of the screen, but, after pressing the AF Frame button, you can change the frame's size to very small with the DISP. button. Press the DISP. button again to toggle back to the original size. You can move either size focus frame around the screen with the four cross keys or the control dial. (See Figure 6.6.) You can move the focus frame rapidly with the control or the front dial, or in finer steps with the four cursor buttons.

Figure 6.5
In Face Detect mode, the PowerShot will detect up to three faces, placing a white block around the main subject's face, and gray blocks around additional faces.

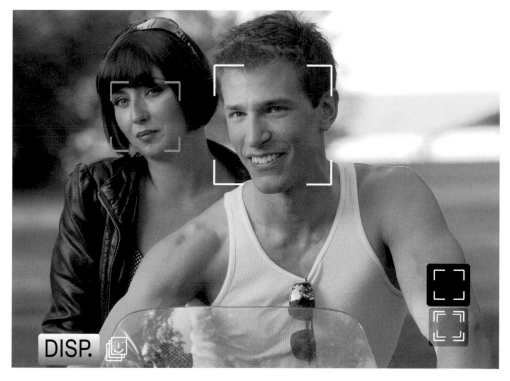

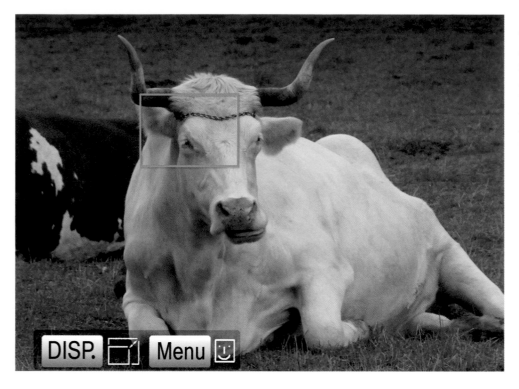

Figure 6.6
The FlexiZone autofocus frame can be moved around the screen and resized by pressing the DISP. button.

So, what should a photographer do when faced with all of these focusing options? Following are some general guidelines based on my own preferences. You very well may develop a different set of guidelines that are more suitable for your own situations.

- If you're taking casual snapshots or are in a hurry and don't have time to make detailed settings, set the shooting mode to Auto and the chances are very good that the pictures will be in focus.

- If your subject is an orderly group of people standing still, set the focus mode to Single-shot AF (Continuous AF off) and set the AF Frame to Face AiAF.

- If your subject is a general group of people, animals, or other objects in constant motion, set the camera to Continuous AF and set the AF Frame to Face AiAF.

- If your subject is a particular person or other object among a general group of people, animals, or objects in constant motion, set the camera to Continuous AF and to Servo AF; set the AF Frame to Face AiAF. Then aim the AF Frame at your particular subject using Tracking AF, and press the shutter button halfway, and keep the blue focus frame locked on your subject until you take the picture.

- If your subject is a particular, small area of the overall scene, set the camera to Single-shot AF (Continuous AF off), and set the AF Frame to FlexiZone. Then set the focus frame to its smallest size and move it over the area of the scene that needs to be in sharpest focus.

Locking Manual Focus

When you have composed your image and pressed the shutter button down halfway so that the camera's autofocus system has locked in its exposure and focus, press the MF button (up cross key). Now the MF icon and other information will appear on the screen, and the focus will be locked at this distance until you either take the picture or press the MF button again to release the lock. This procedure could be useful if you need to preset the focus distance for a subject that isn't available yet but will need to be shot quickly, and you know in advance at what distance it will be from the camera.

Macro Shooting

Shooting with the macro focusing option, which means shooting extreme close-ups, is an entire branch of photography in itself. The most serious practitioners of macro photography use highly specialized equipment, including special lenses, extension tubes, bellows, racks, tripods, lights, and on and on. But, with the PowerShot G12, you actually have an amazingly capable instrument for general macro photography, which can be of considerable use to you even if you don't join the ranks of the true macro-philes.

Although macro shooting is not something you're likely to do every day unless you're a coin collector, student of insects, or aficionado of other very small things, the chances are you will have some occasion to use the remarkable capabilities of the PowerShot G12 to focus down to a vanishingly small distance from your subject (see Figure 6.7).

Figure 6.7
These crayons were photographed from just three inches away.

Without the use of any add-on lenses or other extra equipment, the PowerShot G12 can focus down to 1 centimeter from the end of the lens—that is just four-tenths of an inch, or about the thickness of my little finger! And the camera can achieve this marvel of focusing while still using its various autofocus modes, though, of course, several of them (Face AiAF, Servo AF, etc.) would not be useful while shooting at that range, or anywhere close to it. Note that the 1-centimeter distance is available only when the PowerShot's lens is zoomed back to its wide-angle setting; when it's zoomed in to its full telephoto focal length of 120mm, the closest it can focus in macro mode is 30 centimeters (about 12 inches).

Before I detail the steps for successful use of the macro focusing mode, here are some ideas for how you might make use of it:

- Document the contents of coin and stamp collections, or collections of any small items.

- Take close-up shots of flowers and plants while they're in full bloom. Explore them in different lighting conditions and from various angles to uncover different aspects of their beauty.

- Get close enough to insects, reptiles, and other living creatures to capture their activities and appearances in documentary-like detail.

- Unleash your creative side by putting together elaborate (or simple) tabletop still-life tableaus in the spirit of Salvador Dali, or that are just fun to look at.

- Take sharply focused close-ups from various angles to illustrate items you are selling on eBay or other online auction sites.

- If you need a quick copy of a receipt, instruction sheet, check, or other document and don't have access to a copy machine, pull out your trusty PowerShot G12 and make a perfectly serviceable photographic copy. You can view the image on your camera's display (magnified to show details if need be), display it on a computer screen, send it by e-mail, or print it out.

Chances are there's something in that list that you may want to do at some point. So let's go through the steps that will accomplish a solid macro photograph. Of course, if you're in a hurry you won't have time to carry out all of these steps, but here's the full list for when you do have time:

1. Secure the camera firmly on a solid tripod. Turn Image Stabilization off.

2. Arrange for lighting that will not be blocked by the camera itself, which is likely to cast a shadow because of its extreme proximity to the subject.

3. Select a shooting mode that fits the situation at hand. Consider using Aperture priority and setting the aperture as small as possible with the lighting available, to achieve the greatest depth-of-field you can so as to keep the subject in sharp focus.

4. Turn Continuous AF off, so the camera focuses only once. In the alternative, use manual focus, with Safety MF turned on.

5. Set the AF Frame mode to FlexiZone and set the AF Frame to its smallest size.

6. Press the Macro button (left cross key) to engage Macro mode.

7. Press the AF Frame button, then press the DISP. button to make the frame as small as possible. Use the cross keys to move the AF Frame to cover the part of the subject that needs to be in sharpest focus.

8. Activate the self-timer or use the remote Switch RS60-E3 so the shutter will be tripped without your pressing the shutter button and possibly shaking the camera.

9. Compose the shot, check the focus, press the shutter button, and stand clear while the self-timer counts down, to make sure that you don't cast any shadows over the subject and that you don't touch the camera while it's making the exposure.

More Exposure Options

In Chapter 5, you learned techniques for getting the *right* exposure, but I haven't explained all your exposure options just yet. You'll want to know about the *kind* of exposure settings that are available to you with the Canon PowerShot G12. There are options that let you control when the exposure is made, or even how to make an exposure that's out of the ordinary in terms of length. The sections that follow explain your camera's special exposure features, and even discuss a few it does not have, to put the others in context.

A Tiny Slice of Time

Exposures that seem impossibly brief can reveal a world we didn't know existed. In the 1930s, Dr. Harold Edgerton, a professor of electrical engineering at MIT, pioneered high-speed photography using a repeating electronic flash unit he patented called the *stroboscope*. As the inventor of the electronic flash, he popularized its use to freeze objects in motion, and you've probably seen his photographs of bullets piercing balloons and drops of milk forming a coronet-shaped splash.

Electronic flash freezes action by virtue of its extremely short duration—as brief as 1/50,000th second or less. Although the PowerShot G12's built-in flash unit can give you these ultra-quick glimpses of moving subjects, an external flash, such as one of the Canon Speedlites, offers even more versatility. You can read more about using electronic flash to stop action in Chapter 8.

Of course, the PowerShot is fully capable of immobilizing all but the fastest movement using only its shutter speeds, which range all the way up to a speedy 1/4,000th second. Indeed, you'll rarely have need for such a brief shutter speed in ordinary shooting. If you wanted to use an aperture of f/2.8 at ISO 100 outdoors in bright sunlight, for some

reason, a shutter speed of 1/4,000th second would more than do the job. You'd need a faster shutter speed only if you moved the ISO setting to a higher sensitivity (but why would you do that?). Under less than full sunlight, 1/4,000th second is more than fast enough for any conditions you're likely to encounter.

Most sports action can be frozen at 1/2,000th second or slower, and for many sports a slower shutter speed is actually preferable—for example, to allow the wheels of a racing automobile or motorcycle, or the propeller on a classic aircraft to blur realistically. But if you want to do some exotic action-freezing photography without resorting to electronic flash, the PowerShot's top shutter speed is at your disposal. Here are some things to think about when exploring this type of high-speed photography:

- **You'll need a lot of light.** High shutter speeds cut very fine slices of time and sharply reduce the amount of illumination that reaches your sensor. To use 1/4,000th second at an aperture of f/6.3, you'd need an ISO setting of 800—even in full daylight. To use an f/stop smaller than f/6.3 or an ISO setting lower than 1600, you'd need *more* light than full daylight provides. (That's why electronic flash units work so well for high-speed photography when used as the sole illumination; the short duration of the flash—1/1,000th second or less—provides both the effect of a brief shutter speed and the high levels of illumination needed.)

- **Forget about reciprocity failure.** If you're an old-time film shooter, you might recall that very brief shutter speeds (as well as very high light levels and very *long* exposures) produced an effect called *reciprocity failure,* in which given exposures ended up providing less than the calculated value because of the way film responded to very short, very intense, or very long exposures of light. Solid-state sensors don't suffer from this defect, so you don't need to make an adjustment when using high shutter speeds (or brief flash bursts).

- **No elongation effect.** This is another old bugaboo that has largely been solved through modern technology, but I wanted to bring it to your attention anyway. In olden times, cameras used shutters that traveled horizontally. To achieve faster shutter speeds, focal plane shutters (located just in front of the focal plane) open only a smaller-than-frame-sized slit so that, even though the shutter is already traveling at its highest rate of speed, the film/sensor is exposed for a briefer period of time as the slit moves across the surface. At very short shutter speeds, and with subjects moving horizontally at very fast velocities, it was possible for the subject to partially "keep up" with the shutter if it were traveling in the same direction as the slit, producing an elongated effect. Conversely, subjects moving in the opposite direction of shutter motion could be compressed. Today, shutters like those in the PowerShot move vertically and at a higher maximum rate of speed. So, unless you're photographing a rocket blasting into space, and holding the camera horizontally to boot (or shooting a racing car in vertical orientation), it's almost impossible to produce unwanted elongation/compression.

Working with Short Exposures

You can have a lot of fun exploring the kinds of pictures you can take using very brief exposure times, whether you decide to take advantage of the action-stopping capabilities of your built-in or external electronic flash or work with the Canon PowerShot G12's faster shutter speeds. Here are a few ideas to get you started:

■ **Take revealing images.** Fast shutter speeds can help you reveal the real subject behind the façade, by freezing constant motion to capture an enlightening moment in time. Legendary fashion/portrait photographer Philippe Halsman used leaping photos of famous people, such as the Duke and Duchess of Windsor, Richard Nixon, and Salvador Dali to illuminate their real selves. Halsman said, "*When you ask a person to jump, his attention is mostly directed toward the act of jumping and the mask falls so that the real person appears.*" Try some high-speed portraits of people you know in motion to see how they appear when concentrating on something other than the portrait.

■ **Capture unseen perspectives.** Some things are *never* seen in real life, except when viewed in a stop-action photograph. Edgerton's balloon bursts were only a starting point. Freeze a hummingbird in flight for a view of wings that never seem to stop. Or, capture the splashes as liquid falls into a bowl, as shown in Figure 6.8. No

Figure 6.8

A large amount of artificial illumination and an ISO 1600 sensitivity setting allowed capturing this shot, taken with the Sepia color toning option, at 1/2,000th second without use of an electronic flash.

electronic flash was required for this image (and wouldn't have illuminated the water in the bowl as evenly). Instead, a clutch of high-intensity lamps and an ISO setting of 1600 allowed the camera to capture this image at 1/2,000th second.

■ **Create unreal images.** High-speed photography can also produce photographs that show your subjects in ways that are quite unreal. A helicopter in mid-air with its rotors frozen or a motocross cyclist leaping over a ramp, but with all motion stopped so that the rider and machine look as if they were frozen in mid-air, make for an unusual picture. The college basketball players never stopped to pose for the tableaux you see in Figure 6.9, but a fast shutter speed froze them in place.

Figure 6.9
This basketball shot captures a brief moment in time.

Long Exposures

Longer exposures are a doorway into another world, showing us how even familiar scenes can look much different when photographed over periods measured in seconds. At night, long exposures produce streaks of light from moving, illuminated subjects like automobiles or amusement park rides. Extra-long exposures of seemingly pitch-dark subjects can reveal interesting views using light levels barely bright enough to see by. At any time of day, including daytime (in which case you'll often need the help of the neutral-density filter to make the long exposure practical), long exposures can cause moving objects to vanish entirely, because they don't remain stationary long enough to register in a photograph.

Three Ways to Take Long Exposures

There are actually three common types of lengthy exposures: *timed exposures, bulb exposures*, and *time exposures*. The PowerShot G12 offers only the first one of these, but it's helpful to understand what other options exist, to put this camera's capability into context. Because of the length of the exposure, all of the following techniques should be used with a tripod to hold the camera steady.

- **Timed exposures.** These are long exposures from 1 second to 15 seconds, measured by the camera itself. To take a picture in this range with the PowerShot G12, simply use Manual or Tv mode and use the control dial to set the shutter speed to the length of time you want, choosing from preset speeds of 1.0, 1.3, 1.6, 2.0, 2.5, 3.2, 4.0, 5.0, 6.0, 8.0, 10.0, 13.0, or 15.0 seconds. The advantage of timed exposures is that the camera does all the calculating for you. There's no need for a stopwatch. If you review your image on the LCD and decide to try again with the exposure doubled or halved, you can dial in the correct exposure with precision. The disadvantage of timed exposures is that you can't take a photo with this camera for longer than 15 seconds.

- **Bulb exposures.** This type of exposure, not available with the G12, is so-called because in the olden days the photographer squeezed and held an air bulb attached to a tube that provided the force necessary to keep the shutter open for the desired period of time.

- **Time exposures.** This is a setting found on some cameras to produce longer exposures. Although the G12 lacks this capability, with cameras that implement this option, the shutter opens when you press the shutter release button, and remains open until you press the button again.

Working with Long Exposures

Because the PowerShot G12 produces such good images at longer exposures, and there are so many creative things you can do with long exposure techniques, you'll want to do some experimenting. Get yourself a tripod or another firm support and get started. Here are some things to try:

■ **Make people invisible.** One very cool thing about long exposures is that objects that move rapidly enough won't register at all in a photograph, while the subjects that remain stationary are portrayed in the normal way. That makes it possible to produce people-free landscape photos and architectural photos at night or, even, in full daylight if you use the neutral-density filter (set from the FUNC. menu) to allow an exposure of at least a few seconds. If you find the technique isn't working, you may need to wait for an overcast day to allow for a long enough exposure, if daylight people-vanishing is your goal. They'll have to be walking *very* briskly and across the field of view (rather than directly toward the camera) for this to work. At night, it's much easier to achieve this effect with the 15-second exposures that are possible, as you can see in Figure 6.10.

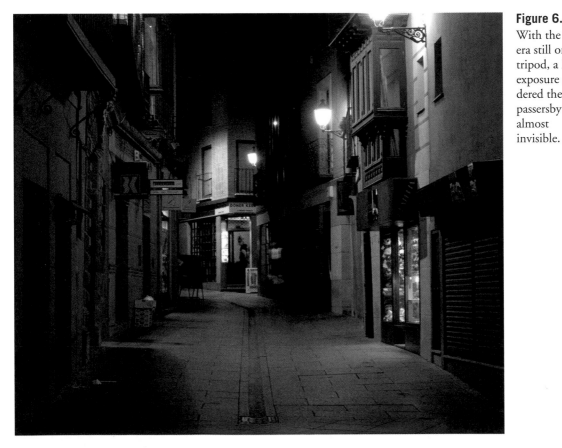

Figure 6.10
With the camera still on a tripod, a longer exposure rendered the passersby almost invisible.

■ **Create streaks.** If you aren't shooting for total invisibility, long exposures with the camera on a tripod can produce some interesting streaky effects, as shown in Figure 6.11. You don't need to limit yourself to indoor photography, however. Depending on the light conditions, using the neutral-density filter may darken the scene sufficiently to allow you to take photographs outdoors with a shutter speed slow enough to paint streaks on your image.

Figure 6.11
This Korean dancer produced a swirl of color as she spun during the 1/4 second exposure.

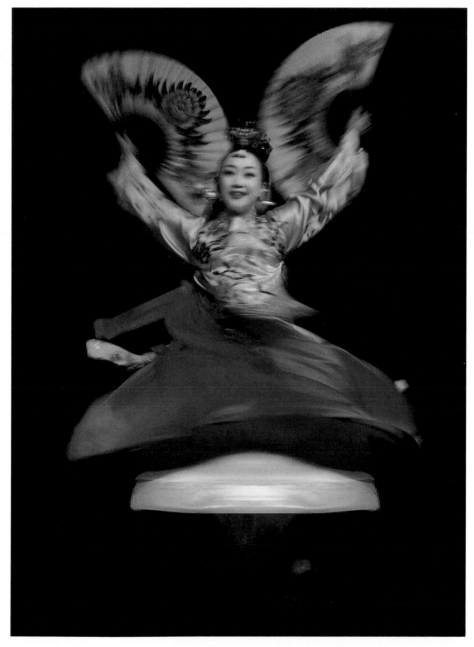

- **Produce light trails.** At night, car headlights and taillights and other moving sources of illumination can generate interesting light trails. Your camera doesn't even need to be mounted on a tripod; hand-holding the PowerShot for longer exposures adds movement and patterns to your trails. If you're shooting fireworks, a longer exposure may allow you to combine several bursts into one picture, as shown in Figure 6.12.

- **Blur waterfalls, etc.** You'll find that waterfalls and other sources of moving liquid produce a special type of long-exposure blur, because the water merges into a fantasy-like veil that looks different at different exposure times, and with different waterfalls. Cascades with turbulent flow produce a rougher look at a given longer exposure than falls that flow smoothly.

- **Show total darkness in new ways.** Even on the darkest, moonless nights, there is enough starlight or glow from distant illumination sources to see by, and, if you use a long exposure, there is enough light to take a picture, too.

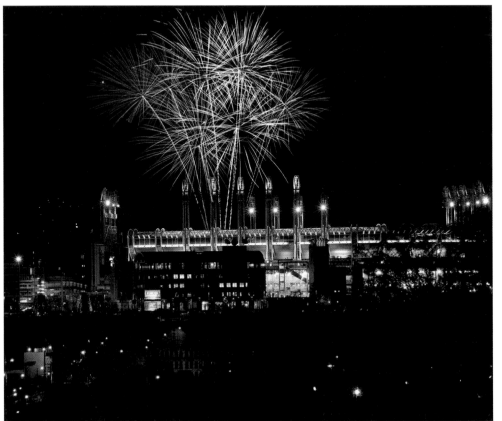

Figure 6.12
A long exposure allows capturing several bursts of fireworks in one image.

Delayed Exposures

Sometimes it's desirable to have a delay of some sort before a picture is actually taken. Perhaps you'd like to get in the picture yourself, and would appreciate it if the camera waited 10 seconds after you press the shutter release to actually take the picture. Maybe you want to give a tripod-mounted camera time to settle down and damp any residual vibration after the release is pressed to improve sharpness for an exposure with a relatively slow shutter speed. It's possible you want to explore the world of time-lapse photography. The next sections present your delayed exposure options.

Self-Timer

The PowerShot G12 has a built-in self-timer with a range of delay options from 0 to 30 seconds. (I'm not sure why you'd want a zero second delay, but it's there.) Your camera also has a self-timer/multiple shot setting that allows taking 1 to 10 shots after the delay. You call the self-timer into action by pressing the self-timer button, which doubles as the bottom cross key. The operation of the self-timer is easy to follow from the camera's prompts, but if you need a refresher, see Chapter 3.

Forget to bring along your tripod, but still want to take a close-up picture with a precise focus setting? Set your digital camera to the Self-timer function, then put the camera on any reasonably steady support, such as a fence post or a rock. When you're ready to take the picture, press the shutter release. The camera might totter back and forth for a second or two, but it will settle back to its original position before the self-timer activates the shutter.

Beyond Visible Light with Infrared

Congratulations—you have won the Infrared Lottery! What I mean by that is, by your wise choice of purchasing a PowerShot G12, you have acquired one of the modern digital cameras that is capable of using infrared light to take some very interesting and unusual looking photographs. Not every digital camera can take infrared photographs in this way. Many cameras nowadays have an infrared-blocking filter built into them, so they can't take advantage of the exotic looking properties of infrared images.

You can test any digital camera for infrared picture taking ability by aiming an infrared remote control at the camera's lens and clicking any button on the remote a few times, or holding it down. If the camera is sensitive to infrared light, you will see a bright light being emitted from the remote, though it's invisible to the naked eye. The PowerShot G12 model passes this test quite nicely. This camera is not designed for infrared picture taking, and may not be as good at it as some other cameras that are built (or converted) for that purpose, but I consider this model to do a pretty decent job in this esoteric area.

So, what do you do with your newfound power to take infrared photographs? If you want, you can delve quite deeply into the topic and become immersed in lots of arcane information about how infrared works. An internet search on "infrared digital photography" will get you going on that endeavor.

The purpose of this book, though, is to give you enough practical information to get you started without bogging you down. So, to give you a sample of what the PowerShot G12 can do in this area, I'll give you a set of steps you can take to enter the world of infrared photography. These steps represent just one approach, but they will work. Here is my suggested scenario:

- **Get an infrared filter.** In order to take interesting looking infrared photographs, you need not only to have a camera like the PowerShot G12 which can "see" infrared light, you also need to have a way to block the normal, humanly visible light. If you don't take that step, the visible light will overwhelm the infrared light and the resulting photograph will look rather ordinary. Some people use exposed, developed photographic film as a makeshift infrared filter. You would be better off, though, with a commercially available photographic filter such as the Hoya R72, available from good photo supply firms. Then you need to find a way to secure it in front of the lens. You could try cobbling together a holder from a cardboard tube or the like, or you could get a more permanent device such as a filter adapter sold by Canon or lensmateonline.com. Or you could start out by just holding it firmly in front of the lens.

- **Set the camera on a tripod.** This is required because the infrared filter is quite dark, and you will need a long exposure, possibly of more than one second, to get a usable image.

- **Use custom white balance.** If you need a refresher on the procedure, see Chapter 4's discussion of the FUNC. menu. But there is a twist here: instead of aiming the camera at a white (or gray) surface to get the white balance set, for infrared, I suggest you aim at green foliage, if possible (trees, grass, bushes), because those make some of the best subjects for infrared photos, which render green objects in white in dramatic contrast to their normal appearance.

- **Use Aperture priority (Av) mode.** Because the camera is on a tripod, you don't have to worry about having a long exposure. Try f/4.5 for a start. The camera will probably select a long exposure.

- **Find a suitable subject.** As I noted above, you might want to start with green trees and plants outdoors. Include sky and clouds as well, if possible, for contrasty, dramatic images. Once you've gotten started, though, experiment with a variety of subjects.

- **Use the self-timer.** This isn't a strong requirement, but I like to use the self-timer when possible, to avoid camera shake for long exposures.

Figure 6.13
This infrared shot was taken with the Power-Shot G12 in Aperture priority mode with a Hoya R72 filter, exposed at f/3.5 for 0.4 second at ISO 800. Custom white balance was set based on the color of the green bushes.

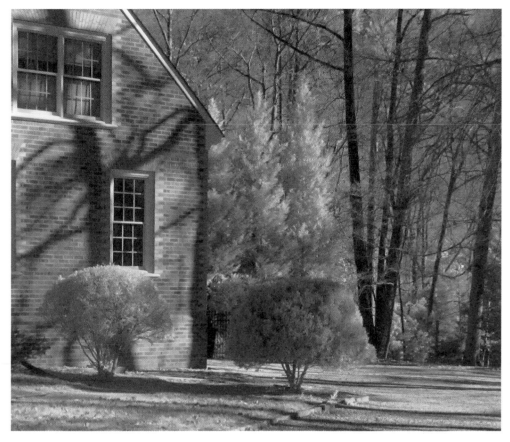

See Figure 6.13 for an example of a photograph shot with the PowerShot G12 using the above technique.

Making Movies

Canon has considerably beefed up the movie-making capabilities of the PowerShot G12, compared to the fairly rudimentary video features of its predecessors, the G10 and G11. The G12 can record high-definition (HD) video at 1280 × 720 pixels, with stereo sound, as well as recording in a couple of smaller formats, and it can output its high-quality HD footage to an HDTV with great fidelity through an HDMI connection. Of course, as you might expect, the G12 is not a serious rival to a dedicated camcorder or to some of the high-end Canon still cameras, such as the EOS 5D Mark II or the EOS 7D, which are endowed with advanced video capabilities. But the PowerShot G12 can record about half an hour of HD video in one continuous shot, and can record about an hour of uninterrupted standard quality video.

You can zoom in and out while recording video (but only with digital zoom, not the "real" optical zoom), and the camera will use its automatic exposure and focus mechanisms while the video is being recorded. In short, the PowerShot G12 brings this line of cameras up to a fairly high level of functioning in the video realm. If you're out and about and develop a sudden need to make a video record of an event, from a school sports event to a breaking news story, your G12 will get the footage down on your SD card with very acceptable quality.

Here are the basic points you need to know before you start shooting video:

- **Set the mode dial to Movie mode.** With some other cameras, there is a "movie" button you can push to start recording video, no matter what shooting mode the camera is set to. This is not the case with the PowerShot G12. Before you can record any video footage, you have to turn the mode dial on top of the camera to the Movie position, represented by the movie camera icon.

- **Choose a shooting mode.** Use the FUNC. menu, discussed in Chapter 4, to choose the video shooting mode. There are four choices: Standard, Miniature Effect, Color Accent, and Color Swap. (See Figure 6.14.) As you can see from the names, there is really only one choice—Standard—that you will want to use for most of

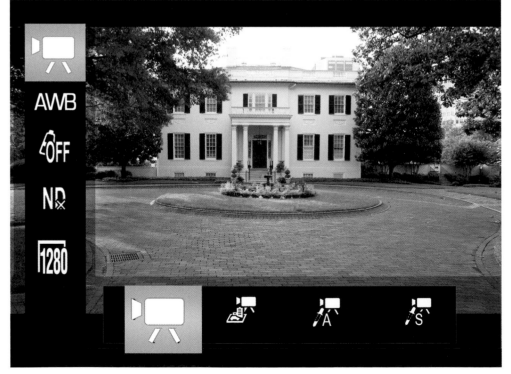

Figure 6.14
When the mode dial is set to Movie mode, the top choice on the FUNC. menu lets you select among the four movie shooting modes: Standard, Miniature Effect, Color Accent, and Color Swap.

your video shooting. The other three modes are specialized ones that function essentially in the same way as their still-image counterparts, discussed in Chapter 5. With the miniature model effect, though, you also have the option to record the scene at a slow speed, so it will appear to run from 5 to 20 times faster than normal when played back. It's good to know that they are available, but they are not what you want to use to record your child's school play or any other memorable event. In addition, when you're using any of the three secondary modes, the zoom is disabled, which limits the possibilities for your shooting.

■ **Choose your resolution.** The last selection at the bottom of the FUNC. menu (when the mode dial is set to Movie mode) lets you choose the resolution for your movie. (See Figure 6.15.) There are just three possibilities: HD quality at 1280 × 720 pixels, standard VGA quality at 640 × 480 pixels, and lower quality at 320 × 240 pixels. All video is recorded in PCM stereo sound in the Motion JPEG format, resulting in file extensions of .MOV. This is the format used by Apple's QuickTime software, and is an excellent format for viewing and editing on either PC or Macintosh computers.

Figure 6.15
The bottom choice on the FUNC. menu in Movie mode gives you your choice of resolution for your movie: 1280 × 720 (HD), 640 × 480 (standard quality), or 320 × 240 (lowest quality).

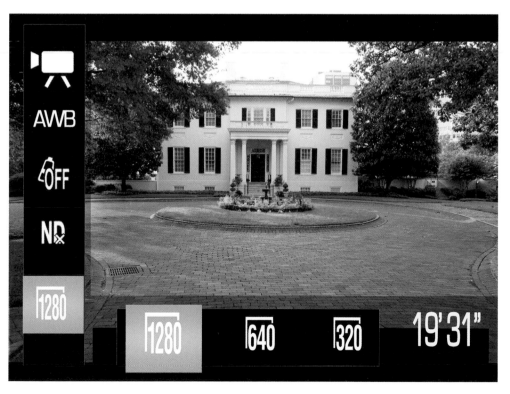

■ **Make other settings if desired.** The settings mentioned above are the only ones you really need to make to get ready to record your video. The camera will take care of most other settings, using autofocus with the AF Frame set to Face AiAF and adjusting the exposure as you record using Evaluative metering. But, if you want, you can use manual focus, and you can adjust white balance, image stabilization, digital zoom, and a few other items, using the Shooting menu. On the FUNC. menu, in addition to the basic settings discussed above, you can set white balance, My Colors, and the neutral-density filter.

■ **Use the right card.** You'll want to use an SD Class 6 memory card or better to store your clips; slower cards may not work properly. Choose a memory card with at least 4GB capacity. 8GB or 16GB are even better; if you're going to be recording a lot of HD video, that could be a good reason to take advantage of the G12's ability to use SDXC cards of 64GB capacity. Just make sure your computer can read the files from the card.

■ **Use a fully charged battery.** Canon says that a fresh battery will allow about one hour of filming at normal (non-Winter) temperatures.

■ **Press the shutter button.** You don't have to hold it down. Press it again when you're done.

MOVIE TIME

I've standardized on 16GB SDHC cards when I'm shooting movies; one of these cards will hold about 1 hour and 42 minutes of video at the HD 1280 × 720 resolution, about 3 hours at the standard 640 × 480 resolution, and about 8 hours at the lower 320 × 240 quality. However, the camera cannot shoot a continuous movie scene for more than one hour or create a file greater than 4GB. Therefore, one solid hour of video without pausing is your practical limit. (Though you could start right back in again to record a second hour-long scene, if you still had space on your memory card and still had battery power.)

GETTING INFO

The information display shown on the LCD screen when shooting movies is quite sparse; the screen will show time elapsed and the REC indicator to show that you are shooting a movie. The only other option is to display grid lines or the electronic level, or both, if you have selected those features through the Shooting menu under Custom Display.

Editing Movies in the Camera

The PowerShot G12 provides a very basic capability for editing movies in the camera. This is not a technique I would recommend for general use in editing your videos, and you won't be doing a lot of post-production work with this simple tool, but there may be a situation in which you have no computer available and you need to trim the beginning or end of a video by a few seconds so you can show it on a TV set, perhaps at a conference. Here's how to do it:

- **Get the video on the screen.** Press the Playback button and press the Jump key, then move with the down cursor button to the fourth icon, for stills/movies. Press either the left or right cursor button to select movies, then turn the control dial to find the movie you're looking for.

- **Press the FUNC./SET key twice.** Once to select the movie you want, and again to call up the playback and editing controls (see Figure 6.16).

- **Select the scissors icon.** Scroll with the control dial or with the left cursor button (wrapping around to the left) over to the icon of a pair of scissors. Press FUNC./SET to select it.

Figure 6.16
The movie editing screen provides tools for moving through the movie and performing basic edits by trimming the beginning and end of the movie clip.

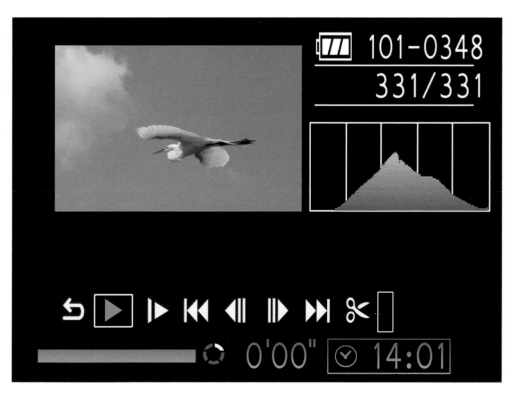

- **Select beginning or end to trim.** At the top left of the screen, scroll with the down cursor button to either the icon showing the scissors before a frame of film (trim beginning) or the scissors after a frame of film (trim end).

- **Scroll to select the portion to trim.** Using the right cursor button (if trimming beginning) or left cursor button (if trimming end), or the control dial for faster selection, move the orange marker along the bar at the bottom of the screen that represents the length of the film.

- **Select and use the trimming tool.** Use the down cursor button to move down the column of icons at the top left of the screen to the next-to-last icon, labeled "Save." Select it, and the camera will prompt you with three choices: New File, Overwrite, and Cancel. Your safest option is to choose New File, unless you're 100% sure that it's safe to overwrite the existing movie with the new, shorter version.

Tips for Shooting Better Video

There are a number of different things to consider when planning a video shoot:

Use a Shooting Script/Storyboards

A shooting script is nothing more than a coordinated plan that covers both audio and video and provides order and structure for your video. A detailed script will cover what types of shots you're going after, what dialogue you're going to use, audio effects, transitions, and graphics. A storyboard is a series of panels providing visuals that help you visualize locations, placement of actors/actresses, props, and furniture. It also helps show how you want to frame or compose a shot.

Advance a Story

A lot of the work will come after you shoot, when your video is assembled using a movie-editing program like iMovie or Windows Movie Maker. Audio and video should always be advancing the story. While it's okay to let the camera linger from time to time, it should only be for a compelling reason and only briefly. It only takes a second or two for an establishing shot to impart the necessary information, and the same goes for a dramatic stare. Provide variety too. Change camera angles and perspectives often and never leave a static scene on the screen for a long period of time.

Keep Transitions Basic

Fancy transitions that involve exotic "wipes," dissolves, or cross fades take too long for the average viewer and make your video ponderous. Save dissolves to show the passage of time (it's a cinematic convention that viewers are used to and understand).

Composition

Movie shooting calls for careful composition, and, in the case of HD video format, that composition must be framed by the 16:9 aspect ratio of the format. (See Figure 6.16.) Static shots where the camera is mounted on a tripod and everything's shot from the same distance are a recipe for dull videos. Try these tricks:

- **Establishing shot.** This composition, shown in Figure 6.17, establishes the scene and tells the viewer where the action is taking place.

- **Medium shot.** This shot is composed from about waist to headroom (some space above the subject's head). It's useful for providing variety from a series of close-ups and also makes for a useful first look at a speaker. (See Figure 6.18.)

- **Close-up.** The close-up, usually described as "from shirt pocket to head room," provides a good composition for someone talking directly to the camera. (See Figure 6.19.)

- **Extreme close-up.** This shot has been described as the "big talking face" shot. Styles and tastes change over the years and now the big talking face is much more commonly used (maybe people are better looking these days?) and so this view may be appropriate. (See Figure 6.20.)

Figure 6.17

Figure 6.18

Figure 6.19

Figure 6.20

- **"Two" shot.** A two shot shows a pair of subjects in one frame. They can be side by side or one in the foreground and one in the background. Subjects can be standing or seated. A "three shot" is the same principle except that three people are in the frame. (See Figure 6.21.)

- **Over the shoulder shot.** Long a tool of interview programs, the "over the shoulder shot" uses the rear of one person's head and shoulder to serve as a frame for the other person. This puts the viewer's perspective as that of the person facing away from the camera. (See Figure 6.22.)

Figure 6.21

Figure 6.22

Lighting for Video

Much like in still photography, how you handle light pretty much can make or break your videography. You can significantly improve the quality of your video by increasing the light falling in the scene. An inexpensive shoe mount video light, which will easily fit in a camera bag, can be found for $15 or $20. You can even get a good-quality LED video light for less than $100. Work lights sold at many home improvement stores can also serve as video lights since you can set the camera's white balance to correct for any colorcasts. Much of the challenge depends upon whether you're just trying to add some fill light on your subject versus trying to boost the light on an entire scene. A small video light in the camera's hot shoe mount or on a flash bracket will do just fine for the former. It won't handle the latter.

Lighting can either be hard (direct) light or soft (diffused). Hard light is good for showing detail, but can also be very harsh and unforgiving. "Softening" the light, but diffusing it somehow, say, with an umbrella or white cardboard reflector, can reduce the intensity of the light but make for a kinder, gentler light as well.

Getting the Most from Your Zoom

The 28-140mm f/2.8 zoom lens mounted on your Canon PowerShot G12 is the "eye" of your camera. It captures the light that's focused on the sensor to produce the image. Through its zooming capability, the lens changes the magnification of the image, and, indirectly, the perspective of your photograph. The maximum aperture (or f/stop) of your lens also affects your ability to shoot under varying light conditions. The size of the lens opening you choose helps determine the range of sharpness (depth-of-field) and the absolute *amount* of sharpness.

Those aspects are very important to your picture taking. With a camera like the G12, the lens is fixed and cannot be interchanged (although you can adjust its characteristics with add-on attachments). So, the quality and features of the lens itself is one of the most crucial factors you should consider in choosing a camera. Fortunately, the lens mounted on the G12 is a very good one, and to a large extent, one of the key reasons why these cameras are so popular.

This chapter explains some of the things you should keep in mind when using your zoom, how to select the best focal lengths for the kinds of photography you want to do, and things you can do to increase the versatility of your camera's built-in optics.

How Lenses Affect Your Pictures

The first thing to get out of the way is the notion of absolute and equivalent focal lengths. Your 28-140mm zoom lens is actually a 6.1-30.5mm zoom in absolute terms, because those are the true focal lengths available from the optics built into the camera.

The effective focal lengths in use, however, are customarily given in the form of the *equivalent* focal length compared to a 35mm film camera or "full-frame" digital camera. Because the sensor on the G12 measures just 5.7 × 7.6 mm, rather than the 24 × 36mm of a full-frame camera, the smaller sensor in your PowerShot requires shorter focal lengths to produce the same field of view.

That is, at 6.1mm, your lens has the same field of view as a 28mm lens on a full-frame camera; at 30.5mm, it has the same field of view as a 140mm telephoto on a full-frame camera. Because various cameras in this class have sensors of varying sizes, it makes sense to always convert their "real" focal lengths to the full-frame equivalent. So, in specifications for digital cameras, and throughout this book, I'll always refer to the *equivalent* focal lengths, and ignore the "real" focal lengths, because the latter have little meaning to the average photographer.

- **Change magnification.** Zooming in and out changes the magnification of your image in the viewfinder, on the LCD, and in the final image captured by your sensor. With the G12, this magnification factor is 1X to 5X. In Figure 7.1 you can see that the image at the 140mm maximum zoom position (bottom) is five times larger than the image produced at the 28mm setting (top).

- **Change perspective.** As you move closer or farther away from your subject, your perspective changes. At closer distances, with the lens zoomed out wider, objects in the foreground become exaggerated in size and more prominent compared to shots taken from a greater distance, and the lens zoomed in to telephoto settings. This change in perspective is intertwined with the magnification of your zoom. To keep an image the same size in the frame, you can zoom in or out, changing the magnification, or you can move closer or farther away, changing the perspective.

- **Control exposure.** The aperture built into your lens controls the exposure, as well as what exposures you can use. For example, with the G12, the maximum aperture is f/2.8 (at the wide-angle setting) and the smallest f/stop available is f/8. So, you can use only exposure combinations that call for f/2.8 to f/8. For example on a bright day with an ISO setting of ISO 200, you could shoot at 1/800th second at f/8, 1/1600th second at f/5.6, or 1/3200th second at f/4. To use other combinations, you'd need to reduce the ISO setting to less than ISO 200 (the G12 goes down to ISO 80), or turn on the built-in neutral-density filter. (Note that 1/6400th second at f/2.8 is unavailable in bright sunlight, anyway, because the G12 does not have a 1/6400th second setting; 1/4000th second is tops.) Keep in mind that at the maximum zoom position, the f/2.8 aperture becomes an effective f/4.5.

- **Affects depth-of-field.** The range of sharpness of your image, also called depth-of-field (DOF), is affected by the size of the f/stop. Your camera has the least amount of DOF at f/2.8, and the most at f/8. Fortunately (and unfortunately), the smaller sensor and smaller sensor size means that the 6.1-30.5 *true* focal lengths of your

Figure 7.1
At its 28mm setting, the PowerShot's zoom lens provides a true wide-angle view (top); at 140mm, the zoom offers a telephoto perspective (bottom).

lens provide vast amounts of depth-of-field at any of these f/stops at normal shooting distances. Whether you're using f/2.8 or f/8 you'll probably have more than enough DOF, except when shooting macro pictures a few inches from the lens, when even the DOF provided at f/8 may not be enough. The *unfortunate* part comes from having so much DOF in most instances that selective focus techniques may be more difficult or impossible.

- **Affects sharpness.** The f/stop built into your lens affects the absolute sharpness, too, not just the range of sharpness. As with most camera lenses the largest f/stop does not produce the best image quality; f/2.8 is good, but not as good as f/4 or f/5.6. At f/8 and smaller, lenses start to lose a little sharpness because of a phenomenon called *diffraction*. (The light entering the lens is scattered slightly by the edges of the aperture's diaphragm.) Diffraction grows worse as lens focal lengths become shorter, which is one of the reasons why the G12's lens stops at f/8 and doesn't continue on to smaller stops, such as f/11 or f/16, found in lenses for other types of cameras, including digital SLRs. (Sensor design can affect diffraction, too, and optical physics is another limitation on the minimum f/stop available with cameras like the G12.)

So, what can you do with the zoom built into your Canon PowerShot G12? Here's what you need to know:

- **Bring you closer.** A longer focal length brings distant subjects closer to you, offers better control over depth-of-field, and avoids the perspective distortion that wide-angle lenses provide. They compress the apparent distance between objects in your frame.

- **Wider perspective.** Sometimes you need the widest view that your lens offers. Often, your back is up against a wall and you *can't* take a step backwards to take in more subject matter. Perhaps you're standing on the rim of the Grand Canyon, and you want to take in as much of the breathtaking view as you can. You might find yourself just behind the baseline at a high school basketball game and want an interesting shot with a little perspective distortion tossed in the mix. In all these cases, you'll need to use the widest focal length that your lens offers, which in the G12 provides the same field of view as a 28mm lens on a full-frame camera.

- **Bring your camera closer.** The macro setting of your lens allows you to autofocus from 0.39 inches to 1.6 feet at the wide-angle zoom position, and 12 inches to 1.6 feet at the telephoto position. In Manual focus mode you can focus from 0.39 inches to infinity when set to wide angle, or 12 inches to infinity at the telephoto setting. This provides quite a bit of flexibility when you want to vary your subject distance (say, to avoid spooking a skittish creature).

- **More speed.** Your lens's f/2.8 maximum aperture at 28mm (f/4.5 at 140mm) means you can shoot many scenes in available light, using reasonable ISO speeds of ISO 1600 or below. ISO 12,800 can be used only at reduced resolution. You have to evaluate whether the image you want to capture is worth the noise penalty of higher IS settings.

- **Special features.** The optical image stabilization built into your lens makes your lens "faster" by allowing you to shoot at a slower shutter speed. For example, if 1/30th second at f/2.8 won't cut it, and raising the ISO isn't an option (say, you're already at ISO 1600), you can often grab your shot at an even slower shutter speed, assuming that it's camera shake and not subject movement you're trying to freeze. Your PowerShot can often get good images at 1/15th second or even 1/8th second, if you've turned on the Image Stabilization feature in the Shooting menu.

Using the Wide-Angle Zoom Settings

The zoom settings from 28mm to about 45mm are considered wide angle with your PowerShot G12. To use these focal lengths effectively, you need to understand how they affect your photography. Here's a quick summary of the things you need to know.

- **More depth-of-field.** Practically speaking, even with the copious amounts of depth-of-field that your camera's true 6.1-30mm focal length range offers, wide-angle settings still offer more depth-of-field at a particular subject distance and aperture. (But see the sidebar below for an important note.) You'll find that helpful when you want to maximize sharpness of a large zone, but not very useful when you'd rather isolate your subject using selective focus (telephoto focal lengths are better for that).

- **Stepping back.** Wide-angle focal lengths have the effect of making it seem that you are standing farther from your subject than you really are. They're helpful when you don't want to back up, or can't because there are impediments in your way.

- **Wider field of view.** While making your subject seem farther away, as implied above, a wide-angle setting also provides a larger field of view, including more of the subject in your photos.

- **More foreground.** As background objects retreat, more of the foreground is brought into view by a wide-angle setting. That gives you extra emphasis on the area that's closest to the camera. Photograph your home with a medium zoom setting, and the front yard probably looks fairly conventional in your photo (that's why these medium focal lengths are called "normal"). Switch to a wider setting and you'll discover that your lawn now makes up much more of the photo. So, wide-angle focal lengths are great when you want to emphasize that lake in the foreground, but problematic when your intended subject is located farther in the distance.

■ **Perspective distortion.** When you tilt the camera so the plane of the sensor is no longer perpendicular to the vertical plane of your subject, some parts of the subject are now closer to the sensor than they were before, while other parts are farther away. So, buildings, flagpoles, or NBA players appear to be falling backwards, as you can see in Figure 7.2. While this kind of apparent distortion (it's not caused by a defect in the lens) can happen with any focal length, it's most apparent when a wide-angle lens setting is used.

Figure 7.2
When you tilt the camera upwards, tall buildings appear to be falling backward.

■ **Super-sized subjects.** The tendency of a wide-angle lens to emphasize objects in the foreground, while de-emphasizing objects in the background can lead to a kind of size distortion that may be more objectionable for some types of subjects than others. Shoot a bed of flowers up close with a wide-angle setting, and you might like the distorted effect of the larger blossoms nearer the lens. Take a photo of a family member with the same lens from the same distance, and you're likely to get some complaints about that gigantic nose in the foreground. Figure 7.3 shows a dry creek bed using a medium focal length at top. At bottom, a wide-angle setting emphasizes the rocks in the foreground, making them appear huge, and making the background trees (and even the horizon) seem farther away.

Figure 7.3
At top, a normal view of a dry creek bed. At bottom, the wide-angle perspective from a slightly lower angle makes the small rocks in the foreground appear to be huge.

- **Steady cam.** You'll find that you can hand-hold a wide-angle focal length at slower shutter speeds, without need for image stabilization, than you can with a telephoto lens setting. The reduced magnification of the wide-zoom setting doesn't emphasize camera shake like a telephoto setting does.

- **Interesting angles.** Many of the factors already listed combine to produce more interesting angles when shooting with wide-angle focal lengths. Raising or lowering a telephoto lens a few feet probably will have little effect on the appearance of the distant subjects you're shooting. The same change in elevation can produce a dramatic effect for the much-closer subjects typically captured with a wide-zoom setting.

DOF IN DEPTH

The depth-of-field (DOF) advantage of wide-angle focal lengths is diminished when you enlarge your picture; believe it or not, a wide-angle image enlarged and cropped to provide the same subject size as a telephoto shot would have the *same* depth-of-field. Try it: take a wide-angle photo of a friend from a fair distance, and then zoom in to duplicate the picture in a telephoto image. Then, enlarge the wide shot so your friend is the same size in both. The wide photo will have the same DOF (and will have much less detail, too).

Potential Wide-Angle Problems

Wide-angle focal lengths have a few quirks that you'll want to keep in mind when shooting. Here's a checklist of common problems:

- **Symptom: converging lines.** Unless you want to use wildly diverging lines as a creative effect, it's a good idea to keep horizontal and vertical lines in landscapes, architecture, and other subjects carefully aligned with the sides, top, and bottom of the frame. That will help you avoid undesired perspective distortion. Sometimes it helps to shoot from a slightly elevated position so you don't have to tilt the camera up or down.

- **Symptom: color fringes around objects.** Lenses are often plagued with fringes of color around backlit objects, produced by *chromatic aberration*, which comes in two forms: *longitudinal/axial*, in which all the colors of light don't focus in the same plane; and *lateral/transverse*, in which the colors are shifted to one side. Lens designers must use special techniques to reduce these effects.

- **Symptom: lines that bow outward.** Some wide-angle focal lengths cause straight lines to bow outwards, with the strongest effect at the edges. You can minimize barrel distortion simply by framing your photo with some extra space all around, so the edges where the defect is most obvious can be cropped out of the picture.

- **Symptom: light and dark areas when using polarizing filter.** If you know that polarizers work best when the camera is pointed 90 degrees away from the sun and have the least effect when the camera is oriented 180 degrees from the sun, you know only half the story. With focal lengths in the 28mm vicinity, the angle of view (75 degrees diagonally, or 44 degrees horizontally) is extensive enough to cause problems. Think about it: when a 28mm lens is pointed at the proper 90-degree angle from the sun, objects at the edges of the frame will be oriented at 112 to 68 degrees, with only the center at exactly 90 degrees. Either edge will have much less of a polarized effect. The solution is to avoid using a polarizing filter with focal lengths having an equivalent focal length of less than about 35mm. Zoom out, if necessary, and avoid extreme wide-angle shots.

Using Telephoto Settings

Telephoto focal lengths also can have a dramatic effect on your photography. Here are the most important things you need to know. In the next section, I'll concentrate on telephoto considerations that can be problematic—and how to avoid those problems.

- **Selective focus.** Long focal lengths have reduced depth-of-field within the frame, allowing you to use selective focus to isolate your subject. You can open the lens up as wide as possible to create shallow depth-of-field, or close it down a bit to allow more to be in focus. The flip side of the coin is that when you *want* to make a range of objects sharp, you'll need to use a smaller f/stop to get the depth-of-field you need. Like fire, the depth-of-field of a telephoto lens can be friend or foe. Figure 7.4 shows a photo of a statue with an ugly background, so I photographed it using the 140mm setting and the widest f/stop available to de-emphasize the background.

- **Getting closer.** Telephoto focal lengths bring you closer to wildlife, sports action, and candid subjects. No one wants to get a reputation as a surreptitious or "sneaky" photographer (except for paparazzi), but when applied to candids in an open and honest way, a long lens setting can help you capture memorable moments while retaining enough distance to stay out of the way of events as they transpire.

- **Reduced foreground/increased compression.** Telephoto focal lengths have the opposite effect of wide angles: they reduce the importance of things in the foreground by squeezing everything together. This compression even makes distant objects appear to be closer to subjects in the foreground and middle ranges. You can use this effect as a creative tool.

- **Accentuates camera shakiness.** Telephoto focal lengths hit you with a double-whammy in terms of camera/photographer shake. The focal lengths themselves are bulkier, more difficult to hold steady, and may even produce a barely perceptible see-saw rocking effect when you support them with one hand halfway down the

lens barrel. Telephotos also magnify any camera shake. It's no wonder that image stabilization is popular in longer focal lengths.

■ **Interesting angles require creativity.** Telephoto focal lengths require more imagination in selecting interesting angles, because the "angle" you do get on your subjects is so narrow. Moving from side to side or a bit higher or lower can make a dramatic difference in a wide-angle shot, but raising or lowering a telephoto lens a few feet probably will have little effect on the appearance of the distant subjects you're shooting.

Figure 7.4
A wide f/stop and telephoto focal length helped isolate this statue from its background.

Avoiding Telephoto Lens Problems

Many of the "problems" that telephoto focal lengths pose are really just challenges and not that difficult to overcome. Here is a list of the seven most common picture maladies and suggested solutions.

- **Symptom: flat faces in portraits.** Head-and-shoulders portraits of humans tend to be more flattering when a focal length in the 50mm to 85mm range is used. Longer focal lengths compress the distance between features like noses and ears, making the face look wider and flat. A wide-angle might make noses look huge and ears tiny when you fill the frame with a face. So stick with 50mm to 85mm focal length ranges, going longer only when you're forced to shoot from a greater distance, and wider only when shooting three-quarters/full-length portraits, or group shots.

- **Symptom: blur due to camera shake.** Use a higher shutter speed (boosting ISO if necessary), and image stabilization, or mount your camera on a tripod, monopod, or brace it with some other support. Of those three solutions, only the first will reduce blur caused by *subject* motion; IS (image stabilization) or a tripod won't help you freeze a race car in mid-lap.

- **Symptom: color fringes.** Chromatic aberration is the most pernicious optical problem found in telephoto focal lengths in cameras like the G12. There are others, including spherical aberration, astigmatism, coma, curvature of field, and similarly scary-sounding phenomena. Your only solution may be to correct the fringing in your favorite RAW conversion tool or image editor. Photoshop's Lens Correction filter (found in the Distort menu) offers sliders that minimize both red/cyan and blue/yellow fringing.

- **Symptom: lines that curve inwards.** Pincushion distortion is sometimes found at many telephoto focal lengths. You might find after a bit of testing that it is worse at certain focal lengths with your particular zoom lens. Like chromatic aberration, it can be partially corrected using tools like Photoshop's Lens Correction filter.

- **Symptom: low contrast from haze or fog.** When you're photographing distant objects, a long lens shoots through a lot more atmosphere, which generally is muddied up with extra haze and fog. That dirt or moisture in the atmosphere can reduce contrast and mute colors. Some feel that a skylight or UV filter can help, but this practice is mostly a holdover from the film days. Digital sensors are not sensitive enough to UV light for a UV filter to have much effect.

- **Symptom: low contrast from flare.** To reduce flare from bright light sources at the periphery of the picture area, or completely outside it, avoid pointing your camera directly at the sun. Because telephoto focal length settings often create images that are lower in contrast in the first place, you'll want to be especially careful, and perhaps shade the front of the lens with your hand.

- **Symptom: dark flash photos.** A long lens setting might make a subject that's 50 feet away look as if it's right next to you, but your camera's flash isn't fooled. You'll need extra power for distant flash shots, and probably more power than your built-in flash provides. The shoe-mount Canon 580EX II Speedlite, for example, can automatically zoom its coverage down to that of a medium telephoto lens, providing a theoretical full-power shooting aperture of about f/8 at 50 feet and ISO 400. (Try *that* with the built-in flash!) Of course, this flash is expensive and larger than your entire camera. One of the other Canon external flash units might be all you need, however. I'll explain more about flash in Chapter 8.

Image Stabilization

Image stabilization provides you with camera steadiness that's the equivalent of at least two or three shutter speed increments. This extra margin can be invaluable when you're shooting under dim lighting conditions or hand-holding with the camera set for its longest optical focal length of 140mm. Perhaps that shot of a foraging deer calls for a shutter speed of 1/250th second at f/5.6, and you fear that the image will be blurry. Relax, with image stabilization turned on, you can shoot at 1/250th second and get virtually the same results as if you had used 1/500th or even 1/100th second, as long as the deer doesn't decide to bound off.

Or, maybe you're shooting a high school play without a tripod or monopod, and you'd really, really like to use 1/15th second at f/4. Assuming the actors aren't flitting around the stage at high speed, your PowerShot and its IS feature can let you grab the shot at the wide-angle position. However, keep these facts in mind:

- **IS doesn't stop action.** Unfortunately, no image stabilization is a panacea to replace the action-stopping capabilities of a higher shutter speed. Image stabilization applies only to camera shake. You still need a fast shutter speed to freeze action. IS works great in low light, when you're using long focal lengths, and for macro photography. It's not always the best choice for action photography, unless there's enough light to allow a sufficiently high shutter speed. If so, IS can make your shot even sharper.

- **IS slows you down.** The process of adjusting the lens elements takes time, just as autofocus does, so you might find that IS adds to the lag between when you press the shutter and when the picture is actually taken. That's another reason why image stabilization might not be a good choice for sports.

- **Use when appropriate.** In some situations, IS can produce worse results if used while you're panning the camera from side to side during exposure. The camera can confuse the motion with camera shake and overcompensate. You might want to switch off IS when panning or when your camera is mounted on a tripod.

■ **Do you need IS at all?** Remember that an inexpensive monopod might be able to provide the same additional steadiness as an IS lens. If you're out in the field shooting wild animals or flowers and think a tripod isn't practical, try a monopod first.

Lens Add-Ons

For those looking for a super-compact camera, one of the advantages of a camera like the G12 is that it *doesn't* have interchangeable lenses. Its fixed, all-in-one zoom lens, designed to handle *most* of the shooting situations you're likely to encounter, allows for a very small, virtually pocket-sized design. Of course, the type of avid photographer that the PowerShots appeal to are the same kind who will, eventually, want to push their camera to its limits and do a few things that aren't quite possible with the G12's unadorned zoom lens.

That's where lens add-ons come in. To look at the G12's trim, retractable zoom lens, devoid of any sort of thread to allow attaching so much as a filter, you'd think that expansion is out of the question. Not true! The ring around the base of the lens comes off as easy as 1-2-3, revealing a bayonet mount that can be used to attach various adapters that allow using several useful accessories, including filters.

Filters and other lens attachments change the way your lens views the world. Filters are add-on disks or squares of glass, gelatin, or some other transparent/translucent material that you fasten to the front of your lens (or, sometimes, drop into a special slot at the rear of the lens barrel). They modify the light in some way, changing its color, reducing the amount of light that reaches the sensor (frequently both at the same time), or, in the case of *polarizing* filters, wholly or partially eliminating glare. Other kinds of lens attachments do different things in changing the characteristics of light before it passes through the lens. Some change the magnification of the lens, producing a more pronounced telephoto or wide-angle effect. Lens attachments can also allow you to focus more closely, or, distort your image in some way.

As far as the 1-2-3 goes, just look at Figure 7.5 to see how to remove this ring from the front of your camera. Press and hold the release button (1.) Rotate the ring in a counterclockwise direction, as you face the camera. (2.) Slide it forward. (3.) The bayonet mount will be revealed.

You can attach to this bayonet the Canon Conversion Lens Adapter LA-DC58K, a sort of tube that has threads on the front that allow attaching the Canon Tele-converter TC-DC58D. They are sold separately, which is a good thing, because that leaves you free to purchase more useful adapters from Lensmate (www.lensmateonline.com) instead. Go ahead and get the TC-DC58D Tele-converter if you want to increase the telephoto range of your camera, but strongly consider the versatile Lensmate adapters if you also want to use filters and other accessories with your G12. All Lensmate adapters fit the G12 and earlier models like the G10 and G11.

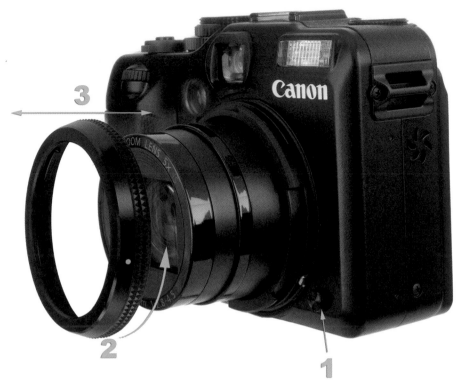

Figure 7.5
Remove the ring around the lens to reveal the bayonet mount.

The adapter consists of three parts, each available separately. Part A is a base ($24.95), which is always used in conjunction with Parts B or C ($22.95 each) and has a 58mm thread on its outer edge. You can use Part A alone, but only with a low profile 58mm polarizing filter like the Kenko Pro1 Digital Circular Polarizer. In that case, the zoom range of the combo is limited to 28-50mm, because at longer focal lengths, the lens will strike the filter. A Quick Change Filter Holder for 52mm filters is also available.

Part B, when attached to the Part A base, flares outwards enough to allow using large 72mm filters with no vignetting in the corners at any focal length (although you must use one of the filters tested and recommended by Lensmate to ensure no vignetting). (See Figure 7.6.)

Part C is used instead of Part B, to allow attaching the Canon TC-DC58D Tele-converter (see Figure 7.7) (or, alternately, a Raynox DCR250 macro attachment with the recommended 58-52mm step-down ring—Figure 7.8). Unlike the plastic LA-DC58K adapter, the Lensmate G11/G12 adapters are custom-made of machined aluminum, and fit more snugly. While Canon's adapter uses an odd-ball 57mm thread and requires an adapter for 58mm filters, the basic Lensmate adapter has a standard 58mm or 72mm thread to accept two of the most common filter sizes.

If you already use the Cokin P filter system with your dSLR, Lensmate offers an adapter to attach the Cokin filter holder to the 72mm Part B adapter, so you can work with 84mm-wide Cokin filters, too. Cokin also has an adapter for Lee 100mm wide square filters.

Figure 7.6
Lensmate's Part B adapter attaches to Part A to allow use of 72mm filters.

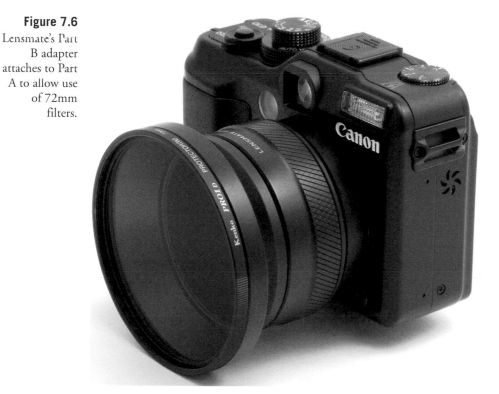

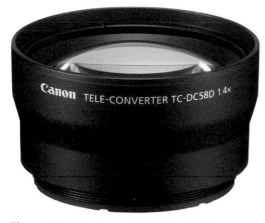

Figure 7.7 The Canon TC-DC58D Tele-converter increases the maximum focal length of your lens to 192mm.

Figure 7.8 The Raynox Super Macro Conversion lens also fits on the Lensmate to allow closer focusing at any focal length setting.

Working with Filters

Filters add a lot of versatility. Just among Cokin-style filters alone, there are hundreds of different filter models offered for special effects, color correction, neutral density, diffusion, and other applications. As you investigate the Cokin system, you'll see that its flexibility accounts for much of its popularity.

There are more than 200 different Cokin filters, but other manufacturers also produce filters and holders in the standard Cokin sizes. You can place two different square filters in the pair of slots on the holder. They're held in place by friction, so you can move them up and down to partially or fully cover the lens when you want to vary your effect. A third, circular filter, can be dropped into a special slot that's closest to the camera lens. These include star filters, polarizers, and other filters, and they can be rotated within the slot to produce a particular effect (say, to vary the amount of polarization).

Polarizers

Polarizing filters, first mentioned earlier in this chapter, are a type of filter that can provide richer and more vibrant colors while reducing some of the reflective glare that affects many photos taken in bright daylight. Polarizing filters operate in much the same way as polarized sunglasses. The polarizer itself consists of two rings; one is attached to the lens, while the outer ring rotates the polarizing glass. This lets you selectively filter out different light waves. You can rotate the ring until the effect you want is visible. The amount of glare reduction depends heavily on the angle from which you take the photograph, and the amounts of scattered light in the reflections (which is determined by the composition of the subject). Polarizers work best when the sun is low in the sky and at a 90-degree angle from the camera and subject (that is, off to your left or right shoulder). Blue sky and water, which can contain high amounts of scattered light, can be made darker and more vibrant as glare is reduced. You can also reduce or eliminate reflections from windows and other nonmetallic surfaces. Figure 7.9 shows an example of how an image can be improved with a polarizing filter.

Neutral-Density Filters

Although your G12 has a built-in electronic ND filter, found in the FUNC. menu, sometimes you can use a little more filtration. In such cases, you'll want to use an add-on filter, attached using an adapter, like the Lensmate adapters described in the previous section. Neutral-density filters are one of those high-concept tools with a function that's easy to grasp: they add nothing to the image except density (by preventing some of the light from reaching the sensor), and they are neutral (so the colors remain the same). A straight gray ND (neutral-density) filter increases the amount of exposure required, so that you'll need to use a larger aperture, slower shutter speed, or higher ISO

Figure 7.9
If the sky is too light (top), a polarizing filter can darken it and enrich the other colors in your image.

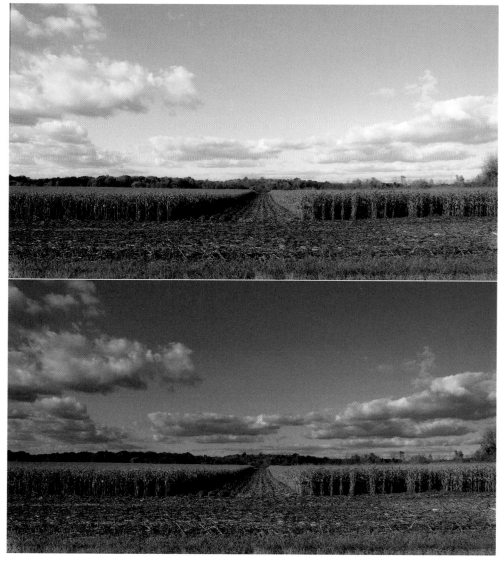

setting to achieve correct exposure with the filter in place. You can even use all three in appropriate proportions, if you like. The net effect is the same as if there were less light illuminating the subject, so extra exposure is required.

The exact amount of neutral density supplied can be found in the filter's name, which usually includes either the *filter factor* or *optical density* of the particular filter. For example, you might see neutral-density filters labeled ND2, ND4, and ND8, which would signify that these filters would require 1-stop (2X), 2-stops (4X), and 3-stops (8X), of additional exposure, respectively. If you think about the relationship between f/stops—

a one-stop difference requires twice as much exposure, a two-stop difference calls for four times as much exposure—the nomenclature makes sense. Your camera's built-in filter is an 8X ND filter, and will reduce exposure by three stops; add-on filters offer different amounts of filtration.

Given the eternal quest for faster and more sensitive sensors, what good are neutral-density filters? You'll find them useful anytime you want to use a slower shutter speed or a larger f/stop in a situation in which your camera's lowest ISO setting won't allow the use of one or the other. A slow shutter speed (for creative blurring purposes) *and* wide f/stop (also for creative selective focus applications) may be almost impossible to achieve. Proper use of ND filters can give you both options. As I mentioned, you can *split* the effects among all the exposure factors: an ND8 filter (like the one built into the G12) has three-stops of light-blocking power that will let you use a shutter speed that is half as fast, an f/stop that is twice as large, and an ISO setting that is twice as sensitive, all in the same photograph if that's what you want.

- **Slower shutter speeds.** Your G12 has a minimum ISO setting of ISO 80. Your lens has a minimum f/stop of f/8. So, outdoors in bright daylight you may find it impossible to use a shutter speed longer than 1/50th or even 1/100th second. If your mountain stream is not in bright sunlight, it's still unlikely you'll be able to use a shutter speed any longer than about 1/30th to 1/15th second. That's a shame when you have a beautiful waterfall or crashing ocean waves in your viewfinder and want to add a little creative motion blur. An ND8 filter can give you the 1/2 second to several-second exposures you'll need for truly ethereal water effects.

- **Larger f/stops.** Frequently there is too much light to use the large f/stop you want to apply to reduce depth-of-field. The wide-open f/stop you prefer for selective focus applications might demand shutter speeds of 1/4,000th second or higher. With a 2X or 4X ND filter, you can use the widest f/stop available at 1/4,000th second.

- **Countering overwhelming electronic flash.** I have several older manual studio flash units that are simply too powerful for *both* my available range of f/stops and ISO settings, even when switched from full power to half power. (Newer units generally offer 1/4, 1/8, 1/16, and 1/32 power options and may be continuously variable over that or an even larger range.) An ND filter allows me to shoot flash pictures with these strobes at my camera's lowest ISO setting and apertures larger than f/8.

- **Vanishing act.** Create your own ghost town despite a fully populated image by using a longer shutter speed. With an ND8 filter and shutter speeds of 15 to 30 seconds, moving vehicular and pedestrian traffic doesn't remain in one place long enough to register in your image. With enough neutral density, you can even make people and things vanish in full daylight.

■ **Sky and foreground balance.** A special kind of neutral-density, the split ND, or graduated ND filter, is a special tool for landscape photographers. In the average scene, the sky is significantly brighter than the foreground and well beyond the ability of most digital camera sensors to capture detail in both. An ND filter that is dark at the top and clear at the bottom can even out the exposure, restoring the puffy white clouds and clear blue sky to your images. There are other types of split and graduated filters available, as you'll learn from the next section.

Split-density and graduated filters are available in both traditional round screw-in filter types as well as in square versions that can be slipped into a Cokin or similar filter holder. The most useful variety is the graduated neutral-density filter, which is a "must have" filter that belongs in any serious photographer's kit.

A graduated ND filter (or its kin, the non-graduated split-density filter) has gray coloration in its "top" half, and clear glass in its "bottom" region. In practice, though, the filter can be rotated in use so that the neutral density is placed in the bottom or left/right orientations. The filter holds back light in the neutral-density region, while allowing all the light to pass through the clear portion. The most common usage is to darken the sky in landscape photos shot in horizontal format (which would otherwise be overexposed) and allow the foreground area of the scene to be exposed normally. Because the filter can be rotated, you can use it for this purpose when shooting vertical landscape photos, as well, or, simply to darken the left, right, or bottom of an image when taking pictures in any orientation.

Infrared Filters

One of the most exciting emerging applications for digital cameras is infrared photography, which provides a new and eerie perspective on many familiar subjects. The majority of cameras are fully capable of taking photographs using only infrared illumination when equipped with a *cut-off* filter that blocks visible light and allows only IR light to continue on to the sensor. An IR filter will let you produce images with dramatic dark skies, vivid puffy white clouds, and ghostly foliage on trees. IR can be used on subjects other than landscapes, too, to image humans with strange, pale complexions, and architecture quite unlike anything you may have seen before. However, because your camera itself includes a filter designed to *pass* visible light and *block* most (but not all) infrared illumination, you'll have to shoot using very slow shutter speeds, because so little light is left for the exposure once the majority of both visible and infrared light have been removed.

Even though an IR filter seems virtually black to the human eye, and will obscure your image on the LCD, the G12 is perfect for infrared photography, because you can view, unhindered, through the camera's optical viewfinder.

To use an IR filter, you'll almost always want to mount the camera on a tripod. First, set your white balance manually—but point the lens at a subject that reflects a lot of IR, such as grass or foliage. Then, set up the camera, frame your image, focus, and set exposure with the camera set on Manual (start with ISO 200 and about 1/4 second at f/8). You might want to use the self-timer to avoid residual camera shake that can result from pressing the shutter release button.

Review your image on the camera's LCD. If you've set the white balance correctly, the image will appear in a black-and-white or sandstone-and-gray color scheme. (See Figure 7.10.) Otherwise, the image may be tinted slightly red. You can remove color casts later in your image editor (see my book *David Busch's Digital Infrared Pro Secrets* for detailed instructions on post-processing IR photos). The most important thing to look for during the shooting session is proper exposure. If the image appears too dark or light, change the exposure appropriately. It might be a good idea to bracket your shots (making several exposures of more and less than your first guesstimate) in any case.

Special Effects Filters

You can make your own special effects filters. With a little work, you can sometimes duplicate the effects of filters that would be quite costly to buy, or create brand-new filters that have never been seen before outside your imagination. It's easy to manufacture new filters out of ordinary, otherwise-useless filters like skylight or UV filters. You can use a Cokin-style filter holder and make square filters.

Here are some ideas for some do-it-yourself special effects filters:

- **Glamour filter.** Take an old UV filter (it doesn't even matter if it is scratched), and carefully smear the outer edges with petroleum jelly. Such a filter is a great tool for romantic portraits of females who want to be seen with flawless skin. The smaller the center spot, the larger the area of diffusion.

- **More glamour.** A piece of stocking material or other material with texture can be used to provide even more diffusion over the entire image—or cut a hole in the middle to allow the central portion of the image to remain sharp. Many years ago, Hollywood cinematographers photographed aging stars through a chicken feather to provide the needed softening effect. (One wag pointed out that a certain actress was so wrinkled that it would be advisable to use an entire chicken, instead.)

- **Starry night.** A piece of window screen material can produce a star-point effect. The advantage of going the do-it-yourself route is that your screen "filter" can be fitted even to lenses that don't normally accept filters. Just use a large enough piece.

Figure 7.10
Infrared
photography
provides other-
worldly effects.

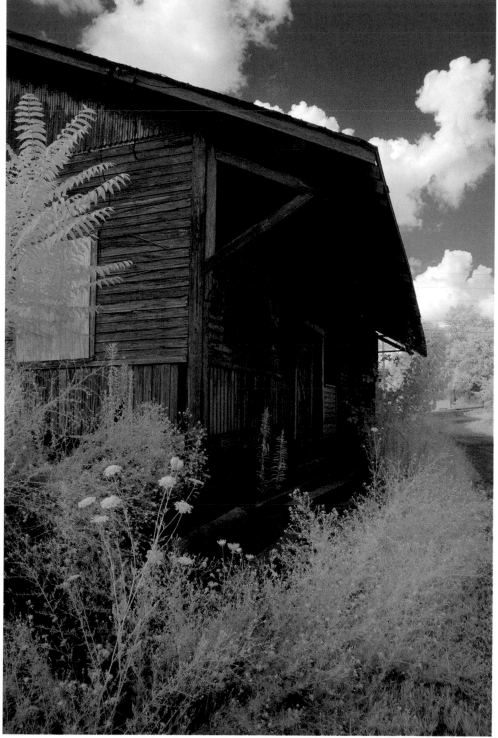

- **Split filters.** Get yourself a sample book of Lee or Roscoe lighting filter swatches and use pieces to construct a split neutral-density filter (use gray swatches) or split color filters. While lighting filters may not have the optical quality you need for super sharp photos, you may find them good enough for experimentation.

- **Go wild.** Anything that you can fit in front of your lens, from a kaleidoscope with the colored-speckle end removed, to diffraction gratings can be used to produce a special effects filter. You can try out various possibilities just by holding them in front of the camera lens; then convert the ones that work best into permanent make-shift filters.

8

Making Light Work for You

Successful photographers and artists have an intimate understanding of the importance of light in shaping an image. Rembrandt was a master of using light to create moods and reveal the character of his subjects. Artist Thomas Kinkade's official tagline is "Painter of Light." The late Dean Collins, co-founder of Finelight Studios, revolutionized how a whole generation of photographers learned and used lighting. It's impossible to underestimate how the use of light adds to—and how misuse can detract from—your photographs.

All forms of visual art use light to shape the finished product. Sculptors don't have control over the light used to illuminate their finished work, so they must create shapes using planes and curved surfaces so that the form envisioned by the artist comes to life from a variety of viewing and lighting angles. Painters, in contrast, have absolute control over both shape and light in their work, as well as the viewing angle, so they can use both the contours of their two-dimensional subjects and the qualities of the "light" they use to illuminate those subjects to evoke the image they want to produce.

Photography is a third form of art. The photographer may have little or no control over the subject (other than posing human subjects) but can often adjust both viewing angle *and* the nature of the light source to create a particular compelling image. The direction and intensity of the light sources create the shapes and textures that we see. The distribution and proportions determine the contrast and tonal values: whether the image is stark or high key, or muted and low in contrast. The colors of the light (because even "white" light has a color balance that the sensor can detect), and how much of those colors the subject reflects or absorbs, paint the hues visible in the image.

As a PowerShot G12 photographer, you must learn to be a painter and sculptor of light if you want to move from *taking* a picture to *making* a photograph. This chapter provides an introduction to using the two main types of illumination: *continuous* lighting (such as daylight, incandescent, or fluorescent sources) and the brief, but brilliant snippets of light we call *electronic flash*.

Continuous Illumination versus Electronic Flash

Continuous lighting is exactly what you might think: uninterrupted illumination that is available all the time during a shooting session. Daylight, moonlight, and the artificial lighting encountered both indoors and outdoors count as continuous light sources (although all of them can be "interrupted" by passing clouds, solar eclipses, a blown fuse, or simply by switching off a lamp). Indoor continuous illumination includes both the lights that are there already (such as incandescent lamps or overhead fluorescent lights indoors) and fixtures you supply yourself, including photoflood lamps or reflectors used to bounce existing light onto your subject.

The surge of light we call electronic flash is produced by a burst of photons generated by an electrical charge that is accumulated in a component called a *capacitor* and then directed through a glass tube containing xenon gas, which absorbs the energy and emits the brief flash. Electronic flash is notable because it can be much more intense than continuous lighting, lasts only a brief moment, and can be much more portable than supplementary incandescent sources. It's a light source you can carry with you and use anywhere.

Indeed, your PowerShot G12 has an electronic flash unit built in, as shown in Figure 8.1. But you can also use an external flash, either mounted on the camera's accessory shoe or used off-camera and linked with a cable to the accessory shoe with an adapter, or triggered by a slave light (which sets off a flash when it senses the firing of another unit). Studio flash units are electronic flash, too, and aren't limited to "professional" shooters, as there are economical "monolight" (one-piece flash/power supply) units available in the $200 price range. A serious PowerShot G12 photographer (or someone who uses a G12 as a backup to a digital SLR) might want to buy a couple to store in a closet and use to set up a home studio, or use as supplementary lighting when traveling away from home.

There are advantages and disadvantages to each type of illumination. Here's a quick checklist of pros and cons:

- **Lighting preview—Pro: continuous lighting.** With continuous lighting, you always know exactly what kind of lighting effect you're going to get and, if multiple lights are used, how they will interact with each other. With electronic flash, the general effect you're going to see may be a mystery until you've built some

experience, and you may need to review a shot on the LCD, make some adjustments, and then reshoot to get the look you want. (In this sense, a digital camera's review capabilities replace the Polaroid test shots pro photographers relied on in decades past.)

- **Lighting preview—Con: electronic flash.** While some external flash units have a modeling light function (consisting of a series of low-powered bursts that flash for a period of time), your PowerShot G12 lacks such a capability in its internal flash, and, in any case, this feature is no substitute for continuous illumination, or an always-on modeling lamp like that found in studio flash. As the number of flash units increases, lighting previews, especially if you want to see the proportions of illumination provided by each flash, grow more complex.

- **Exposure calculation—Pro: continuous lighting.** Your PowerShot G12 has no problem calculating exposure for continuous lighting, because the illumination remains constant and can be measured through a sensor that interprets the light reaching the viewfinder. The amount of light available just before the exposure will, in almost all cases, be the same amount of light present when the shutter is released. The PowerShot G12's Spot metering mode can be used to measure and compare the proportions of light in the highlights and shadows, so you can make an adjustment (such as using more or less fill light) if necessary. You can even use a handheld light meter to measure the light yourself and set the exposure in Manual mode.

Figure 8.1
One form of light that's always available is the built-in flash on your PowerShot G12.

- **Exposure calculation—Con: electronic flash.** Electronic flash illumination doesn't exist until the flash fires, and so can't be measured by the PowerShot G12's exposure sensor during the exposure. Instead, the light must be measured by interpreting the intensity of a pre-flash triggered an instant before the main flash, as it is reflected back to the camera and through the lens. If you have a do-it-yourself bent, there are hand-held flash meters, too, including models that measure both flash and continuous light.

- **Evenness of illumination—Pro/con: continuous lighting.** Of continuous light sources, daylight, in particular, provides illumination that tends to fill an image completely, lighting up the foreground, background, and your subject almost equally. Shadows do come into play, of course, so you might need to use reflectors or fill-in light sources to even out the illumination further, but barring objects that block large sections of your image from daylight, the light is spread fairly evenly. Indoors, however, continuous lighting is commonly less evenly distributed. The average living room, for example, has hot spots and dark corners. But on the plus side, you can *see* this uneven illumination and compensate with additional lamps:

- **Evenness of illumination—Con: electronic flash.** Electronic flash units (like continuous light sources such as lamps that don't have the advantage of being located 93 million miles from the subject) suffer from the effects of their proximity. The *inverse square law*, first applied to both gravity and light by Sir Isaac Newton, dictates that as a light source's distance increases from the subject, the amount of light reaching the subject falls off proportionately to the square of the distance. In plain English, that means that a flash or lamp that's eight feet away from a subject provides only one-quarter as much illumination as a source that's four feet away (rather than half as much). (See Figure 8.2.) This translates into relatively shallow "depth-of-light."

- **Action stopping—Con: continuous lighting.** Action stopping with continuous light sources is completely dependent on the shutter speed you've dialed in on the camera. And the speeds available are dependent on the amount of light available and your ISO sensitivity setting. Outdoors in daylight, there will probably be enough sunlight to let you shoot at 1/2,000th second and f/6.3 with a non-grainy sensitivity setting of ISO 400. That's a fairly useful combination of settings if you're not using a super-telephoto with a small maximum aperture. But inside, the reduced illumination quickly has you pushing your PowerShot G12 to its limits. For example, if you're shooting indoor sports, there probably won't be enough available light to allow you to use a 1/2,000th second shutter speed (although I routinely shoot indoor basketball at ISO 1600 and 1/500th second at f/4). In many indoor sports situations, you may find yourself limited to 1/500th second or slower.

Figure 8.2
A light source that is twice as far away provides only one-quarter as much illumination.

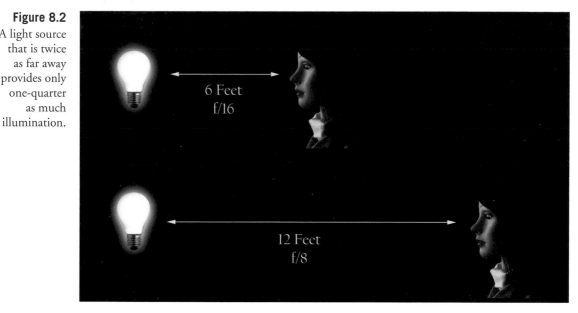

■ **Action stopping—Pro: electronic flash.** When it comes to the ability to freeze moving objects in their tracks, the advantage goes to electronic flash. The brief duration of electronic flash serves as a very high "shutter speed" when the flash is the main or only source of illumination for the photo. Your PowerShot G12's shutter speed may be set for 1/200th second during a flash exposure, but if the flash illumination predominates, the *effective* exposure time will be the 1/1,000th to 1/50,000th second or less duration of the flash, because the flash unit reduces the amount of light released by cutting short the duration of the flash. Figure 8.3 shows an eye-catching "hammer breaks bulb" photo by Cleveland photographer Kris Bosworth, who reports that syncing the flash with the event was the trickiest part of the whole experiment. The only fly in the ointment is that, if the ambient light is strong enough, it may produce a secondary, "ghost" exposure, as I'll explain later in this chapter.

■ **Cost—Pro: continuous lighting.** Incandescent or fluorescent lamps are generally much less expensive than electronic flash units, which can easily cost several hundred dollars. I've used everything from desktop hi-intensity lamps to reflector floodlights for continuous illumination at very little cost. There are lamps made especially for photographic purposes, too, priced up to $50 or so. Maintenance is economical, as well; many incandescent or fluorescent lamps use bulbs that cost only a few dollars.

- **Cost—Con: electronic flash.** Electronic flash units aren't particularly cheap. The lowest-cost dedicated flash designed specifically for the Canon digital cameras is about $110. (I'll tell you about specific flash units later in this chapter.) Such units are limited in features, however. Plan to spend some money to get the features that a sophisticated electronic flash offers.

Figure 8.3
A switch that was closed by the impact of the hammer on the bulb triggered the electronic flash that froze this action.

■ **Flexibility—Con: continuous lighting.** Because incandescent and fluorescent lamps are not as bright as electronic flash, the slower shutter speeds required (see Action stopping, above) mean that you may have to use a tripod more often, especially when shooting portraits. The incandescent variety of continuous lighting gets hot, especially in the studio, and the side effects range from discomfort (for your human models) to disintegration (if you happen to be shooting perishable foods like ice cream). The heat also makes it more difficult to add filtration to incandescent sources.

■ **Flexibility—Pro: electronic flash.** Electronic flash's action-freezing power allows you to work without a tripod in the studio (and elsewhere), adding flexibility and speed when choosing angles and positions. Flash units can be easily filtered, and, because the filtration is placed over the light source rather than the lens, you don't need to use high-quality filter material. Roscoe or Lee lighting gels, which may be too flimsy to use in front of the lens, can be mounted or taped in front of your flash with ease.

Continuous Lighting Basics

While continuous lighting and its effects are generally much easier to visualize and use than electronic flash, there are some factors you need to take into account, particularly the color temperature of the light. (Color temperature concerns aren't exclusive to continuous light sources, of course, but the variations tend to be more extreme and less predictable than those of electronic flash.)

Color temperature, in practical terms, is how "bluish" or how "reddish" the light appears to be to the digital camera's sensor. Indoor illumination is quite warm, comparatively, and appears reddish to the sensor. Daylight, in contrast, seems much bluer to the sensor. Our eyes (our brains, actually) are quite adaptable to these variations, so white objects don't appear to have an orange tinge when viewed indoors, nor do they seem excessively blue outdoors in full daylight. Yet, these color temperature variations are real and the sensor is not fooled. To capture the most accurate colors, we need to take the color temperature into account in setting the color balance (or *white balance*) of the PowerShot G12—either automatically using the camera's smarts or manually, using our own knowledge and experience.

Color temperature can be confusing, because of a seeming contradiction in how color temperatures are named: warmer (more reddish) color temperatures (measured in degrees Kelvin) are the *lower* numbers, whereas cooler (bluer) color temperatures are *higher* numbers. It might not make sense to say that 3,400K is warmer than 6,000K, but that's the way it is. If it helps, think of a glowing red ember contrasted with a white-hot welder's torch, rather than fire and ice.

The confusion comes from physics. Scientists calculate color temperature from the light emitted by a theoretical object called a black body radiator, which absorbs all the radiant energy that strikes it, and reflects none at all. Such a black body not only *absorbs* light perfectly, but it *emits* it perfectly when heated (and since nothing in the universe is perfect, that makes it theoretical).

At a particular physical temperature, this imaginary object always emits light of the same wavelength or color. That makes it possible to define color temperature in terms of actual temperature in degrees on the Kelvin scale that scientists use. Incandescent light, for example, typically has a color temperature of 3,200K to 3,400K. Daylight might range from 4,500K to 6,000K. Each type of illumination we use for photography has its own color temperature range—with some cautions. The next sections will summarize everything you need to know about the qualities of these light sources.

Daylight

Daylight is produced by the sun, and so is moonlight (which is just reflected sunlight). Daylight is present, of course, during daytime hours, even when you can't see the sun. When sunlight is direct, it can be bright and harsh. If daylight is diffused by clouds, softened by bouncing off objects such as walls or your photo reflectors, or filtered by shade, it can be much dimmer and less contrasty.

Daylight's color temperature can vary quite widely. It is highest (most blue) at noon when the sun is directly overhead because the light is traveling through a minimum amount of the filtering layer we call the atmosphere. The color temperature at high noon may be 6,000K. At other times of day, the sun is lower in the sky and the particles in the air provide a filtering effect that warms the illumination to about 5,500K for most of the day. Starting an hour before dusk and for an hour after sunrise, the warm appearance of the sunlight is even visible to our eyes when the color temperature may dip to 5,000–4,500K, as shown in Figure 8.4.

Because you'll be taking so many photos in daylight, you'll want to learn how to use or compensate for the brightness and contrast of sunlight, as well as how to deal with its color temperature. I'll provide some hints later in this chapter.

Incandescent/Tungsten Light

The term incandescent or tungsten illumination is usually applied to the direct descendants of Thomas Edison's original electric lamp. Such lights consist of a glass bulb that contains a vacuum, or is filled with a halogen gas, and contains a tungsten filament that is heated by an electrical current, producing photons and heat. Tungsten-halogen lamps are a variation on the basic light bulb, using a more rugged (and longer-lasting) filament that can be heated to a higher temperature, housed in a thicker glass or quartz envelope, and filled with iodine or bromine ("halogen") gases. The higher temperature

Figure 8.4 At dawn and dusk, the color temperature of daylight may dip as low as 4,500K.

allows tungsten-halogen (or quartz-halogen/quartz-iodine, depending on their construction) lamps to burn "hotter" and whiter. Although popular for automobile headlamps today, they've also been popular for photographic illumination.

Although incandescent illumination isn't a perfect black body radiator, it's close enough that the color temperature of such lamps can be precisely calculated and used for photography without concerns about color variation (at least, until the very end of the lamp's life).

The other qualities of this type of lighting, such as contrast, are dependent on the distance of the lamp from the subject, type of reflectors used, and other factors that I'll explain later in this chapter.

Fluorescent Light/Other Light Sources

Fluorescent light has some advantages in terms of illumination, but some disadvantages from a photographic standpoint. This type of lamp generates light through an electro-chemical reaction that emits most of its energy as visible light, rather than heat, which is why the bulbs don't get as hot. The type of light produced varies depending on the phosphor coatings and type of gas in the tube. So, the illumination fluorescent bulbs produce can vary widely in its characteristics.

That's not great news for photographers. Different types of lamps have different "color temperatures" that can't be precisely measured in degrees Kelvin, because the light isn't produced by heating. Worse, fluorescent lamps have a discontinuous spectrum of light that can have some colors missing entirely. A particular type of tube can lack certain shades of red or other colors (see Figure 8.5), which is why fluorescent lamps and other alternative technologies such as sodium-vapor illumination can produce ghastly look-ing human skin tones. Their spectra can lack the reddish tones we associate with healthy skin and emphasize the blues and greens popular in horror movies.

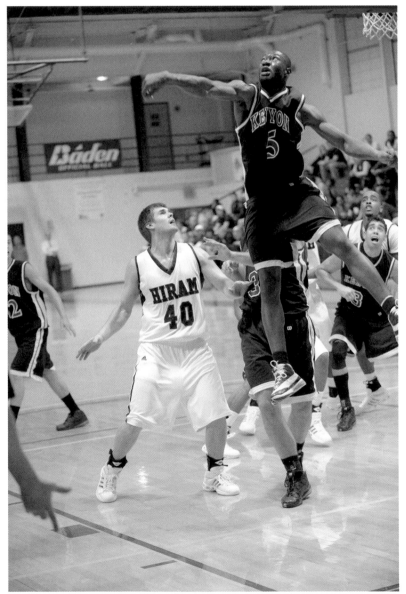

Figure 8.5
The fluorescent lighting in this gym added a distinct green-ish cast to the image.

Adjusting White Balance

I showed you how to adjust white balance in Chapter 4, using the PowerShot G12's built-in presets and custom white balance capabilities.

In most cases, however, the PowerShot G12 will do a good job of calculating white balance for you, so Auto can be used as your choice for the white balance setting most of the time. Use the preset values or set a custom white balance that matches the current shooting conditions when you need to. The only really problematic light sources are likely to be fluorescents. Some lighting vendors, such as GE and Sylvania, may actually provide a figure known as the *color rendering index* (or CRI), which is a measure of how accurately a particular light source represents standard colors, using a scale of 0 (some sodium-vapor lamps) to 100 (daylight and most incandescent lamps). Daylight fluorescents and deluxe cool white fluorescents might have a CRI of about 79 to 95, which is perfectly acceptable for most photographic applications. Warm white fluorescents might have a CRI of 55. White deluxe mercury vapor lights are less suitable, with a CRI of 45, while low-pressure sodium lamps can vary from CRI 0-18.

Remember that if you shoot RAW, you can specify the white balance of your image when you import it into Photoshop, Photoshop Elements, or another image editor using your preferred RAW converter. While color-balancing filters that fit on the front of the lens exist, they are primarily useful for film cameras, because film's color balance can't be tweaked as extensively as that of a digital camera's sensor.

Electronic Flash Basics

Until you delve into the situation deeply enough, it might appear that serious photographers have a love/hate relationship with electronic flash. You'll often hear that flash photography is less natural looking, and that the built-in flash in most cameras should never be used as the primary source of illumination because it provides a harsh, garish look. Indeed, most "pro" cameras like the Canon EOS 1D Mark III and 1Ds Mark III don't have a built-in flash at all. Available ("continuous") lighting is praised, and built-in flash photography seems to be roundly denounced.

In truth, however, the bias is against *bad* flash photography. Indeed, flash has become the studio light source of choice for pro photographers, because it's more intense (and its intensity can be varied to order by the photographer), freezes action, frees you from using a tripod (unless you want to use one to lock down a composition), and has a snappy, consistent light quality that matches daylight. And even pros will concede that the built-in flash of the Canon PowerShot G12 has some important uses as an adjunct to existing light, particularly to fill in dark shadows.

But electronic flash isn't as inherently easy to use as continuous lighting. As I noted earlier, electronic flash units are more expensive, don't show you exactly what the lighting

effect will be (unless you use a second source called a *modeling light* for a preview), and the exposure of electronic flash units is more difficult to calculate accurately.

How Electronic Flash Works

The built-in flash is somewhat limited in range (Canon rates it effective out to 23 feet); you'll see why external flash units are often a good idea later in this chapter.

An electronic flash (whether built in or connected to the PowerShot G12 through its hot shoe) is triggered at the instant of exposure, during a period when the sensor is fully exposed by the shutter. The PowerShot G12 has a combination mechanical and electronic shutter. The shutter completely opens, at which point the flash can be triggered. This is called *1st-curtain sync*, although in the case of the G12 there is no "curtain" (the term refers to the pair of curtains that travel across the sensor frame with so-called *focal plane* shutters). The flash fires; then, after a delay that can vary from 15 seconds to 1/2,000th second with the PowerShot G12, the shutter closes. If the flash is triggered just before the shutter starts to close, then *2nd-curtain sync* is used. In both cases, though, a shutter speed of 1/2,000th second is the maximum that can be used to take a photo. If you try to set the PowerShot G12's shutter to a faster speed in Tv or M mode while using flash, the camera will automatically adjust the shutter speed down to that model's maximum shutter speed when using flash.

Ghost Images

The difference between triggering the flash when the shutter just opens, or just when it begins to close might not seem like much. But whether you use 1st-curtain sync (the default setting) or 2nd-curtain sync (an optional setting) can make a significant difference to your photograph *if the ambient light in your scene also contributes to the image.*

At faster shutter speeds, particularly 1/500th second or faster, there isn't much time for the ambient light to register, unless it is very bright. It's likely that the electronic flash will provide almost all the illumination, so the choice of 1st-curtain sync or 2nd-curtain sync isn't very important. However, at slower shutter speeds, or with very bright ambient light levels, there is a significant difference, particularly if your subject is moving, or the camera isn't steady.

In any of those situations, the ambient light will register as a second image accompanying the flash exposure, and if there is movement (of camera or subject), that additional image will not be in the same place as the flash exposure. It will show as a ghost image and, if the movement is significant enough, as a blurred ghost image trailing in front of or behind your subject in the direction of the movement.

As I noted, when you're using 1st-curtain sync, the flash's main burst goes off the instant the shutter opens fully (a pre-flash is used to measure exposure in auto flash modes fires *before* the shutter opens). This burst produces an image of the subject on the sensor.

Then, the shutter remains open for an additional period (in the range of 15 seconds to 1/2,000th second, as I said). If your subject is moving, say, towards the right side of the frame, the ghost image produced by the ambient light will produce a blur on the right side of the original subject image, making it look as if your sharp (flash-produced) image is chasing the ghost. For those of us who grew up with lightning-fast superheroes who always left a ghost trail *behind them*, that looks unnatural (see Figure 8.6).

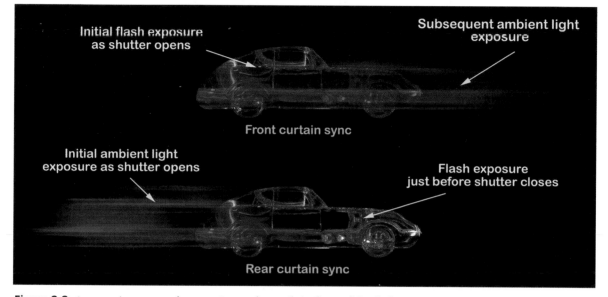

Figure 8.6 1st-curtain sync produces an image that trails in front of the flash exposure (top), while 2nd-curtain sync creates a more "natural looking" trail behind the flash image.

So, Canon uses 2nd-curtain sync to remedy the situation. In that mode, the shutter opens, as before. The shutter remains open for its designated duration, and the ghost image forms. If your subject moves from the left side of the frame to the right side, the ghost will move from left to right, too. *Then*, about 1.5 milliseconds before the second shutter curtain closes, the flash is triggered, producing a nice, sharp flash image *ahead* of the ghost image. Voilà! We have monsieur *Speed Racer* outdriving his own trailing image.

Avoiding Sync Speed Problems

In the past, before cameras and flash units became as sophisticated as they are today, photographers sometimes ran into problems when the camera's shutter speed was too fast to synchronize properly with the flash. Nowadays, I generally end up with sync speed problems only when shooting using third-party flash units, rather than my PowerShot G12's built-in flash or a Canon dedicated Speedlite. That's because if you're using either type of "smart" flash, the camera knows that a strobe is attached, and remedies any unintentional goof in shutter speed settings. That luxury is not available when using non-dedicated, "dumb" flash units.

In addition, the PowerShot G12 can sync with the flash at any speed up to 1/500th second, and in some circumstances, with a Canon-dedicated external flash it can sync at speeds up to 1/2,000th second. If you happen to set the PowerShot G12's shutter to a faster speed in Tv or M mode, the camera will automatically adjust the shutter speed down to 1/2,000th on the G12. In Av, P, or any of the more automatic shooting modes, where the PowerShot G12 selects the shutter speed, it will never choose a shutter speed higher than 1/2,000th for the G12 when using flash.

Determining Exposure

Calculating the proper exposure for an electronic flash photograph is a bit more complicated than determining the settings by continuous light. The right exposure isn't simply a function of how far away your subject is (which the PowerShot G12 can figure out based on the autofocus distance that's locked in just prior to taking the picture). Various objects reflect more or less light at the same distance so, obviously, the camera needs to measure the amount of light reflected back and through the lens. Yet, as the flash itself isn't available for measuring until it's triggered, the PowerShot G12 has nothing to measure.

The solution is to fire the flash twice. The initial shot is a pre-flash that can be analyzed, then followed by a main flash that's given exactly the calculated intensity needed to provide a correct exposure. As a result, the primary flash may be longer for distant objects and shorter for closer subjects, depending on the required intensity for exposure. This through-the-lens evaluative flash exposure system operates whenever the built-in internal flash is used, or if you have attached a Canon dedicated flash unit to the PowerShot G12.

Guide Numbers

Guide numbers, usually abbreviated GN, are a way of specifying the power of an electronic flash in a way that can be used to determine the right f/stop to use at a particular shooting distance and ISO setting. In fact, before automatic flash units became prevalent, the GN was actually used to do just that. Today, guide numbers are most useful for comparing the power of various flash units, and Canon doesn't even provide GN figures for the G12's built-in flash. They are available for external flash units, described later in this chapter, and you can use the guide numbers to directly compare how powerful these add-on flashes are.

Using the Built-In Flash

The Canon PowerShot G12's built-in flash is a handy accessory because it is available as required, without the need to carry an external flash around with you constantly. This section explains how to use the built-in flash in the various shooting modes. This explanation is not as quick and easy as you might expect, because this camera, as you've

already seen, is quite sophisticated in its general shooting capabilities, and it's also no slouch in the area of flash control options. There are numerous features and functions that I need to describe before I get into the nitty-gritty of which settings to use when. I also need to make a few general points about the nature of your camera's built-in flash.

The Always-Ready Flash

Although this is an obvious point, it's worth emphasizing. The built-in flash of the PowerShot G12 is always available for use without any physical movement of the flash mechanism. In other words, unlike the built-in units on some other Canon cameras, including both dSLRs and compacts, you don't have to pop up the flash unit with a switch or other mechanism. This fact has a couple of important implications.

First, you need to be sure you have the flash set the way you want it, especially if you're in a location where flash should not be used, such as certain museums, theaters, or other locations or gatherings. With some other cameras, you can close the built-in flash unit physically and be certain it cannot fire. With the PowerShot G12, there's no way to be certain from looking at the camera that the flash will not fire; you need to check the settings to make sure there's no chance it will go off just when its brilliant discharge is least welcome. One bit of good news in this area: as I'll discuss a bit later in this section, with the PowerShot G12, unlike some other cameras in this class, you can *always* force the flash to its Off setting, even when shooting in the Auto mode.

Another point about the PowerShot G12's always-ready flash is that you never have to worry about fumbling for a switch or button to get the flash into position to fire; it's constantly ready to do its job, if you have the camera's settings arranged so it will fire. So, in that sense, the always-deployed flash can provide a considerable boost to the speed of your shooting in situations where flash suddenly becomes necessary. If you need to use it to fill in dark shadows as fill flash when shooting in sunlight, set the flash to On, and it's ready to go. (See Figure 8.7.)

Range and Angle of View

The PowerShot G12's built-in flash unit has several virtues, but extensive range is not one of them. As I mentioned above, the G12 flash's effective range is no more than about 23 feet, which is less powerful than the larger external flash units available for the PowerShot. Therefore, you need to be mindful of the fact that the built-in flash can be a useful tool for filling in shadows and grabbing snapshots indoors, but it's not a substitute for a stronger, dedicated unit such as those used by photojournalists and wedding photographers.

When you're deciding whether the built-in flash is likely to be of use in a particular situation, here are a couple of important factors to keep in mind: distance and ISO setting. The farther away your subject is from the camera, the greater the light fall-off,

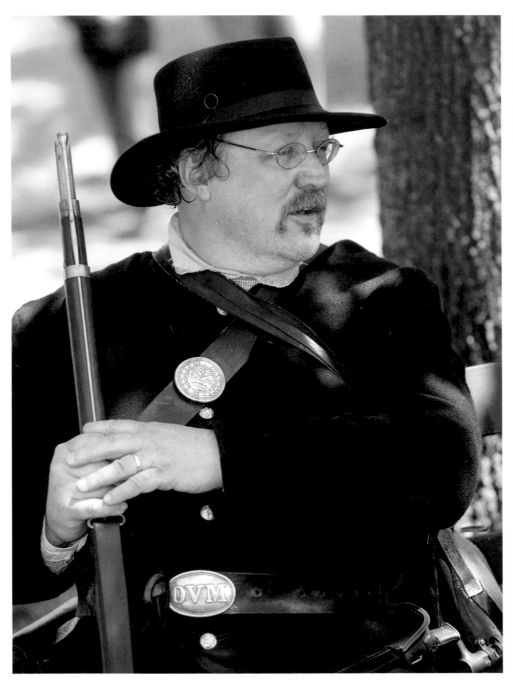

Figure 8.7
The G12's built-in flash is instantly ready for fill-flash duties to brighten shadows in daylight shots.

thanks to the inverse square law discussed earlier. Keep in mind that a subject that's twice as far away receives only one-quarter as much light, which is two f/stops' worth. Also, the higher the ISO sensitivity, the more photons captured by the sensor. So, doubling the sensitivity from ISO 100 to 200 produces the same effect as, say, opening up your lens from f/8 to f/5.6.

There's one other factor that often affects the performance of built-in flash units, but that is not as big an issue with the PowerShot G12 as with many other cameras: the focal length or angle of view of the lens for any given shot. With many other compact cameras (and even some dSLRs), the built-in flash unit does not have a variable angle of view. In other words, every time the flash fires, it sends out the same size or width beam of light; it does not vary the shape of the beam to match the zoom factor of your shot. So, if you are taking a wide-angle shot, the flash may not fully cover the area in the scene, or, if you have zoomed your lens in for a telephoto shot, a good portion of the flash's coverage may be "wasted" by falling outside of the field of view of the lens. The PowerShot G12, though, has what Canon calls the Light Guide Zoom Flash, whose angle of view changes as the lens zooms in and out. So, with this flash unit, there is a relatively close match between the coverage by the lens and the coverage by the flash, resulting in a more efficient use of this resource than with some other cameras.

Available Settings for the Built-In Flash

Now it's just about time to get into the details of how to work with the settings for the PowerShot G12's built-in flash. As I've indicated, though, the flash system with this camera is remarkably sophisticated for a compact camera, and I need to go over a few general points about how the flash settings are structured before I discuss the details of the various settings.

The main point to bear in mind when working with the built-in flash is that your choices of flash settings will change, depending on other choices you have made in setting up the camera for your shot. There are three levels of decisions you can make when you're deciding how the built-in flash should operate, and all three decisions, one after the other, have an impact on how the flash will operate when you press the shutter button to take the picture.

First, you choose a shooting mode; second, you can press the Flash button to choose a general status for the flash; and third, if you're using flash, you can use the Flash Control submenu to make further choices about how the flash will operate when and if it fires. Of course, you don't have to consciously make all three of those choices; if you don't think about them yourself, the camera will use its default settings and make the choices for you. But I'm assuming you are the sort of photographer who wants to take control over such decisions. So let's look at those three choices in more detail now.

Mode Dial: Shooting Mode

The shooting mode you select with the mode dial can have considerable influence over the behavior of the flash. In some modes (for example, the Fireworks and Sports versions of SCN mode), the flash is forced off and there's nothing you can do to turn it on—except switch out of Fireworks or Sports mode. In many of the SCN modes and Auto mode, the camera will initially set the flash to Auto, but will let you override that choice. However, in those more automatic shooting modes, although you can choose whether the flash is on or off, your other choices of flash behavior, such as controlling flash output and shutter sync, are limited. In the most advanced shooting modes, M, Av, Tv, and P, most of the decisions about the use of flash are completely within your control. With the G12, and P mode, you can select Auto, On, Slow Synchro, and Off; with Tv you can choose On or Off; with Av, the selections are On, Slow Synchro, and Off. In Manual mode, you can choose Off or On.

Flash Button: On, Off, or Auto (and Sometimes Slow Synchro)

After selecting the shooting mode, the next stage of control you have over the flash is exercised with the Flash button, which also acts as the right cross key. In rare cases (Fireworks and Sports types of SCN mode on both the G12, as discussed previously, and also the ISO 3200 type of SCN mode), the Flash button is disabled. You can press it until you have a lightning bolt imprinted on your thumb, and nothing will happen (except to your thumb). (Also, it should go without saying, the Flash button has no effect when the camera is set to Movie mode.)

But, in every other shooting mode, the camera lets you make choices with the Flash button. For the few shooting modes for which Slow Synchro flash is a possible choice, you select Slow Synchro with the Flash button (see Figure 8.8). The only choices available through the Flash button are setting the flash to On, Auto, or Off. (See Figure 8.9.) In some cases, only two of those three choices are available.

Conversely, if the built-in flash is set to Off, the flash will not fire, even if a solar eclipse takes place while you're shooting. The screen will show the lightning bolt inside the universal negative symbol—a circle with a line through the center. If you make that setting, of course, no other flash settings come into play. This is the setting you use in that museum with a $500 fine for using flash.

Finally, if you use the Flash button to set the flash to Auto, putting the lightning bolt with the letter "A" beside it on the LCD screen, then the camera will use its autoexposure circuitry to determine whether the flash needs to fire in order to expose the scene properly. In that case, you're telling the camera, in effect, "I'm not sure if we're going to need flash—you decide."

Figure 8.8
On the PowerShot G12, pressing the Flash button can give you access to as many as four choices for setting the built-in flash: Auto, On, Slow Synchro, and Off.

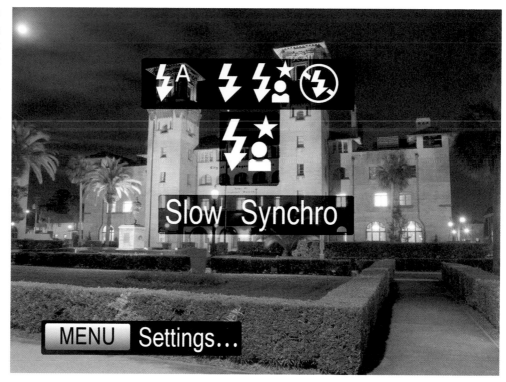

Figure 8.9
The lightning bolt on the LCD display means that the built-in flash unit is forced to its "On" setting and will definitely fire when the shutter button is pressed.

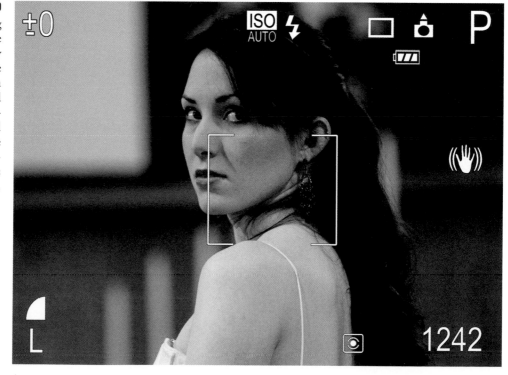

Flash Control Menu: Other Settings

Okay, let's assume you have chosen your shooting mode and you have used the Flash button to set the flash to Auto or On, so there's a good chance it will fire. Now, you have a third set of choices to make. You can call up the Flash Control submenu (see Figure 8.10) and pick from an array of further options for how the flash will operate if it does fire. This array of options will vary according to the other choices you have made. Right now, I'm going to discuss all of the possible choices that can be made from this submenu, even though you're never going to see all of the choices at any one time.

As a reminder, there are three ways to get to the Flash Control submenu: select Flash Control from the Shooting menu; press the Flash button once lightly, then the MENU button; or hold down the Flash button until the Flash Control submenu appears. If you just need the Flash Output/Flash Exposure Compensation setting, you can select that item by pressing the FUNC./SET key and selecting the fourth item down on the FUNC. menu.

Here are all the choices that may be available on the Flash Control submenu, depending on the context:

■ **Flash Mode.** This option can be set to either Manual or Auto (see Figure 8.11). Now, here's a slightly tricky point to be aware of: This is one of two uses of the term "Auto" in connection with the operation of the flash, with two different meanings. Here is what "Auto" means in this case: Unlike the setting of Auto as opposed to On or Off, which controls *whether* the flash will fire, this setting of Auto controls *how* the flash will be fired—that is, through automatic exposure control, or manual setting of the flash output (which we'll discuss next). In many cases, such as with the Auto shooting mode and almost all of the SCN modes, this option is not available on the Flash Control submenu, because the camera sets Flash mode to Auto without asking you. Also, when the shooting mode is set to Manual, the camera sets Flash mode to Manual, again without consulting you. The only times this setting is available for you to set are when the Shooting mode is set to Av or Tv.

■ **Flash Exposure Compensation.** This setting is available only when Flash mode (see above) is set to Auto, meaning the camera will use its metering to determine the intensity of the flash exposure. The Flash Exposure Compensation setting is analogous to the standard exposure compensation setting. Although the camera will initially determine the correct flash exposure, you have the option of dialing in positive or negative amounts of flash output, relative to that automatic setting. The adjustment is displayed numerically in 1/3 EV steps, up to 2 full steps positive or negative. When the Flash mode is set to Manual, this option stays available, except that its name changes to Flash Output, discussed next.

Figure 8.10
The Flash Control submenu can be accessed from the Shooting menu, by pressing and holding the Flash button, or by pressing the Flash button and then pressing the MENU button.

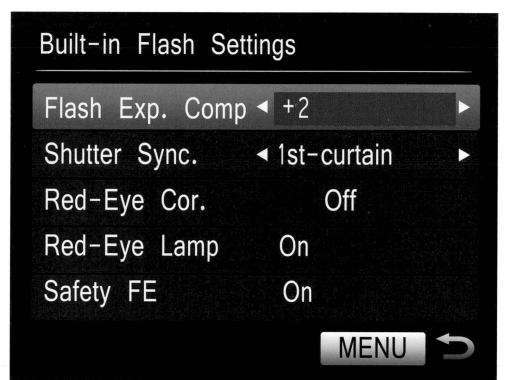

Figure 8.11
The Flash mode setting on the Flash Control submenu can be set to either Auto or Manual, which determines whether or not the camera uses metering to determine the flash output.

- **Flash Output.** As noted above, this setting is the counterpart to Flash Exposure Compensation, when Flash mode is set to Manual (see Figure 8.12). In that case, you can dial in the amount of flash intensity, except that, because the flash exposure will be manual, you are actually determining the *absolute* amount of flash to be emitted, rather than the relative amount, as with Flash Exposure Compensation. When using the built-in flash, your choices for Flash Output are Minimum, Medium, or Maximum. If you use that setting, you are responsible for setting the camera so that the image is properly exposed; the camera will not be using any automatic exposure settings to determine the proper flash output.

- **Shutter Sync.** You can choose 1st-curtain sync, which fires the flash as soon as the shutter is completely open (this is the default mode). Alternatively, you can select 2nd-curtain sync, which fires a pre-flash used to measure exposure as soon as the shutter release is pressed down all the way, but before the shutter opens, and then triggers a second flash at the end of the exposure, just before the shutter starts to close. This action allows photographing a blurred trail of light of moving objects with sharp flash exposures at the beginning and the end of the exposure, as I described earlier in this chapter. This setting is available in the M, Av, Tv, and P shooting modes, as well as in the Quick Shot shooting mode on the PowerShot G12.

Figure 8.12
When Flash mode is set to Manual, the Flash Output setting is available for you to set at Minimum, Medium, or Maximum.

- **Red-Eye Correction.** This setting is available in most SCN shooting modes, but not for the advanced modes, P, Av, Tv, and M. With this option, the camera attempts to apply digital corrective measures to remove red areas near the eyes. You should note that, although all images you take will be processed somewhat by the camera for sharpness, noise, contrast, and the like, this option applies a form of processing that goes beyond those normal adjustments in that it can actually alter the content of the image, so you should be sure you want to take that risk before activating it. Remember that this option also can be applied to images after the fact, through the Playback menu.

- **Red-Eye Lamp.** This option, also, is available in the great majority of shooting modes. This feature is distinct from Red-Eye Correction; this one causes the camera to shine its bright lamp into the subject's eyes for an instant before the flash in an effort to cause his or her pupils to contract (assuming the subject is looking at the camera), thereby reducing the red-eye effect, as I explained in Chapter 4.

- **Safety FE.** This setting is available in the Av, Tv, and P shooting modes, as well as the Quick Shot shooting mode on the G12. It is available only when Flash mode is set to Auto, meaning the flash intensity is determined through the camera's auto-exposure system. This setting, which can be set either On or Off, acts as a safety net. If the camera senses that the image will be overexposed, if this option is activated, the camera adjusts the aperture or shutter speed to reduce the exposure so as to avoid blowing out the highlights. There is one other aspect of this setting that you should bear in mind. On the G12, it is possible to set the shutter speed as high as 1/2,000th second, even when using flash. However, if Safety FE is set to Off, then the highest shutter speed that can be used with flash is 1/500th second.

- **Slow Synchro.** This setting is available for you to set in a few shooting modes, including Av and P. In several other modes, it is set to On and cannot be changed. When this option is turned on, the camera will set the shutter speed slower than it otherwise would, in order to allow time for the ambient light to expose the background, so the final image is not overwhelmed by the portion that is illuminated by the flash. This option is accessed through the Flash button on the G12. When Slow Synchro is available on the G12, it appears as one more option along with Auto, On, and Off on the Flash button's menu of options.

Using Built-In Flash with the Various Shooting Modes

We have now explored all of the options that are available for using the PowerShot G12's built-in flash. As we have seen, although the little unit is not very powerful in terms of its flash intensity, it comes armed with an impressive set of control options that make it a very versatile and useful tool. Now, to make it clearer how these settings work in

practice, I'm going to go through the various shooting modes briefly to point out just how the built-in flash acts in those modes, and what flash settings are available in each of them.

Auto Mode

When the PowerShot G12 is set to the Auto shooting mode, the built-in flash will initially be set to Auto, and it will fire when needed to provide extra illumination in low-light situations, or when your subject matter is backlit and could benefit from some fill flash—with a few exceptions. You have the option of turning the flash off, which is good if you're in a location with a "no-flash zone." However, you cannot force the flash to be on; if you want flash, you have to rely on the camera's native intelligence to figure out if the flash will actually be fired. You can activate Red-Eye Correction and the Red-Eye Lamp. Other settings, such as Flash Exposure Compensation, are not available.

Program Mode

In P mode, just about all of the flash control options are available for you to set. However, you cannot set Flash Mode to Manual, and, therefore, you cannot control the absolute amount of flash (Flash Output). You can, however, adjust the relative amount of flash (Flash Exposure Compensation) and you can control the flash's other settings.

Manual, Aperture Priority, and Shutter Priority Modes

In M, Av, and Tv modes, virtually all of the flash control settings are available, except that you can't set the flash to Auto (the "Auto" meaning that the camera decides whether to fire the flash); if you want the flash to fire in either of these shooting modes, the flash has to be set to On. The other flash control settings are almost all available, although, on the G12, Slow Synchro is not available in M or Tv mode. Flash mode cannot be set to Auto (the "Auto" meaning the camera determines the amount of flash) in M mode.

SCN Modes and Special G12 Modes (Low Light and Quick Shot)

In the various SCN modes there are various flash control options, depending on the nature of the shooting scenario. On the G12, in Sports and Fireworks modes the flash is always turned off. In Low Light mode on the G12, the flash can be set to either Auto or Off, but it cannot be set to On. In most of the SCN modes on both models, the flash is set to Auto, and the only flash control options available are Red-Eye Correction and Red-Eye Lamp. In Quick Shot mode on the G12, all flash control options are available except Flash Mode and Flash Output; the Flash Mode is set to Auto, so Flash Exposure Compensation is available rather than Flash Output.

If you happen to be shooting a sports or fireworks photo and do want to use flash for some reason, you will have to switch to another shooting mode. However, if you're using any one of the automatic modes (including Auto) and decide that you definitely *don't*

want the flash to fire—in a museum with a "no flash" rule for example—you're in luck. With the PowerShot G12 Canon has expressed its confidence in the ability of its users to make their own decisions about turning off the flash. So, unlike the situation with some other compact cameras, with the PowerShot G12, you always have the option of turning the flash to its "Off" setting, ensuring that it will not fire, even if you enter the museum's simulation of the inside of King Tut's tomb and the door clanks shut behind you.

Using FE Lock

If you want to lock flash exposure for a subject that is not centered in the frame, you can use the FE Lock button (*) to lock in a specific flash exposure. First, you have to make sure the flash is set to On, not Auto. Then, depress and hold the shutter button halfway to lock in focus, center the viewfinder on the subject you want to correctly expose, and press the * button. The pre-flash fires and calculates exposure, displaying the * on the LCD screen to show that the exposure is locked. Then, recompose your photo and press the shutter down the rest of the way to take the photo. Of course, this procedure works only when the camera is using its automatic metering to determine the flash exposure. It will work at all times in P mode; when you're using Tv or Av mode, you need to make sure that Flash mode is set to Auto. (It won't work in M mode, because the Flash mode is always set to Manual in that shooting mode.)

Using External Electronic Flash

Canon offers a broad range of accessory electronic flash units that will work with the PowerShot G12. They can be mounted to the flash accessory shoe, or used off-camera with a dedicated cord that plugs into the flash shoe to maintain full communications with the camera for all special features. They range from the Speedlite 580EX II, which can correctly expose subjects up to 24 feet away at f/11 and ISO 200, to the 270EX, which is good out to 9 feet at f/11 and ISO 200. (You'll get greater ranges at even higher ISO settings, of course.)

When you attach one of the compatible Canon Speedlites, you will notice some changes in the displays on the LCD screen and menus of the PowerShot G12. First, once the external flash is attached, the built-in flash is disabled and cannot fire or be controlled, even if the external flash is turned off. (The exception is the Canon HF-DC1 High Power Flash, which is actually a *slave* unit triggered by other flashes, and needs no connection to the camera.) Second, once the non-slave external unit is attached and turned on, you will see an orange-red lightning bolt on the right side of the screen, indicating that an external flash is attached. You will never see any other flash icon, such as the

icon for Auto or Off, because those settings would have no meaning once you have decided to use an external flash. Also, the Flash Control submenu will have different settings, depending on what flash unit you have attached. For example, you likely will have a greater range of Flash Exposure Compensation and Flash Output settings available than with the built-in flash, and there may be a setting for Hi-speed sync, along with 1st-curtain and 2nd-curtain sync.

Here are some details about the various external flash units that are compatible with the PowerShot G12.

Canon HF-DC1 High-Power Flash

This is a tiny, pocket-sized portable slave flash that requires no connection to the G12. It's triggered by the main flash's illumination (whether that main flash is the built-in flash or an external flash you've connected to the camera). The HF-DC1 mounts on a small, fold-down bracket that positions the flash at the side of the camera body by attaching to the camera's tripod socket. When the slave's sensor "sees" the camera's flash fire, it will also fire, in perfect synchronization with the main flash to increase the usable flash range (of the built-in flash) or to provide a kicker or fill light when used with another external flash.

The unit has two simple sliding controls on the back. One switch selects Auto or Manual operation, while the other switch adjusts the output level to any of three levels. In Auto there is a built-in delay, which keeps the slave flash from being triggered by the G12's pre-flash. Instead, the slave waits and synchronizes with the main picture-taking flash.

Speedlite 220EX

This most basic Canon Speedlite offers automatic operation only, and none of the fancy features of its more expensive siblings. It is a lot beefier than the PowerShot G12's built-in flash, making it a good choice as an auxiliary flash unit. It lacks a zoomable flash head to adjust coverage for different focal lengths, and offers fixed coverage equivalent to the field of view of a 28mm full-frame lens. Expect 250 to 1,700 flashes from a set of four AA batteries and recycle times of 0.1 to 4.5 seconds.

Speedlite 270EX

This newest Canon Speedlite (shown in Figure 8.13) is small enough at five ounces to fit in a pocket, and, instead of zooming, uses two fixed coverage levels for 28mm and 50mm focal lengths. It offers bounce-lighting capabilities, and uses two AA batteries, which provide enough power to recycle the unit in four seconds between flashes.

Speedlite 430EX II

This affordable electronic flash is nearly four times as powerful as the 270EX, and has zoom coverage from 24mm to 105mm. If you want to use this with your dSLR, too, it has a wide-angle pullout panel that covers the area of a 14mm lens on a full-frame camera, and automatic conversion to the cropped frame area of some Canon digital cameras. The 430EX also communicates white balance information with your dSLR camera, and has its own AF assist beam. It, too, uses AA batteries, and offers recycle times of 0.1 to 3.7 seconds for 200 to 1,400 flashes, depending on subject distance.

Speedlite 580EX II

This flagship of the Canon accessory flash line is the most powerful unit the company offers, and probably is a bit of overkill for the PowerShot G12. It's slightly more than twice as powerful as the 430 EX II, and has a zoom flash head that covers the full frame of lenses from 24mm wide angle to 105mm telephoto. (There's a flip-down wide-angle diffuser that spreads the flash to cover a 14mm lens's field of view, too.) The unit offers full-swivel, 180 degrees in either direction, and has its own built-in AF assist beam. Powered by economical AA-size batteries, the unit recycles in 0.1 to 6 seconds, and can squeeze 100 to 700 flashes from a set of alkaline batteries. (See Figure 8.14.)

Figure 8.13 The Canon 270EX is small and makes a good add-on flash for the PowerShot G12.

Figure 8.14 The Canon Speedlite 580EX II is the most powerful shoe-mount flash Canon offers.

More Advanced Lighting Techniques

As you advance in your Canon PowerShot G12 photography, you'll want to learn more sophisticated lighting techniques, using more than just straight-on flash, or using just a single flash unit. Entire books have been written on lighting techniques. I'm going to provide a quick introduction to some of the techniques you should be considering.

Diffusing and Softening the Light

Direct light can be harsh and glaring, especially if you're using the flash built into your camera, or an auxiliary flash mounted in the hot shoe and pointed directly at your subject. The first thing you should do is stop using direct light (unless you're looking for a stark, contrasty appearance as a creative effect). There are a number of simple things you can do with both continuous and flash illumination.

- **Use window light.** Light coming in a window can be soft and flattering, and a good choice for human subjects. Move your subject close enough to the window that its light provides the primary source of illumination. You might want to turn off other lights in the room, particularly to avoid mixing daylight and incandescent light. (See Figure 8.15.)

Figure 8.15
Window light makes the perfect diffuse illumination for informal soft-focus portraits like this one.

- **Use fill light.** Your PowerShot G12's built-in flash makes a perfect fill-in light for the shadows, brightening inky depths with a kicker of illumination when it's switched on.

- **Bounce the light.** As I noted, some external electronic flash units mounted on the PowerShot G12 usually have a swivel that allows them to be pointed up at a ceiling for a bounce light effect. You can also bounce the light off a wall. You'll want the ceiling or wall to be white or have a neutral gray color to avoid a color cast.

- **Use reflectors.** Another way to bounce the light is to use reflectors or umbrellas that you can position yourself to provide a greater degree of control over the quantity and direction of the bounced light. Good reflectors can be pieces of foamboard, Mylar, or a reflective disk held in place by a clamp and stand. Although some expensive umbrellas and reflectors are available, spending a lot isn't necessary. A simple piece of white foamboard does the job beautifully. Umbrellas have the advantage of being compact and foldable, while providing a soft, even kind of light. They're relatively cheap, too, with a good 40-inch umbrella available for as little as $20.

- **Use diffusers.** Some other vendors offer clip-on diffusers like the one shown in Figure 8.16, that fit over your electronic flash head and provide a soft, flattering light. These add-ons are more portable than umbrellas and other reflectors, yet provide a nice diffuse lighting effect.

Figure 8.16
Some softboxes use Velcro strips to attach to third-party flash units (like the one shown) or any Canon medium-sized or larger external flash.

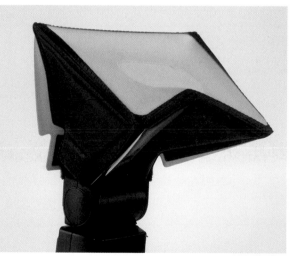

Downloading and Editing Your Images

Taking the picture is only half the work, and, in some cases, only half the fun. After you've captured some great images and have them safely stored on your Canon PowerShot G12's memory card, you'll need to transfer them from your camera and memory card to your computer, where they can be organized, fine-tuned in an image editor, and prepared for web display, printing, or some other final destination.

Fortunately, there are lots of software utilities and applications to help you do all these things. This chapter will introduce you to a few of them.

What's in the Box?

Your Canon PowerShot G12 came with software programs on CD for both Windows PCs and Macs. Pop the CD into your computer and it will self-install a selection of these useful applications and utilities. Manuals for the key programs are included on CD, too, but here's a summary of what you get on the Canon Digital Solutions disk:

ZoomBrowser EX/ImageBrowser

This is an image viewing and editing application for Windows PCs (the equivalent program for Macs is called ImageBrowser and performs the same functions). You can organize, sort, classify, and rename files, and convert JPEG files in batches. This utility is especially useful for printing index sheets of groups of images. It can also prepare images for e-mailing. It works with RAW Image Task for converting CR2 files to some other format, and it can be used to select images for merging using PhotoStitch.

When you connect your G12 to your computer using a USB cable, ZoomBrowser first loads the CameraWindow DC utility, shown in Figure 9.1. There are three functions with this window. You can import images from the camera, choosing to preview the images to be transferred by date shot (as in Figure 9.2), by folder on the memory card, only the images that have not yet been transferred, or all the images on the memory card. Click on the images you'd like to transfer, then click the Import button in the lower-left corner of the window. The CameraWindow utility can also be used to make certain limited camera settings from your computer. You can select a start-up image, choose sounds, or select a theme, as shown in Figure 9.3.

Once you've transferred photos, you can do simple editing using the ZoomBrowser window that appears when you close CameraWindow. (See Figure 9.4.) The simple image-editing facilities of ZoomBrowser allow red-eye correction, brightness/contrast and color correction, manipulating sharpness, trimming photos, and a few other functions. For more complex editing, you can transfer images directly from this application to Digital Photo Professional, Photoshop, or another image editor.

Figure 9.1
ZoomBrowser EX's Camera-Window DC utility pops up when you connect the camera to your computer with a USB cable.

Figure 9.2
Select which
files on the
memory card
to download
from the
camera to the
computer.

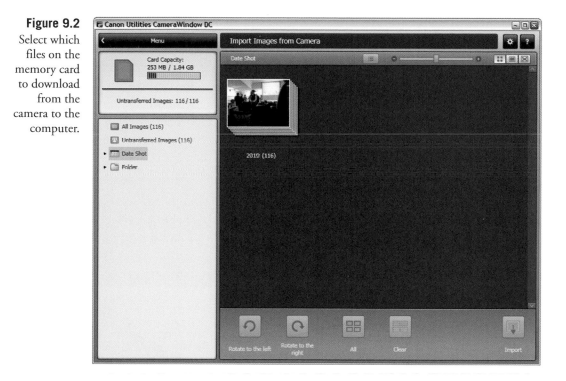

Figure 9.3
You can change
camera settings
from your
computer.

Figure 9.4
ZoomBrowser allows organizing your images and performing simple fixes.

PhotoStitch

This Windows/Mac utility allows you to take several JPEG images and combine them to create a panorama in a single new file. You can choose the images to be merged in ZoomBrowser and then transfer them to PhotoStitch, or operate the utility as a stand-alone module and select the images using the standard File > Open commands (see Figure 9.5).

Digital Photo Professional

While far from a Photoshop replacement, Digital Photo Professional is a useful image-editing program that helps you organize, trim, correct, and print images. You can make RAW adjustments, correct tonal curves, color tone, color saturation, sharpness, as well as brightness and contrast. Especially handy are the "recipes" that can be developed and saved so that a given set of corrections can be kept separate from the file itself, and, if desired, applied to other images (see Figure 9.6).

Transferring Your Photos

While it's rewarding to capture some great images and have them ensconced in your camera, eventually you'll be transferring them to your laptop or PC, whether you're using a Windows or Macintosh machine. You have three options for image transfer: direct transfer over a USB cable, automated transfer using a card reader and transfer software such as ZoomBrowser EX/ImageBrowser or, if you've installed it, Adobe

Figure 9.5
Panoramas
are easy to
create with
PhotoStitch.

Figure 9.6
Digital Photo
Professional
will never
replace Photo-
shop, but it has
some basic
image-editing
features.

Photoshop Elements Photo Downloader, or manual transfer using drag and drop from a memory card inserted in a card reader.

Direct Transfer

There are some advantages to transferring photos directly from your G12 to a computer. The destination computer doesn't need to have a card reader; all it requires is a USB port. So, if you have the USB cable that came with your camera, you can transfer photos to any computer that has the Canon utility software installed. However, direct transfer uses your G12's internal battery power, while removing the card and transferring the photos with a card reader installed on the destination computer does not.

You can select which images are transferred to the computer, or transfer all the images, both RAW and JPEG, that are on the memory card. Just connect your camera to the computer using a USB cable, and either the Canon software will pop up or another file transfer program you may have installed, such as the Photoshop Elements Photo Downloader Utility, will appear. Or, the file transfer program built into your computer's operating system may offer to do the job.

Elements' downloader includes a simple dialog box, like the one shown in Figure 9.7, and a more advanced set of choices. In the simple dialog box, you can choose the destination folder, whether to rename files (and a filename template if you do decide to rename them), and the choice of deleting the original photos from your memory card after they've been transferred, or leaving them on the card. I prefer the latter; it's best not to erase images until you're *positive* they've been transferred correctly and, in any case, reformatting the memory card in your camera rather than just deleting its old files is a better choice for starting over with a "clean" card.

Figure 9.7
You can rename images as they are downloaded using Photoshop Elements' downloader.

The advanced dialog box lets you choose individual files to download, selecting from a thumbnail preview of the image on your camera. You can apply advanced options, such as automatic red-eye repair, or import the images into a suggested Elements "photo stack" (a group of like images organized for easier browsing). You can even add a copyright notice to the data embedded within your images.

Using a Card Reader and Software

You can also use a memory card reader and software to transfer photos and automate the process using the Canon utility, Photoshop Elements' Photo Downloader, or the downloading program supplied with some other third-party applications. This method is more frugal in its use of your G12's battery and can be faster if you have a speedy USB 2.0 or FireWire card reader attached to an appropriate port.

The installed software automatically remains in memory as you work, and it recognizes when a memory card is inserted in your card reader; you don't have to launch it yourself. With Photoshop Elements Photo Downloader, you can click Get Photos to begin the transfer of all images immediately or choose Advanced Dialog to produce a dialog box like the one shown in Figure 9.8, and then select which images to download from

Figure 9.8
With Advanced view activated, Photoshop Elements' Photo Downloader allows you to select the photos you want to copy to your computer and apply some options such as new filenames, or red-eye fixes automatically.

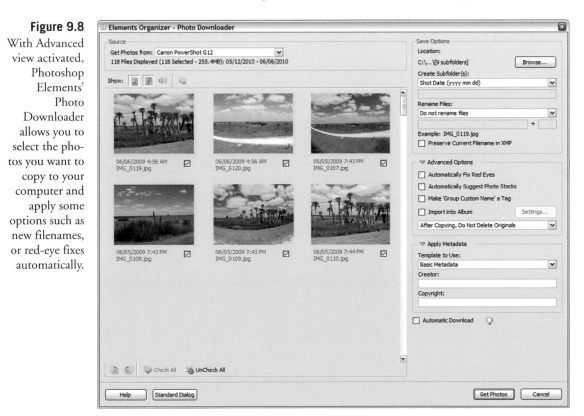

the memory card by marking them with a check. You can select the photos you want to transfer, plus options such as Automatically Fix Red Eyes. Start the download, and a confirmation dialog box like the one in Figure 9.9 shows the progress.

Figure 9.9
The Photo Downloader's confirmation dialog box shows the progress as images are transferred.

Dragging and Dropping

The final way to move photos from your memory card to your computer is the old-fashioned way: manually dragging and dropping the files from one window on your computer to another. The procedure works pretty much the same whether you're using a Mac or a PC.

1. Remove the memory card from the PowerShot G12 and insert it in your memory card reader.

2. Using Windows Explorer, My Computer, or your Mac desktop, open the icon representing the memory card, which appears on your desktop as just another disk drive.

3. Open a second window representing the folder on your computer that you want to use as the destination for the files you are copying or moving.

4. Drag and drop the files from the memory card window to the folder on your computer. You can select individual files, press Ctrl/Command+A to select all the files, or Ctrl/Command+click to select multiple files.

Editing Your Photos

Image manipulation tasks fall into several categories. You might want to fine-tune your images, retouch them, change color balance, composite several images together, and perform other tasks we know as image editing, with a program like Adobe Photoshop, Photoshop Elements, or Corel Photo Paint.

You might want to play with the settings in RAW files, too, as you import them from their CR2 state into an image editor. There are specialized tools expressly for tweaking RAW files, ranging from Canon's own Digital Photo Professional to Adobe Camera Raw, and PhaseOne's Capture One Pro (C1 Pro). A third type of manipulation is the specialized task of noise reduction, which can be performed within Photoshop, Adobe

Camera Raw, or tools like Bibble Professional. There are also specialized tools just for noise reduction, such as Noise Ninja (also included with Bibble) and Neat Image.

Each of these utilities and applications deserves a chapter of its own, so I'm simply going to enumerate some of the most popular image-editing and RAW conversion programs here and tell you a little about what they do.

Image Editors

Image editors are general purpose photo-editing applications that can do color correction, tonal modifications, retouching, combining of several images into one, and usually include tools for working with RAW files and reducing noise. So, you'll find programs like those listed here good for all-around image manipulation. The leading programs are as follows:

Adobe Photoshop/Photoshop Elements. Photoshop is the serious photographer's number one choice for image editing, and Elements is an excellent option for those who need most of Photoshop's power, but not all of its professional-level features. Both editors use the latest version of Adobe's Camera Raw plug-in, which makes it easy to adjust things like color space profiles, color depth (either 8 bits or 16 bits per color channel), image resolution, white balance, exposure, shadows, brightness, sharpness, luminance, and noise reduction. One plus with the Adobe products is that they are available in identical versions for both Windows and Macs.

Corel Photo Paint. This is the image-editing program that is included in the popular CorelDRAW Graphics suite. Although a Mac version was available in the past, this is primarily a Windows application today. It's a full-featured photo retouching and image-editing program with selection, retouching, and painting tools for manual image manipulations, and it also includes convenient automated commands for a few common tasks, such as red-eye removal. Photo Paint accepts Photoshop plug-ins to expand its assortment of filters and special effects.

Corel Paint Shop Pro. This is a general purpose Windows-only image editor that has gained a reputation as the "poor person's Photoshop" for providing a substantial portion of Photoshop's capabilities at a fraction of the cost. It includes a nifty set of wizard-like commands that automate common tasks, such as removing red eye and scratches, as well as filters and effects, which can be expanded with other Photoshop plug-ins.

Corel Painter. Here's another image-editing program from Corel for both Mac and Windows. This one's strength is in mimicking natural media, such as charcoal, pastels, and various kinds of paint. Painter includes a basic assortment of tools that you can use to edit existing images, but the program is really designed for artists to use in creating original illustrations. As a photographer, you might prefer another image editor, but if

you like to paint on top of your photographic images, nothing else really does the job of Painter.

Corel PhotoImpact. Corel finally brought one of the last remaining non-Adobe image editors into its fold when it acquired PhotoImpact. This is a general-purpose photo-editing program for Windows with a huge assortment of brushes for painting, retouching, and cloning, in addition to the usual selection, cropping, and fill tools. If you frequently find yourself performing the same image manipulations on a number of files, you'll appreciate PhotoImpact's batch operations. Using this feature, you can select multiple image files and then apply any one of a long list of filters, enhancements, or auto-process commands to all the selected files.

RAW Utilities

Your software choices for manipulating RAW files are broader than you might think. Camera vendors always supply a utility to read their cameras' own RAW files, but sometimes, particularly with those point-and-shoot cameras that can produce RAW files, the options are fairly limited.

The third-party solutions are usually available as standalone applications (often for both Windows and Macintosh platforms), as Photoshop-compatible plug-ins, or both. Because the RAW plug-ins displace Photoshop's own RAW converter, I tend to prefer to use most RAW utilities in standalone mode. That way, if I choose to open a file directly in Photoshop, it automatically opens using Photoshop's fast and easy-to-use Adobe Camera Raw (ACR) plug-in. If I have more time or need the capabilities of another converter, I can load that, open the file, and make my corrections there. Most are able to transfer the processed file directly to Photoshop even if you aren't using plug-in mode.

This section provides a quick overview of the range of RAW file handlers, so you can get a better idea of the kinds of information available with particular applications. I'm going to include both high-end and low-end RAW browsers so you can see just what is available.

Digital Photo Professional

Digital Photo Professional, introduced earlier in this chapter, is preferred by many for Canon digital cameras like the PowerShot G12.

DPP offers much higher-speed processing of RAW images, rivaling third-party stand-alone and plug-in RAW converters in speed and features. It supports both Canon's original CRW format and the newer CR2 RAW format used by the G12, along with JPEG and other file formats.

You can save settings that include multiple adjustments and apply them to other images, and use the clever comparison mode to compare your original and edited versions of an image either side by side or within a single split image. The utility allows easy adjustment of color channels, tone curves, exposure compensation, white balance, dynamic range, brightness, contrast, color saturation, ICC Profile embedding, and assignment of monitor profiles. A new feature is the ability to continue editing images while batches of previously adjusted RAW files are rendered and saved in the background.

IrfanView

At the low (free) end of the price scale is IrfanView, a Windows-only freeware program you can download at www.irfanview.com. It can read many common RAW photo formats. It's a quick way to view RAW files (just drag and drop to the IrfanView window) and make fast changes to the unprocessed file. You can crop, rotate, or correct your image, and do some cool things like swap the colors around (red for blue, blue for green, and so forth) to create false color pictures.

Phase One Capture One Pro (C1 Pro)

If there is a Cadillac of RAW converters for Nikon and Canon digital cameras, C1 Pro has to be it. This premium-priced program does everything, does it well, and does it quickly. If you can't justify the price tag of this professional-level software, there are "lite" versions for serious amateurs and cash-challenged professionals called Capture One digital camera and Capture One digital camera SE.

Aimed at photographers with high-volume needs (that would include school and portrait photographers, as well as busy commercial photographers), C1 Pro is available for both Windows and Mac OS X, and supports a broad range of Canon digital cameras. Phase One is a leading supplier of megabucks digital camera backs for medium and larger format cameras, so they really understand the needs of photographers.

The latest features include individual noise reduction controls for each image, automatic levels adjustment, a "quick develop" option that allows speedy conversion from RAW to TIFF or JPEG formats, dual-image side-by-side views for comparison purposes, and helpful grids and guides that can be superimposed over an image. Photographers concerned about copyright protection will appreciate the ability to add watermarks to the output images. See www.phaseone.com.

Bibble Pro

One of my personal favorites among third-party RAW converters is Bibble Pro, which just came out with a new version as I was writing this book. It supports one of the broadest ranges of RAW file formats available (which can be handy if you find yourself with the need to convert a file from a friend or colleague's non-Canon camera), including

NEF (Nikon), CRW/CR2 (Canon), ORF (Olympus), DCR (Kodak), RAF (Fuji), PEF (Pentax), and ARW (Sony).

The utility supports lots of different platforms, too. It's available for Windows, Mac OS X, and, believe it or not, Linux. Bibble works fast because it offers instantaneous previews and real-time feedback as changes are made. That's important when you have to convert many images in a short time. Bibble's batch-processing capabilities also let you convert large numbers of files using settings you specify without further intervention.

Its customizable interface lets you organize and edit images quickly and then output them in a variety of formats, including 16-bit TIFF and PNG. You can even create a web gallery from within Bibble. I often find myself disliking the generic filenames applied to digital images by cameras, so I really like Bibble's ability to rename batches of files using new names that you specify.

Bibble is fully color managed, which means it can support all the popular color spaces (Adobe sRGB and so forth) and use custom profiles generated by third-party color-management software. There are two editions of Bibble, a Pro version and a Lite version. Because the Pro version is reasonably priced at $199.95 ($159.95 when on sale), I don't really see the need to save $60 with the Lite edition, which lacks the top-line's options for tethered shooting, embedding IPTC-compatible captions in images, and can also be used as a Photoshop plug-in (if you prefer not to work with the application in its standalone mode). Bibble Pro now incorporates Noise Ninja technology, so you can get double-duty from this valuable application. See www.bibblelabs.com.

BreezeBrowser

BreezeBrowser was long the RAW converter of choice for Canon digital camera owners who run Windows and who were dissatisfied with Canon's lame antique File Viewer Utility (which has been gone from the scene for many years now). It works quickly and has lots of options for converting CRW and CR2 files to other formats. You can choose to show highlights that will be blown out in your finished photo as flashing areas (so they can be more easily identified and corrected), use histograms to correct tones, add color profiles, auto rotate images, and adjust all those raw image parameters, such as white balance, color space, saturation, contrast, sharpening, color tone, EV compensation, and other settings.

You can also control noise reduction (choosing from low, normal, or high reduction), evaluate your changes in the live preview, and then save the file as a compressed JPEG or as either an 8-bit or 16-bit TIFF file. BreezeBrowser can also create HTML web galleries directly from your selection of images. See www.breezesys.com.

Adobe Photoshop

The latest version of Photoshop includes a built-in RAW plug-in that is compatible with the proprietary formats of a growing number of digital cameras, both new and old. This plug-in also works with Photoshop Elements.

To open a RAW image in Photoshop, just follow these steps (Elements users can use much the same workflow, although fewer settings are available):

1. Transfer the RAW images from your camera to your computer's hard drive.

2. In Photoshop, choose Open from the File menu, or use Bridge or the Organizer.

3. Select a RAW image file. The Adobe Camera Raw plug-in will pop up, showing a preview of the image, like the one shown in Figure 9.10.

4. If you like, use one of the tools found in the toolbar at the top left of the dialog box. From left to right, they are as follows:

 ■ **Zoom.** Operates just like the Zoom tool in Photoshop.

 ■ **Hand.** Use like the Hand tool in Photoshop.

 ■ **White Balance.** Click an area in the image that should be neutral gray or white to set the white balance quickly.

 ■ **Color Sampler.** Use to determine the RGB values of areas you click with this eyedropper.

 ■ **Crop.** Pre-crops the image so that only the portion you specify is imported into Photoshop. This option saves time when you want to work on a section of a large image, and you don't need the entire file.

 ■ **Straighten.** Drag in the preview image to define what should be a horizontal or vertical line, and ACR will realign the image to straighten it.

 ■ **Retouch.** Used to heal or clone areas you define.

 ■ **Red-Eye Removal.** Quickly zap red pupils in your human subjects.

 ■ **ACR Preferences.** Produces a dialog box of Adobe Camera Raw preferences.

 ■ **Rotate Counterclockwise.** Rotates counterclockwise in 90-degree increments with a click.

 ■ **Rotate Clockwise.** Rotates clockwise in 90-degree increments with a click.

5. Using the Basic tab, you can have ACR show you red and blue highlights in the preview that indicate shadow areas that are clipped (too dark to show detail) and light areas that are blown out (too bright). Click the triangles in the upper-left corner of the histogram display (shadow clipping) and upper-right corner (highlight clipping) to toggle these indicators on or off.

6. Also in the Basic tab you can choose white balance, either from the drop-down list or by setting a color temperature and green/magenta color bias (tint) using the sliders.

7. Other sliders are available to control exposure, recovery, fill light, blacks, brightness, contrast, vibrance, and saturation. A check box can be marked to convert the image to grayscale.

8. Make other adjustments (described in more detail below).

9. ACR makes automatic adjustments for you. You can click Default and make the changes for yourself, or click the Auto link (located just above the Exposure slider) to reapply the automatic adjustments after you've made your own modifications.

10. If you've marked more than one image to be opened, the additional images appear in a "filmstrip" at the left side of the screen. You can click on each thumbnail in the filmstrip in turn and apply different settings to each.

11. Click Open Image/Open Image(s) into Photoshop using the settings you've made, or click Save Image at the bottom left to save the settings you've made without opening the file.

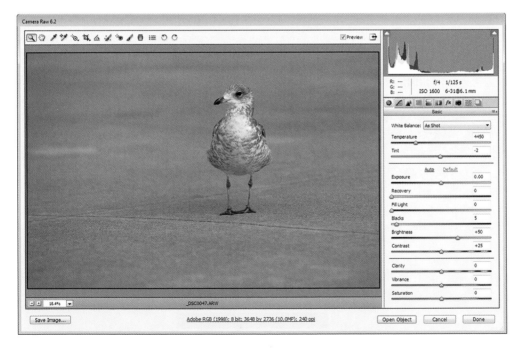

Figure 9.10
The basic ACR dialog box looks like this when processing a single image.

The Basic tab is displayed by default when the ACR dialog box opens, and it includes most of the sliders and controls you'll need to fine-tune your image as you import it into Photoshop. These include:

- **White Balance.** Leave it As Shot or change to a value such as Daylight, Cloudy, Shade, Tungsten, Fluorescent, or Flash. If you like, you can set a custom white balance using the Temperature and Tint sliders.

- **Exposure.** This slider adjusts the overall brightness and darkness of the image.

- **Recovery.** Restores detail in the red, green, and blue color channels.

- **Fill Light.** Reconstructs detail in shadows.

- **Blacks.** Increases the number of tones represented as black in the final image, emphasizing tones in the shadow areas of the image.

- **Brightness.** This slider adjusts the brightness and darkness of an image.

- **Contrast.** Manipulates the contrast of the midtones of your image.

- **Convert to Grayscale.** Mark this box to convert the image to black-and-white.

- **Vibrance.** Prevents over-saturation when enriching the colors of an image.

- **Saturation.** Manipulates the richness of all colors equally, from zero saturation (gray/black, no color) at the −100 setting to double the usual saturation at the +100 setting.

Additional controls are available on the Tone Curve, Detail, HSL/Grayscale, Split Toning, Lens Corrections, Camera Calibration, and Presets tabs, shown in Figure 9.11. The Tone Curve tab can change the tonal values of your image. The Detail tab lets you adjust sharpness, luminance smoothing, and apply color noise reduction. The HSL/Grayscale tab offers controls for adjusting hue, saturation, and lightness and converting an image to black-and-white. Split Toning helps you colorize an image with sepia or cyanotype (blue) shades. The Lens Corrections tab has sliders to adjust for chromatic aberrations and vignetting. The Camera Calibration tab provides a way for calibrating the color corrections made in the Camera Raw plug-in. The Presets tab (not shown) is used to load settings you've stored for reuse.

Figure 9.11 More controls are available within the additional tabbed dialog boxes in Adobe Camera Raw.

Glossary

Here are some terms you might encounter while reading this book or working with your Canon PowerShot G12.

additive primary colors The red, green, and blue hues that are used alone or in combinations to create all other colors that you capture with a digital camera, view on a computer monitor, or work with in an image-editing program, such as Photoshop.

ambient lighting Diffuse, non-directional lighting that doesn't appear to come from a specific source but, rather, bounces off walls, ceilings, and other objects in the scene when a picture is taken.

analog/digital converter The Canon DIGIC 4 electronics built into the G12 that convert the analog information captured by the camera's sensor into digital bits that can be stored as an image bitmap.

angle of view The area of a scene that a lens can capture, determined by the focal length of the lens. Lenses with a shorter focal length have a wider angle of view than lenses with a longer focal length.

anti-alias A process that smoothes the look of rough edges in images (called *jaggies* or *staircasing*) by adding partially transparent pixels along the boundaries of diagonal lines that are merged into a smoother line by our eyes. *See also* jaggies.

Aperture priority A camera setting, called Av (for Aperture value), that allows you to specify the lens opening or f/stop that you want to use, with the camera selecting the required shutter speed automatically based on its light-meter reading. This setting is represented by the abbreviation Av on the G12's mode dial. *See also* Shutter priority.

artifact A type of noise in an image, or an unintentional image component produced in error by a digital camera during processing, usually caused by the JPEG compression process in digital cameras.

aspect ratio The proportions of an image as printed, displayed on a monitor, or captured by a digital camera.

autofocus A camera setting that allows the Canon PowerShot G12 to choose the correct focus distance for you, based on the contrast of an image (the image will be at maximum contrast when in sharp focus).

Automatic exposure bracketing Automatic exposure bracketing takes a series of pictures at different exposure increments to improve the chances of producing one picture that is perfectly exposed.

back lighting A lighting effect produced when the main light source is located behind the subject. Back lighting can be used to create a silhouette effect, or to illuminate translucent objects. *See also* front lighting and side lighting.

barrel distortion A lens defect that causes straight lines at the top or side edges of an image to bow outward into a barrel shape. *See also* pincushion distortion.

blooming An image distortion caused when a photosite in an image sensor has absorbed all the photons it can handle so that additional photons reaching that pixel overflow to affect surrounding pixels, producing unwanted brightness and overexposure around the edges of objects.

blur To soften an image or part of an image by throwing it out of focus, or by allowing it to become soft due to subject or camera motion. Blur can also be applied in an image-editing program.

bokeh A term derived from the Japanese word for blur, which describes the aesthetic qualities of the out-of-focus parts of an image. Some lenses produce "good" bokeh and others offer "bad" bokeh. Some lenses produce uniformly illuminated out-of-focus discs. Others produce a disc that has a bright edge and a dark center, producing a "doughnut" effect, which is the worst from a bokeh standpoint. Lenses that generate a bright center that fades to a darker edge are favored, because their bokeh allows the circle of confusion to blend more smoothly with the surroundings. The bokeh characteristics of a lens are most important when you're using selective focus (say, when shooting a portrait) to deemphasize the background, or when shallow depth-of-field is a given because you're working with a macro lens, a long telephoto, or a wide-open aperture. *See also* circle of confusion.

bounce lighting Light bounced off a reflector, including ceiling and walls, to provide a soft, natural-looking light.

bracketing Taking a series of photographs of the same subject at different settings, including exposure and white balance, to help ensure that one setting will be the correct one.

buffer The digital camera's internal memory where an image is stored immediately after it is taken until it can be written to the camera's non-volatile (semi-permanent) memory or a memory card.

burst mode Known as continuous shooting modes in the PowerShot, burst shooting is the digital camera's equivalent of the film camera's motor drive, used to take multiple shots within a short period of time, with each shot stored in a memory buffer temporarily before writing it to the media.

calibration A process used to correct for the differences in the output of a printer or monitor when compared to the original image. Once you've calibrated your scanner, monitor, and/or your image editor, the images you see on the screen more closely represent what you'll get from your printer, even though calibration is never perfect.

Camera Raw A plug-in included with Photoshop and Photoshop Elements that can manipulate the unprocessed images captured by digital cameras, such as the Canon PowerShot G12's .CR2 files. The latest versions of this module can also work with JPEG and TIFF images.

camera shake Movement of the camera, aggravated by slower shutter speeds, which produces a blurred image. You can minimize camera shake by using the PowerShot's image stabilization feature.

Center-weighted metering A light-measuring device that emphasizes the area in the middle of the frame when calculating the correct exposure for an image. *See also* Spot metering and Evaluative metering.

chromatic aberration An image defect, often seen as green or purple fringing around the edges of an object, caused by a lens failing to focus all colors of a light source at the same point. *See also* fringing.

circle of confusion A term applied to the fuzzy discs produced when a point of light is out of focus. The circle of confusion is not a fixed size. The viewing distance and amount of enlargement of the image determine whether we see a particular spot on the image as a point or as a disc. *See also* bokeh.

close-up lens A lens add-on accessory that allows you to take pictures at a distance that is less than the closest-focusing distance of the lens alone.

color correction Changing the relative amounts of color in an image to produce a desired effect, typically a more accurate representation of those colors. Color correction can fix faulty color balance in the original image, or compensate for the deficiencies of the inks used to reproduce the image.

compression Reducing the size of a file by encoding using fewer bits of information to represent the original. Some compression schemes, such as JPEG, operate by discarding some image information, while others, such as RAW, preserve all the detail in the original, discarding only redundant data.

contrast The range between the lightest and darkest tones in an image. A high-contrast image is one in which the shades fall at the extremes of the range between white and black. In a low-contrast image, the tones are closer together.

Creative Zone modes The PowerShot G12's semi-automated and manual shooting modes, including Program, Aperture priority, Shutter priority, and Manual, that allow you to select shutter speed and/or aperture yourself, with the camera calculating the proper exposure based on those parameters.

dedicated flash An electronic flash unit, such as the Canon 220EX Speedlite, designed to work with the automatic exposure features of a specific camera.

depth-of-field A distance range in a photograph in which all included portions of an image are at least acceptably sharp. With the Canon PowerShot G12, you can see the available depth-of-field at the taking aperture by pressing the depth-of-field preview button, or estimate the range by viewing the depth-of-field scale found on many lenses.

diaphragm An adjustable component, similar to the iris in the human eye, that can open and close to provide specific-sized lens openings, or f/stops, and thus control the amount of light reaching the sensor or film.

diffuse lighting Soft, low-contrast lighting.

digital processing chip A solid-state device found in digital cameras, such as the DIGIC 4 chip in the PowerShot G12, that's in charge of applying the image algorithms to the raw picture data prior to storage on the memory card.

diopter A value used to represent the magnification power of a lens, calculated as the reciprocal of a lens's focal length (in meters). Diopters are most often used to represent the optical correction used in a viewfinder to adjust for limitations of the photographer's eyesight, and to describe the magnification of a close-up lens attachment.

Evaluative metering One system of exposure calculation used by the PowerShot G12 that looks at many different segments of an image to determine the brightest and darkest portions. *See also* Center-weighted metering and Spot metering.

exchangeable image file format (Exif) Developed to standardize the exchange of image data between hardware devices and software. A variation on JPEG, Exif is used by most digital cameras, and includes information such as the date and time a photo was taken, the camera settings, resolution, amount of compression, and other data.

Exif *See* exchangeable image file format (Exif).

exposure The amount of light allowed to reach the film or sensor, determined by the intensity of the light, the amount admitted by the iris of the lens, the length of time determined by the shutter speed, and the ISO sensitivity setting for the sensor.

exposure values (EV) EV settings are a way of adding or decreasing exposure without the need to reference f/stops or shutter speeds. For example, if you tell your camera to add +1EV, it will provide twice as much exposure by using a larger f/stop, slower shutter speed, or both.

fill lighting In photography, lighting is used to illuminate shadows. Reflectors or additional incandescent lighting or electronic flash can be used to brighten shadows. One common technique for outdoors is to use the camera's flash as a fill.

filter In photography, a device that fits over the lens, changing the light in some way. In image editing, a feature that changes the pixels in an image to produce blurring, sharpening, and other special effects. Photoshop includes several interesting filter effects, including Lens Blur and Photo Filters.

focal length The distance between the film and the optical center of the lens when the lens is focused on infinity, usually measured in millimeters.

format To erase a memory card and prepare it to accept files.

fringing A chromatic aberration that produces fringes of color around the edges of subjects, caused by a lens's inability to focus the various wavelengths of light onto the same spot. Purple fringing is especially troublesome with backlit images.

front lighting Illumination that comes from the direction of the camera. *See also* back lighting and side lighting.

f/stop The relative size of the lens aperture, which helps determine both exposure and depth-of-field. The larger the f/stop number, the smaller the f/stop itself.

graduated filter A lens attachment with variable density or color from one edge to another. A graduated neutral-density filter, for example, can be oriented so the neutral-density portion is concentrated at the top of the lens's view with the less dense or clear portion at the bottom, thus reducing the amount of light from a very bright sky while not interfering with the exposure of the landscape in the foreground. Graduated filters can also be split into several color sections to provide a color gradient between portions of the image.

gray card A piece of cardboard or other material with a standardized 18-percent reflectance. Gray cards can be used as a reference for determining correct exposure or for setting white balance.

HDMI (High Definition Multimedia Interface) An interface for transmitting audio and video information between a source, such as a digital camera or television tuner, to an output device, such as a high-definition television (HDTV) monitor.

high contrast A wide range of density in a print, negative, or other image.

highlights The brightest parts of an image containing detail.

histogram A kind of chart showing the relationship of tones in an image using a series of 256 vertical bars, one for each brightness level. A histogram chart, such as the one the Canon PowerShot G12 can display, typically looks like a curve with one or more slopes and peaks, depending on how many highlight, midtone, and shadow tones are present in the image.

hot shoe A mount on top of a camera used to hold an electronic flash, while providing an electrical connection between the flash and the camera.

hyperfocal distance A point of focus where everything from half that distance to infinity appears to be acceptably sharp. For example, if your lens has a hyperfocal distance of four feet, everything from two feet to infinity would be sharp. The hyperfocal distance varies by the lens and the aperture in use. If you know you'll be making a grab shot without warning, sometimes it is useful to turn off your camera's automatic focus, and set the lens to infinity, or, better yet, the hyperfocal distance. Then, you can snap off a quick picture without having to wait for the lag that occurs with most digital cameras as their autofocus locks in.

image rotation A feature that senses whether a picture was taken in horizontal or vertical orientation. That information is embedded in the picture file so that the camera and compatible software applications can automatically display the image in the correct orientation.

image stabilization A technology that compensates for camera shake, usually by adjusting the position of the camera sensor (with some vendors) or, in the case of Canon's PowerShot G12 cameras, lens elements that shift in response to movements of the camera.

incident light Light measured as it falls on a surface, as opposed to light reflected from that surface.

International Organization for Standardization (ISO) A governing body that provides standards used to represent film speed, or the equivalent sensitivity of a digital camera's sensor. Digital camera sensitivity is expressed in ISO settings.

interpolation A technique digital cameras, scanners, and image editors use to create new pixels required whenever you resize or change the resolution of an image based on the values of surrounding pixels. Devices such as scanners and digital cameras can use interpolation to create pixels in addition to those actually captured, thereby increasing the apparent resolution or color information in an image.

ISO *See* International Organization for Standardization (ISO).

jaggies Staircasing effect of lines, most easily seen at large magnifications, that are not perfectly horizontal or vertical, caused by pixels that are too large to represent the line accurately. *See also* anti-alias.

JPEG Short for Joint Photographic Experts Group. A file "lossy" format that supports 24-bit color and reduces file sizes by selectively discarding image data. Digital cameras generally use JPEG compression to pack more images onto memory cards. You can select how much compression is used (and, therefore, how much information is thrown away) by selecting from among the Standard, Fine, Super Fine, or other quality settings offered by your camera. *See also* RAW.

Kelvin (K) A unit of measure based on the absolute temperature scale in which absolute zero is zero; it's used to describe the color of continuous-spectrum light sources and applied when setting white balance. For example, daylight has a color temperature of about 5,500K, and a tungsten lamp has a temperature of about 3,400K.

lag time The interval between when the shutter is pressed and when the picture is actually taken. During that span, the camera may be automatically focusing and calculating exposure. With digital cameras like the Canon PowerShot G12, lag time is generally very short.

latitude The range of camera exposure that produces acceptable images with a particular digital sensor or film.

lens flare A feature of conventional photography that is both a bane and a creative outlet. It is an effect produced by the reflection of light internally among elements of an optical lens. Bright light sources within or just outside the field of view cause lens flare. Flare can be reduced by the use of coatings on the lens elements or with the use of lens hoods. Photographers sometimes use the effect as a creative technique, and Photoshop includes a filter that lets you add lens flare at your whim.

lighting ratio The proportional relationship between the amount of light falling on the subject from the main light and other lights, expressed in a ratio, such as 3:1.

lossy compression An image-compression scheme, such as JPEG, that creates smaller files by discarding image information, which can affect image quality.

maximum burst The number of frames that can be exposed at the current settings until the buffer fills.

midtones Parts of an image with tones of an intermediate value, usually in the 25 to 75 percent brightness range. Many image-editing features allow you to manipulate midtones independently from the highlights and shadows.

neutral color A color in which red, green, and blue are present in equal amounts, producing a gray.

neutral-density filter A gray camera filter that reduces the amount of light entering the camera without affecting the colors. The PowerShot G12 has a feature that acts as a neutral-density filter built into the camera.

noise In an image, pixels with randomly distributed color values. Noise in digital photographs tends to be the product of low-light conditions and long exposures, particularly when you've set your camera to an ISO rating higher than about ISO 800.

noise reduction A technology used to cut down on the amount of random information in a digital picture, usually caused by long exposures at increased sensitivity ratings. In the Canon PowerShot G12, noise reduction is automatically applied for long exposures. Noise reduction can be switched off if you'd rather not use it.

overexposure A condition in which too much light reaches the film or sensor, producing a dense negative or a very bright/light print, slide, or digital image.

pincushion distortion A type of lens distortion in which lines at the top and side edges of an image are bent inward, producing an effect that looks like a pincushion. *See also* barrel distortion.

polarizing filter A filter that forces light, which normally vibrates in all directions, to vibrate only in a single plane, reducing or removing the specular reflections from the surface of objects. Such filters tend to increase the contrast between colors and make blue skies more dramatic, most strongly when the sun is located at a 90-degree angle from the direction the camera is pointed.

RAW An image file format, such as the CR2 format in the Canon PowerShot G12, which includes all the unprocessed information captured by the camera after conversion to digital form. RAW files are very large compared to JPEG files and must be processed by a special program such as Canon Digital Photo Pro or Adobe's Camera Raw filter after being downloaded from the camera.

saturation The purity of color; the amount by which a pure color is diluted with white or gray.

selective focus Choosing a lens opening that produces a shallow depth-of-field. Usually this is used to isolate a subject in portraits, close-ups, and other types of images, by causing most other elements in the scene to be blurred.

self-timer A mechanism that delays the opening of the shutter for some seconds after the release has been operated.

sensitivity A measure of the degree of response of a film or sensor to light, measured using the ISO setting.

shadow The darkest part of an image, represented on a digital image by pixels with low numeric values.

sharpening Increasing the apparent sharpness of an image by boosting the contrast between adjacent pixels that form an edge, whether done in the camera or in image editing software.

shutter In a conventional film camera, the shutter is a mechanism consisting of blades, a curtain, a plate, or some other movable cover that controls the time during which light reaches the film. Digital cameras may use actual mechanical shutters for the slower shutter speeds (less than 1/200th second) and an electronic shutter for higher speeds.

Shutter priority An exposure mode, represented by the letters Tv (Time value) on the G12's mode dial, in which you set the shutter speed and the camera determines the appropriate f/stop. *See also* Aperture priority.

side lighting Applying illumination from the left or right sides of the camera. *See also* back lighting and front lighting.

slave unit An accessory flash unit that supplements the main flash, usually triggered electronically when the slave senses the light output by the main unit, through radio waves, or through a pre-burst emitted by the camera's main flash unit.

slow syncro An electronic flash synchronizing method that uses a slow shutter speed so that ambient light is recorded by the camera in addition to the electronic flash illumination. This allows the background to receive more exposure for a more realistic effect.

specular highlight Bright spots in an image caused by reflection of light sources, often from shiny surfaces.

Spot metering An exposure system that concentrates on a small area in the image. *See also* Center-weighted metering and Evaluative metering.

time exposure A picture taken by leaving the shutter open for a long period, usually more than one second. The camera is generally locked down with a tripod to prevent blur during the long exposure.

tungsten light Light from ordinary room lamps and ceiling fixtures, as opposed to fluorescent illumination.

underexposure A condition in which too little light reaches the film or sensor, producing a thin negative, a dark slide, a muddy looking print, or a dark digital image.

vignetting Dark corners of an image, often produced by using a lens hood that is too small for the field of view, a lens that does not completely fill the image frame, or generated artificially using image-editing techniques.

white balance The adjustment of a digital camera to the color temperature of the light source. Interior illumination is relatively red; outdoor light is relatively blue. Digital cameras like the PowerShot G12 set correct white balance automatically or let you do it through menus. Image editors can often do some color correction of images that were exposed using the wrong white balance setting, especially when working with RAW files that contain the information originally captured by the camera before white balance was applied.

Index

Right cursor button, 56, 58
Ring release button, 48–49
Roscoe lighting gels, 231
rotating images
 with Adobe Camera Raw, 267
 Playback menu's Rotate option, 93–94

S

Safety FE feature, 81
 with built-in flash, 247
Safety MF feature, 38, 78, 174
Safety Shift feature, 83
 with Av (Aperture-priority) mode, 142
 with Tv (Shutter-priority) mode, 143
saturation
 Adobe Camera Raw control, 269
 Custom Color parameter, 116–117
 Super Vivid mode for, 33
Save Settings option, Shooting menu, 88–89
saving power, 105–106
Scene modes. *See* SCN (Scene) modes
Scenery category for images, 95
SCN (Scene) modes, 30–31. *See also* specific modes
 with built-in flash, 248–249
 built-in flash and, 242
 ISO sensitivity settings for, 158
 selecting type of, 32–35
 working with, 150–154
scripts for movies, 200
Scroll Display feature, Playback menu, 66, 97–98
Scroll transition option, Playback menu, 98
scrolling
 through images, 41, 66
 through movies, 200
SDXC memory cards, 11–12
second-curtain sync, 80, 236–238
 with built-in flash, 246

Secure Digital cards. *See* memory cards
self-portraits, LCD screen for, 52
self-timer
 for candid photography, 61
 delay, setting, 59
 for infrared photography, 194
 number of shots, setting, 59
 working with, 40, 59–61, 193
Self-timer button, 56, 58–60
self-timer lamp, 48–49
sensors, light captured by, 135
Sepia setting with My Colors option, 97, 114–117
Servo AF, 77, 170, 180
 Auto shooting mode and, 72
 Set Shortcut button option for, 88
 working with, 178–179
Set Dial Functions, Shooting menu, 47, 57, 87–88
Set Shortcut Button, Shooting menu, 54–55, 88
Set up menu, 71, 99–109. *See also* sound
 Create Folder option, 104
 Ctrl via HDMI option, 107–108
 Date/Time option, 107
 Distance Units option, 107
 Electronic Level feature, 107
 Eye-Fi Settings option, 108
 File Numbering option, 103–104
 Format memory card option, 19–22, 103
 Hints & Tips options, 101–102
 Language options, 108–109
 LCD Brightness option, 102
 Lens Retract option, 105
 Power Saving option, 105–106
 Reset All option, 109
 Start-up Image option, 102
 Time Zone option, 106
 Video System option, 107
 Volume option, 101